Creating Pátzcuaro,
Creating Mexico

JOE R. AND TERESA LOZANO LONG SERIES IN
LATIN AMERICAN AND LATINO ART AND CULTURE

Creating Pátzcuaro, Creating Mexico

ART, TOURISM, AND NATION BUILDING UNDER LÁZARO CÁRDENAS

Jennifer Jolly

UNIVERSITY OF TEXAS PRESS ᗐ AUSTIN

Requests for permission to reproduce material
from this work should be sent to:
 Permissions
 University of Texas Press
 P.O. Box 7819
 Austin, TX 78713-7819
 http://utpress.utexas.edu/index.php/rp-form

♾ The paper used in this book meets the minimum
requirements of ANSI/NISO Z39.48-1992 (R1997)
(Permanence of Paper).

Library of Congress Cataloging-in-Publication Data

Names: Jolly, Jennifer, author.
 Title: Creating Pátzcuaro, creating Mexico : art, tourism, and nation building
 under Lázaro Cárdenas / Jennifer Jolly.
 Description: First edition. | Austin : University of Texas Press, 2018. | Includes
 bibliographical references and index.
 Identifiers: LCCN 2017025392
 ISBN 978-1-4773-1419-7 (cloth : alk. paper)
 ISBN 978-1-4773-1420-3 (pbk. : alk. paper)
 ISBN 978-1-4773-1421-0 (library e-book)
 ISBN 978-14773-1422-7 (non-library e-book)
 Subjects: LCSH: Pátzcuaro (Mexico)—History. | Cárdenas, Lázaro, 1895–1970. |
 Mexico—Politics and government—1910–1946. | Politics and culture—Mexico. |
 Culture and tourism—Mexico.
 Classification: LCC F1391.P33 J65 2018 | DDC 972/.37—dc23
 LC record available at https://lccn.loc.gov/2017025392

doi:10.7560/314197

To Chris, Joey, and Teo

Contents

Acknowledgments

The seed for this project was planted many years ago when friends in Mexico City introduced me to the murals of Ricardo Bárcenas (plates 5 and 6) and encouraged me to visit them in Pátzcuaro myself. I had been living in Mexico City as a Fulbright–García Robles predoctoral fellow. The trip to Pátzcuaro, by then a city of 30,000 people, felt curiously like a homecoming. I myself am from Saratoga Springs, New York: a city of a similar size, also situated near a lake, hills, and forests; subject to seasonal waves of tourists; developed for mass tourism with federal New Deal money in the 1930s; and governed by urban planning laws that seek to preserve a distinctive period aesthetic. While the aesthetics of Saratoga and Pátzcuaro are completely distinct, my own ambivalence about growing up in a tourist town perhaps piqued my interest in the history of this region in Mexico. My lingering art historical question about why the most succinct artistic pronouncement of President Lázaro Cárdenas's political and cultural agenda is painted on the walls of a theater in this small city began to mingle with my observation that the majority of visitors to Pátzcuaro during our Holy Week visit were Mexicans. As I learned more, my question as to why there was a concentration of industrial-themed murals in Michoacán was reframed as I realized that Cárdenas had chosen Pátzcuaro as a laboratory for the development of a regional, tourism-based economy, using a program that combined radical modernization with a commitment to "preserving" (reinventing, really) traditional Mexico.

A 2010 Fulbright–García Robles fellowship allowed me to return to the region with my family for a sustained period of research. I am grateful to the Universidad Michoacana de San Nicolás de Hidalgo (UMSNH) and the Facultad de Filosofía for hosting my stay in Morelia, and for the collegial support of Ana Cristina Ramírez Barreto, Adriana Piñeda, Catherine Ettinger, Carmen López, Gerardo Sánchez Díaz, and Guadalupe Chávez, among others, who were all generous with their time and knowledge during my various visits. Ivonne Solano and Teresa Fernández Martínez at the Centro de Documentación e Investigación de las Artes provided invaluable support, information, and resources. Thanks also to the staff at Morelia's Hemeroteca, the Instituto de Investigaciones Históricos (IIH) library, and the Archivo General e Histórico del Poder Ejecutivo de Michoacán (AGHPEM), especially María Teresa Carmona León in the Fototeca. I extend special appreciation for the work and hospitality of Sofía Irene Velarde Cruz and to Eduardo Rubio for welcoming me into his home. And I would like to acknowledge the assistance that I received at the Colegio de Michoacán in Zamora, particularly the guidance of Verónica Oikión Solano and Paul Kersey Johnson.

In Pátzcuaro, Enrique "El Chino" Soto González provided invaluable direction, sharing photographs and referring me to local families who could help me piece together my understanding of the region's history. Gloria Blancas López at the Bocanegra Library was always generous with time and information, as were the staffs at the municipal archive, at the Centro de Cooperación Regional para la Educación de Adultos en América Latina y el Caribe (CREFAL), and at the Museo de Artes e Industrias Populares. Aida Castilleja González was wonderful to talk with; I am especially grateful to her for introducing me to the region's *miradores* (scenic overlooks) and sharing her insights about their role in unifying the region. Various locals provided information and resources, including the González Serín family, Gerardo Díaz, Monica Grey, and Miguel Monje. Thank you also to Enrique Garnica Portillo for always helping my family and me feel at home and welcome in Pátzcuaro.

In Mexico City, I am grateful to the numerous individuals at the Universidad Nacional Autónoma de México (UNAM) and the Archivo General de la Nación (AGN) who facilitated my research. I would particularly like to thank Ernesto Peñaloza and Dafne Cruz Porchini for sharing their own research, images, and films with me. I am also grateful for the assistance, suggestions, and time of various scholars, including Alicia Azuela, Renato González Mello, Clara Bargellini, Karen Cordero, Tely Duarte, and Héctor Mendoza Vargas. I would also like to acknowledge the long-term work that Leticia López Orozco has done to promote the study of muralism in Mexico.

I offer a special thank you to the family members and students of artists that I have been studying, including Ana María de la Cueva, J. J. González, Liza Arredondo, and Melchor Peredo. Their stories and the images that they shared helped enrich my understanding of the artists who visited Pátzcuaro. Additional thanks to David Haun and Tracy Novinger for help with images.

A host of scholars have provided invaluable feedback and support along the way. I am grateful for the early support of Alejandro Anreus, Leonard Folgarait, and Robin Greeley as I developed this project. The feedback that I received as I shared this material in various formats has been invaluable. Thus I wish to acknowledge a range of colleagues and friends, including Jordana Dym, Jay Oles, Alexis Salas, Mary Coffey, Rick López, Anna Indych-López, and Barry Carr; my New York State Latin American Workshop (NYSLAW) colleagues and participants, including Nancy Applebaum, Ray Craib, Thomas Rath, and Alan Knight; Kathryn O'Rourke and Mike Schreyach; and Staci Widdefield and her students and colleagues participating in Arizona State University's Water Seminar. I am also grateful for the thorough and thoughtful comments of my readers, Mary Coffey and Jason Ruiz, and the guidance of the editorial staff at the University of Texas Press, Angelica Lopez-Torres, Lynne Chapman, and Kerry Webb.

Ithaca College has provided support for this project at key moments, including a 2009 Summer Research Grant and support for image rights. I would also like to acknowledge Lauren O'Connell, Jennifer Germann, Jonathan Ablard, Annette Levine, Patricia Rodríguez, Paul Wilson, Nancy Brcak, and Gary Wells for the guidance, feedback, and support that made writing this book possible, as well as my student assistant Gabriella Jorio. Thank you also to my department and Dean Leslie Lewis for making it possible for me to take a leave to write much of this book when I received a 2013 National Endowment for the Humanities Research Fellowship.

I could not have seen this project through without the support of my family. From helping herd three-year-old twins around Pátzcuaro, Morelia, and Ithaca while I was visiting archives to providing moral support and sharp ears along the way, thanks go to George Jolly, Caroline Seligman, Jay Rogoff, and Coral Crosman. Special thanks go to my mother Penny Jolly, whose mentorship during my career as an art historian has been invaluable. To Chris Gonzales, I can say thank you for your patience and support—it has been wonderful having you at my side during the various adventures that accompanied the research and writing of this book. And all my love to Joey and Teo, whose fascination with Los Viejitos dance and places like Janitzio helped me see the world of tourism with fresh eyes.

Creating Pátzcuaro, Creating Mexico

Introduction

esidents of Pátzcuaro in Michoacán still claim that this piece of western Mexico might have become Mexico's capital, if the Purépecha Indians hadn't thrown rocks to scare away the migrating Aztecs' prophesied omen: an eagle alighting on a cactus, destined to indicate where the Aztecs should settle.¹ This appropriation of the Aztecs' migration story, used to legitimate first Tenochtitlan and later Mexico City as Mexico's center, suggests simultaneously a willful rejection of and lost claim to centralized authority. Patzcuareños grappled with such an opportunity again in the 1930s, when former Michoacán governor Lázaro Cárdenas was elected president of Mexico. Cárdenas's cultural and economic investment in transforming and promoting the Pátzcuaro region began soon after he built an estate there in 1928. Following his election as president in 1934, he mobilized federal resources to re-create and promote Pátzcuaro as Mexico's heart. Thus Pátzcuaro, a city of 8,000 residents, and its neighboring lake became the setting for the most coherent projection of Cardenista artistic and cultural policy. He commissioned public monuments and archaeological excavations; supported new schools, libraries, and a public theater; developed tourism sites and infrastructure, including scenic overlooks and a Museo de Artes e Industrias Populares; and hired artists to paint murals celebrating regional history, traditions, and culture. I argue that Cárdenas's attention trans-

formed the region into a microcosm of cultural power in 1930s Mexico and that in its creation we find the foundations of modern Mexico.

Pátzcuaro emerged as a microcosm of cultural power and as a model for regional development both because of its favored status and because its creation addressed specific needs in postrevolutionary Mexico. However, Pátzcuaro was not created out of whole cloth in the 1930s. Rather, Pátzcuaro's rich history and location primed it for this moment. A sacred site near and barrio (ward) under the control of the fifteenth-century lakeside Purépecha imperial capital, Tzintzuntzan, the region has long been a center for the Purépecha people (referred to as the "Tarascans" during the 1930s). Pátzcuaro itself became the region's capital during the first century of Spanish conquest, when the region's founding bishop, Don Vasco de Quiroga, moved the seat of his new bishopric to the site and established the modern city in 1540. While power shifted north to Valladolid (now Morelia) in 1580, Pátzcuaro retained its customs house and remained on trade routes linking Acapulco and Mexico City, allowing the city to develop into a cosmopolitan center in the eighteenth century. This location and history made Pátzcuaro a point of interest for elite travelers starting in the eighteenth century. It continued to draw a range of travelers in the early twentieth century, from religious pilgrims and artists to regional politicians retreating to lakeshore estates from the capital, Morelia.

Following the lead of Michoacán political elites, the newly installed Governor Cárdenas began constructing an estate, La Quinta Eréndira, on the outskirts of Pátzcuaro in 1928. To appreciate what it meant for Cárdenas to assimilate himself into this region, however, one must understand that Michoacán was highly unstable in the 1920s. It was divided between the emerging agrarian movement, which organized around programs of land redistribution and secular education promoted by Cárdenas and his mentor, former governor General Francisco Múgica, and the conservative Cristeros, who violently opposed such reforms. Engaging the local elite, local activists, and neighbors, Cárdenas began to create networks of power and support in this contested region. He launched the Confederación Revolucionaria Michoacana del Trabajo (CRMDT) in 1929 in Pátzcuaro, redistributed land, founded *ejidos* (land grants for farming collectives) and public schools, and directed state funds to infrastructure development and cultural projects around the ideologically divided lake area, working to facilitate a new regional tourism economy. While support for his radical political vision was limited, local patronage effectively mobilized adherents. For his efforts, municipal leaders named him *hijo predilecto* (favorite son) in 1931.[2]

As Cárdenas rose to national leadership, he continued to support the lake region. Appointed secretary of war (1933–1934), he deployed the Zapateros battalion and the 22nd Regiment to construct a 40-meter monument to independence hero José María Morelos on Janitzio, an island in Lake Pátzcuaro, initiating a program of redirecting the Mexican army to civic development projects.[3] As president (1934–1940), Cárdenas channeled federal resources into Pátzcuaro's transformation. The Secretaría de Educación Pública (SEP) reported working in Pátzcuaro at the president's request: a new fountain, a public theater filled with murals, monuments, a museum, and a library.[4] As Michoacanos were assigned key posts within the new administration, and as government officials and intellectuals recognized Cárdenas's interest in this region, federal involvement in Pátzcuaro (and Michoacán) grew.[5] Eager to demonstrate the usefulness of history and culture in the nation-building context, artists and intellectuals made their cases for Pátzcuaro's central role in the country's development, in federally funded archeological explorations, linguistic and cultural studies, artworks, and histories. Notably, many who contributed to this nation-building project found their ways, at least temporarily, to prominent positions within the country's developing Mexico City–based institutions: archeologist Alfonso Caso at the Instituto Nacional de Antropología e Historia (INAH, founded in 1939), historian Silvio Zavala at the Instituto de Historia (Colegio de México, founded in 1940), art historian Manuel Toussaint at the Instituto de Investigaciones Estéticas (founded in 1936), and artist Ricardo Bárcenas at the Escuela Nacional de Artes Plásticas (ENAP, founded in 1781 as the Academia de San Carlos); sculptor Guillermo Ruiz was already the director of the Escuela Libre de Escultura y Talla Directa (founded in 1927) when he began working for Cárdenas. Meanwhile, Michoacano politician and historian Jesús Romero Flores led the history department within Mexico City's Museo Nacional de Arqueología, Historia y Etnografía (founded in 1910) and guided its transition into the Museo Nacional de la Historia (in 1944).[6] Thus the creation of Pátzcuaro was integrated into Mexico's postrevolutionary creation, from its national ideology to the foundation of its professional research and educational institutions.

The creation of Pátzcuaro, however, was not purely an elite project. A key question for scholars of nation building has been: if nationalism is artificial and constructed at the elite level, why is it so persuasive and persistent? The answer lies in the degree to which nationalism is maintained via mass participation.[7] Pátzcuaro's creation provided such an opportunity for the mass generation and maintenance of national ideologies, origin stories, and myths, as the city was transformed from an elite retreat into a center for mass tour-

ism. The tourism magazine *Mapa* praised Pátzcuaro's revitalization precisely for its potential to generate nationalism, musing:

> The foreigner who comes to Pátzcuaro cannot return without a profound sympathy for Mexico; the Mexican who visits this town understands the sense of our nationality, [in a] trajectory [that] continues, tacitly, through a succession of generations to affirm a country with character, with its own soul, loyal to our lands and our blood.[8]

Such effusive language suggests that it was visitors' embodied, affective, and aesthetic experience of a place—its historic architecture and space, newly framed vistas, monuments, and traditional market (the *tianguis*)—that held this potential to transform a Mexican into an authentic citizen or a foreigner into Mexico's friend. Meanwhile, popular press essays, guidebooks, and exhibitions introduced the masses to regional history and encouraged domestic travel. The creation of Mexico's domestic tourism industry allowed Mexico's intellectuals, artists, town planners, and government officials to translate national ideologies into localized forms that the masses could reproduce, consume, assimilate, and even reinterpret. In this context, art and tourism functioned together as a technology of nation building.

ART, VISUAL CULTURE, AND NATION BUILDING

Art historians agree that art was fundamental in Mexico's postrevolutionary reconstruction and have examined artists' contributions to creating a national ideology and the Mexican state's institutionalization of art, including the celebrated Mexican Mural Movement.[9] Starting under President Álvaro Obregón (1920–1924), the Mexican state dramatically expanded funding for public education, recognizing its centrality to postrevolutionary nation building.[10] The federal Secretaría de Educación Pública shaped state cultural policy by funding and coordinating education, research, and art commissions (including murals). However, scholarship on postrevolutionary art tends to focus on Mexico City, the nation's capital, or on the SEP's foundational role in the 1920s. My examination of regional art and visual culture's contribution to Mexico highlights an understudied phenomenon within Mexican art history. Cultural geographers, following the lead of Henri LeFebvre, emphasize the spatial dimension of modern capitalism and nation building, while anthropologist Claudio Lomnitz has called for regional studies of cultural production that combine the material concerns of regional systems theory with

the ideological and rhetorical concerns of cultural studies.[11] Mexico's postrevisionist historians have used regional history to assess Mexico's national reintegration and state building following the Mexican Revolution and assert that the national was necessarily defined via the regional and vice versa.[12] Yet, despite a growing number of studies of modern Mexican art outside Mexico City, the phenomenon of artistic regionalism as a product of modern nation building has yet to be addressed systematically.[13]

By centering Pátzcuaro's art and visual culture, I reconstruct a largely obscured history of art under Cárdenas, Mexico's most celebrated twentieth-century president. Art historians typically argue that state art patronage was diffuse under Cárdenas. Mexico's celebrated murals are rare in Mexico City (art historians' focus), as efforts were redirected toward posters, radio, film, and the mass media more broadly, under the newly established Departamento Autónomo de Prensa y Propaganda (DAPP), which competed with the SEP for control of cultural policy.[14] I demonstrate that Cárdenas was the patron of an elaborate program of monuments and murals, commissioned through the SEP and realized in the Pátzcuaro region. This turn to regional cultural development spoke both to Cárdenas's own trajectory—his personal connection to the region and his longtime efforts at cultural and economic modernization there—and to a broad concern at the federal level with regional integration. Art and visual culture were instrumental in the process of linking the local to the national, which proceeded, according to Alex Saragoza, within four arenas: the discourse of *indigenismo*, the development of monuments, the celebration of folklore, and a quest to define the vernacular.[15] Such projects intersect in Pátzcuaro's creation, suggesting that Cárdenas's artistic legacy was developing a model for cultural regionalism, which has become central to defining modern Mexico both ideologically and institutionally.

Meanwhile, many have framed 1930s Mexican art in terms of internationalism or cosmopolitanism, tracing leading artists' ventures abroad and engagements with technology, communism, and the Popular Front struggle against fascism.[16] Such a focus is entirely appropriate, given the internationally recognized leadership of artists like Diego Rivera and David Alfaro Siqueiros, as well as Mexico's international profile under Cárdenas. However, the view from Pátzcuaro presents a rather different 1930s Mexican art scene and needs to be understood as a strategic counterpoint to this internationalist vision. In Pátzcuaro, art largely focused on local history and culture, reimagined through a national lens. Here the demands of nation building and economic development worked together to project a redemptive vision

of indigenous, rural Mexico for Mexican and international audiences alike — affirming and refining a vision of "authentic" Mexico that since the 1920s has been officially promoted at home and abroad as Mexico's national image.[17]

The coexistence of such visions of Mexico is neither ironic nor contradictory; instead it demonstrates two features of 1930s art. First, it reminds us that polemics defined the art world in the 1930s, in Mexico and internationally. Collapsing private art markets coupled with the rise of fascism inspired the development of antifascist art groups, like Mexico's Liga de Escritores y Artistas Revolucionarios (LEAR), which debated the best course for art during a time of crisis. Within Mexico's art world, where a small private art market was supported in part by foreign patrons and the tourism industry and where the state increasingly looked to tourism for economic development, art addressing so-called touristic themes — beautiful or soulful Indians, folklore, and archeology — was heavily critiqued by Mexico's avant-garde.[18] The stakes were high: what would Mexican art look like, who was its audience, and which artists would survive or thrive as professionals? Simultaneously, the rise of multiple visions of Mexican art during this period also reveals artists' and patrons' growing attention to, and even creation of, *spatially differentiated* publics and agendas. Beyond mere evidence of the very real disagreements that defined 1930s artistic and political cultures, the difference between art in Pátzcuaro and art in Mexico's center, Mexico City, represents a political strategy of national integration.

While art, architecture, and visual culture created an aesthetic illusion of a Pátzcuaro steeped in the traditional and regional — coded as *lo típico* (the typical) — the Pátzcuaro project was fundamentally about radical modernization. For Cárdenas, the creation of Pátzcuaro was the answer to an essential question: how can a contentious region be integrated economically, politically, and culturally into the modern nation? Although the question was hardly unique to Pátzcuaro, the city's prominence during this period makes it an ideal vantage point from which to analyze the role of art and culture within regional modernization. Regional political modernization required generating institutional infrastructures and facilitating mass participation in the modern nation-state — from secular public education and labor organizations to secular festivals and new communication networks, like the radio.[19] Regional economic modernization involved land redistribution; expanded communications infrastructure, including electrification and highway development; and the development of regional economies. In this context, cultural tourism emerged as a key technology of modern nation building. It generated a logic for circulating people and resources around the

nation's territory; it materialized and put on public display many intangible elements of national identity, including history, culture, and the landscape; and it offered the emerging middle and organized working classes secular, ritualized leisure-time activities that would allow them to engage with these signs of nationhood, both individually and collectively.

Artists and intellectuals—some working for the state, others independently—appropriated, transformed, and represented the region's history and culture, contributing ideological and affective mechanisms for modern nation building. The creation of Pátzcuaro *típico* implied a scientific process of systemization and categorization, in which the architecture, people, culture, and scenery of Pátzcuaro were put on display, gazed upon, researched, cataloged, analyzed, commodified, and subjected to regulation and legislation. The result of this transformation, stimulated as it was by a federal logic of nation building, was a city whose history and aesthetics informed and were informed by national needs and prototypes. And as Pátzcuaro embodied national ideals, its creation simultaneously required a forgetting of those local elements that exceeded the version of the national that was in the process of being reinvented—thus denying the city's history of racial diversity (including a large Afro-mestizo population), trade with Asia, and cosmopolitanism. In this context of remembering, forgetting, and reinventing, Pátzcuaro became a microcosm of Mexico.

THE REGIONAL AND THE NATIONAL

The "nation" is an ideological concept, created and re-created in the historical claims made in its name.[20] The same is arguably true for the region. My premise is that in the 1930s two competing ways of imagining the region vis-à-vis the nation crystallized. The first suggested that Mexico was the sum of its regions, each with distinctive cultures, products, and landscapes to contribute to the national whole. This tradition emerges from scientific collecting practices, in which scientists create a "type"—an abstract ideal generated via empirical study that represents a category within a larger classification system. Within nineteenth-century national atlases, such types signified regional pieces of a whole. José María Morelos's portrait and an image of a fisherman with a butterfly net canoeing on Lake Pátzcuaro graced for many years Mexico's fifty-peso note, which speaks to the perseverance of Pátzcuaro *típico* within this tradition of imagining the nation. Meanwhile, an alternative paradigm emerged to assert that the regional could embody the national; under certain circumstances, the local might serve as a microcosm

of the nation. Both models still operate today, and art and visual culture contribute to their maintenance.

Following the upheaval of the Mexican Revolution, "Mexico" was reconstituted by metaphorically assembling its fragmented territory (albeit selectively). Various 1920s artistic projects testify to this approach to understanding the nation, building on and expanding eighteenth- and nineteenth-century celebrations of regional distinctiveness. Hugo Brehme, in *México pintoresco* (1923), presents photographs from around the country; the natural splendor, monuments, and customs of each region mark the parts of a whole, offering a semblance of healing to the war-torn nation. The 1921 Exhibition of Popular Art in Mexico City, coordinated by Roberto Montenegro, Jorge Enciso, and Dr. Atl (Gerardo Murillo), brought together *artesanías* (handicrafts) from selected regions in Mexico in an attempt to identify a national aesthetic coherence within popular art, instill an appreciation for this aesthetic in viewers, and stimulate regional economies.[21] Diego Rivera signified Mexican unity in his "Court of Labor" murals at the SEP by presenting climates, economies, genders, and revolutionary potentials of the country's different regions. Oriented to the four cardinal directions (and three levels), Rivera's mural cycle constitutes the SEP and Mexico City as an axis mundi. Meanwhile artists, photographers, and elite collectors used the format of a regional series (for example, Carlos Mérida's 1945 print portfolio featuring regional costumes) to imagine the nation as a collection of parts and offered a model that could be emulated by the emerging middle class, traveling or even just collecting regional postcards, calendar prints, and portable *artesanías*. Such strategies suggest that in order to conceptualize the nation, it was equally necessary to differentiate its regions. While this postrevolutionary nation was created as the sum of its regions, however, the nation's universality became contingent on the region's specificity.

Of course it is important to remember that the ideological construction of a nation is distinct from the creation of a centralized state. Thus while projects like Rivera's worked to constitute Mexico City as the nation's center, this centralization—both spatial and metaphorical—around the nation's capital was not to be taken for granted. As scholars have demonstrated, centers are constituted as part of historical and hegemonic processes of capitalism and nation-state building.[22] Yet today's historians have argued that in contrast to revisionist accounts describing the postrevolutionary consolidation of an authoritarian state in Mexico in the 1920s and 1930s, in actuality the framework for such a state was just being put into place at this time. The coherence of the country, its revolutionary project, its economic future, and its center were being negotiated (and contested) at national and local levels.[23]

Within the fields of history and anthropology, examining the regional has been key to such critical assessment; as Claudio Lomnitz notes, analysis of regional culture can disrupt the myth of *lo mexicano* (Mexicanness).[24]

Art historians have certainly debated the relative coherence of postrevolutionary cultural policy and its role in consolidating political authority in Mexico but have not focused sustained attention on the *spatial* elements of this process.[25] Not only did artists and intellectuals generate visual practices and structures that would ideologically center the nation's regions, but the state itself developed a cultural policy designed to facilitate regional integration and centralization. The SEP used its postrevolutionary control of arts education and funding to claim a central role in Mexico's art world, and in the 1930s extended its regional control of arts and education.[26] The SEP ran art schools in and around the capital, drawing students to Mexico City from various regions. It also distributed artists and intellectuals around the country in "cultural missions" (1920–1938), which were designed to provide rural literacy and arts instruction as well as to recover, reconstruct, and collect regional art and culture and bring it back to Mexico City.[27] The SEP's Department of Monuments likewise sent inspectors around the country to document and monitor a growing roster of federally controlled regional museums, archaeological sites, and historical monuments, until 1939, when it was reorganized within the Instituto Nacional de Antropología e Historia (INAH: National Institute of Anthropology and History). And higher education contributed to this cultural centralization. When the Universidad Nacional Autónoma de México (UNAM) promised in 1937 to serve as a "scientific informant" for the federal government and dedicate itself to national problems, it also accepted responsibility for studying regional Mexico.[28] Thus Mexico City was gradually institutionalized as the national center, charged with educating, studying, and regulating regional Mexico.

Of course, such centralization did not proceed unfettered. As historian Mary Kay Vaughan has demonstrated, federal projects were inevitably negotiated at the local level.[29] SEP representatives worked in dialog with local officials in Pátzcuaro, community members, and historical memory and were not accepted wholesale. Policarpo Sánchez (the school inspector), Alberto Leduc Montaño (architect and monuments inspector), Ramón Alva de la Canal (artist), and Juan E. Noguez Becerril (library director) all reported resistance, frustration, and outright opposition to their local efforts or presence.[30] Regional subordination to federal institutions and their representatives could not be taken for granted.

Further undermining the centralization of Mexico's art world, the SEP and its institutions were highly unstable in their early years. An uneasy truce

governed the realm of art education, as a revolving succession of controversial directors at ENAP was balanced by support for a series of alternative schools, including the Open-Air Painting Schools (1913–1935) and the Escuela Libre de Escultura y Talla Directa (1927–1942), which in 1942 integrated painting and graphic arts and became the Escuela de Artes Plásticas (renamed again in 1943 as the Escuela Nacional de Pintura, Escultura y Grabado and today best known as La Esmeralda).[31] Thus Mexico institutionalized parallel systems of art education.

Meanwhile, Cárdenas attempted to restructure and centralize governmental communications and coordinate Mexico's image at home and abroad—from government publicity and publications to exhibitions, concerts, films, and radio broadcasts.[32] Recent studies have stressed the authoritarian elements of the Departamento Autónomo de Prensa y Propaganda (DAPP, 1937–1940), including its use of communication media as weapons of social control.[33] Art historian Dafne Cruz Porchini notes that the department was inspired by examples set by communications ministries in Germany, France, and Italy and sought not only to inform but also to convince, or even control, the public through a coordinated propaganda effort.[34] Radio and film were key new media exploited within what Fernando Mejía Barquera has described as Mexico's "laboratory of social communications."[35] The DAPP also took increasing control over the graphic arts, including photography, posters, and the publication of pamphlets, books, and journals like *El Maestro Rural* and *Mexican Life* (renamed *Mexican Art and Life* under the DAPP), employing multiple artists and photographers, including Fernando Ledesma and Francisco Díaz de León (posters), Enrique Gutmann and Manuel Álvarez Bravo (photography), and Carlos Mérida, to give "visual coherence" to state propaganda.[36] Thus the DAPP competed with the SEP and, according to Cruz Porchini, even displaced it (albeit briefly) as the state's main "emissary of culture" in the 1930s.[37] But the DAPP lasted barely two years and arguably failed precisely due to resistance to centralization by the SEP and other offices within the federal government itself.

Broadly speaking, 1930s federal arts funding was fickle. Artists learned not to rely purely on the government, instead finding alternative patrons and publics for their movement—many outside the nation's capital. State universities in Guadalajara, Michoacán, and Veracruz became patronage sources. In the 1930s labor organizations as well as hotels around the country began to offer work to artists. Such opportunities allowed alternative artistic centers to develop, in regional capitals like Jalapa, Guadalajara, and Morelia as well as in emerging tourism centers like Taxco, San Miguel de Allende, and Pátzcuaro. Meanwhile, foreign patronage and international engagements like-

wise offered Mexican artists alternatives to state support. Thus efforts to centralize Mexican art and visual culture met centrifugal forces decentralizing the artworld.

A growing body of art and visual culture literature emphasizes the importance of the local and regional, although few have explicated a theoretical framework for its study. An exception is Esther Gabara, who argues in her excellent study of Mexican and Brazilian modernist photography that the ethos of modernism is not purely hegemonic but also contains a theory of the local, within which practices of tourism, trade, and colonization "constituted difference rather than homogeneity."[38] This resurrection of local distinctiveness was a key element of modernity and extended beyond the photographic to the re-creation and promotion of regional *artesanías* and performing arts as well as modernist efforts in the realms of painting, printmaking, film, music, and theater. Art historian María Fernández, applying a cosmopolitan lens to the study of Mexican visual culture, would tell us that this is nothing new: since colonization, the vernacular and local have provided core elements shaping cosmopolitanism in New Spain and later Mexico.[39] For both Gabara and Fernández, this insistence on the local emerges in the context of colonization and the global circulation of goods, peoples, and ideas. Each makes a case for generating narratives of postrevolutionary visual culture that transcend a centering national narrative: Fernández, though an engagement with cosmopolitanism; Gabara, by tracing images that "err."

Thus the ideological stakes of conceiving the region as a mere piece of the nation become clear. This not only promotes regional subservience to the nation but also becomes a strategy for imagining a national coherence that exceeds reality. At the same time, it does not take into account that the local might define itself within an alternative system, beyond the national. Such was Pátzcuaro at other historical moments; for example, when it served as a sacred site with its own axis mundi under the Purépechas; when it was the sixteenth-century seat of the bishopric of Michoacán under Don Vasco de Quiroga; or when it thrived as an eighteenth-century cosmopolitan trading center, bringing goods and people from Asia, the Americas, Africa, and Europe through its customhouse. Meanwhile, it also suggests that we should critically assess an alternative means of conceiving the region vis-à-vis the nation: the microcosm.

REGION AS MICROCOSM

While multiple centers of artistic and cultural activity emerged in postrevolutionary Mexico to contest the singular authority of state art and cul-

ture, what happened in Pátzcuaro in the 1930s is distinct and offers a means to understand how a region might promote itself as emblematic of Mexico itself. Pátzcuaro's privileged status in the 1930s was the result of Cárdenas's special attention; as such, Pátzcuaro's emergent authority was not at the expense of a nation-building effort, even as it offered an alternative, localized interpretation of *lo mexicano*. In positing Pátzcuaro as a microcosm of cultural power in Mexico—asserting that the creation of Pátzcuaro provides a compelling analog to the creation of Mexico—I argue not only that artists and intellectuals were able to generate a robust variation of national ideology in Pátzcuaro but also that their efforts contributed to the development of national institutions and techniques of governance relevant to the nation at large.

Anthropologist Néstor García Canclini suggests that regional types or symbols become emblematic of *lo mexicano* as a product of mid-twentieth-century capitalism.[40] While this is indubitably part of the story, study of this process in 1930s Pátzcuaro suggests a broader context, in which local elites, artists, and intellectuals reinvented local types and stories as national in order to make claims for relevance, recognition, and federal funding within the modern nation. Examination of other regional *cum* national symbols—the China Poblana or the Tehuana (women of Puebla and Tehuantepec), for example—reveals a core element of national-symbol making: these regional symbols become national when inscribed and recast in terms of national foundation myths. Artists and intellectuals cast Oaxaca's Tehuantepec region as Mexico's mythical Eden, populated by Mexico's ultimate symbol of unconquered indigenous purity, the matriarchal Tehuana (her mixed heritage and celebrated sexuality notwithstanding).[41] Poet Amado Nervo paints a patriotic verbal picture of a nineteenth-century China Poblana, dressed in the colors of the Mexican flag, tending the wounded and searching for her lover, who has fought against the French intervention in Puebla.[42] The key elements of these mythic constructions—especially the idea that the nation's origins lie in a realm of unconquered purity and resistance to foreign intervention—are likewise mobilized and rehearsed in the creation of Pátzcuaro. As we shall see, however, such mythmaking strategies may help fix regional symbols in national memory even as they equally require the forgetting of historical realities—for example, the likely Southeast Asian origins of the original China Poblana or the mixed indigenous, Spanish, African, and Asian heritage of Tehuanas.[43] Such strategies are used throughout Mexico to claim national relevance. As in the case of Pátzcuaro (not unlike the Tehuantepec region under President José de la Cruz Porfirio Díaz Mori),[44] however, the

elevation of the regional as the national is enhanced when the ideological work of symbol making aligns with political and economic patronage.

To pursue my proposition that Pátzcuaro can be understood as a microcosm of cultural power in 1930s Mexico, we must consider not just the local generation of national ideology but also how the Pátzcuaro project contributed to Mexico's state-building efforts during this fundamental period. Mary Coffey's excellent study *How a Revolutionary Art Became Official Culture* draws our attention to the way in which processes of institutionalization—both the creation of state governance structures and techniques of governance—have helped unite postrevolutionary Mexico's heterogeneous artistic and cultural propositions. While her focus is on museums and murals in the national capital between the 1930s and 1960s, my study of Pátzcuaro highlights the emergence or transformation of a range of Mexican institutions under Cárdenas, including educational and research institutes. Intellectuals participating in Pátzcuaro's creation were key players in the larger period academic debates, and the surge of state-supported publications about Michoacán was not coincidental. In what terms should art or history be useful to the nation? How much autonomy should be sacrificed in the name of professional stability? What was the proper balance between teaching and pursuing a creative project? How far should social science methodologies extend into the humanities? The fallout from such debates—reflected in the reassertion of the UNAM's autonomy, the rise of the *arte puro* (pure art) faction within the ENAP, and the creation of a series of research institutes and schools outside the purview of the UNAM, including the Instituto Politécnico Nacional (IPN: National Polytechnic Institute), Colegio de México (1940), the INAH (1939), and the Escuela Nacional de Antropología e Historia—speaks to the limits of the Cárdenas administration's cultural policies and the turn toward a somewhat decentered model for academic Mexico.

In examining institutionalization, Coffey specifically asks us to consider how murals and museums offer new techniques of governance for the modern world. I suggest that the study of Pátzcuaro can expand our view of such technologies beyond murals and museums to include an even broader array of art and cultural forms, from the visual culture and literature of tourism to art history texts and the creation of historical preservation zones. I am not the first to suggest Pátzcuaro's importance for postrevolutionary nation building in this regard. Anthropologist Ruth Hellier-Tinoco, in her excellent study of how Pátzcuaro's Noche de los Muertos and Los Viejitos folk dance became national symbols, asserts that intellectuals' efforts in Pátzcuaro offered a strategy for incorporating indigenous and rural practices into the nation:

"Unmistakable are the *processes* of collecting, appropriation, authentication, commodification, exhibition, and nationalization of objects and peoples of Lake Pátzcuaro within a Mexican paradigm."[45] Beyond developing processes, I suggest that creating Pátzcuaro helped define the terms of professional viability. Artists and intellectuals learned to frame their work as useful to the nation: academics published guidebooks and newspaper articles, museums and research institutes offered courses for tour guides, artists created public monuments and murals. Popular rituals developed: touring and sightseeing become a national rite of passage not only for artists and intellectuals but also for the masses. And tourism's practices—gazing, contemplating, witnessing, reading, ascending, exploring, encountering, transacting, collecting—took on special significance within an industry increasingly aware of its social, political, and ideological role. What emerges is an engagement with nation building within academic and popular channels alike.

Finally, in considering Pátzcuaro as a microcosm of cultural power in Mexico, it is worth reiterating that not all cultural production in Pátzcuaro proceeded under the federal government's auspices. The state of Michoacán and the municipal government itself supported various projects, and others developed as private enterprise. Pátzcuaro's history both predated and post-dated Lázaro Cárdenas; its long-standing place on travelers' and historians' maps helps account for Pátzcuaro's ability to increase its role on the national stage beyond Cárdenas's *sexenal* (six-year presidential term). By contrast, Cárdenas also poured cultural resources into his hometown, Jiquilpan, even hiring José Clemente Orozco to paint murals in a former chapel turned library (in addition to works by Guillermo Ruiz, Roberto Cueva del Río, and Alberto Leduc, all active in Pátzcuaro). However, while historians visiting Cárdenas's archives or studying Orozco may know Jiquilpan, it is not on the casual traveler's agenda today, despite Cárdenas's patronage. The persistence of Pátzcuaro reflects its longtime location along well-worn travel routes and its ability to accommodate and cater to artists, intellectuals, locals, and tourists by engaging multiple and at times competing discourses.

DOMESTIC TOURISM AND NATION BUILDING

As scholars Dina Berger and Alex Saragoza point out, tourism has helped create modern Mexico, from spurring economic development to providing a space in which leaders can negotiate, represent, and celebrate national identity.[46] The tourism sector developed through collaboration between the Mexican state and private enterprise, and scholars debate the extent to which

we should understand tourism as contributing to the consolidation of post-revolutionary state authority. For Saragoza, tourism served as an instrumental interface between the local and the national and its study "illuminates the workings of an authoritarian regime, including its ideological and cultural project."[47] By contrast, Esther Gabara asserts that the modernist engagement with tourism demonstrates that domestic tourism was on the "margins of the state's cultural project" and even claimed an oppositional role.[48] Pátzcuaro provides a compelling site to assess this debate, given that it was central to Cárdenas's vision for state-facilitated tourism development and simultaneously a site of modernist experimentation.

Of particular interest in considering the relationships among intellectuals, citizens, and the state is the understudied realm of domestic tourism—an arena tapped in various countries during the early twentieth century for popular mobilization and nation building.[49] If tourism's potential to foment nationalism and create citizens rests in tourists' individual participation in imagining the nation, however, as Dennis Merrill suggests, then tourism inherently will have limits as a means of exercising state power.[50] Tourism studies offer a lens to study the circulation of people, capital, and goods among regions and centers and provide a range of methodologies allowing us to assess how the "soft power" generated around touristic encounters has shaped modern Mexico.

While tourism has roots in nineteenth-century Mexico, the postrevolutionary period offered new opportunities for the industry's expansion and institutionalization.[51] In 1928 the federal government formally recognized tourism's potential with creation of the Pro-Tourism Commission and launched the industry's private-public collaboration.[52] While it was initially oriented toward foreign tourism, a series of new policies, tightly linked to Mexico's newly emerging social order, facilitated the growth of domestic tourism.[53] According to John Urry and Jonas Larsen, tourism emerges when a broad sector of the population has access to a viable communications and transportation network along with the desire to travel, manufactured by photographs and film, advertising, travel literature, and other mechanically reproducible media.[54] Mexico began to expand its highway system under President Plutarco Elías Calles in 1925, and nationalizing its railroad in the 1930s reduced rail prices for workers and government employees.[55] Additional efforts promoting domestic tourism came from the private sector. The Mexican Automobile Association launched its travel magazine *Mapa* in 1934. Domestic newspaper stories promoted regional tourism, covering regional festivals, history, and elite travel, and published railroad and hotel advertise-

ments. Under Cárdenas, the federal government further targeted domestic tourism for expansion. It sponsored promotions encouraging government employees to travel, published regional guidebooks in Spanish (largely for destinations in Michoacán), and during World War II encouraged businesses to offer reduced rates for Mexican tourists.[56]

The other major factor enabling domestic tourism was the growing availability of leisure time and disposable income. The Labor Code of 1931 mandated paid days off for contract laborers. Various labor unions expanded the mandated minimum.[57] Extragovernmental activities again were key; unions not only won their employees leisure time and benefits but also promoted domestic travel in their trade journals and even developed resorts for their employees.[58] The Cárdenas government's supportive relationship with unions, coupled with expanded federal legislation mandating paid vacation for credit unions in 1937, helped create a middle class and an organized working class with the resources, time, and desire to tour their country.

Cárdenas's interest in tourism extended back to his time as Michoacán's governor, when he clearly recognized tourism's potential not just for economic modernization but also for social pacification and integration. Dennis Merrill has discussed tourism's role as "soft power," arguing that it drives change by deploying an authority associated with consumption, values, and habits and proceeds via negotiation and exchange rather than by military force.[59] Under Governor Cárdenas, Michoacán reeled from tensions surrounding agrarian reform and secularization. Cárdenas repeatedly left office to lead the army and put down pockets of Cristero (rebels working in the name of Christ to oppose state secularization programs) resistance, even after the ostensible end of the Cristeros Rebellion (1926–1929). While the communal *ejido* system served to revitalize, if briefly, the agricultural economy, communities without access to *ejido* lands (including those who rejected land reform) turned to alternatives, including artisanal labor, which appeared increasingly viable as regional tourism grew.[60] Cárdenas's efforts to foment tourism in Michoacán emerged in 1931, when the state passed "Law Number 45: For the Protection and Conservation of Monuments and Natural Beauty," and he began to direct resources toward Lake Pátzcuaro's cultural and economic revitalization.[61] Michoacán also promoted internal solidarity at this time by developing a lakeside guesthouse for government employees on Lake Pátzcuaro's northern end, in Chupícuaro, where Cárdenas was fond of swimming.[62] And Cárdenas's most radical early contribution to tourism, the *Monumento a Morelos* (Monument to Morelos) on Janitzio, not only dramatically transformed the island's economy but also kept the

federal army active and highly visible in this unstable region, albeit in a civic capacity. Notably, tourism development united various rival factions of Michoacán's political elite: under Cárdenas's successor and opponent, Governor Benito Serrato (1933–1935), references to tourism development became regular within discussion of the regional allocation of state resources. Thus tourism development emerged as an instrument of power in Michoacán, offering economic integration for a marginalized and frustrated population; community, solidarity, and status for the bureaucratic sector; and a new mandate and "softer" image for the nation's standing army.

Clearly Pátzcuaro and the lake region claimed a prominent role in Cárdenas's vision for tourism, in large part because of its preexisting status as a retreat. In his 1936 Pátzcuaro guidebook, Justino Fernández suggests that the city was a recreation site dating back to the Purépechas, who called Pátzcuaro the "place of happiness."[63] The 1886 inauguration of the regional railroad line allowed local leaders and business owners to take advantage of Pátzcuaro's esteemed reputation as they began developing a modern tourism industry. The Hotel Concordia opened in 1884, a new boating company was launched in 1886, and members of the regional elite began building lakeshore houses.[64] The prevalence of religious souvenir guides from this period suggests that Pátzcuaro was also a site for pilgrimages and religious festivals surrounding Nuestra Señora de la Salud (Our Lady of Health) at the turn of the century. However, the postrevolutionary period brought a new and secular touristic logic; if Pátzcuaro's picturesque scenery and religious icons called travelers to the region in the nineteenth century, secular cultural tourism figured more heavily in the twentieth.

Cultural tourism—dedicated to witnessing and experiencing a region's distinctive cultures, heritage, and history, and often contrasted with beach tourism—developed in Mexico in dialog with artists' and intellectuals' search for the roots of Mexican identity in indigenous, folk, and regional culture.[65] Such artists and intellectuals helped translate a desire to see and experience Pátzcuaro to a larger and newly mobile audience. Crucially, Pátzcuaro's leaders were ready and eager to participate in this process; figures like Salvador Solchaga—local artist from a former *hacendado* (hacienda-owning) family that came to own the Hotel Concordia—were instrumental in cultivating ties with Mexico City intellectuals and artists and inserting Pátzcuaro into the national consciousness. Minutes from municipal meetings reveal an ongoing local engagement with transforming the town into a tourist destination as well as debates about what that entailed. In 1936 the Friends of Pátzcuaro organized to guide the process, and in 1938

(after Abraham Mejía, the federal tourism department chief, stopped there on his national circuit to stimulate tourism promotion) municipal officials, business owners, hoteliers, and local intellectuals formed Pátzcuaro's Pro-Tourism Committee.[66] Cárdenas and SEP officials worked with locals to found the Museo de Artes e Industrias Populares and sponsored archaeological excavations—the gold standard in tourist attractions cum national monuments[67]—in Tzintzuntzan and Ihuatzio, expanding the array of local touristic offerings. Thus city leaders, working in tandem with state and federal government officials and in aesthetic dialog with local images, old and new, re-created the region for tourists. The negotiation of this process and what art historian Krista Thompson refers to as the "reciprocal relationship" that develops between images of the region and its material re-creation form the heart of this book.[68]

Fundamentally, tourism appealed to nation builders in this postrevolutionary context because it promised transformation. As much as Pátzcuaro was transformed both by and in anticipation of tourists and their gazes, Pátzcuaro, we are told, transformed tourists. A visit to Pátzcuaro could create better citizens, *Mapa*'s article tells us, who could feel and understand their nationality and its heritage. Or as the DAPP writers stated in their talking points: "National tourism contributes to the formation of the spirit of our youth" and "Tourism should be oriented towards the people's education, in order to elevate their intellectual level, unify them, and affirm their patriotism through the objective study of natural, monumental, and artistic beauty, such as those works that make up our national patrimony."[69] Tourism offered aesthetic, affect-rich experiences: visitors could explore historical sites, be in the presence of national relics, enjoy folkloric performances, and be awestruck by the region's natural beauty.

As various scholars would attest, we can imagine such a transformation if we understand tourism as productive: it creates a performative space, in which tourists encounter the land, space, representations, and people.[70] Thus, as anthropologist Ruth Hellier-Tinoco points out, tourism and nation building can work hand in hand not only because both "require the formation of a set of iconic referents and stereotypes" but also because the participatory engagement required to constitute a national identity is integral to tourist practice as well.[71] While Hellier-Tinoco uses this principle to understand the essential role that Lake Pátzcuaro's indigenous performances of dance, music, and ritual took on in the shared context of nation building and tourism, I expand that focus here to consider how the experiences of the built environment, monuments, murals, scenic lookouts, and visual culture (the

world evoked by *Mapa* in promoting Pátzcuaro) were imagined to contribute to this nation-building effort.

Tourism provides a transformative experience, which is central to its rhetoric and rituals. Nelson Graburn tells us that tourism is a kind of play involving travel; the very term "recreation" suggests that we are to re-create and regenerate ourselves prior to returning to our everyday lives, work, and home.[72] Various scholars have explored the liminal space, extraordinary and separate from the everyday, created by tourism.[73] For Victor Turner, such liminality borrows from the rituals of pilgrimages: travelers journey from home; join with others for a communal, quasi-sacred bonding; and then return to reintegrate, having attained a higher status.[74]

For Alma Gottlieb, tourism's liminality stems from inverting the everyday, including class status.[75] For this reason, tourism is tied up with the *possibility* (if not reality) of class mobility: it not only requires sufficient leisure time and discretionary income—and thus constitutes an exercise of privilege—but also offers an opportunity to seemingly transcend class by purchasing elite experiences, if just for a brief vacation. While many describe early domestic tourists in Mexico as middle class, Barry Carr cautions that we should question that assumption; the range of hotels, *mesones* (inns), and guesthouses in early twentieth-century Pátzcuaro, for example, suggests something of the socioeconomic diversity of visitors.[76] The formative nature of early twentieth-century class identities, coupled with the historical instability of middle-class identity, suggests that we should consider how tourism practices helped to both constitute and manipulate class in Mexico.[77] Thus, beyond providing Mexicans with the opportunity to transform themselves into better citizens, tourism also presented a set of practices within which middle-class identity could be created, claimed, or even rejected.

Of course, tourism also transformed the lives of those living in the Lake Pátzcuaro region. As Michiel Baud and Annelou Ypeij point out, cultural tourism inserts tourists into the center of communities and thus has profound cultural, economic, and political implications for local populations.[78] As much as such tourism promises economic development, it also can place outside agendas at the center of local decision-making. So while the creation of Pátzcuaro certainly enabled local elite to explore new business and professional opportunities—from hotels and restaurants to investment in electrification and infrastructure projects—it also opened the door to national, and sometimes foreign, business interests. The Posada Don Vasco is a case in point. This elaborate hotel complex on the outskirts of town, celebrated for its traditional style and its modern amenities (from state-of-the-

art plumbing to a bowling and gaming room), was built by the Mexico City-based Hoteles Regionales, S. A., in 1938 and today is part of the Best Western hotel chain, based in Phoenix, Arizona. Its construction displaced multiple families, who petitioned Cárdenas in an attempt to save their homes; while the project went forward, Cárdenas's administration assisted the families.[79] Furthermore, while those with capital were able to establish (or re-create) themselves as proprietors of shops, hotels, and restaurants, the vast majority of tourism jobs are seasonal and unstable service positions.[80] Meanwhile, in project after project, we see a pattern emerge in Pátzcuaro whereby federal projects initially accommodated local control but eventually were subsumed under federal institutions.

Simultaneously, locals had to negotiate what it meant to have their city, culture, and bodies on display. Some learned to see and experience their own community as tourists, a project that artist Gabriel García Maroto implied could help locals appreciate and ultimately reclaim their community and its land.[81] Photographs show local families enjoying the views from the scenic overlooks surrounding the lake and picnicking at the *Monumento a Morelos*. Meanwhile, reports from the 1920s suggest a great deal of hostility toward outsiders seeking to photograph and visit local sites, especially in some of the smaller regional centers like Janitzio and Tupátaro.[82] However, as Luis Vázquez León asserts, local Purépechas learned to mediate their own image, based on a selective appropriation of images produced by outsiders. The rise of an archeological Purépecha culture, thanks to excavations led by Alfonso Caso, stimulated ethnic pride, such that the locals claimed a role as heirs of tradition.[83] However, not all communities came to appreciate this role and its obligations; while excavations continued at Ihuatzio, the community rejected the plan for an on-site museum, resisting transformation into a tourist destination.[84]

Ultimately tourism performed a fundamental role in creating Pátzcuaro and Mexico not merely because it provides a space for the mass consumption, representation, and rehearsal of national ideologies but also because it involves a set of policies, alliances, practices, and behaviors that proved useful in the nation-building process. Domestic tourism, in particular, became part of the nation's reorientation of leisure culture around secular collective activity. The rituals of sightseeing allow tourists to participate in what Tony Bennett describes as an "exhibitionary complex," wherein the viewer not only sees, interprets, and assimilates new sights and information but also learns to understand his or her own position within a larger order.[85] And, as Ron Broglio argues, it is the optics of tourism—sightseeing, map reading,

gazing, and sketching (we might add photographing)—that lends tourism the potential to serve a politics of nationalism, paralleling state projects of surveying, mapping, and coordinating the nation's territory.[86] It is in these practices of seeing and being seen, in this growing self-consciousness of participation in a collective enterprise, that tourism emerges as a core technology of nation building.

CREATING PÁTZCUARO IN THE 1930S

In sum, art and tourism stimulated the emergence of new political, economic, and cultural institutions; restructured collective leisure activities; and generated new modes of seeing, experiencing, and imagining Mexico and its culture. Pátzcuaro's role as a microcosm of cultural power allows us to understand this process as formative for Mexico as a whole. The creation of Pátzcuaro demonstrates how Mexico's artists and intellectuals claimed a central role in reshaping Mexico by staking claims to national relevance in both elite academic and popular contexts and how participation in tourist rituals helped generate distinct variations of nationalism.

I begin by highlighting the role of vision in this process, and focus on the changing modes of seeing and imagining Lake Pátzcuaro that were employed by artists, the tourism industry, and the State. Chapter 1 traces the creation of what sociologist Rob Shields describes as a region's "place image" or "widely disseminated and commonly held set of images of a place or space."[87] I start in the nineteenth century, when travelers generated the picturesque ideal of the region in text and image to stand in as one piece of a larger Mexico. The appropriation of elite travelers' picturesque images for tourism promotion in the 1930s demonstrates how images worked to manufacture a desire to travel—not merely to see sights but also to experience a newly learned, privileged form of vision.

The rise of modernist, antipicturesque images alongside tourism's expansion in the 1920s and 1930s suggests a link to tourism, even as their authors sought to work "off the beaten track" and subvert the tourist gaze's conventions and assumptions. Further destabilizing the picturesque, I argue that under Cárdenas the region increasingly began to be seen and represented (especially in murals and film) from above, as part of a larger engagement with touristic modes of vision, including maps, scenic overlooks, and aerial views. This view from on high is ideologically loaded—repeatedly representing a national, unifying, and collective vision—and enabled the region to transcend the local and stand in for the nation.

Paying attention to the diverse modes of seeing deployed in Pátzcuaro, I argue, allows us to understand how Pátzcuaro came to appeal to a range of subjectivities and interests, some of which worked alongside the state's nation-building project. It also reveals that seeing and representing the land was intimately connected to transforming it.

If the earliest imaginings of Pátzcuaro revolved around its picturesque lake, in the 1930s the city, its architecture, and its inhabitants came under the regulating gazes of tourists, bureaucrats, and academics. Chapter 2 explores the creation of Pátzcuaro *típico*, focusing on the intersection of architecture, race, and historic preservation.

Under a 1931 Michoacán law, Cárdenas designated Pátzcuaro a "typical" town and marked it for historic preservation. At a moment when the field of colonial art history was just being formulated, however, what this meant had to be negotiated by local leaders, government officials, and architects. Because this negotiation happened around key contests over social space—projects to build a modern market and secularize local churches—I argue that the rhetoric of *lo típico* serves as a pretense for modernization, defined by particular ideological concerns.

Crucially, *lo típico* operates historically as a tool of racial categorization; with this in mind we can see how creating "typical" Pátzcuaro was equally about regulating architecture and people within the city. Given academic form in Manuel Toussaint's 1942 monograph on Pátzcuaro, typical colonial architecture was defined as the product of both indigenous and Spanish cultures (erasing the history of regional Afro-mestizos). This aesthetic recasting of the national myth of *mestizaje* (a national ideology that claims Mexico is the product of the mixing of European and indigenous cultures) at the expense of regional specificity has broad implications for the foundations of Mexican art history.

Chapter 3 uses paired murals by Ricardo Bárcenas to examine the historical development of rhetoric surrounding key ideologically loaded binaries: nation versus region, modern versus tradition. The mural's constructivist depiction of Mexico's modernizing program, titled *El Plan Sexenal* (The Six-Year Plan, plate 5), gave monumental form to ephemeral publicity materials, books, and exhibitions promoting Cárdenas's ambitious transformation of Mexico, while its mate across the hall, titled *Industrias de Michoacán* (Michoacán Industries, plate 6), depicted a virtual marketplace of Michoacán-based handicrafts, corresponding to the state promotion of regional *artesanías*.

The pairing of these newly articulated worlds of "tradition" and "modern" marks the emergence of a state ideological strategy that promises that

Mexico can embrace both realms simultaneously. As such, the state effectively defined and laid claims to both these arenas: it would drive forward Mexico's modernization, while it preserved its traditional, regional *artesanías* and cultures. Barcenas's murals highlight the role racial ideology and its logic of social relationships play in defining the prerogatives of the Mexican state and its citizens: to be modern is to be mobile, national, and a benevolent patron and protector of Mexico's Indians, while to be traditional is to be indigenous, rooted, regional, and patronized by bureaucrats, intellectuals, and tourists.

The murals position Patzcuaro as a microcosm of the nation: it is traditional and modern, regional and national, and of the past and the future. Along these lines, they also provide insight into Mexico's contemporary art world and its polemics: how can art engage the contemporary political struggles? Should artists compromise their convictions by participating in the capitalist marketplace, with its emphasis on tourism? Should art disavow political engagement in an effort to be pure? With these murals Bárcenas demonstrated his commitment to art in the service of the nation, and soon after completing them he became director of the Escuela Nacional de Artes Plásticas, once again placing Pátzcuaro at center stage nationally.

History was also key to casting Pátzcuaro in the image of the nation. Tourism promoters suggested that a trip to Michoacán could serve as a proxy for visiting Mexico because monuments from all major periods of Mexican history could be found there.[88] Beginning with the 1911 local history parade and exploring public monuments and murals, chapter 4 examines the process by which historians and artists transformed the local past into national history, thereby contributing to Cárdenas's nation-building project and guaranteeing their academic disciplines' institutional viability.

Artists and historians appropriated national narratives and aesthetic models from the liberal humanistic tradition to grant Pátzcuaro a central historical role in the nation. In the process, however, they erased key elements of the regional—including the local history of African peoples and the clash between secular and religious society. Ending with Juan O'Gorman's mural *La historia de Michoacán* (History of Michoacán, 1942, plate 4), the chapter also considers the rise of an alternative to allegorical "national history": history as a social science.

Finally, chapter 5 analyzes the construction of the Cárdenas myth during this period, by examining press coverage, government publicity efforts, and artistic and architectural portraits of the president. Here I explicate the central role that "creating Pátzcuaro" played in the larger creation of the

Cárdenas narrative, which provides the foundation for political populism in Mexico.

Ultimately, I argue that the Pátzcuaro project helped define a new modern body politic for Mexico, in which the population was asked to emulate Cárdenas by touring the country; seeing and embracing its land, history, and people; and becoming Mexican in the process. By offering Mexicans a means to identify and engage with power and privilege, the creation of Pátzcuaro placed art and tourism at the center of Mexico's postrevolutionary nation-building project.

Seeing Lake Pátzcuaro, Transforming Mexico

1940s chromolithographic postcard by Miguel Gómez Medina presents Lake Pátzcuaro as the heart of Michoacán (figure 1.1). While Lake Pátzcuaro has long been central to travelers' imaginings of the region, however, this bird's-eye lake view should not be taken for granted. Instead such a panorama was largely a product of the 1930s: it was imagined within the spatial world of mass tourism, with its scenic overlooks, maps, and aerial flights, and was promoted in guidebooks, magazines, postcards, murals, and films. These new ways of seeing and thinking about the world were hardly limited to the realm of tourism; they were an integral part of President Lázaro Cárdenas's larger project to modernize and transform Mexico and had profound implications for how this region, and Mexico generally, was imagined and understood. A study of images of Pátzcuaro demonstrates how nineteenth century travelers' picturesque way of seeing was transformed with the rise of mass tourism, until ultimately Pátzcuaro could be used to stand for Mexico itself and national viewers could claim the foreign traveler's privileged vantage. And it reveals a history in which seeing and representing the region served as a prelude to transforming it.

Landscapes are integral to this story of Pátzcuaro's transformation because landscapes are a primary tool for recording, imagining, and projecting relationships. Linear perspective has taught us to read spatial relation-

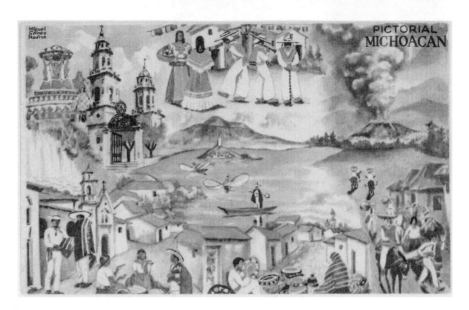

Figure 1.1. Miguel Gómez Medina, "Pictorial Michoacán" postcard, ca. 1943.
Collection of the author.

ships rendered in two-dimensional landscape views; equally important, however, are the social, temporal, and political relationships that they describe. Thus the landscape paintings, photographs, prints, postcards, and even newly framed landscape vistas contributed to the reimagining of this region and its people. Circulating both within the emerging private market and in government-sponsored channels, they developed as technologies of nation building.

New modes of viewing Lake Pátzcuaro, along with new spaces for seeing and experiencing it, were introduced as part of Mexico's political, economic, and cultural modernization project. This project extended back to the nineteenth century, when, as Magali Carrera has demonstrated, elements of the visual culture of travel—cartography's maps, lithographs, photographs, atlases, and statistics—came together to define the emergent Mexican nation.[1] Lake Pátzcuaro and its environs appeared in various travel accounts, in modest oil paintings, and even in ethnographic and waterscape vignettes from Antonio García Cubas's *Atlas pintoresco e histórico de los Estados Unidos Mexicanos* project of 1885. Yet it was in the postrevolutionary context that Pátzcuaro and its representation competed for center stage in representing Mexico at home and abroad. Pátzcuaro resonated with the period's ideological needs. Its malleable association with the indigenous past and pres-

ent, colonial history, land, and *artesanías* gave it great currency within the Mexican imaginary. Artists continued to paint Pátzcuaro, but increasingly their media of choice—prints, photography, and film—were mass reproducible and accessible to a wide middle-class audience. Pátzcuaro appeared in public murals, state-sponsored films, and scenic overlooks (*miradores*)—representational spaces that encouraged a collective viewing experience, allowing its artists, directors, and architects, as well as its viewing audiences, a distinct role in shaping Mexico's postrevolutionary nationalism. These new viewing technologies and the institutions that supported them transformed what were once images for an elite, literate, and often international audience into sights for the nation's masses.

Lake Pátzcuaro, with its *mariposa* (butterfly) fishing nets and monument to Morelos on the island of Janitzio, has long served as what sociologist Rob Shields would call the region's "place image," and its regional cultural practices compete for prominence in the national imaginary.[2] However, it was not merely the setting in its geographical, cultural, and historical specificity that resonated in the national imaginary; rather, artists mobilized different modes of viewing that landscape, each with potential to contribute to nation building. Nineteenth-century travel writers and artists regularly figured views of Lake Pátzcuaro from ground level in a tranquil picturesque mode, presenting an otherworldly retreat.[3] As such images entered the touristic vernacular, they made palpable a distance between the image's content and the viewer and provided the building blocks of a nation, ready to be consumed and assembled. Modernist images of the 1920s varied greatly but regularly manipulated picturesque conventions and challenged many (though not all) expectations of the "tourist gaze," a term coined by sociologist John Urry to characterize the ways in which touristic practices have socially constructed ways of seeing.[4] Crucially, a recurring theme is their efforts to promote identification or renewed engagement with the indigenous subjects of said gazes. By contrast, the 1930s state-funded images—and especially murals—increasingly featured Lake Pátzcuaro as viewed from on high. Such representations worked hand in hand with sightseeing rituals as a technology of nationalism; like virtual reality devices, they promoted a particular way of seeing (from above) and a means of organizing the region holistically, which projected an illusive unity and integration over this highly unstable region.

Urry coined the term "tourist gaze" to bring attention to the ways in which the visual practices of tourism are socially organized, not natural, and structured in order to shape, order, and classify the world. The tourist gaze constitutes a distinct category of learned seeing because touristic experi-

ences are defined by their difference from the everyday; tourist gazes—and they are multiple, according to Urry—are structured around difference.[5] Likewise, Ron Broglio has suggested that the techniques for generating the touristic picturesque (particularly linear perspective and arguably its modern counterpart, the camera), like cartographic technologies, emphasize distance, to the end of promoting the viewing subject's individuality.[6] Yet I also want to draw attention to the ways in which artists manipulate difference, even to the point of promoting transcendence—in a process that was essential to nation building. Thus twentieth-century tourism and its visual culture extended and reworked for an ever-larger audience what Carrera refers to as the nineteenth-century's "scopic regime," contributing to Mexico's development as a nation.[7] In the end, Pátzcuaro's ability to appeal to multiple sectors and subjectivities within modern Mexico is inseparable from its history of being seen, represented, and imagined in a range of modes.

PICTURESQUE LAKE PÁTZCUARO

Nineteenth-Century Depictions

The modes of seeing and representing Lake Pátzcuaro established by nineteenth-century traveler writers and artists, and the social relationships that they describe, persist today in the region's place image. When German scientist and explorer Alexander von Humboldt dubbed Pátzcuaro one of the world's most picturesque lakes, he also posited the area as an unchanging, Eden-like foil for the tumultuous, uncontrollable forces of transformation unleashed by the newly emergent Jorullo volcano.[8] His opposition between this latter-day paradise populated by Mexico's ideal indigenous people, the Purépechas, and the awe-inspiring power of volcanic Michoacán provides a structure repeated in the paintings of traveler artists and revived in 1943 with the eruption of Paricutín. Beyond placing Pátzcuaro on elite travelers' itineraries and establishing its picturesque credentials, however, the efforts of Humboldt and his foreign colleagues reveal the privileged subjectivity associated with the picturesque, which became part of tourism's promise.

As Mary Louise Pratt has demonstrated, travel writing in various guises, from natural history projects that render the world empirically knowable to romantic tales of intrepid explorers, functioned ideologically alongside projects of European imperial and capitalist expansion.[9] Humboldt and his team explored New Spain and South America on behalf of the Spanish Crown between 1799 and 1811, and Humboldt's 30-volume encyclopedia documenting

the topographies, flora and fauna, industries, transportation networks, and histories of Spain's American holdings made the region's potential visible and accessible to his royal patron and readers around the world. Appearing in the multivolume *Political Essay on the Kingdom of New Spain* (1811), his writings on Mexico designate "Pascuaro" as a perfect picturesque setting, populated by Mexico's ideal Indians—notable for their "gentle manners," "industry in the mechanical arts," and "harmonious language."[10] His images of the Purépecha Indians of Michoacán present early examples of a "regional type," an abstracted ideal marked by distinctive features (clothes, customs, and habitat) that seeks to catalog a culture empirically and link it to geography. However, Humboldt's authority lay not only with his own experience and documentation of New Spain and its inhabitants. He also built on the work of locals, accumulating regional histories and literature, informant testimonies, scientific studies, and images; his illustration of Michoacán Indians, for example, was based on dolls that he collected.[11] What distinguishes his study is its cumulative effect: the tension that he builds between such picturesque details and the sublime destruction of the Jorullo volcano that structures his account of the region. As Carrera notes, Humboldt sought to divine the order of a larger system, to uncover natural laws; these larger patterns would work to connect Mexico's world to the world of his international readers.[12] Thus Humboldt projected a persona that is part romantic volcano-exploring adventurer and part all-knowing, scientific cataloger of the world's people, places, and histories as he represented, in text and image, New Spain to its king and future investors.

Following independence (1821), foreign traveler artists and writers in Mexico continued to have elite and often diplomatic status. The French chargé d'affaires, Baron Jean-Baptiste Louis de Gros, painted a crumbling structure on the verdant shores of Lake Pátzcuaro in the 1830s. Gros's paintings served diplomatic roles themselves, introducing viewers in South America and Europe to Mexico (*El lago de Pátzcuaro* [Lake Pátzcuaro] wound up in Paris). Humboldt's friend and disciple Johann Moritz Rugendas circulated in these same diplomatic sets before a political scandal forced his departure in 1834. As he left Mexico, he traveled with a scientist friend to Michoacán, where he produced works that reveal his Parisian studies and contact with Eugène Delacroix, François Gérard, and Antoine-Jean Gros, more than Humboldt's scientific priorities.[13] Like Humboldt, however, he reproduced a Michoacán containing sweeping, even sublime, panoramas and volcanoes and tranquil, picturesque retreats. His small painting of Lake Pátzcuaro used academic conventions to present a picturesque lakeshore scene, balanced around a cen-

Figure 1.2. Johann Moritz Rugendas, *El lago de Pátzcuaro, Michoacán* (Lake Pátzcuaro, Michoacán), 5.4 × 8.3 in., oil/panel, 1834. Private Collection. © Christie's Images Limited 2018.

tral tree and extending to a hazy horizon (figure 1.2). To the left, regional types of various races visit the shore to water their horses; we are invited to enter the scene to the right and follow a path past livestock and up the bank toward a hut and its indigenous inhabitants. Rugendas sold the small work in Chile, where it provided its South American owner with a virtual visit to a distinctive corner of the American continent.

Meanwhile, Scots-born Frances "Fanny" Erskine Inglis Calderón de la Barca, wife of the first Spanish ambassador to independent Mexico, read Humboldt en route to Mexico in 1839. While Humboldt's exploratory adventures were off-limits to a lady, travel writing was an established female genre.[14] De la Barca edited and published her richly descriptive letters as a travelogue, *Life in Mexico* (1843). Like Humboldt's, her account of the Pátzcuaro region begins with the beautiful lake, its islands, and its picturesque indigenous inhabitants preparing for religious festivals; she, too, weaves together contemporary and historical anecdotes. Her account is further laced with racial commentary, allowing her to map race spatially: the Indians are connected to the lake, its islands, and Catholicism; the elite within the town are described as very white and have "better color" than their equals in Mexico City, an assessment that she justifies with a combination of culture and climate.[15] Such details were repeated verbatim in a late-nineteenth-

century description of the region from *Picturesque Mexico*, published in the United States expressly to promote US investment and tourism, which speaks to the enduring impression that Calderón de la Barca's account likewise left on the genre of picturesque travel writing.[16]

Picturesque accounts emphasized the privileged status of firsthand observation and visual description associated with experiencing a new place. More than merely describing a setting, they defined an artist subject and inspired a viewing subject. In the "traveler artist" we find an artistic type for the modern, empirical world: an intrepid explorer and careful observer who does the difficult work of travel and performs a valued service by bringing images back for audiences of gallery visitors and armchair tourists.

While the esteem granted to such projects was the traveler's prerogative, viewers could also reap the benefits. As Pratt argues, travel writing—and arguably travel art—also produced the "domestic subjects of Euro-imperialism" in its metropolitan reading and viewing publics.[17] Texts and images—especially when presented as collections, in either books, galleries, or the homes of collectors—helped teach their audiences to see, imagine, contemplate, organize, and develop their knowledge of the world and their own place within it. Such work developed attention to detail and comparison skills, as picturesque landscapes helped viewers learn to recognize the flora and fauna, topographic features, and cultural traditions of a region and to differentiate them from other regions. Meanwhile, sublime landscapes taught the art of contemplation: their expansive vistas, freed of framing and often lacking an access point or *repoussoir* (or alternatively with *male* figures on a precipice modeling contemplation), encouraged a disembodied view that required a conceptual leap into and identification with the land.[18] For Humboldt, this contemplation had a spiritual potential, as its enjoyment was "heightened by an insight into the connection of occult forces."[19] Finally, as much as these works taught ways of seeing, some also taught a consciousness of being viewed. This is particularly overt in the writings of Fanny Calderón de la Barca, who notes that her own presence in Pátzcuaro inspired great curiosity.[20] In sum, such training prepared viewers in specifically gendered ways for the empirical world, in which vision was granted a new authority, science was the basis of knowledge, and spirituality was sought outside religious institutions—particularly in art and in the natural world.

Pátzcuaro's picturesque also engendered values that helped reinforce the modern artists' and viewers' authority. Pátzcuaro is repeatedly shown to be a tranquil, pristine world with a deteriorating colonial past. People and the occasional building coexist harmoniously with nature, and the viewer is simultaneously distanced and yet invited to wander into the scene. Un-

like images of other regions of Michoacán, we are placed at ground level, facilitating access. This framing of Pátzcuaro presented the area as available and underdeveloped and played to viewers' emerging consciousness of being modern and cultured. In Europe and the United States such picturesque views invited investment and justifications for interference. For the Mexican and South American elites, however, intimate picturesque views such as those of Rugendas might equally help generate a version of national and hemispheric identity that celebrated regional distinctiveness, while simultaneously granting emergent metropolitan audiences the privilege of access and modernity, constituted in contrast to a regional past. At the same time, the essential structure of picturesque images and their linear-perspective-based composition, according to Ron Broglio, function much as the cartographer's survey does, both to map and to lay claim to the land. The optics of such images, in short, emphasize distance and help develop an individualism that can visually possess the land without being dirtied by it.[21] On multiple levels, then, picturesque images promote a privileged and modern subjectivity.

These nineteenth-century renderings of Pátzcuaro proved formative, not only because they became popular in their own rights but also because the itineraries, images, and texts of such figures as Humboldt and Calderón de la Barca were copied and rehearsed by later authors, artists, and travelers. The idea of Pátzcuaro as a timeless Eden and foil for the changing modern world, as we shall see, resonated with the desires of twentieth-century tourists and politicians. The traveler's privilege, authority, and sense of individuality produced within these elite foreign travelers' visual and textual accounts also provided domestic tourism with an emotional incentive that proved essential for the work of nation building.

The Postrevolutionary Picturesque

Following the Mexican Revolution (1910–1917), picturesque texts and images took on additional import. While they continued to function externally to promote investment, tourism, and international rapprochement — crucially important during postrevolutionary reconstruction — they also worked to restore a national consciousness. The ideal of a national whole was formed in relationship to the articulation of regional specificity. Both familiar publications like the picturesque album, travel memoir, portfolio, and postcard and new creations (the tourism magazine and guidebook) were well poised to make that case in their collections of images from all over the country.

To some extent these practices represented a continuation of prerevo-

lutionary visual culture and its imagining of the independent nation. Yet the postrevolutionary context added a new impetus to nation building and inspired a flurry of projects casting Mexico as the sum of its parts, reconstituted in the capital via collections of regional images, *artesanías*, dances, and other cultural practices. Simultaneously, the state began to promote tourism in 1928, both as an economic development endeavor and as another means to "define, negotiate, and preserve national identity."[22] In this context, nineteenth-century visual culture took on renewed importance, providing tourism promoters with a visual rhetoric newly translated into experience for the emergent middle class. As one Michoacán guidebook promised, "A trip to Michoacán will be as emotional as a trip through the impossible scenery of some lithographs."[23] Here the picturesque became the basis of Pátzcuaro's "destination-image," a term that Kye-Sung Chon uses to describe tourism promotion images.[24] The images not only contributed to the nation's re-creation but also claimed important roles in generating a new economy for the Pátzcuaro region and creating Mexico's emerging middle class.

The other change between Pátzcuaro's nineteenth-century picturesque and that of the postrevolutionary period lies in its new scale of distribution, enabled by photographic printing technology, state-sponsored publications, and the growth of tourism as a mass-market phenomenon. In the modern context of mass-reproduced and -circulated images, photography performed a privileged role in presenting regional Mexico to its people. Yet, by preserving the language of the picturesque, these photographers offered modern tourists in an era of class instability the semblance of the intimacy and individuality experienced by the elite nineteenth-century traveler. A distinction between the elite traveler and the common tourist, according to James Buzard, developed hand in hand with mass tourism in order to preserve the illusion of the tourist's authenticity and individuality.[25] Ultimately the distinction was more ideological than empirical and thus needed to be generated and rehearsed. By manipulating the visual language of the traveler artist in promoting regional tourism, the tourism industry offered an illusion of elite subjectivity to the masses. Together with new practices of tourism and programs of public education, their images helped create Mexico's modern middle class.

Hugo Brehme

The visual artist most associated with the photographic picturesque during this transitional period is Hugo Brehme, a German photographer active in Mexico from 1906 who has been credited with helping to establish the "visual

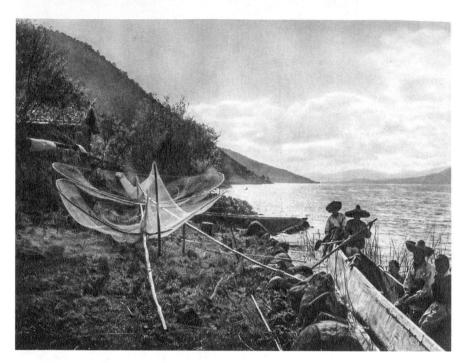

Figure 1.3. Hugo Brehme, *Lago de Pátzcuaro* (Lake Pátzcuaro).
From *México pintoresco* (Mexico City, 1923).

vocabulary" of *mexicanidad* (Mexicanness).[26] As a pictorialist, Brehme took
the painted landscapes of the traveling artists discussed above as his aesthetic
point of reference; like Rugendas and Gros before him, he composed and
framed his photographic landscapes by using both picturesque and sublime
painting conventions. His Lake Pátzcuaro photographs are largely taken at
ground level and manipulate the picturesque end of that spectrum. However,
his images, in contrast to those already discussed, place the lake's indige-
nous inhabitants at a distance from the audience. More than his nineteenth-
century predecessors, he gives his twentieth-century audience a rural Eden
set in an inaccessible past (figure 1.3).

Brehme's images of Pátzcuaro most famously were part of his acclaimed
book *México pintoresco*, published in 1923 in German and Spanish editions
and in 1925 in English. This volume brought together images from all over
Mexico, offering the war-torn nation a semblance of wholeness and healing.
Signs of revolution, along with signs of modernization and change in gen-
eral, are conspicuously absent from the album (despite Brehme's activity as
a photographer during the Mexican Revolution). Regional Mexico, with its

indigenous and colonial monuments and rural populations dwarfed by dramatic landscapes, seemingly offers stability and counters the chaos of contemporary history.[27] While the German edition failed, the success of the others secured Brehme's reputation and speaks to the ideological role that the book—as well as its images that circulated as postcards—performed during this period of reconstruction and modernization.

Aesthetics were key to creating this illusion of timelessness and transcendence. Brehme offered viewers a particular and specifically privileged way of seeing Pátzcuaro, and, by extension, their country. His photos teach the art of seeing, organizing the world according to aesthetic principles, which was the modus operandi of the pictorialists (and the painters that they emulated). These principles create visual hierarchies of space based on the visual logic of linear perspective and define the relationship between the viewer (-cum-artist) and the object of his or her view. A photograph like *Lago de Pátzcuaro* (Lake Pátzcuaro) works to lead the viewer's eye into the work, following a series of asymmetrical diagonal lines to create an illusion of deep space, but at the same time the artist sets limits: compositional devices place us on land, while the indigenous locals are separated from us in their canoe on the water. This contrasts with the Rugendas painting discussed above, which offers access to land, water, and people. For the traveler artists, the illusion of accessibility was what they had to offer sedentary armchair tourists; for Brehme, as travel was becoming increasingly viable for his middle-class audience, limits on access created visual appeal, manufactured the desire necessary to promote tourism, and provided evidence of the viewer's own emerging (and unstable) modernity. Meanwhile, the rustic content reinforces this distance; as Eder García Sánchez describes, authors and photographers generating Pátzcuaro's picturesque emphasized the "primitive" character of the region.[28] The creation of such difference and distance became the defining feature of the tourist gaze.[29]

The effect of this picturesque is to separate the modern urban viewer from Lake Pátzcuaro's indigenous inhabitants, who by contrast appear part of a timeless natural paradise. For photohistorian John Mraz, this aesthetic project is fundamentally flawed: Brehme created an illusion of beauty that denied the hardships of poverty and created an image of *lo mexicano* in which indigenous peoples and campesinos are reduced to products of nature, incapable of agency and history and denied relevance in the modern world.[30] Despite the timeless illusion that Brehme created, his photos were the product of a particular historical moment: this project not only was attuned to the needs of postrevolutionary nationalism but also promoted opening Mexico

to economic development, soliciting international investment, and promoting travel. Meanwhile, the purchase of a volume like *Mexico pintoresco* allowed its upper- and middle-class audiences a virtual vacation, enabling them to establish their own modernity vis-à-vis Mexico's land and inhabitants. Ultimately, as Roger Bartra argues, modern capitalist culture requires the myth of a subverted paradise; this image of melancholy Indians in a remote Eden becomes a defining feature of Mexican national identity.[31]

Brehme and his photos were also contemporary in that they worked in tandem with the development of Mexico's tourism industry; his enthusiastic promotion of tourism is registered in a 1930 article published in Mexico City.[32] Beyond his books, Brehme's works appeared as postcards and were reproduced in posters and advertisements to publicize Mexico's growing travel industry, in tourism guides and brochures, and in magazines like *National Geographic* (starting in 1917). Brehme's Pátzcuaro photographs were used in this manner. They advertised the railroad line to Pátzcuaro and appeared in the pages and on the covers of Mexico's newest magazines dedicated to the tourism industry: *Mexican Life* (1924–1972, published as *Mexican Art and Life* under the DAPP, 1937–1939), a Mexican magazine produced by the state for an English-speaking audience, and *Mapa: Revista de Automovilismo y Turismo* (founded in 1934), the magazine of the Mexican Automobile Association (figure 1.4). One oft-reproduced image of a fisherman casting his net into water played with the idea of accessibility and visibility—we see him only from the back, standing in the water, registered as a near void—to tease the modern viewer with a promise of a traditional world just beyond reach.

This quest for an indigenous past in the modern present served as a major draw for tourists from urban centers. Thus it should hardly be surprising that picturesque views of the lake and its indigenous inhabitants became the primary destination-images employed by the emergent tourism industry. As Dean MacCannell argued in his landmark study *The Tourist*, the leisure-time search for authenticity in an ever more mechanized and systematized modern workplace helped drive the development of mass tourism.[33] In Mexico nationalist rhetoric gave added impetus to this search, and the need to see and experience regional Mexico became part of becoming authentically Mexican. In fact, Brehme's increasingly otherworldly and remote Indians, so popular within the emerging tourism market, suggest one path by which the newly circulating Mexican people came to define their relationship to the melancholy inhabitants of a lost paradise.

Beyond developing regional tourism markets by manufacturing a desire for an authentic Mexico, picturesque photography also served as an ideal

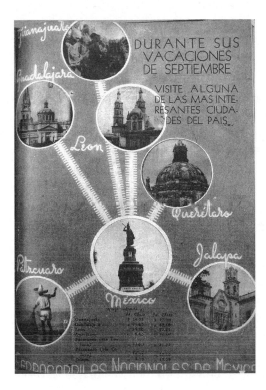

Figure 1.4. Ferrocarriles Nacionales de México advertisement. *Mapa* (September 1936).

souvenir of touristic visits when used on postcards or practiced by amateur photographers. The spatial and temporal distance that I describe as governing the compositional logic of Brehme's picturesque photographs is an essential element of the successful souvenir, which according to Susan Stewart works by replacing lived experience of a place with a memory tinged by a "nostalgic myth of contact."[34] The photographic souvenir allows the possessor to internalize that experience by freezing a moment in time and space, miniaturizing it in a commodifiable and transportable form.[35] Ultimately, it becomes a mnemonic device that can open up narratives, invented by its possessor, which allow that individual to generate a sense of self. In the age of mass tourism, postcards and amateur photography came to perform a crucial role in allowing tourists to reinvent and create their own subjectivities as part of the travel experience.

The Picturesque Boom

The demand for souvenirs helped generate professional opportunities for photographers, many of whom followed Brehme's lead, as evidenced in

the abundance of postcards of the lake and its inhabitants. Such photographers found audiences both through this private tourism market and in state-sponsored commissions (through the SEP and DAPP) for guidebooks, magazines, and expositions, as the state under Cárdenas explored the potentials of tourism for economic development, national integration, and international diplomacy.

While landscape views in general were common, the most popular photographs were images of the fishermen in their dugout canoes, just offshore and out of reach.[36] This iconography extends back to the sixteenth-century manuscript *Relación de Michoacán*. Such postcards tie indigenous bodies, marked with signs of distinctive cultural traditions, to the regional landscape, effectively condensing the work of the nineteenth-century atlases and encyclopedias that mapped cultures, resources, and geography into a newly compact, inexpensive, and easily circulated form. Notably, the *vapor* (steamship) that transported visitors around the lake was conspicuously absent from most postcards and lake images in the postrevolutionary period (although it may well have provided a shooting platform for photographers, who regularly have a vantage point slightly above the canoes). Rather than celebrating engineering, Lake Pátzcuaro's photographers of the 1930s preferred images of fishermen, most often shown with their celebrated *mariposa* nets, positioned like giant butterflies resting on the canoes' prows or occasionally shown in use, displaying the day's catch. Luis Márquez, in particular, helped make these the region's iconic image (figure 1.5). In 1937 *National Geographic* published a story on Michoacán entitled "A Mexican Land of Lakes and Lacquers," illustrated with photos by both Márquez and German photographer Helene Fischer.[37] The lake and its fishermen are prominent among a range of photographs illustrating cultural practices that would become synonymous with the region, including the Night of the Dead and the Dance of the Viejitos.[38]

Márquez first visited Lake Pátzcuaro and the island of Janitzio in 1923, while working for the SEP's division of cinema and photography.[39] The area made a lasting impression: he returned to work there many times and even wrote a screenplay, organized a film crew, and shot stills for the film *Janitzio* (dir. Carlos Navarro, 1934, discussed below). In many ways his regional photographs perpetuate the romantic picturesque and place his work alongside Brehme's in creating a place-image of Lake Pátzcuaro as a timeless Eden.[40] One such image, of a flutter of Pátzcuaro's fishermen with their *mariposa* nets just beyond reach, was published in *National Geographic* and distributed as postcards in colorized form by Eugenio Fischgrund. Márquez

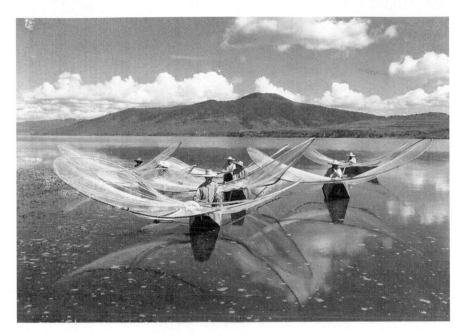

Figure 1.5. Luis Márquez, *Janitzio*, 1928. Archivo Fotográfico Manuel Toussaint del Instituto de Investigaciones Estéticas de la UNAM.

exhibited a similar shot internationally (figure 1.5). Yet his work also demonstrates engagement with new trends in Mexican photography, from formalism to social realism, which he uses to lend a sense of monumentality to his depictions of Pátzcuaro's indigenous fishermen.[41]

Márquez's movie still of *Janitzio*'s star standing poised on the prow of a rugged canoe presents Emilio "El Indio" Fernández as an idealized classical nude, again just out of reach and fit to be desired or emulated (figure 1.6). *National Geographic*'s caption refers to Fernández as "An Adonis of the Lakes, Proud and Virile" and evokes Humboldt's characterization of Pátzcuaro's local population as Mexico's ideal Indian people: "Many fishermen of the Pátzcuaro region are magnificent physical specimens. Chroniclers say that the Purépecha, when the early Spaniards arrived, were the finest looking of all Mexican aborigines."[42] The telling irony here is that Fernández was not a Purépecha Indian but a mestizo movie star from Coahuila, with a Kickapoo Indian mother. This speaks to the ways in which Márquez's photographs here and elsewhere helped to create not just the emerging genre of indigenous film but also the mythic ideal of the twentieth-century Mexican "Indian." Márquez strategically posed his subjects and staged them with loaded attributes—here the "lollipop" paddles, the canoe, and Lake Pátz-

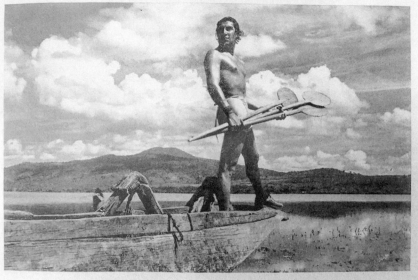

AN ADONIS OF THE LAKES, PROUD AND VIRILE

Many fishermen of the Pátzcuaro region are magnificent physical specimens. Chroniclers say that the Taras-
cans, when the early Spaniards arrived, were the finest looking of all Mexican aborigines.

Figure 1.6. Luis Márquez, "An Adonis of the Lakes, Proud and Virile."
National Geographic (May 1937).

cuaro itself—to reinvent and mobilize the idealized (whitened) Purépecha body and people as a sign of authentic Mexico.

Márquez's picturesque photographs introduced both national and international audiences to Pátzcuaro. This happened in an official capacity when Márquez was put in charge of revamping Mexico's pavilion after the 1939 World's Fair in Queens, New York, was extended for a year. As Magali Carrera has argued, picturesque traveler images and their attendant visual culture were generated as "object lessons in power" within a culture of display and exhibition; in this sense, Márquez's photos exhibited at the World's Fair were in their element.[43] After the Mexican Pavilion's ancient, colonial, and modern art had been sent to New York's Museum of Modern Art for the *Twenty Centuries of Mexican Art* exhibition, Márquez reoriented its exhibitions yet more overtly toward promoting tourism.[44] He combined imposing displays celebrating Mexico's modern highways and infrastructure projects (in photographs, charts, and models) with folkloric dresses, a souvenir shop of *artesanías*, and smaller photographs, including a series of images from Pátzcuaro. In a group of eleven photographs, presented side by side with

dynamic images of Mexico City's Palacio de Bellas Artes, the eighteenth-century equestrian statue of Carlos IV, and people posed in folkloric costumes, were three images of the Lake Pátzcuaro region: an older fisherman seated with his catch, a cluster of *mariposas* (figure 1.5), and a man selling reed mats and figurines. Deploying the rhetoric of contrasts established by travel narratives and appropriated by the tourism industry, the photos displayed one side of Mexico: the rural, rustic, and indigenous foil to the urban, refined Palacio and the icon of Spanish viceregal legacy, Carlos IV.

At the utopian, future-looking fair dedicated to the "World of Tomorrow," Márquez's presentation of traditional and folkloric Mexico was a hit: as one official congratulated him, "the Mexican Government has made one of the greatest contributions to the Fair in displaying these typical costumes, your photographs, and the dances which are so typical of your country."[45] In these works as well as in *Los patriarcas* (The Patriarchs), which Márquez entered into the Fair's *International Photography Exhibition*, Márquez combined internationally popular picturesque themes with refined modern aesthetics.[46] *Los patriarcas*, for example, frames three elderly Purépecha fishermen to give them a sense of immediacy and monumentality often missing within the picturesque, while posing them in profile to maintain their distance from the viewer—thus preserving the inaccessibility of the twentieth-century picturesque. Such images project the end of a proud generation (Mexico's version of the "vanishing race" myth) and worked to generate a sense of nostalgia that Tenorio-Trillo has described as typical of world fairs (and tourism), intensified within the international political and social climate of economic depression and war.[47] Again Márquez's ability to tap into the modern moment is apparent: he won first prize in the photo exhibit.[48]

Márquez's Lake Pátzcuaro photographs circulated nationally and internationally as postcards as well. A number of other prominent Mexico City–based photographers also came to the region and distributed Pátzcuaro images, including "Desentis Jr." and the photographers working for "Posta Mex," México Foto (México Fotográfico, signed "MF"). Their works largely embraced the canonical picturesque modes of representing the lake, presenting the fishermen with their canoes and nets, Janitzio, and its inhabitants and maintaining a sense of distance. Yet the occasional picturesque image grants us a degree of accessibility, a mode most typically reserved for images of women and children (such as Posta Mex's *Niños tarascos* [Tarascan Children]) or employed specifically by local photographers. Rafael offers the viewer the opportunity to step into a boat, while Valdés (of Valdés Foto) and Zavala

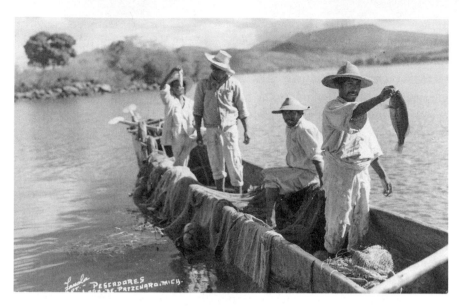

Figure 1.7. Zavala, "Fishermen, Lake Pátzcuaro, Mich." postcard.
Courtesy of the David Haun Postcard Collection.

both present fishermen smiling at the viewer, offering the day's catch (figure 1.7). This contrast to both Brehme and Márquez suggests a different set of priorities and possibly a different kind of engagement with their subjects. Not all picturesque appropriations of the indigenous inhabitants of the lake were for the same end or had the same result.

Local postcard makers had been active in Pátzcuaro from the turn of the century, when Antonio Cachú set up shop ca. 1900. While his brother left Pátzcuaro to work out of Mexico's capital, by the 1940s at least four other photographers were active regionally: Rafael in Tzintzuntzan; Valdés, active ca. 1930–1950, and the prolific Zavala, active ca. 1910–1960, in Pátzcuaro and around Michoacán; and Navarro, active in Michoacán in the 1940s.[49] Valdés appears to have sold his images directly to the public from a shop in the *portales* (arches) surrounding Pátzcuaro's main plaza.[50] From his Pátzcuaro base he traveled around the state making postcards and shooting for guidebooks, like Pemex's *Mexico's Western Highways* (ca. 1943). Thus the growth of tourism in the 1930s and 1940s clearly generated a photographic economy in the region that supported numerous local professional photographers, in addition to contributing to the careers of national and international photographers.

Beyond the professional photographers, of course, amateur photographers also learned to manipulate the photographic picturesque in appealing

ways. A worker from the Mexican Electricians' Syndicate, for example, won a prize for his picturesque lakeshore photograph of Lake Pátzcuaro in 1940, during a period in which the syndicate sought to develop workers' participation in the arts.[51] This attests not only to a changing Mexico in which labor reform allowed workers sufficient cash and leisure time to participate in domestic tourism but also to the role of tourism and picturesque photography in guiding this emergent class of organized workers as they documented and defined their own experiences of the nation.

The picturesque was an aesthetic intimately tied to travelers and tourism, reinvented by local artists and photographers. Its practitioners used its allure to different ends, playing with accessibility and varying the level of ethnographic detail. Yet ultimately these modes of seeing remained wrapped up in the promotion of difference and regional distinctiveness—providing the viewer with just one piece of a larger whole, the nation. New aesthetics would be developed in attempts to disrupt this way of seeing Pátzcuaro. Ultimately, new modes of viewing the lake would allow Pátzcuaro to be promoted as the nation itself.

ANTIPICTURESQUE LAKE PÁTZCUARO
Heading Left Off the Beaten Track

If some image-makers embraced the picturesque and thrived professionally on the demand created for such images by the nascent tourism industry, others registered a deep discomfort with art's position within that market, even as they themselves participated in some of the rituals and ideological assumptions of tourism. Intellectuals' ambivalence in the face of the picturesque and tourism is clear in comments like this one by composer and musician Silvestre Revueltas, who came to Pátzcuaro and composed "Janitzio" in 1933 (revised in 1936).

> Janitzio is a small island on Lake Pátzcuaro. The lake is dirty. Travelers looking for romantic sensations have beautified it with phrases fit for postcards and light music. To take advantage of this, I chipped in as well. Posterity will surely award me a prize for this contribution to touristic commerce.[52]

While scholars have argued about the precise meaning and implications of these lines, one thing is clear: they need to be understood within the artistic culture of Revueltas's time. They are part of the way in which travelers

experienced Pátzcuaro and its lake and part of the story of Mexican modernism, which incorporated the experience of travel and negotiation of touristic practices—both ritual and aesthetic—into its very foundations.

The ideal of experiencing and incorporating (appropriating) rural, indigenous, and natural Mexico—conceived as authentic Mexico—is central to modernist projects that sought to redefine postrevolutionary Mexico. Revueltas, for example, worked to revitalize classical music and make it authentically Mexican by incorporating rhythms and themes from "popular" (often rural or regional) Mexican music. Such popular expressions were seen as an antidote to European cultural education and training, even as their deployment by modernists sometimes reeked of primitivist ideology in the name of *indigenismo* (an ideology celebrating indigenous contributions to Mexican culture). Likewise, we are reminded that when Diego Rivera returned to Mexico from Europe, the secretary of public education, José Vasconcelos, sent him to visit Tehuantepec—a region coded as Mexico's mythical paradise during the Porfiriato—to ground him in his native land. Roberto Montenegro, Jorge Enciso, and Dr. Atl traveled Mexico to collect popular art forms, seeking to provide models of indigenously Mexican aesthetic traditions to inspire its artists. And regional musicians, including Nicolás B. Juárez from Jarácuaro in Lake Pátzcuaro, were brought to the capital to perform music and reconstruct folk dances like Los Viejitos, which eventually became nationally recognized as emblematic of Lake Pátzcuaro.[53] Mexico's modernists (many returned from abroad) embraced travel within an emerging culture of revolutionary nationalism. Artistic voyages to enable documentation, collecting, and experience of an "authentic" Mexico were incorporated into modern artistic identity and often sponsored with state funds.

Yet many leftist artists recognized that tourism could function as what Dennis Merrill describes as "soft power," a gentler yet still powerful arm of imperialism, exercising economic, political, and cultural muscle.[54] In a postrevolutionary Mexico with a small private art market, visiting foreigners and the hotels catering to them represented a new audience for artists.[55] Communist painter David Alfaro Siqueiros was a prime voice cautioning against aligning one's art with the tourist market and its desire for folkloric and romantic images of Mexico. Speaking at the closing of his 1933 exhibit in Mexico City, he asserted that "Mexican curious" painting was the greatest danger to the Mexican art movement, linking it to tourism and arguing that it was "one of the effects of Yankee imperialist penetration."[56] Rather than creating art that responded to their racial and geographical imperative, Mexico's artists were creating what tourists wanted to see, he warned; mean-

while, imitative popular arts (*artesanías*) were gaining attention, rather than the work of the Indian masters. Siqueiros's critique identified both the picturesque and "descriptive" tendencies as decisive in steering Mexicans away from the formal purity and universal vision that he sought.[57] His critique rested on two assumptions about tourism: that it was still largely a prerogative of foreigners and that as a growing middle-class (bourgeois) practice it had a significant impact on the economy, and culture, of Mexico's art world.

The photographers Edward Weston and Tina Modotti provide a prime example of how such objections to tourism helped generate new ways of seeing Pátzcuaro. The pair left California as part of a wave of US-based artists and intellectuals who came to Mexico to participate in its postrevolutionary cultural renaissance; Modotti remained until she was forced to leave for political reasons in 1929. Fellow émigré intellectual Anita Brenner commissioned the pair to travel Mexico and photographically document colonial art and *artesanías* from around the country. Weston and Modotti, along with Miguel and Rosa Covarrubias, visited Pátzcuaro in June 1926 as part of this assignment. Salvador Solchaga, an artist and key player in the revitalization of the region and its *artesanías* economy, served as their local guide. They stayed at his family's hotel, La Concordia. Joined by René d'Harnoncourt, the three foreigners read D. H. Lawrence's *The Plumed Serpent* while in Pátzcuaro and poked fun at the Englishman's impressions of Mexico. They shot photos for Brenner's book, collected handicrafts, and photographed for their own interest as well.[58]

While the couple visited many sites frequented by tourists, Weston and Modotti registered their discomfort with both the picturesque and tourism, in which the seeing of sites and artworks had been commodified. Modotti particularly resented being asked to pay to see Precolumbian artifacts during their visit to Janitzio.[59] After all, Weston and Modotti were not merely touring, they were working. Disruption of the picturesque was at the center of Weston's aesthetic project in Mexico—he wrote that he was "irritated" by the picturesque.[60] One of the key works that Weston made in Mexico was shot during that "bad trip" to Janitzio and has become iconic in articulating how his formalist project differed from that of Brehme and other picturesque photographers who had come before him. As Amy Conger writes, comparing Brehme's and Weston's views of the Lake taken from Janitzio:

> Brehme recorded a quaint and somewhat condescending scene to remind
> the tourist at home of the peaceful, complacent, and colorful poverty of
> rural Mexico: dilapidated shacks, spindly trees, and fishermen on the edge

of a lake with gentle hills and cotton-puff clouds receding back to the horizon. From the same spot, Weston organized a composition on this ground glass that was divided into three horizontal bands. . . . This complex study of light and form is an extremely dynamic composition.[61]

By transforming the lake into a two-dimensional play of light and dark, Weston repudiated picturesque photographic practice, which had offered the tourist a virtual experience. Instead, his work turns the lake into an aesthetic symbol, making it an autonomous aesthetic object. Yet it is worth considering how the photographer's participation in the touristic experience—even in his frustration—shaped his artistic output. In this case it provided both the setting—the island of Janitzio and the lake viewed from a well-trod path leading to its summit—and the motivation for finding a new way to represent the seen, and photographed, world. As James Buzard would argue, antitourism and a desire to separate oneself from the crowd is also a product of mass tourism.[62]

Weston and Modotti's work has been credited with originating a new mode of photography in Mexico: formalism, intimately associated with the modernist project. Numerous modernist photographers followed this antipicturesque approach to the Pátzcuaro region, including Mexican Agustín Jiménez and German-born Fritz Henle (who would later settle in the United States). Both creatively crop out the typical signs of regional culture—the butterfly nets, canoes, and indigenous people themselves—in favor of fragments that emphasize textures and patterns. Arguably, the antipicturesque was equally influential in a range of media, from Miguel Covarrubias's modernist silver jewelry depicting a Purépecha couple fishing in their canoe (*sans* butterfly net) to Carlos Merida's stylized reinvention of a series of lithographic types from around Mexico, published as a portfolio in 1945. For these artists the category "modern art" provided a space for transforming the picturesque and disavowing the touristic. As this section shows, a series of antipicturesque projects came to re-imagine Lake Pátzcuaro during the 1930s. Their artists worked self-consciously to disrupt the picturesque and often made the region's surfacing political and social tensions visible. In fact, it was precisely the touristic gaze established by the picturesque—that expectation of difference and separation from the audience's world of the everyday—that artists like Paul Strand and Marion Greenwood worked to disrupt. In doing so they helped define new ways of seeing and imagining Pátzcuaro, and Mexico, and offered travelers sights off the beaten track.

Acción Plástica Popular

In 1932 Spanish modernist Gabriel García Maroto arrived in Pátzcuaro, Michoacán. Maroto had seen an exhibit of children's art from Mexico's Open-Air Schools in Spain; inspired, he came to Mexico, where he worked with the Contemporáneos (an informal group of artists and writers that advocated "pure art" and coalesced around a journal of the same name) and then traveled to New York and Cuba, where he established art schools aimed at providing disadvantaged children the opportunity to make art about their local environment.[63] When he returned to Mexico, the SEP hired him to teach in Michoacán, at the request of Governor Cárdenas. The governor hosted Maroto at his Pátzcuaro home and introduced him to key regional figures and settings. Maroto's plan was threefold: he would begin by working in a rural school, then establish a school in Michoacán's capital, Morelia, before returning to Mexico City for the final installment, which would include artistic exchange among the three schools. It is not clear whether the final stage was realized, but Maroto worked in four schools in Pátzcuaro, in addition to shorter visits to schools around the state (including schools in Jiquilpan, Zamora, Zacapu, and Ixtlán de los Hervores), and taught teachers in Morelia. His students, new to art-making, ranged in age from ten to forty. He taught drawing, painting, and woodblock printmaking; staged exhibitions; and published books describing the project, illustrated with the students' woodblock prints.[64]

The project was ideologically aligned with revolutionary ideals on multiple levels. Maroto sought out the most disadvantaged schools in Pátzcuaro, including in Ibarra (on recently expropriated hacienda land near the lake) and on Janitzio. His premise was that teaching people to make art teaches them to see the world around them in new ways, in addition to exposing them to the pleasure of converting those views into concrete form. He worked with local teachers and asked them to introduce his visits by talking to the students about the region's beauty and history, which tourists from around the world came to enjoy.[65] In addition, he ideologically aligned his work with Cárdenas's project of land distribution, explaining that he was teaching "women and children" to take possession of their local land.[66] This last claim is particularly striking, as it reveals the extent to which artists themselves understood landscape painting and photography, and perhaps even the act of gazing, to be a kind of laying claim to or possessing land. Thus his project was positioned in anti-imperialist and revolutionary terms, compatible with the revolutionary slogan that land should be redistributed to those who worked it.

The published prints certainly exhibit a commitment to an antipicturesque aesthetic, privileging the modernist approach found in other projects promoting naive art. The project, like the Open-Air Schools and direct-carving workshops in Mexico City and Morelia, celebrated the notion that the untrained eye would not know the imported conventions of the picturesque and would instead intuitively register form, color, and pattern. Without training in linear perspective, the prints' artists learned to focus on patterns and the flat play of light and dark as they approached their local surroundings. Of course we should not be surprised that such published prints bear a strong resemblance to modernist experiments in Mexico and abroad; the artist-teacher likely elected to publish works that approximated his own modernist aesthetic.

The published works also exhibit content and themes that spoke to contemporary debates and suggest a concern with the historical present rather than a lost past. Not surprisingly, given that their teacher was involved with the Contemporáneos, images of Morelia display the city's hallmark colonial architecture coexisting with signs of its modernization: railroad tracks and electrical and communications poles and wires. By contrast, however, works by Pátzcuaro's children speak to a persistent division between images of rural and urban life and do not include modern technologies, typically representing either fields and livestock or colonial architecture. Their subjects do address many controversial topics of the day, however, particularly the conflict around the closing of churches (discussed in the next chapter) and land reform.

A print by fourteen-year-old Rodolfo Medellín from the new Ibarra Escuela Federal in Pátzcuaro—on the new Ibarra *ejido*—represents one of only a few lake views; unlike picturesque photographers' images taken at ground level near the shore, however, here our view is from fields above the lake (figure 1.8). Notably, the image focuses our attention on an enclosed field, denoting land that is claimed and marked off, suggesting that when this young local artist views the lake, he registers, perhaps first and foremost, the land surrounding it, complete with its property boundaries. Furthermore, while we register traces of picturesque representational conventions here (framing, diagonal bands of light and dark to evoke layers of space), it becomes apparent that we are shown not just fenced-in land but marks that prevent the artist's and the viewer's access to the lake. The flattening of the picture plane and lack of illusionism further refuse entry. Such a work becomes the visual equivalent of Cardenista agrarian reform, matching Maroto's goals for this project: this student from a local *ejido* has visually reclaimed control of rural land surrounding the lake.

Figure 1.8. Rodolfo Medellín, *El lago* (The Lake), woodcut. Published in Gabriel García Maroto, *Acción Artística Popular Plástica: 24 grabados en madera* (Morelia, 1932).

A second print, *El lago y la isla* (The Lake and the Island) by Máximo López, presents a view from Janitzio down onto the lake and its boats (figure 1.9). Again, while maintaining the content and diagonal compositional devices common in picturesque landscapes, the work dispenses with the accessibility illusions of picturesque landscapes. The artist/viewer stands high above the lake, looking down on a pair of indigenous fishermen in the immediate foreground, with a dark band suggesting Janitzio's rooftops, nets, and churchyard gate immediately above them and an expanse of white punctuated by canoe wakes and waves in the middle, topped by a thin band of

Figure 1.9. Máximo López, *El lago y la isla* (The Lake and the Island), woodblock. Published in Gabriel García Maroto, *Seis meses de Acción Artística Popular, Michoacán, México* (Morelia, 1932).

mountains and clouds. The composition suggests the lake's dominance over its inhabitants and dramatizes the height of its creator's point of view. It registers the power of this elevated vantage, suggesting that Maroto's desire to empower his students through seeing and representing their world resonated with his student. This pair of prints represents an early view of the lake from on high (along with a pair of images by Weston and Modotti), helping to transform the way we see Lake Pátzcuaro.

While this larger project certainly speaks to progressive ideals, democratizing who makes art and validating everyday life as art, the project is also underscored by rather troubling assumptions grounded in the European tradition of primitivism. The celebration of a supposed "aesthetic naiveté" as

a kind of purity and authenticity fundamentally assumes a lack of culture, rather than acculturation within a distinct—yet equally learned—system that is not trained in European landscape painting. Read as such, Maroto's paternalistic claim to educate "women and children" reiterates the gendered, raced, and classed power imbalances that defined his relationship to his students—largely young, working-class, and/or indigenous boys in Pátzcuaro and middle-class female teachers in Morelia. While this antipicturesque project disputed a number of picturesque premises, from aesthetic conventions to social assumptions about who enjoys the privilege of art making and viewing, it perpetuated the assumption that indigenous, female, and rural people are of a natural rather than cultural world and thus more in touch with their authentic selves. Thus such images continue to function and circulate as fraught signs of authenticity within the modern world.

Social Realist Photography: Paul Strand

Acción Plástica Popular was one of a number of artistic projects promoted by regional and federal officials during the early 1930s in their efforts to expand art's reach within Michoacán. The SEP, Governor Cárdenas, and the Universidad Michoacana de San Nicolás de Hidalgo all helped develop regional arts; they all sought to use art to transform society and lend political stability to a region still teetering in the aftermath of the Cristeros Rebellion (1926–1929). Many artists who committed to this transformation embraced the visual language of social realism, a style that sought to depict contemporary social realities, with an emphasis on the heroic and monumental qualities of common people going about their everyday lives. While social realist artists often self-consciously challenged the romantic aesthetics of the picturesque, politicized the passive or carefree inhabitants of its scenes, and rejected the superficiality and spectacle that were seen as hallmarks of tourism and the world of commodities, in other ways this activist aesthetic reinvented the central temporal myth of the twentieth-century picturesque by simultaneously presenting indigenous peoples as contemporary and yet temporally out of sync within modern society. Arguably, it was the socialist realists who most directly contributed to the myth of paradise subverted described by Roger Bartra as well as the ideal that one should identify with its inhabitants.

American photographer Paul Strand traveled Michoacán in 1933 with Agustín Velázquez Chávez (the nephew of composer Carlos Chávez, Strand's friend and sponsor) for the SEP, organizing an exhibit of regional children's

art and preparing a report on art in Michoacán.[67] Strand praised photographers who rejected the picturesque and, like Weston and Modotti, self-consciously created images that rejected its conventions, as he negotiated the intersection of work, travel, and tourism.[68] Strand's portfolio of selections from his travels, *Photographs of Mexico* (1940), was celebrated for this departure. As Gerald Sykes wrote in a promotional quote: "No superficial tourist's view is found in this candidate for the most beautiful volume of the year. Agony and strength elevating the common man to heroic proportions are what Strand saw in Mexico."[69] Such was the social realist critique of the picturesque and its damning conflation with tourism. If the picturesque offered superficial views of and access to a country populated by quaint, distant, and stereotypical symbols of an exotic world fit for touristic consumption, social realists claimed to present their working-class human subjects in their own right, according to the expectations of humanism: monumental and beautiful in form, heroic and dignified in spirit.

Thus while *Mexican Portfolio* presents a record mapping a traveler's itinerary through Mexico, at the same time Strand worked to transform the genre, beginning with a format that positions the twenty photographs as an artistic "portfolio" rather than a travelogue. While the portfolio begins strategically by setting the scene as "Mexican," presenting a northern cactus-filled landscape (*Landscape Near Saltillo*, 1932), followed by the gated baroque entrance of *Church, Cuapiaxtla* (1933), Strand soon shifts gears to focus on the human form, presenting images of Catholic sculptures (for example, a deposition entitled *Calvario, Pátzcuaro, Michoacán*, 1933) interspersed with photographs of members of Mexico's indigenous communities, including three from Lake Pátzcuaro. Yet these images are distinct from the ethnic types that have been used to represent the region, and Mexico, before this. Strand approaches statues and his living subjects in the same aesthetic manner: the tight framing of the bodies and a view from below (a product of using his Graflex with prism attachment, held at waist height) grant both a monumentality, while lighting, intimacy, and detail further emphasize the figure's expressions, individuality, and emotional qualities.[70] As photo historian Katherine Ware notes, formal resemblances resonate between the Indians and sculptures as Strand's sequence "juxtaposes human qualities of the sculpted figure against the sculptured qualities of the man, but also ascribes a Christ-like nobility, dignity, and humility to the man's struggles, suggesting that his burdens are redemptive and that surviving with tenacity is a virtue."[71] In such a reading, the *Women of Santa Ana* and *Woman, Pátzcuaro* (1933) become modern-day Madonnas, upright, yet humble: a time-

Figure 1.10. Paul Strand, *Woman, Pátzcuaro*, 1933. From *The Mexican Portfolio*, 1940. © Aperture Foundation Inc., Paul Strand Archive.

less vision of rebozo-covered female modesty and endurance (figure 1.10). This elevation of the commoner to the beautiful and artistic was the hallmark of social realism, which since the nineteenth century had worked to give moral privilege to the marginal by monumentalizing and aestheticizing their bodies, while simultaneously providing detailed evidence of their disadvantaged status.

Yet it is in this conflation of colonial art and contemporary individuals that we see the emergence, yet again, of the temporal and racial ideology that haunts the picturesque. While Strand removes these Mexicans from the lakeshore landscape that becomes the picturesque hallmark of regional photography, his images and his writing reveal an attempt to grapple with contradictory temporalities. On one hand Strand was critical in his writing about art policies that privileged imitation of the past, and he found attempts to revitalize past art hypocritical, like asking contemporary Greeks to redo the Elgin Marbles:[72]

> The living designs which the Aztecs, Toltecs, Tarascans and other peoples used were vital because they came out of their lives, particularly out of their religious life. This has been destroyed. The inevitable result of these attempted revivals is merely to impose upon these people forms which no longer have meaning.[73]

Strand singled out for praise art that remained engaged with everyday life, and in his social realist photographs sought to make a contemporary "portrait of a land and its people."[74]

On the other hand, however, Strand's photographs equating religious statues and living Michoacanos suggest that their contemporary state is equally out of place, or time, in the modern world. And as far as modern urban

intellectuals aligned with the state's modernization project were concerned, religion was indeed out of place in the modern world. The very statues that Strand photographed were from churches that the state would close to their parishioners in the wake of religious violence.[75] Strand himself described the statues as being "so alive with the intensity of those who made them. That is what interested me, the faith, even though it is not mine; a form of faith that is passing, that has to go. But the world needs a faith equally intense in something else, something more realistic, as I see it."[76]

By extension, we are told visually, not only is such faith passing, but so is the defining expressive feature of peasant life in Mexico. Thus the photographs preserve the temporal dislocation of the picturesque and ideologically link it with the immediacy and contemporaneity of social realism.

Social Realism on a Monumental Scale: Marion Greenwood

A similar message is found in Marion Greenwood's social realist mural depicting the inhabitants of Lake Pátzcuaro, although her focus on the enduring labor of the region's peasants is more overtly aligned with a leftist agenda. While the SEP sent artists to Michoacán, it is worth noting that regional intellectuals and politicians also worked independently to bring art to the state. In 1932 Governor Cárdenas invited Fermín Revueltas to Morelia to paint a pair of mural-scale oil paintings for the Government Palace. Soon afterward Revueltas painted a series of murals for Cárdenas's Pátzcuaro estate, La Quinta Eréndira, treating Purépecha history (see chapter 4). A more sustained effort to develop regional muralism took place in Morelia, the capital of Michoacán, in 1933–1935, led by the rector of the Universidad Michoacana San Nicolás de Hidalgo. Rector Gustavo Corona promoted this cultural development plan in both nationalistic and humanistic terms, heralding muralism as a national art movement and asserting the importance of exposing students and the masses to culture, and eventually sponsored four murals in Morelia.[77] For the first one Corona hired Marion Greenwood, from New York, to paint murals in the Colegio de San Nicolás de Hidalgo. The growing prestige of Mexican muralism meant that artists from around the world came to Mexico to participate in its great cultural experiment. Between 1933 and 1934 Greenwood worked in Pátzcuaro and Morelia, creating a mural dedicated to the *Paisaje y economía de Michoacán* (Landscape and Economy of Michoacán), which presents the fishing, handicraft, and agricultural industries of Michoacán's lake district (figure 1.11).

Greenwood's work reveals both an engagement with and transformation

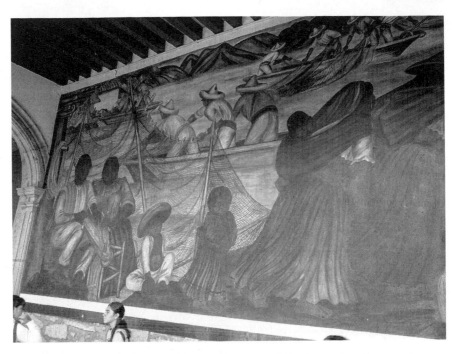

Figure 1.11. Marion Greenwood, *Paisaje y economía de Michoacán* (Landscape and Economy of Michoacán), fresco, Morelia, Colegio de San Nicolás de Hidalgo, 1933–1934. Photograph by author.

of the picturesque. Like traveler artists of previous generations, she toured various regions of Mexico. Upon coming to Michoacán, she began her project by studying in the field, sketching local indigenous populations at work. She stayed at the Hotel Ocampo in Pátzcuaro and ran into Paul Strand, who was at the Concordia.[78] Greenwood's familiarity with regional picturesque iconography is clear in the subjects that she chose to depict: handicrafts and fishing around Lake Pátzcuaro, the draped nets of Janitzio fishermen (also seen in the postcards that she sent to her family),[79] and the distinctive pleated skirts and rebozos (shawls) of Purépecha women. Her approach was distinct, however, and belied the picturesque romanticism employed by traveler artists, writers, and guidebooks. Instead, she brought her sense of "class-consciousness," generated in dialog with leftist artists, to her experience traveling in Mexico and to the images and ideas circulating within the guidebooks and oeuvres of her traveling predecessors.[80] Unlike the passive Purépechas captured in Humboldt's lithographs or Brehme's widely distributed photographs, these men and women are at work.[81] And unlike Weston's or Strand's images of Janitzio (not included in the *Photographs of Mexico*

portfolio), people are the focus of the image. Fishermen haul in their nets, women paddle a canoe, and a couple weaves nets. Men and women alike shoulder their loads—the women carry ollas (pots), bundles, and children strapped to their backs with rebozos, while the men haul agricultural bounty. Both sexes work the fields and plant corn. Male and female potters shape their wares, while a man paints them. They are presented as agents, albeit disenfranchised ones, who authentically pursue manual labor. Further, as James Oles points out, Greenwood's signature on the female potter's skirt suggests that she identified with her subjects.[82]

Greenwood used the mural's form to press her modern viewers to engage and identify with her subjects. The figure's monumental scale, along with her muted earth-toned color palate (now darkened with age), speaks to the style of social realism, popular among the socially committed painters who were on the verge of forming the LEAR (with whom she would collaborate upon returning to Mexico City). Like her leftist colleagues, she used the style to emphasize contemporary social hardships and committed to representing the region's inhabitants in all "their sorrow, their apathy, and their beauty."[83] This statement, with its emphasis on beauty and hardship, reveals the liberal humanism found at the heart of social realism: a basic belief in art's ability to convey a shared humanity and generate empathy, which would enable it to serve as a mechanism of social transformation. Men, women, and children are pressed to the foreground of the image, their immediacy breaking the divide between artist/viewer and viewed subject that Brehme's picturesque had preserved. And Lake Pátzcuaro tilts up to become a vertical backdrop to the scene. As in the murals of Diego Rivera, this postcubist spatial device combined multiple viewing systems: face-on monumentality for subjects synthesized with an all-encompassing backdrop. The resulting aesthetic worked to integrate the people with the land, to produce a synthetic image of Mexico.

It is in this call to identify with the mural's subjects that Roger Bartra's description of Mexico's national character becomes particularly resonant. Bartra argues that the literature of the postrevolutionary period revives a mythic figure, the fallen and melancholic peasant or Indian. This inhabitant of a paradise subverted was not only a foil but also a model for the national subject, especially the modern intellectual.[84] Notably, the melancholy of Greenwood's monumental figures presented the Purépechas as a sorrowful people on the verge of extinction; as James Oles asserts, Greenwood commemorated a world condemned by modernity, "on the verge of disappearing with the industrial age."[85] Thus while much picturesque touristic imagery generated subjectivity via distance and desire, the compositional immediacy

of the social realist mural presses identification with its subject, even as the class, race, setting, and labor of the figures preserve differences from major factions of its primary audience: Colegio de San Nicolás students and tourists (already in the 1930s, guidebooks recommended visiting the murals).[86] In this formal tension between identification and difference, and in the intersection of travel imagery and the leftists' revolutionary agenda, we find social realism's contribution to the national subjectivity described by Bartra.

Thus Greenwood's mural and Strand's photographs are part of a trend existing side by side with the picturesque. While they depart from the picturesque in important ways, compositionally creating a sense of immediacy and drawing on the humanist emphasis on noble physicality, they can be mobilized to do similar ideological work. In both cases, the images offered viewers—be they middle-class tourists and privileged students at Morelia's Colegio de San Nicolás or cosmopolitan visitors to Strand's exhibits in New York City and patrons of his portfolio—a rural and rustic past-in-the-present through which to understand their own worlds. This imagined place and its people, in short, serve a mythic function, whose task, as Roland Barthes would tell us, is to mask the irreconcilable realities and inequalities of modern life.[87] For one viewer, the drama critic and director Harold Clurman, Strand's photos provided an elusive stability in a changing world, serving as "little shining pure symbols of permanence and stability in a world worn with care and the destruction of ages."[88] For others, this social realist idealization of the tragic Indian/peasant is part of the fabric of Mexican nationhood—what Bartra describes as the re-creation of Mexico's agrarian history that was essential to Mexico's modern national culture. In this case, as Bartra explains, this myth responds to the wounds of the Mexican Revolution and the accompanying destruction of traditional ways of life in rural Mexico.[89] Strand's images of a tragic Catholic peasantry suggest that this way of life will just die out, belying the governmental policies that worked to dislodge religion's hold in Michoacán and Mexico more broadly. Greenwood's rural workers and the potter with Greenwood's signature on her skirt ask whether all manual laborers—artists included—will share the same fate within the modern world. It is this opportunity to cross race and class boundaries to empathize with, rather than disavow, the mural's subjects that speaks to the alternative subjectivity offered by social realist artists.

The Aesthetics of Conflict in Janitzio (1935)

We have already seen that the island of Janitzio figures prominently in twentieth-century images of Lake Pátzcuaro. Its fishermen, canoes, and

shores were destinations for picturesque and antipicturesque photographers alike—Brehme, Márquez, Fischer, Weston, Modotti, Henle, Agustín Jiménez, and multiple postcard makers—and its distinctive Night of the Dead celebrations drew anthropologists, musicians, and artists starting in the 1920s. Its formative role in Mexican film should also be noted. Working with the screenplay written by Luis Márquez, director Carlos Navarro filmed *Janitzio* on location in November 1934 and created one of the earliest sound productions supported by Mexico's new national cinema and the progenitor of the *indigenista* film movement.[90] The film complicates picturesque aesthetics by deploying the social realism of documentarians and Sergei Eisenstein's dramatic formalist experimentation and confronts its ideological assumptions.

The film tells the story of the tragic disruption of Janitzio's traditional life, and its drama is communicated by manipulating the picturesque and its conventions of vision—particularly its tendency to distance its subjects in time and space. Early scenes celebrate picturesque labors: Purépecha men fishing from their canoes and spinning their nets while women work, washing and cleaning, along the island's shores. The world is not idyllic, however, for even as we are introduced to the heroic romantic pair at the center of the story, Zirahuén (Emilio "El Indio" Fernández: figure 1.6) and Eréndira (María Teresa Orozco), we learn of the rivalry between local women and the threat that other indigenous communities pose to Janitzio's right to fish the lake, which we are told extends back to preconquest times. The greater challenge arrives with outsider businessmen, however, including one who lowers the price of fish and covets the island's women. As James Ramey points out, fishing nets are deployed as symbolic forms throughout the film; when the outsiders arrive, for example, we are visually aligned with the islanders and first view the visitors through the nets that separate Janitzio from the world.[91] The problems specifically develop with the arrival of Manuel Moreno, a representative of the Mexico City company that buys the islanders' fish, whose penetration of the picturesque island and implied rape of Eréndira drive the tragedy. He exploits the fishermen and attempts to seduce Eréndira, despite being told that island tradition warns that a Purépecha woman who consorts with an outsider will be stoned and drowned. When Zirahuén challenges and fights Moreno, he is thrown in jail and is released only after Eréndira makes a deal to run off to Pátzcuaro with the businessman. While Zirahuén ultimately rescues her and carries her off to a hidden lakeshore camp, her reputation has already been damaged. The villagers take their revenge, stoning Eréndira to death, and Zirahuén returns her lifeless body to the lake.

While we can understand this film as presenting a piece of distinctive regional folklore to a national audience, arguably what emerges here is a projection of Janitzio and its story as a national allegory. The disruption of the island's picturesque purity is likened to the conquest of Mexico, in which local resources, labor, and women's bodies were subjugated. Yet in the ensuing culture clash, the islanders' traditions are shown to be incompatible with the newly emerging reality, as they condemn Eréndira to death. Thus the film presents a narrative of unresolved conflict, a clash of worlds, in which neither the corruption of modern capitalism nor the traditions of the Indians will provide a path toward the future, and the viewer is left to ponder a solution. This premise speaks to a dialectical structure applied regularly in the discourse of leftist intellectuals, used to frame Mexico's crisis of the early 1930s. The path forward, or the synthesis in this dialectical structure, is not clear, although it is notable that viewers (largely Mexican) are asked to identify with the Indians' viewpoint—from the island, looking outward—which arguably seeks to privilege their primary position. Paradise has been subverted. Again, in this social realist rendering of Mexico's crisis, we find the melancholic (unable to act) character that Bartra describes as the essence of Mexican identity.

For Luis Vázquez León, however, the import of the film comes in the opportunity that it presented to Janitzio's residents to perform for a national audience. While the islanders and their culture had already served as the focus of photographs, short ethnographic films, and anthropological studies (and, as Weston and Modotti attested, were already asking for money to share such sites with tourists), performing in a movie filmed on location over several days arguably contributed to the community's growing self-consciousness regarding its image and its value in the eyes of outsiders.[92] The remarkable footage of the island's now famous Night of the Dead rituals included in *Janitzio* presented what was then a rare opportunity for urban audiences to view a traditional version of the November celebrations on the big screen. The continued popularity of Janitzio as a site for witnessing and imagining this tradition—today the region is overwhelmed with tourists for the holiday—speaks to the persuasive transformation of regional culture into a national icon.[93] Like the antipicturesque experiments discussed above, the film's modernist aesthetics offer a possibility of engagement and identification that is quite different from the touristic picturesque—even if ultimately both contribute to "touristic commerce" (to evoke Revueltas).

The film's promotion vacillated between picturesque and antipicturesque imagery. One film poster showed Fernández dressed for Janitzio's dance of

the Moors, a folkloric image absent from the film, alongside Eréndira in the streets of Janitzio. Many of Márquez's photographs (discussed earlier) used to present Mexico to international audiences in *National Geographic* and at the New York World's Fair were taken while Márquez was working on the film and remained grounded in the picturesque, even in their monumentality. The tourism magazine *Mapa* promoted the film with a photomontage of Márquez's images. While not including the villainous Moreno, the modernist photomontage, with its divergent vantages juxtaposed, evoked the conflict and disruption that characterized the film (figure 1.12). When released in 1935, the film was not a commercial success, despite critical reviews that celebrated the fidelity of the local customs presented, the advances of national cinema, and its ability to present a small corner of the country to new audiences.[94] But its 1948 remake as *Maclovia* (with its former star, Emilio "El Indio" Fernández, as its director and María Félix as its heroine) has become a classic of Mexican film.

A "Yankee Blemish" on Lake Pátzcuaro

Notably, while the film *Janitzio* led viewers to believe that the arrival of capitalist business ethics sparked Janitzio's crisis of modernity, the project that most decisively transformed the island was the controversial modernist statue erected on its summit. In 1933 Lázaro Cárdenas hired Guillermo Ruiz to create the monument commemorating the Mexican independence hero and former priest José María Morelos de Pavón and his brief refuge on the island during Mexico's War of Independence (figure 1.13). The statue was a massive undertaking, reaching the height of 40 meters (just taller than the Statue of Liberty) and constructed by the Mexican army. Inside it Ramón Alva de la Canal painted fifty-five vignettes depicting the *Vida de Morelos* (Life of Morelos), which wound up the monument's ramped interior, leading to an observation deck (*mirador*) in the figure's raised fist. While the historical treatment of Morelos's life is covered in chapter 4, here I focus on the challenge that the modernist statue presented to the picturesque and the ways in which it helped transform how we see Lake Pátzcuaro. In short, in creating a tourism destination on Lake Pátzcuaro that commemorated Morelos and mapped independence history to the island, the monument fundamentally challenged the ahistorical premise of the picturesque and revealed a fissure in the tourism industry surrounding the values associated with Lake Pátzcuaro.

Morelos stands as a personification of liberty, right fist raised, chin held

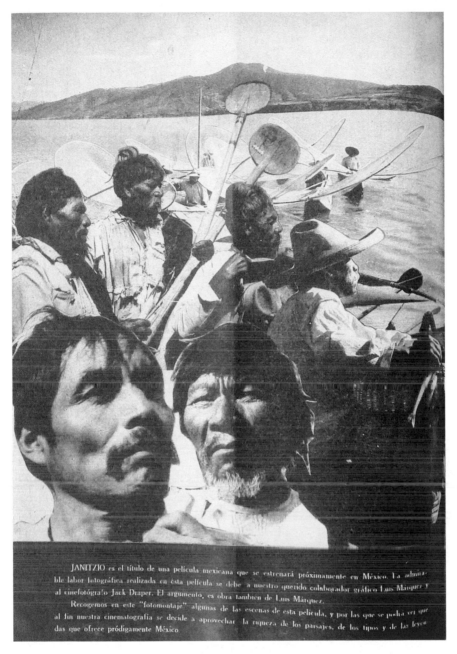

JANITZIO es el título de una película mexicana que se estrenará próximamente en México. La admirable labor fotográfica realizada en ésta película se debe a nuestro querido colaborador gráfico Luis Márquez y al cinefotógrafo Jack Draper. El argumento, es obra también de Luis Márquez.

Recogemos en este "fotomontaje" algunas de las escenas de esta película, y por las que se podrá ver que al fin nuestra cinematografía se decide a aprovechar la riqueza de los paisajes, de los tipos y de las leyendas que ofrece pródigamente México.

Figure 1.12. Promotional montage for *Janitzio* in *Mapa* (Mar. 1935): 20.

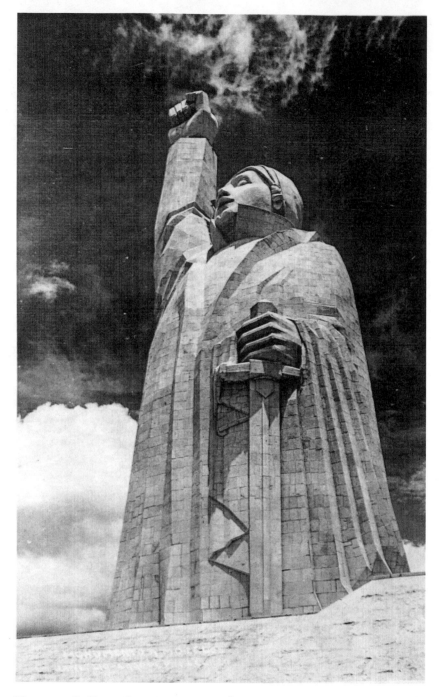

Figure 1.13. Guillermo Ruiz, *José María Morelos*, Janitzio, 1933–1935.
Archivo Histórico Municipal de Pátzcuaro.

high, and mouth open in the act of speech. He wears his signature head-scarf and long, stiffly draped robes, which grant him a massive volume and enhance his monumentality. In his left hand he holds a sword, evoking the battles fought for liberty. Constructed of 15,000 stone blocks, he is carved in an angular, streamlined realism that favors monumentality over detail and naturalism. His neo-indigenous platform includes an open bronze book, inscribed with his own words and flanked by cannons, again evoking the struggle for independence.

Recorded complaints about the monument were largely aesthetic and as-serted that the monument was out of place — even invasive. Manuel Tous-saint found the monument's scale out of sync with the island, and tourism guides note its arrogance and even describe it as a "Yankee blemish" on the island — a reference that simultaneously acknowledges the statue's references (of scale and theme) to the Statue of Liberty and characterizes it as a for-eign imposition.[95] Objections to the monument's clash with its setting or its severe modernist style perhaps registered discomfort with the contrast from *lo típico*, an ideological notion mobilized for the preservation of historical monuments and natural beauty (see chapter 2). Ruiz, an avant-garde artist associated with the Estridentistas and the director of the Escuela Libre de Escultura y Talla Directa, arguably used aesthetics to assert a challenge to the status quo. A photograph in an album that Ruiz presented Cárdenas articu-lated this conflict: Morelos's profile and fist confront the colonial church bell tower, challenging the old order and the Catholic identity often ascribed to indigenous communities (figure 1.14). While later in the 1930s Cardenistas learned to use aesthetics to mask their goals of radical transformation, this monument was perhaps the most aesthetically discordant manifestation of their efforts to modernize rural Mexico and temper church power in the wake of the Cristeros Rebellion.

Of course such complaints were not just about aesthetics: the statue also disrupted the picturesque assumption that rural and indigenous Mexico had no history and that its inhabitants were a passive part of a timeless past. The statue was resolutely contemporary. It was dedicated to Morelos in com-memoration of a historical moment: when he and his troops hid on the island during the War of Independence. Thus it placed the island back into the course of modern Mexican history. And its erection created a new regional economy, at a time when the fishing industry was in decline. The mainte-nance of the statue and its entrances rotates among the island's neighborhood units, which have long provided the island's political organization. Further-more, the islanders began organizing collectives in 1940 to provide conces-

sions and souvenir stands to tourists.[96] Applying such traditional principles, and reversing reports from the 1920s and early 1930s that suggested a hostile relationship between locals and tourists,[97] the islanders entered into the nascent tourism industry and navigated modern capitalism.

The monument was highly promoted by the Cárdenas administration and came to serve as a revolutionary symbol of the nation's modernization. Images of the monument circulated on materials published by the state and federal governments, coverage appeared in both national and foreign presses, and the statue graced a 1940 commemorative stamp celebrating the New York World's Fair and its "World of Tomorrow."[98] Generations of tourists and political leaders have visited the statue, following the ritual climb to the island summit and laying wreaths annually to honor the hero. Guidebooks acknowledge the monument's key role as a local tourism draw, and the island's tourism economy has grown exponentially along the route to its summit, for better or worse (see chapter 4). A transport union based in Pátzcuaro has come to dominate the trade in ferrying tourists to the island, though not without challenges from smaller groups on Janitzio and around the lake.[99] Broader regional support is harder to gauge, but traces can

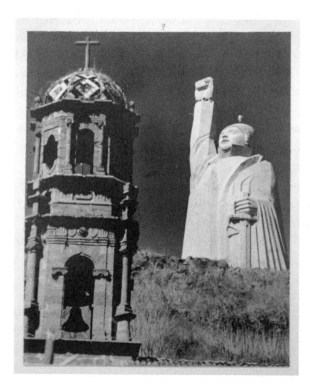

Figure 1.14. Photograph from Cárdenas's album of Guillermo Ruiz's work in Michoacán. Colección Lázaro Cárdenas, álbum 62, foto 14, Archivo Histórico de la Unidad Académica de Estudios Regionales de la Coordinación de Humanidades de la UNAM y el Centro de Estudios de la Revolución Mexicana Lázaro Cárdenas, A.C.

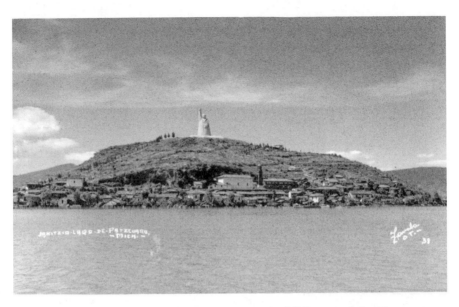

Figure 1.15. Zavala, "Janitzio, Lago de Pátzcuaro, Mich." (Janitzio, Lake Pátzcuaro, Mich.) postcard. Collection of the author.

be found in its replication. Among the many photographers to incorporate the statue in their postcard repertoire, local photographer Zavala included the statue in his shots of Janitzio (the distanced view somewhat dwarfing the monument: figure 1.15), while Mexico City–based México Foto endorsed the monument with dramatic images of its profile and the path leading to it and suggested its ability to ennoble Janitzio's inhabitants (figure 1.16). Perhaps as early as the 1940s, an artisan from Tzintzuntzan rendered the statue in the local black-on-cream pottery, shrinking the island to make it a more appropriate pedestal for the monument (figure 1.17). Since that time, images of the island painted on *bateas* (lacquered platters) and ceramics and embroidered on shirts have provided souvenirs of visitors' pilgrimages to the site.

The monument's presentation reveals tensions within the tourism industry, however, as images of the island address multiple audiences — from those pursuing narratives of national history to those seeking a picturesque escape or panoramic vistas offered from the (awkward) observation deck in the monument's fist. Notably, the *indigenista* films treating the lake and its inhabitants — like *Janitzio*, which was filmed while the statue was under construction, and its 1948 remake as *Maclovia* — avoid the statue (although Morelos's portrait appears in the classroom scenes of *Maclovia*). It is precisely this variation in the touristic public that is acknowledged — or even *cre-*

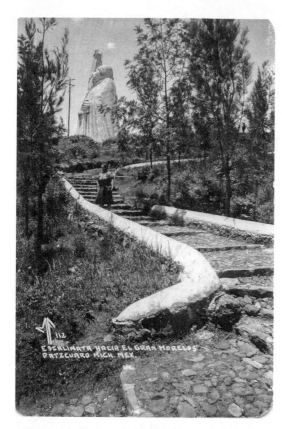

Figure 1.16. México Foto, "Escalinata hacia el gran Morelos, Pátzcuaro, Mich., Méx." (Staircase Leading to the Great Morelos, Pátzcuaro, Mich., Mex.) postcard. Archivo Histórico Municipal de Pátzcuaro.

Figure 1.17. Plate from Tzintzuntzan, ca. 1940s. Private Collection.

ated—by the proliferation of both picturesque and antipicturesque imagery of the region. In this tension generated at the site of tourism, we find the official sanction of yet a third way of seeing the region: in a dramatic view from above.

THE VIEW FROM ON HIGH

Uniting the Lake

The early 1930s antipicturesque projects opened new possibilities for seeing and thinking about Lake Pátzcuaro, informed by emerging ideological agendas, new artistic technologies (murals and films), and growing ambivalence surrounding tourism. This transformation intensified during the *sexenal* of President Cárdenas (1934–1940), which poured resources into the region to promote regional unity and economic development. Accompanying this agenda was an imperative to see and understand the lake in a new way: as a coherent unit.

While conceiving Lake Pátzcuaro as a unit seems natural today, this was not the case in the early 1930s, when land disputes, religious conflict, and long-standing grievances often kept neighboring lakeside communities at odds with one another.[100] Tensions between those who supported land redistribution and secular education and those who sided with the church remained charged even after the ostensible end of the Cristeros War.[101] The effort to reconstitute the lake as a *natural* whole was truly interdisciplinary. Scientists established a limnological station there in 1938 and studied the lake as a closed-basin ecosystem. Japanese researcher Toshie Yamashita's 1939 publication of their early results included a map of the lake.[102] If this study provided a scientific logic for describing the lake as an autonomous entity, the work of historians, art historians, and anthropologists, including the federally published edition of Nicolás León's *Los indios tarascos del Lago de Pátzcuaro* (1934), helped establish the historical roots of unity under the Purépecha Empire. Meanwhile, the federal government began constructing new roads around the lake and promoting electrification, in an effort to enhance regional communication and infrastructure. Finally, murals and the region's growing tourism infrastructure contributed new and explicitly collective means of seeing and experiencing the lake as a unit, from above.

The federal SEP had begun working here in the 1920s, and in 1931 sent a pair of two-month-long cultural missions to Tzintzuntzan, which, among other development projects, held a dance festival featuring the recently

Figure 1.18. Alberto Leduc, Teatro Emperador Caltzontzin and Biblioteca Pública Gertrudis Bocanegra (Emperor Caltzontzin Theater and Gertrudis Bocanegra Public Library), Pátzcuaro, 1937. Photograph by author.

revived local dance tradition, Los Viejitos, from Jarácuaro.[103] The following year Rafael Saavedra worked to reconstruct the Danza de los Moros from Janitzio.[104] SEP investment intensified under Cárdenas, as it opened schools in communities around the lake and appointed Policarpo Sánchez to serve as the regional school inspector. The SEP also funded the centerpiece of Cárdenas's cultural project there: the Teatro Emperador Caltzontzin (figure 1.18). The new public theater was built on the site of a former Augustinian convent and offered a secular opportunity to gather locals as a community. I address the theater in each of the remaining chapters, beginning here with its auditorium. While the theater's exterior architecture quoted the colonial aesthetics of the convent that formerly occupied this site, its interior was modern, eschewing private boxes in favor of a large hall with an open seating plan and setting the standard for modern theaters in historical zones being built around Michoacán.[105] The space itself was premised on unity and a modern understanding of community based in secular leisure culture.

Murals painted by Roberto Cueva del Río decorate the auditorium and serve to equate its space with Lake Pátzcuaro itself (figure 1.19). Cueva del

Río surrounds the theater's audience with frieze-like clusters of figures representing the SEP's regional literary and cultural programs, including images associated with the regional picturesque (Los Viejitos, Los Moros, lacquered gourds and other *artesanías*) here transformed into stylized, iconic symbols. Enveloping the audience and the figures is a continuous and all-encompassing image of the lake, along with a ribbon of water and fish pattern. The lake's main islands (Janitzio, Pancanda, Jarácuaro, and Yunuén) are depicted, along with images of fishermen and women in their boats and waterfowl evoking the lake's celebrated fall duck hunt. Meanwhile, Cueva del Río dramatically flattens the scene, removing the horizon line altogether, which simultaneously raises us high above the scene even as it immerses the lake's diverse cultures, its islands, and its boats and wildlife—not to mention the audience itself—within the whole of the composition. Antipicturesque modernism is the key point of reference for making sense of this bizarre distortion of perspective. Such aesthetics are unimaginable without the developments found in a range of media, including Edward Weston's photographs and Marion Greenwood's murals discussed above. However, it is also hard to

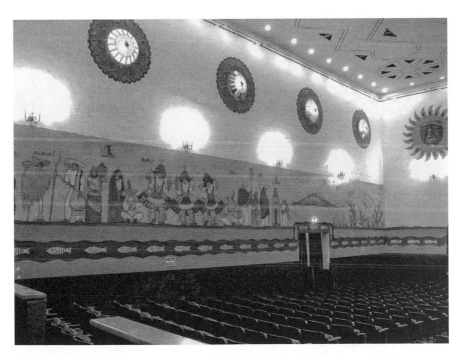

Figure 1.19. Roberto Cueva del Río, *El lago de Pátzcuaro* (Lake Pátzcuaro), Teatro Emperador Caltzontzin, Pátzcuaro, 1937. © Roberto Cueva del Río. Courtesy of Ana María de la Cueva. Photograph by author.

imagine conceiving of this theater mural without the touristic experience of climbing to the *mirador* atop Guillermo Ruiz's statue of Morelos (1933–1935) on the island of Janitzio and taking in the all-encompassing, encircling panorama of the lake and its communities.

It is thus at the intersection of a new means of seeing—facilitated by the visual culture of tourism—and the Cardenista agenda that we find a new visual rhetoric that synthesizes picturesque detail with expansive views of the lake from above. The visual unification accomplished by such a perspectival distortion was ideologically loaded and positioned this particular mural as just one part of a much larger attempt by Cardenistas to consolidate Lake Pátzcuaro. In this context, Cueva del Río's mural and his way of seeing Lake Pátzcuaro were emblematic of Cárdenas's regional cultural and economic project.

Maps and *Miradores*

The local tourism industry's 1930s expansion provided a particularly important means to reimagine the region as a unit. The visual culture and practices of tourism, including maps, tours, and guidebooks, were key. Pátzcuaro's Hotel del Lago promoted visiting the lake's various towns and communities (figure 1.20: note the town names painted vertically in sequence around the

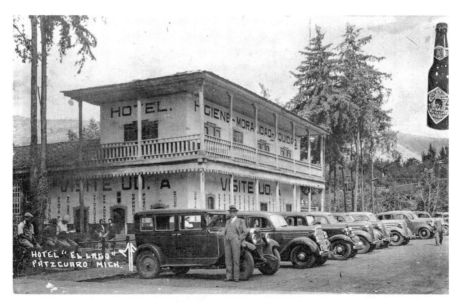

Figure 1.20. "Hotel 'El Lago,' Pátzcuaro, Mich." postcard. Fondo: Municipio Pátzcuaro, Fototeca del Estado de Michoacán, AGHPEM.

porch), providing a new lens through which to unite the region, while guide-books discussed the islands and the lakeshore communities. Maps oriented their viewers to the lake and its peoples, both spatially and ideologically. Furthermore, their systematic organization allowed viewers to conceive of the region as a whole, despite political and religious tensions that sharply divided local communities and threatened national unity. If maps presented viewers with the region's entirety in a foldable and portable form, *miradores* (scenic overlooks) provided an awe-inspiring experience of the lake. In the 1930s the government developed a series of scenic lookouts around the lake, in which the sublime landscape tradition was re-created in living color for tourists. While presenting diametrically opposed experiences for the viewer, both maps and *miradores* offered a view on high from which to imagine the region as a whole.[106]

The first map of the lake from this period was created in 1933 by art historian Justino Fernández and published within a state-sponsored *Pátz-cuaro* guidebook in 1936 (plate 1).[107] This pictorial map pays homage to colonial mapmaking traditions, with its oblique bird's-eye view, hieratic scale, glyphic figures and place-images, and compass, and explicitly references the map and local coat of arms reproduced in Fray Pablo Beaumont's *Crónica de Michoacán* (ca. 1778–1780). Such a rendering fit strategically within the larger project of tourism promotion in Pátzcuaro, which celebrated *lo típico*, under-stood loosely as colonial-styled architecture and aesthetics (see chapter 2).[108] Yet Fernández updates his map in key ways: Beaumont's ecclesiastical figures marking the sixteenth-century transfer of Michoacán's first bishopric from Tzintzuntzan to Pátzcuaro are replaced by secular figures, including a fisherman with his *mariposa* net and a man, woman, child, and loaded burro who follow the road to Pátzcuaro's markets, while a railroad curves around the lake. The tracks encircle the towns to the west and south, while mountains ring the lake to the east and north, compositionally describing the lake as a unit.

In contrast to the *Crónica* map, Fernández reoriented our view, placing us to the south on the Balcón de Tariácuri, a scenic overlook on El Estribo volcano. His guide and those that followed recommended the view from this site, and the state government concurred.[109] Already in 1931, under Cárde-nas, the state had begun repairing the road to the Balcón; Governor C. Rafael Ordorica Villamar continued Cárdenas's project, using army labor to de-velop the road, construct a rustic-style pavilion, and build 417 steps and a neo-indigenous platform leading to the old volcano's summit. Inaugurated in 1936, the Mirador Tariácuri was one of at least four scenic overlooks the fed-eral army constructed around Lake Pátzcuaro, designed to enhance regional

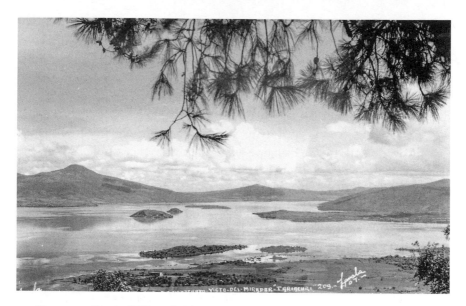

Figure 1.21. Zavala, "El lago de Pátzcuaro visto del mirador Tariácuri" (Lake Pátzcuaro Seen from the Tariácuri Overlook) postcard. Collection of the author.

tourism by providing destinations from which people could enjoy sweeping panoramic vistas (figure 1.21). As one guidebook described the lookout on El Estribo, "from here you can admire the lake and islands in their breathtaking splendor. Down the stairs you find yourself in a place covered by thick foliage of tall trees named 'El Estribo,' a rustic spot where you will rest and the lake views will widen your eyes in wonder."[110] Such language clearly evokes the sublime's awe-inspiring power, befitting the experience of descending 417 steps without a railing to return to the observation deck and its pavilion, with its faux-rough-hewn-tree railings. The pavilion's boughs frame the view, providing an antidote to the sublime experience, as viewers of panoramas around the world have long noted the risk of vertigo in adjusting to such dramatic views and the mismatch of sensory perceptions that they stimulate.[111]

The powerful impact of such experiences was not lost on the region's visitors. Victor Serge, a Russian-Belgian exile living in Mexico, published a short story treating his 1943 visit to Lake Pátzcuaro, a stop en route to the erupting Paricutín volcano. Describing the ascent on Janitzio, he writes:

Why do we feel this delight in climbing? To let the horizons expand? It's too disinterested to include the slightest element of the wish [for power].[112]

Rather it's a delight in escapism, of community with the terrestrial spaces (for all contemplation implies an identification with what is beheld). We're happy to see the sides of the lake emerge under the limitless sky. Lizards and snakes, slithering in the dried grass, make a little metallic rustling noise.

At the island summit, a square, white house. Privileged spot![113]

I will return to power, as its denial ignores part of the allure of tourism and the privilege of escapism; here, however, I draw attention to Serge's characterization of the sublime. The sublime allows Serge to lose track of the self and identify with the surroundings: a natural world that surpasses the individual with its grandeur and power.

Arguably, mobilizing the sublime around the lake enabled tourism to do its ideological work: the Mexican viewer in contemplating the sublime landscape might identify with the land and by extension the nation, while the foreigner was enlisted in diplomatic relations via this potential identification. Thus the nationalist and diplomatic work of sublime nineteenth-century landscape paintings—and here we might cite José María Velasco's nationalistic landscapes overlooking the Valley of Mexico that circulated abroad in international expositions and as diplomatic gifts—has been reinscribed into the experience of actual landscapes, now available to tourists en masse.

To return to the question of power, however, such panoramic vistas have also been connected to the notion of a mastering eye ("the monarch of all I survey")—a literary trope that Mary Louise Pratt identifies within nineteenth-century travel writing, which is arguably present in sublime landscape imagery as well.[114] Such a reading understands the formal devices of travel writing, including this "mastering eye," to work ideologically in tandem with imperial expansion. Stephen Oettermann, historian of panoramas, connects such seeing from on high to philosopher Michel Foucault's discussion of the Panopticon, an eighteenth-century prison in which the control (and self-control) of prisoners was to be managed by surveillance from above.[115] The *miradores*' association with control and regulation takes on a particular resonance when we recall that Mexico's federal army built them. Such civic construction projects kept the army active and publicly visible in an unruly Michoacán. Thus a regime of vision from on high unites surveillance, imperialism, and governance.

The tension in the traditional sublime between the viewer's submission of the self to the whole and the mastering view from above comes together in local historical anecdotes. Nineteenth-century historian Eduardo Ruiz re-

peatedly describes the fierce Purépecha ruler Curatame on a rock outcropping, gazing out over Lake Pátzcuaro; the first time, he is hunting and is awestruck at the sight of the lake and islands below him; the next time, he is with his warriors, and they see below them a fisherman and his daughter, whom they seize.[116] Likewise, Alfredo Maillefert's evocative description of the view from El Estribo in his regional travelogue, *Laudanza de Michoacán*, vacillates between marveling at the view in awe and examining the *indios* down below, making their way to the market in Pátzcuaro—not unlike the image provided by Fernández's map.[117] Such narratives connect being awed by the lake and dominating the lake region—pairing the view from above with the attention to picturesque detail—to define a dualistic experience now offered as a privileged experience for middle-class sightseeing tourists.

The *miradores* and their on-high vantages are visually and rhetorically associated with an indigenous point of view, which speaks to a variation of *indigenismo*, the national ideology and policies that worked to celebrate indigenous contributions to the nation. Touristic *indigenismo* expanded the nineteenth-century mapping of race to place by reshaping and representing the local landscape as a series of destinations for sightseeing, with an eye to highlighting the land's indigenous past. Eduardo Ruiz not only recounted Curatame's lake views but also placed an image of an indigenous woman gazing over the lake on the cover of *Michoacán: Paisajes, tradiciones y leyendas* (1891), a book that repeatedly posits Mexico's national origins in Michoacán history (see chapter 4). Artists, photographers, and illustrators continued such associations in the 1930s; if anyone serves as a proxy for the viewing public high above the lake, it is most consistently a figure coded as indigenous. Arguably, these efforts to recast views from on high as indigenous can be understood as a materialization of Cárdenas's period rhetoric calling for the "elevation" of Mexico's indigenous peoples. On one hand, this agenda led to specific regional programs intended to support indigenous people, from expanding public education around the lake and creating local *ejidos* (collective landholding units) to developing the regional tourism economy, including the statue of Morelos and the promotion of *artesanías*. On the other hand, the projects that I describe suggest a second strategy at work: one that allowed sightseers to appropriate or identify with the indigenous ideal, to enact a privileged status of belonging naturally to the region and the nation.

In such a framework, tourism becomes the site of an encounter quite distinct from the social realists' efforts to encourage humanistic identification with the melancholy inhabitants of a lost paradise. Instead we are pre-

sented with reinvigorated claims regarding the indigenous land. The sublime becomes the vehicle for a new synthesis and identification. And there was another level at which this site mobilized sightseeing as a nation-building strategy. When the state developed the Mirador Tariácuri, it extended the road beyond El Calvario church and the site on El Estribo that had been the destination of choice for previous generations of site-seeing travelers. Not only did this newly expanded lookout offer visitors a virtual indigenous lake view but touring the area reminds us that the regional landscape was loaded with racialized histories from both the pre-Hispanic and colonial eras. Tourism made El Estribo visible as a site of *mestizaje*.

A prominent replication of the view from El Estribo makes this racial legacy explicit. El Estribo is reactivated as a site for an indigenous and colonial encounter—the core element of Mexico's mestizo nationalism—in a mural in the Teatro Emperador Caltzontzin by Roberto Cueva del Río. Here the view from the Mirador Tariácuri becomes the setting for the *Encuentro del Rey Tanganxuan II y el conquistador Cristóbal de Olid en las cercanías de Pátz-cuaro en el año de 1522* (Encounter of King Tanganxuan II and Conquistador Cristóbal de Olid in the Environs of Pátzcuaro in 1522, plate 3). Like renditions of the scene by Fermín Revueltas and Guillermo Ruiz discussed in chapter 4, Cueva del Río appropriates the encounter of Hernán Cortés and Moctezuma II to merge local and national history. However, the exact site (not to mention existence) of such an encounter was unclear and contested. Revueltas returned the setting to a ceremonial center—likely Tzintzuntzan—and Ruiz and multiple period guidebooks associated the encounter with a site on the other side of Pátzcuaro known as El Capilla de Cristo or El Humilladero.[118] Crucially, Cueva del Río's 1937 mural strategically relocates the event to El Estribo, a racialized landscape now tied to both colonial and a newly robust indigenous authority, high above the lake.

Pátzcuaro from the Air

The final touristic mode of seeing that I would like to consider in relation to these views from on high is aviation, which is arguably key to understanding the sublime view of the Michoacán landscape and history in Juan O'Gorman's mural *La história de Michoacán* (The History of Michoacán, plate 4), painted in 1941–1942 in the newly inaugurated Biblioteca Pública Gertrudis Bocanegra, the former San Agustín church (figure 1.18). Here O'Gorman presents us with a panoramic parade of historical figures tying Michoacán history and legend to regional geography, from the legendary creation of

lakes and volcanoes through the region's indigenous history, the conquest, and the independence and revolutionary periods. This marriage of space and time borrows conventional patterns, mapping the distant past to the horizon, and embraces the notion that history, in all its layers, remains tied to the land.[119] O'Gorman's historical panorama becomes the visual equivalent to the idea found repeatedly in tourist literature that Michoacán is an ideal destination for tourists within Mexico, because it is rich in both natural splendor and history from all of Mexico's historical periods.

I shall return to O'Gorman's innovative representation of history in chapter 4, but here I wish to draw attention to the conflation of modes of viewing. While figures from the colonial and modern periods are presented as if parading at ground level in front of us, we are also virtually suspended high above the region, looking down on the lake from the north. Although there was a *mirador* at the lake's northern end—built by the army in 1939 on the Cerro Sandino above San Jerónimo—we virtually soar high above it, even as we literally stand on the ground looking up at the mural in what was once the Augustinian church's apse.

Scholars have recently deemed aerial views "central to the modern imagination" and analyze how aerial surveillance and photography have helped restructure geographical knowledge and authority.[120] Marie-Claire Robic describes aerial photography's role within modern geography as one that objectively combined the spatial properties of a map with the texture of the surface terrain, constituting a new way of knowing the geographical landscape.[121] This combination allows aerial photography to activate both the "mastering eye" and the emotional identification of the sublime. On one hand, aerial photography's origins in military applications and its extension into surveying, monitoring, and archiving testify to its application within state institutions of control and governance. Yet, as Eugenia Macías points out, aerial photography's oblique views are equally an extension of the tradition of the sublime landscape and an emotional experience bound to the experience of sight.[122] In examining this dynamic of control versus identification in Mexican aerial photography around 1942, what must be noted are the complexities surrounding how and by whom such practices of viewing were put to use within the nation-building project.

In Mexico, aerial viewing emerged as a private enterprise, initially facilitated by foreign investors and gradually incorporated into a national project. Aerial photography came to Mexico via the United States–based Fairchild Aerial Camera Corporation (founded in 1924), which published a series of aerial photographs of Mexico City in the journal *Planificación* (1927). The

Figure 1.22. Pátzcuaro, Michoacán, 1933. FAO_01_000763, Fondo Aerofotográfico Acervo Histórico Fundación ICA, A. C.

Compañía Aerofoto Mexicana (CAM) was established around 1930, likely as a Fairchild Corporation franchise, and began creating an archive surveying the Mexican landscape and its developing infrastructure.[123] In 1933, as work was proceeding on the *Monumento a Morelos*, the CAM shot aerial photographs of Pátzcuaro, including photographs that record the monument's progress, link the city of Pátzcuaro to the lake, and register the drama of sweeping oblique views (figure 1.22). While it is unclear what purpose these particular photographs served, and for whom they were created, they certainly contribute to a larger project documenting large-scale public works.

Aerial views entered the public imagination via tourism and the popular press, again emerging from a private context that linked the United States and Mexico. Mexicans eagerly followed the adventures of aviator Charles Lindbergh, the son-in-law of the US ambassador to Mexico, Dwight D. Morrow. Meanwhile, tourism introduced air travel to a wider audience. Anita Brenner, in *Your Mexican Holiday* (1932), advised American tourists that the most spectacular mode of arrival in Mexico was to fly in. Her text once again deploys the sublime's dual possibilities, stating that the view pro-

vides clarity and order as well as awe-inspiring grandeur.[124] Those unable
to fly could marvel at aerial photographs of celebrated tourist sites. Readers
of *Mapa* enjoyed articles on air travel illustrated with aerial photographs of
Mexico City, New York City, and the Grand Canyon, among other destina-
tions.[125] According to Fernández's guide, Pátzcuaro had an airfield by 1933.
Cárdenas was negotiating to buy land for an army landing strip in 1936.[126]

By the late 1930s officials were clearly working to incorporate aviation
into an explicitly national narrative. Francisco Sarabia, a celebrated Mexican
aviator, participated in the 1939 inauguration of the Mexican Pavilion at the
New York World's Fair, and Mexico honored him with a commemorative
stamp. Following Sarabia's deadly crash on his return from the Fair, Cárde-
nas and sculptor Guillermo Ruiz began plans for a memorial to the aviator.[127]
It was in the early 1940s that aerial photography in particular began its insti-
tutionalization, via its incorporation into both the war effort and the study of
geography. The field of geography reentered the public sphere in July 1939,
when Cárdenas sponsored the Primer Congreso de Geografía y Exploración
Geográfica, a geographers' congress publicly recognizing geography's role
in establishing the country's territorial, economic, and social resources.[128]
Soon afterward, in 1940, the Instituto de Geografía was established within
the UNAM's Facultad de Ciencias. Its methodologies and curriculum ex-
panded to incorporate aerial photography, among other new technologies.[129]
President Manuel Ávila Camacho's government took advantage of the ex-
panding field, employing aerial photography in its surveys of unexplored
areas of Guerrero and Michoacán — notably both states that had experienced
instability during the previous decade.[130] And in December 1942 the institute
developed a course on the use and interpretation of aerial photography for
Mexico's air force, to support its efforts in World War II.

O'Gorman's mural was developed at this historical juncture marking the
early institutionalization of aerial vision and operated at the intersection of
these national, international, and personal viewpoints. Perhaps we shouldn't
be surprised that Juan O'Gorman would be the artist to take Pátzcuaro's
views from on high to this new extreme: in his autobiography he discusses
his early fascination with such lofty views. He scaled the metropolitan cathe-
dral to impress a girlfriend, produced aerial paintings of the Tolteca factory
in the Distrito Federal (*Airplane* and *The Factory*, 1931), and painted his in-
famous censored murals for the Mexico City Airport in 1937.[131] The airport
murals *La conquista del aire por el hombre* (Conquest of Air by Man) and *Los
mitos paganos y religiosos* (Pagan and Religious Myths) included satirical por-
traits of Adolf Hitler and Benito Mussolini and clearly referenced aviation's
historical range of uses, from pleasure to warfare.

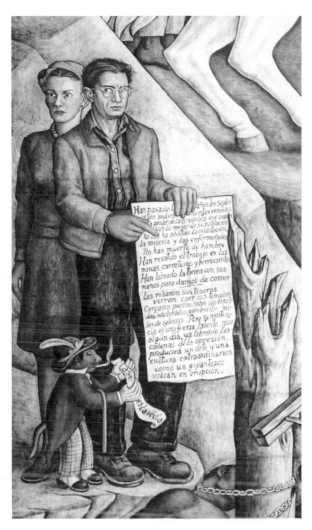

Figure 1.23. Juan
O'Gorman, *La historia
de Michoacán* (The
History of Michoacán)
(detail: self-portrait
with wife, Helen
Fowler), Biblioteca
Pública Gertrudis
Bocanegra, Pátzcuaro,
1941–1942. Photograph
courtesy of Catherine
Ettinger.

O'Gorman deploys this panoramic, aerial approach to sublime effect in
Pátzcuaro. Like the maps and views from the *miradores*, *History of Michoa-
cán* presents history and geography as an all-encompassing whole. He lifts
the viewers—tourists and local library patrons alike—up and out of the re-
gion to help them organize and know local history and potentially identify
with it—unless, of course, they choose to turn away, like his wife, Helen
Fowler (figure 1.23). It is O'Gorman's distinctive vantage point that we must
attend to in order to understand how his aerial mural sits in tension with
the emerging national view from above. Notably, unlike Fernández's map or
the murals replicating views from *miradores* by Cuevas del Río and Ricardo
Bárcenas (discussed in chapter 5), O'Gorman asks us to view Lake Pátzcuaro

from the north. This is also quite distinct from the pictorial map used in the government-produced 1943 guidebook, which uses an aerial perspective to link the Pátzcuaro region visually and ideologically to Mexico City, via a winding highway. The result is a view invoked from outside the sanctioned national channels, by an artist burned by censorship in both Mexico and the United States and now enabled by the private, US-based funding of his project. As I discuss further in chapter 4, O'Gorman's mural uses the aerial to generate a privileged vantage point that offers both objective mastery from afar and sublime identification and a collective vision that could be incorporated into the national project, without being fully grounded in a particular state project.

Pátzcuaro's landscapes presenting this tourism-inspired view from on high exhibit a range of aesthetic effects. While O'Gorman and Cueva del Río's murals arguably exploit a disembodied sublime to full (yet quite distinct) effect, others grounded their particular views from on high, virtually transporting us to specific sites in Pátzcuaro's environs. I would suggest that the artists ultimately drew on their own participation in touristic rituals in Michoacán (reading travel guides, using Fernández's map, visiting local sights) to code the experiences and ideology of these vistas into their landscapes. In doing so, they implicitly acknowledged the parallels between tourism and muralism: both promote collective forms of seeing, ideal for the project of national integration. In this sense, it should not surprise us that similar views from on high will continue to be deployed in later murals as well as in film, another mass art form, as a means to signal the transcendence of the local or regional into the rhetoric of the national.[132] This engagement with touristic modes of vision—and the resulting rhetoric of the view from above—ultimately helped in further consolidating the association between muralism and the state's project of revolutionary nationalism.

CONCLUSION: SURVEYING THE LAND

The modes of seeing Lake Pátzcuaro discussed in this chapter are all quite distinct, and their resultant images vary in style, scale, intent, and impact. A veritable contest among these possibilities for seeing this region, and ultimately seeing Mexico, emerged in this period of national consolidation, as Pátzcuaro offered something for a wide range of interests. While official commissions and projects—from Ruiz's monument and the other *miradores*, to Luis Márquez's photographs and Cueva del Río's murals—would come to embody variants of an official vision, alternative views likewise per-

sisted, supported by tourism markets and a slowly growing art market. And even Cárdenas recognized the utility of deploying different visions of Pátz-cuaro: while his artistic commissions typically promoted sublime views from above, he also strategically mobilized the local picturesque—and its associa-tion with harmless tranquility—when staging an interview with a reporter, José F. Rojas, on the shores of the lake, in which he promised that he was done with national expropriations.[133] Ultimately, however, what the diver-gent visual modes share is the premise that the act of seeing the land and people of Lake Pátzcuaro had a role to play in creating the modern nation.

Within postrevolutionary Mexico, seeing the land was part of trans-forming the land. Historian Ray Craib describes the fundamental role of the postrevolutionary surveyor, for whom the act of seeing preceded the act of mapping, dividing up, and redistributing the land.[134] His vision enabled the landscape's modernization, preparing for its new roads, bridges, and dams. Ricardo Bárcenas shows just such a figure, perched on a hilltop, eye to his theodolite, surveying the region with its new *ejido*, bridge, and housing de-velopments, in one of his two Pátzcuaro murals found in the new public theater (plate 5; see chapter 3). The surveyor was Mexico's "new man"— a gender-specific term. Trained at the Universidad Autónoma de Chapingo (Autonomous University of Chapingo), they received instruction not only in the art of surveying the national territory but also in revolutionary na-tionalism, as Diego Rivera's 1926 mural cycle in the school's auditorium pro-nounced the natural revolutionary imperative of *man*'s control of the nation's natural resources (the national map personified as Rivera's pregnant wife, Lupe Marín). It is telling how various others embodied this heroic role as guide to the land, as well. In *Que hará mi país en seis años*, by Antonio Luna Arroyo, an indigenous man and a conquistador each surveys the land from on high; in Fernando Sáinz's *Método de proyectos* (1938), a male teacher on a hill overlooking a rural school guides his male students' gazes over the land to the new mountainside road (figure 1.24). And of course photographs of President Cárdenas and other male officials, gazing across the land, were also available. As this loaded assortment of figures makes clear, and as artist García Maroto noted as he sought to encourage local women and children to see and represent their local land, the stakes were high: who was going to view the land, represent it, and make decisions about its use? This was one of the most pressing questions in postrevolutionary Mexico.

Tourism, visual culture, and art worked alongside such official projects to translate the powerful experience of viewing the land—the nation—for a broader range of audiences. As we will continue to see throughout this book,

Figure 1.24. Cover, Fernando Sáinz, *Método de proyectos* (Mexico City, 1938).

it also provided a new logic guiding the use and transformation of the land. A 1936 *Mapa* article made it explicit that national tourism promoters hoped that this experience of seeing Pátzcuaro, and by extension seeing Mexico, could transform tourists into better citizens or friends of Mexico.[135] To this end *Mapa* recommended a range of vantage points from which to view Pátzcuaro, including from El Estribo and the basilica's bell tower—a sacred space granted a new secular use.[136] Yet as much as the sublime views prompted contemplative spectators to identify with the national whole, or the social realist images pressed viewers to identify with the humanity of Mexico's people, the visual culture of tourism was also about establishing tourism as a space of privilege, tied to both leisure and sight.

As we have seen, the spaces, artworks, and images considered in this chapter worked to define and delineate this privilege through their spatial, temporal, and gendered logics. The picturesque visual rhetoric translated the subjectivity of nineteenth-century elite travelers into formats available for consumers of postcards, guidebooks, and travel magazines—new signs of Mexico's literate and traveling middle class, at times available even to those falling outside that demographic. By contrast, the modernist images offered a range of alternatives "off the beaten track"—they created visual realities

that challenged elements of the emerging middle-class aesthetics and priorities, at times seeking to establish new class relations, even as they privileged the categories "artist" and "fine art" to facilitate their creation. The sublime views of the *miradores*, murals, and films offered the authority of the view from above and the luxury of contemplation to those who engaged in these collective experiences. Pátzcuaro's visitors and locals alike embraced the privilege of enjoying such vistas, as photographs of local families using their leisure time to relax at the *miradores* attest. In short, the visual culture of tourism used sight as a source of empowerment. The gradual democratization of its views—of this empowerment, often at the expense of those viewed—became an essential element of nation building in Mexico, offering an incentive for various modes of nationalism. Seeing was the prelude to transforming the land, the viewer, and the nation.

Creating Pátzcuaro *Típico*

ARCHITECTURE, HISTORICAL PRESERVATION, AND RACE

n the 1930s the colonial city of Pátzcuaro began to command renewed attention.[1] No longer was the region primarily to be celebrated for its natural beauty; the city itself would now be packaged and promoted as a colonial treasure. A 1936 article in the tourism magazine *Mapa* announced Pátzcuaro's coming-out, likening its development to Taxco's and contrasting it favorably with the "disastrous" development of Cuernavaca (figure 2.1). It credits Lázaro Cárdenas with having defended Pátzcuaro against exotic influences and celebrates the city's efforts to preserve its historical and artistic treasures in the name of the collective and national good, superseding the demands of capitalism.[2] Manuel Toussaint's architectural study *Pátzcuaro* (begun in 1940, published in 1942) represented its apotheosis as a colonial jewel to be celebrated not for individual monuments but for the character of the whole, in its combined parts.[3] If *Mapa*'s piece summoned the affective moral and nationalistic framework for preserving Pátzcuaro, Toussaint's tome provided the documentation, history, and aesthetic analysis that would undergird its conversion into a historical monument.[4] Pátzcuaro's emergence as a cultural destination and monument in its own right happened at the intersection of a multitude of efforts: the reconstruction of the town's buildings and plazas; the creation and circulation of its image in photographs, paintings, and prints; and the publications of scholars, intellectuals, and travel writers.

Figure 2.1. "En defensa de Pátzcuaro" (In Defense of Pátzcuaro).
Mapa (December 1936).

Françoise Choay, in *The Invention of the Historical Monument*, describes the process that transforms monuments, generated via lived experience and local memory, into historical monuments, created post facto by the gaze of both professional and amateur historians.[5] At the heart of this transformation is a process of institutionalization, establishing a legal apparatus to protect designated monuments and creating institutions to oversee and standardize their systematic documentation, study, and conservation. Through this process the historical monument is reinvented in the name of new values and granted a new affective and moral purpose.[6] It is just such a process of transformation that allowed the town of Pátzcuaro to become a site for nation building, both within the realm of tourism and within the discipline of art history.

The state of Michoacán provided the legal framework for preserving and re-creating Pátzcuaro in these terms. *Mapa* noted that Lázaro Cárdenas's efforts in Pátzcuaro went back to his governorship, during which he authored the "Ley de conservación de Pátzcuaro."[7] In 1931 Michoacán passed a statewide law on the Protection and Conservation of Monuments and Natural Beauties.[8] Inspired by earlier federal laws and the process that had recently made Morelia's Colegio de San Nicolás de Hidalgo (the successor to Pátzcuaro's school of the same name) into a national historical landmark,

the law declared such protection a public good and charged authorities with defending numerous archaeological, historical, and natural sites, including the typical and characteristic aspects of selected state population centers.[9] Such conservation laws have accompanied modernization in the industrial age around the world, as they created a moral imperative to maintain contact with a soon-to-be-lost past in response to a rapidly changing present.[10] In the case of Mexico, the legal infrastructure to conserve the past initially prioritized pre-Hispanic archaeological remains, with the "Ley sobre la conservación de monumentos arqueológicos" (1862).[11] Under the reign of President Portfirio Díaz, additional protections were added (1897, 1902). Photographers including Guillermo Kahlo and Eugenio Espino Barros documented colonial-era monuments.[12] During the revolution, new laws expanded protections to historical monuments, including colonial buildings, churches, and historical and artistic objects (1914, 1916). In the postrevolutionary period the SEP published histories to enhance the memories of such sites. With Cárdenas's arrival as president in 1934, the "Ley sobre la protección y conservación de monumentos arqueológicos e históricos, poblaciones típicas y lugares de belleza natural" took Michoacán's protection of typical towns to the federal level and created separate categories for the preservation of pre-Hispanic archaeological sites and colonial historical sites, overseen by the Oficina de Monumentos Prehispánicos and the Oficina de Monumentos Coloniales y de la República, under the Departamento de Monumentos Artísticos, Arqueológicos e Históricos (DMAAH, founded in 1930) within the SEP. As Choay describes, this combination of legal protections, aesthetic and historical documentation, and eventually the professionalization of the field of preservation would come together to create the historical monument.

The 1930s laws provided a legal impetus to think differently about development, but they offered limited instructions for how to preserve Pátzcuaro—especially prior to the professionalization of the preservation field in the 1960s. Furthermore, while officials often conflated "colonial character" with "typical character" in Pátzcuaro, the field of colonial art history was in its infancy and had yet to define the inclusions and limits of the colonial. What would count as "typical" (or even "vernacular") architecture was hardly clear: the city had a wide range of styles associated with the colonial period, and its buildings had been repeatedly modified. The laws did state that new construction had to fit with the local character, while posters, signs, and announcements were to be restricted in these picturesque zones considered *típicos*. Thus the new laws recognized the important (if problematic) role that new construction was playing in historical centers. It might not

surprise us that the DMAAH's Oficina de Monumentos Coloniales y de la República sent a trained architect, Alberto Leduc, to lead the restoration of Pátzcuaro típico, or, more to the point, to create it. Although there has been no systematic study of Pátzcuaro's twentieth-century architecture, and the whereabouts of Leduc's papers remain unknown, municipal and federal records, together with material records of the city's transformation, reveal the negotiations among Cárdenas, local authorities, and Leduc, who represented the federal DMAAH. For Pátzcuaro and other communities seeking to preserve and promote lo típico, the questions were: what exactly was "typical," and who got to decide?

In creating Pátzcuaro típico, Cárdenas, town officials and luminaries, artists, architects, and photographers negotiated a history of seeing and representing the city. Medina Lasansky has described such processes as "urban editing," in which select buildings, monuments, and spaces are reconstructed, added, removed, and reshaped.[13] Importantly, such images of the city also remind us that re-creating the city was not just about architectural space; it was also about the people within those spaces. Preservation photographs taken in 1934 document not only Pátzcuaro's art and architectural monuments but also its indigenous market vendors and fishermen (figures 2.2–2.3). In her essay "Bodies—Cities" Elizabeth Grosz analyzes ways in which cities and bodies mutually define and shape each other. In arguing that "the city must be seen as the most immediately concrete locus for the production and circulation of power," she draws our attention to the ways in which the structures and forms of the city serve as the context for socialization and actively define relations between groups.[14] Thus this process of editing "typical Pátzcuaro" served to re-create and redefine social relations within the city. At their heart, as Pátzcuaro's contemporary urban planning documents make clear, such processes are invested in controlling and regulating the city and its inhabitants, in the name of aesthetic harmony.[15]

Notably, Mapa describes Cárdenas's success in creating Pátzcuaro típico by suggesting that he respected the town's "physiognomy"—a loaded term that racializes the discussion of urban architecture. Since the eighteenth century architectural historians have used this term to describe the physical features of buildings and by extension their character. This helped establish typologies of building styles, which in turn defined a sense of geographical, period, and cultural (or in modern times national) belonging.[16] The use of this term reveals something of the power at stake in the creation of lo típico. First, we should note the historical use of "the type" (lo típico) as a means of scientifically classifying plants, animals, and people. Such types are constituted

Figure 2.2. San Agustín, façade door, ca. 1934. Archivo Histórico Municipal de Pátzcuaro.

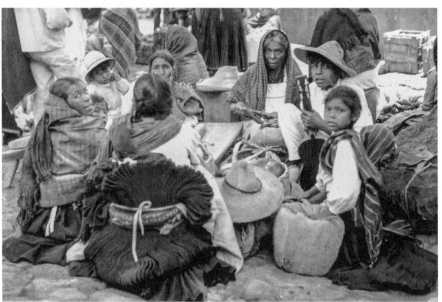

Figure 2.3. Tianguis, ca. 1934. Archivo Histórico de Pátzcuaro.

within an empirical process of collection, observation, and classification and are then re-presented as exemplary of the invented category. Second, it suggests that in discussing Pátzcuaro's architecture, we must be attentive to moments when architecture is used as a proxy for defining race and race relations: how has the construction and editing of Pátzcuaro's built environment shaped the way in which Pátzcuaro's diverse populations—Spaniards, *mulatos*, mestizos, and Indians—interact with one another? Furthermore, how has the tradition of discussing architectural style in racial terms shaped our ability to see race in Pátzcuaro and elsewhere in Mexico?[17] Third, much as we see with the term *lo típico*, the ideals being evoked by "physiognomy" are ultimately not descriptive but rather ideological: this appropriation of scientific language was meant to suggest that Cárdenas's exercise of the new law was both objective and natural, that it systematically and rationally restored Pátzcuaro to the way it *should* be.

The question this raises, of course, is what is at stake? If Pátzcuaro's aesthetic contribution is to embody the diversity of colonial architectural styles that define the mestizo nation, as Toussaint's work suggests, how do we reconcile an architecture described largely in European and indigenous terms with a city that was described in census data in 1754 as having as many as 1,084 Spaniards; 1,628 *mulatos* (descendants of Africans and Europeans), mestizos (descendants of Indians and Europeans), *coyotes* (descendants of Indians and mestizos), and *los de color quebrado* (dark-skinned descendants of Africans and Indians and/or Europeans); and 568 *indios*?[18] Another source explicitly describes *mulatos* as Pátzcuaro's growing demographic in the eighteenth century.[19] As the *Mapa* article evokes Pátzcuaro's restoration and harmonization, and Toussaint and others value it as an aesthetic whole, we might ask: which conflicts and differences are being erased or subdued in order to promote unity?[20]

In this context of urban redevelopment, I argue that architectural and pictorial aesthetics become a key tool of social regulation. In her discussion of reinventing the Bahamas for tourism, Krista Thompson argues that the aesthetic lens is fundamentally about governing spaces and practices.[21] We'll see that images in a variety of genres and media—each with its own disciplinary agenda—contribute to such regulation in Pátzcuaro. I emphasize two areas of control at stake in Pátzcuaro's re-creation, both of which were intimately tied to the Cardenista modernization program. First, attempts to govern and modernize commerce in Pátzcuaro led to conflicts surrounding its market vendors. In this context, new architectural forms and spaces regulate vendors' economic activity, while images of those vendors compete

with efforts to moderate who trades, where, and when. It is precisely here that Pátzcuaro *típico* is constituted in indigenous terms. Second, Pátzcuaro's re-creation was also about a larger secularization agenda, in which restoring and recasting religious structures for new secular ends worked alongside images, histories, and artistic studies of sacred architecture to temper, tame, and regulate local religious practice.

Ultimately I argue that the creation of *lo típico* was the public face of the creation of modern Pátzcuaro. During the 1930s the creators of modern Pátzcuaro selectively appropriated and negotiated its visual history in order to couch radical change in familiar terms and promote national integration. Michoacán's revolutionary leaders of the 1920s had attempted a straightforward implementation of agricultural, educational, and church reform to explosive results and faced violent resistance in the form of the Cristeros Rebellion (1926–1929). While the language of preservation that undergirded the state's new local patrimony law appeared to be a means to forestall change, in fact it provided an ideological and political tool that could be used to promote very specific kinds of change. In the case of Pátzcuaro, Cárdenas and his supporters used *lo típico* to promote transformation—a strategy of evoking history and aesthetics that was soon learned by a wide range of citizens. In this chapter I start by considering the dialog between image and the reconstruction of *lo típico* before turning to the conflicts over religion and commerce. Ultimately *lo típico*, aesthetics, and history served as ideological tools that various parties have used to advance their agendas.

THE PICTURESQUE TOWN

To understand the 1930s creation of Pátzcuaro, we need to understand the competing visions of Pátzcuaro already in place—distinct visions defined equally by their respective genres and their ideological goals. While the nineteenth-century picturesque privileged the idea of a natural paradise centered around life on the lake, the city of Pátzcuaro also made its presence known.[22] Fanny Calderón de la Barca and her contemporaries evoked the red-tiled roofs of the town and commented on the region's churches and convents. She praised the healthy whiteness of the city's Spanish inhabitants but criticized Santa Catarina's nuns, who dressed in Indian rebozos and acted like vulgar commoners, a characterization that suggests discomfort with the women's racial ambiguity.[23] In the accounts of Calderón de la Barca and others, the city and its inhabitants revolved around colonial history and Catholic religious culture. For visiting artists the dilapidated state

of those institutions appealed within the visual language and ideology of the picturesque, emphasizing the region's past glory and inviting modernization and transformation. Yet there were competing notions of how to represent Pátzcuaro. Understanding their stakes allows us to gain a better understanding of the implications of Pátzcuaro's transformation in image and in wood, adobe, and stone.

Souvenir books treating Pátzcuaro from the turn of the century were specifically created with the religious visitor in mind.[24] At the end of the nineteenth century the town initiated a series of petitions to elevate the status of a local corn-paste cult figure dating from the sixteenth century, Nuestra Señora de la Salud, who was the patron of the region's hospitals. Improvements to the Santuario de Nuestra Señora de la Salud began in 1890, and in 1899 the archbishop celebrated her coronation. In 1907 she was moved to the large and prestigious Parroquia en Colegiata—the building initiated in 1573 under Pátzcuaro's founding bishop, Don Vasco de la Quiroga, to serve as the region's cathedral, which was reconstructed in a neoclassical style in 1899. In 1924 it was designated a basilica. Festivals and publications celebrated these events and presented the venerated image within the fabric of the city. The *Álbum de Pátzcuaro* (ca. 1899) celebrates the coronation; a purely photographic album, it begins with images of La Señora de la Salud, her crown, the papal bull conceding the crown to the virgin, and the archbishop. They are followed by images of her sanctuary and her fellow saints, views of local churches and religious structures, images related to her original patron, Don Vasco de Quiroga, general views of the town, and finally panoramas of Lake Pátzcuaro. Such an album was a souvenir for religious pilgrims and locals alike, memorializing the Virgin's growing holy status, her history, and her picture-perfect setting.

Photographs in the *Álbum de Pátzcuaro* represent one trend in images of Pátzcuaro: emphasizing order and harmony. The "Santuario de Nuestra Señora de la Salud" (The Sanctuary of Our Lady of Health) rises in neoclassical splendor, its clean lines and freshly whitewashed façade well maintained and barely recognizable today. The Primitivo Colegio de San Nicolás, founded by Don Vasco de Quiroga, unfolds symmetrically from its distinctive corner doorway in the composition's center, while the Don Vasco fountain (the site of his miraculous discovery of sufficient fresh water to relocate his capital to this site) frames the image. The discreet rubble in front just hints at the site's state of disrepair. If the images include people at all, they are carefully moderated. The "Templo de San Agustín" (Church of St. Augustine) presents neat rows of men and women selling goods on the ground

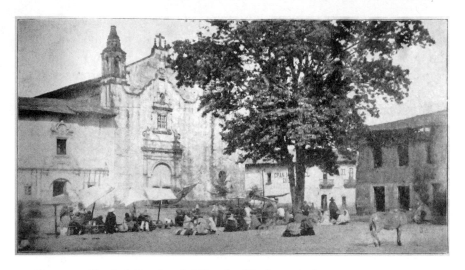

Figure 2.4. *Templo de San Agustín* (Church of St. Augustine).
From *Álbum de Pátzcuaro* (Morelia, ca. 1899).

under the shade of umbrellas and a massive tree, all set off against the old church and convent of San Agustín (figure 2.4). A picturesque donkey waiting in the foreground balances the composition. "Vista de la Plaza Principal" (View of the Main Plaza) shows a neat, disciplined scene, bordered by the plaza's great trees and buildings. Crowds line the buildings and sombrero- and blanket-wearing *indios* gather under the trees, yet the overall effect is of structure and order, in large part thanks to the wide space — the street — that divides the composition and distances the viewer from the scene. The street is populated with small isolated groups of people — a pair of *indios*, a pair of men in suits and hats — and extends back to its vanishing point, creating a sense of rational space. This vision promises a plaza where Indians of the lake and *mulatos*, mestizos, and Hispanics from the town harmoniously congregate, while preserving an essential and differentiating social order. Such is Pátzcuaro, we are told, under the reign of Nuestra Señora de la Salud.

While numerous visitors commented on their visits to religious institutions, it was also clear that tensions were developing between religious pilgrims and secular visitors. The artist Frances Hopkinson Smith, author of *A White Umbrella in Mexico* (1889), traveled around Mexico before concluding his narrative in Pátzcuaro. He framed his journey as an artistic pilgrimage, with the goal of seeing the *Deposition* in the church of San Francisco in nearby Tzintzuntzan, supposedly by Titian. The absurd lengths to which he and his Mexican companion, "Moon," go to access this image — a precari-

ous trip by improvised catamaran, elaborate gifts for the unreceptive priest who guards the painting—underscore the only terms in which foreigners were welcome in this small town: for their money. When our painter gets carried away after buying the privilege of solitude with the work—noting that a "sense of temporary ownership comes over one when left alone in a room containing some priceless treasure or thing of beauty not his own"—he climbs on a table, touches the painting, and is caught.[25] Moon comes to his rescue with a story about a miracle, claiming that Smith was on a religious pilgrimage to the church to restore a lame hand, and the two escape.

Before undertaking that arduous journey to Tzintzuntzan, Smith describes Pátzcuaro's picturesque calm and charm, a perfect foil for his upcoming adventure. For him, the town is the most "Moorish" in Mexico; its architecture, with its columns, arches, overhanging roofs, hanging lanterns, and flower-filled verandas, transports him to southern Spain. While he laments that the plazas are overrun with markets and the churches are either abandoned or renovated, it is Pátzcuaro's picturesque streets that hold the town's charm. His sketch of a portico captures its architectural detailing and wooden-beamed overhanging roof, balcony, and lantern, and just hints at sombreros under the arch. This picturesque architectural fragment offers shelter before the next adventure and provides an aesthetic alternative to the religious narrative found in the *Álbum de Pátzcuaro*. He frames Pátzcuaro's urban spaces in terms of aesthetics and nostalgia, rather than moral order, and reads Pátzcuaro as exotic, even for Mexico.

Artists following in Smith's footsteps sketched the town's picturesque streets, and their sketches in turn circulated to promote local tourism. Such images emphasized colonial trappings, along with their deterioration, capturing a precarious world, stuck in the past. While stylistically diverse, the images manage to engage many of the same picturesque tropes and ideals, offering a sense of timelessness or otherworldly charm. *Mexican Life* included an expressionist charcoal drawing of the street leading to San Juan de Dios by Joseph Sparks, simply entitled *Pátzcuaro* (figure 2.5). The street heaves in the foreground, and the rough-hewn houses with overhanging roofs and the darkened church dome and tower in the distance suggest an unstable colonial world on the verge of transformation. A watercolor published in the same magazine in 1937 by Mexican artist Ricardo Bárcenas likewise presents a deteriorating street scene with iron lamps and balconies and provides for calm reflection. A popular colorized postcard presents the hazy courtyard of the eighteenth-century house of the Casas Navarrete family (figure 2.6). A woman wearing a *huipil* (indigenous embroidered woman's

Figure 2.5. Joseph Sparks, *Pátzcuaro*. From *Mexican Life* (September 1932).

Figure 2.6. Postcard showing courtyard of the eighteenth-century house of the Casas Navarrete family. Collection of the author.

shirt) with braided hair, seated by a fountain and ringed by Spanish *mudéjar* arches (scalloped arches, reflecting the influence of Islamic North Africa in Spain), evoked a nostalgia for the exotic described by Smith.

Such romantic aesthetics clearly were imagined to appeal to modern tourists and their search for an affect-rich experience in the industrial age. On the eve of the new law to conserve *lo típico* in Pátzcuaro, Jorge Bay Pisa published a guidebook, *Los rincones históricos de la ciudad de Pátzcuaro* (1930), affectionately dedicated to President Pascual Ortiz Rubio ("dedicated promoter of tourism"). Bay Pisa promises to "revive things that have been forgotten" and do his part in "this time of growing tourism." He tells of the city's foundations under the Purépechas and its reincarnation under Don Vasco de Quiroga and then provides a series of lively accounts of the town's plazas, monuments, and historical occupants, punctuated with photographs. The grainy images reproduced from México Foto postcards suggest a rundown and overgrown Pátzcuaro, in sharp contrast to the *Álbum of Pátzcuaro*. This time, images of the Primitivo Colegio de San Nicolás and its neighboring fountain, neatly numbered and labeled, make no attempt to minimize the rubble in the streets and general state of disrepair. Three rebozo-covered Indian women and an indigenous man lend picturesque color to the scene. Even more revealing is the "Plaza Mayor," which layers monument upon fountain upon kiosk, while its gardens are rich with a range of palms, banana plants, (presumably flowering) bushes, and other trees. A man in a suit holding a panama hat stands near the center, providing scale and familiarity for urban tourists. Postcards also capture this tropical rendition of the plaza, drawing on strategies employed in other postcolonial contexts to lure tourists with images of tropical abundance, which is part of a larger phenomenon that Krista Thompson terms "tropicalization" in her study of the Caribbean (figure 2.7).[26]

This comparison is important, however, not just because we find in it the internationally resonant framing of a romantic and exotic Pátzcuaro, but because it also reminds us that Pátzcuaro's colonial foundations were part of Spain's extensive colonization project, which linked the areas that we now describe as Mexico, the Caribbean, South America, and the Philippines. As guidebooks remind us, in the sixteenth century Don Vasco de Quiroga introduced to Mexico four varieties of banana plants, acquired in Santo Domingo while en route to New Spain.[27] According to Judith Carney, banana trees (which spread from Asia to Africa and then to the Americas) came to Santo Domingo along with African slaves.[28] Santo Domingo, the first Spanish slave-trading port and early source of Mexico's slave population, was

Figure 2.7. México Foto, "Plaza Principal, Pátzcuaro, Mich." (Main Plaza, Pátzcuaro, Mich.) postcard. Collection of Gerardo Díaz.

most likely the source of Quiroga's own slaves as well. Both the banana plants and the plaza's tropical aesthetic potentially constitute a trace of New Spain's slave economy, which remained visible in the early twentieth century as part of an international postcolonial phenomenon that converted such symbols of tropical empire into currency within the expanding tourism marketplace.[29] Thus it might not surprise us that postcards of Pátzcuaro demonstrate that palm trees and banana plants persist in sites associated with tourism: specifically, the train station and local restaurants and hotels.

Finally, we see the evocation of the exotic repeated in guidebooks surrounding the Puente Salamanca, on the newly renamed road to Morelia, Calle Benigo Serrato. Bay Pisa provides a vivid account of an eccentric one-handed woman who lived by the bridge in the seventeenth century, known for divining the future, finding lost things and lost people, and using her powers to help all the classes of Pátzcuaro who came to visit her *sala*.[30] This landmark bridge on the outskirts of town in what was known as the *infierno* (hell) neighborhood testifies to the persistence of ideas about the exotic and magical within tourism contexts, although later renditions tame the story of the "fortune teller" and emphasize that this is "the bad" section of town.[31] It is unclear whether such talk of divining is a trace of West African culture in the region, first made exotic and later tamed but regulated ("bad").

Figure 2.9. María Izquierdo, *Pátzcuaro*. © Christie's Images Limited 2017.

A horseman with a second packhorse and hazy clusters of men conversing evoke a sense of timelessness and contrast with the power line punctuating the skyline. Flannery deemphasized the presence of the electrical lines, however, removing a closer pole from his original photograph. María Izquierdo presents a haunting scene of a barren street in Pátzcuaro (Calle Alcantarillas) and highlights the strange housing—seemingly emerging, tunnel-like, from the slanted earth—that protects the town's spring (figure 2.9). While these artists shared an interest in structure, they used it very distinctly in their respective searches for timeless or universal truths.

As municipal leaders debated the implications of the new law protecting and promoting Pátzcuaro *típico*, they negotiated this legacy of competing images and the provocative questions raised. How would the drive to modernize the city and its infrastructure compete with the desire to court tourists seeking a "primitive" or exotic visual experience? Should they preserve the ruins and tropical abundance that seemingly appealed to travelers and tourists or return to the image of pristine order and harmony promoted in religious guidebooks? In this era of religious conflict, how should they address

Meanwhile, while the exotic clearly drew some to Pátzcuaro, various postrevolutionary modernist artists brought a different set of concerns and assumptions to depicting Pátzcuaro. In their search for Mexico's national foundations, they present an underlying structure in their images, often seeking modernist alternatives to the picturesque (as discussed in chapter 1). A young Rufino Tamayo gives us a twist on this trend in his pastel of a street scene, entitled *Pátzcuaro* (1921). Here he preserves a sense of order and structure in his scene of a rustic portico overhang and whitewashed house wall. His impressionist style dissolves that structure in shimmering whites and pastels, however, again creating an image of transience and disintegration. Tina Modotti was able to bring order and clarity to one of the plaza's most lively and bustling events: the Friday *tianguis* (open-air market) (figure 2.8). Her view from above uses light and shadow to provide formal structure to the scene of indigenous vendors and customers, surrounded by piles of wares under the plaza's giant old trees. Realist painter Vaughan Flannery reworked a photograph capturing a view through a portico on the main plaza to provide a highly ordered glimpse of both modern and traditional Pátzcuaro.

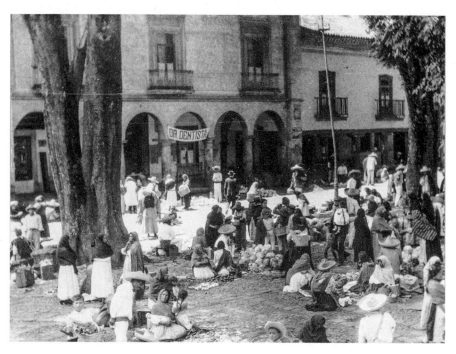

Figure 2.8. Tina Modotti, *Market*, gelatin silver print, 1926.
Courtesy of the George Eastman Museum.

the religious monuments? Which inhabitants of Pátzcuaro should be visible, and where? And given the highly regulated and selective inclusion of people in the images, how far could (or should) their attempts to transform Pátzcuaro into an ideal picture go? We can glimpse their attempts to grapple with these questions in the choices that they made regarding the preservation, destruction, and creation of Pátzcuaro's architectural environment.

LO TÍPICO AS MODERN MEXICO

The 1930s construction of typical Pátzcuaro happened hand in hand with the town's modernization, from the development of its infrastructure and its tourism economy to the transformation of its system of education, cultural activities, and use of social space. The changes were equal parts functional and symbolic—what Umberto Eco refers to as the semiotics of architecture, with the functional serving as the denoted meaning and the symbolic as the architecture's connoted meaning. In fact, function and symbol consistently appear to be strategically misaligned or realigned in radical ways. From the early 1930s the town reported working on new roads, drainage and repaving projects, school repairs, and the expansion of electric and water services—projects that had parallels in many other local communities.[32] Yet Pátzcuaro's leaders framed this modernization in one of two interrelated ways: they were re-creating *lo típico* and were seeking to satisfy tourists, from the taxi stand in the Plaza Chica to the reconstruction of the city's fountains, gardens, and plazas.[33] Yet in seeking to make *lo típico* visible, municipal leaders worried about the terms in which the town should symbolically preserve its links to the past. They clearly equated the town's so-called colonial character with *lo típico*, yet they recognized how loaded that legacy was.[34] Thus they debated, for example, whether they should restore the city's street names—revised in the nineteenth century to commemorate local leaders and historical figures—to their original colonial-era names evoking saints and religious institutions. This discussion was taken up by the federal DMAAH, which in the person of its building inspector and architect, Alberto Leduc, came to be the major adjudicator of things typical in Pátzcuaro.[35] The category of colonial was just being negotiated at this time (the field of Mexican art and architectural history was in its infancy), so these ideas were being created along with Pátzcuaro's creation. In this formative process of inventing *lo típico*, then, we see a negotiation regarding not just what is typical, but also who gets to decide.

The transformation of the ample Plaza Principal, supported by munici-

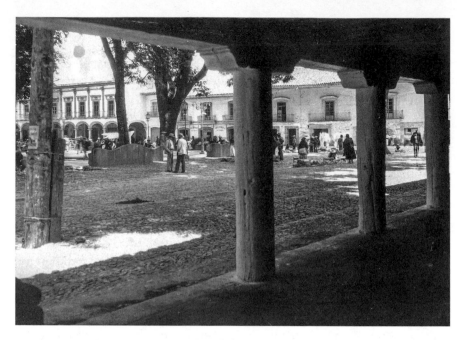

Figure 2.10. "Casa del Portal Chaparro. Al fondo, la Plaza principal" (Chaparro Portico House. Main Plaza in the background). From Enrique Cervantes, *Pátzcuaro en el año mil novecientos treinta y seis* (Mexico City, 1949).

pal, state, and federal funds, demonstrates this negotiation of images past. Predating the "Laws of the Indies" and their call to erect ecclesiastical and political power in a central plaza (1573), the plaza was hardly typical for the Spanish colonies, as the most important church (La Colegiata, formerly Michoacán's cathedral) was built overlooking the town on a sacred Purépecha site, while this ample plaza was built below to house the government, commercial interests, and elite residences (both Spanish and indigenous), perhaps on the site of a former market.[36] Its mix of residential, civic, and commercial structures was noted for its porticos and stately façades in styles ranging from baroque and neoclassical (figure 2.1) to rustic simplicity. Although the Portal Chaparro maintained its original portico (figure 2.10)—with a squat profile and wooden architraves, beams, and columns—most of the buildings had been repeatedly renovated. Updates in the eighteenth century responded to a rising cosmopolitanism, including stonework arched porticos, fine decorative moldings, and ornamentation in eclectic styles. By contrast, during the liberal nineteenth century, owners replaced some of the most exuberant and orientalizing examples of baroque architecture, including the façade of the eighteenth-century house built by Tomás de Casas

Navarrete (see figure 2.6 for the *mudéjar* arches preserved in the courtyard), with neoclassical façades, and added iron grillwork and fixtures. Meanwhile, all the buildings had upgraded their straw roofs in the eighteenth century to shingle and then tile. Thus while many elements of the plaza's architectural profile emerged in the eighteenth century with the local Spanish and *criollo* (born in the Americas of Spanish descent) elite's growing power, its history included multiple modifications.[37]

By 1930, as discussed above, the main plaza's garden (the Jardín Ibarra) was a crowded and dense site of tropical abundance (figure 2.7). As the city began remodeling the plaza to add benches and improve lighting, it clearly made a decision that *lo típico* required a new aesthetic direction, toward the restoration of neoclassical order. The gardens were reorganized, adding four stone benches—a departure from the more delicate iron and wood benches from the previous decades.[38] While some palm trees remained through the 1930s, the gardens were dramatically tamed and eventually maintained with tightly cropped ornamental trees (and no banana trees). Thus Pátzcuaro's version of *lo típico* gradually began to shift away from the vision of abundant tropics associated with coastal and lowland Mexico and the Caribbean and their shared legacy of slave-supported agriculture. Speaking to the injunction that Michoacán could embody all of Mexico in one vacation, Michoacán's major tourism centers began to differentiate: the tropical paradise would become the signature of Uruapan; Pátzcuaro would have its mountain lake, quaint streets, and ordered colonial charm.[39] Thus, in the name of tourism and regional specificity, the urban environment was edited to emphasize the aesthetic order projected by colonial authorities but not the full range of history that came with it.

The most dramatic change to the Plaza Principal came in 1935, at the urging of Cárdenas himself: the removal of the kiosk from the Porfirio Díaz era (1905), with its iron filigree and Victorian flare. In this act of urban editing, a new fountain was planned to re-create the one that had preceded the kiosk. Cárdenas's architect, Alberto Leduc, assisted by "Engineer Ruiz" (likely sculptor Guillermo Ruiz), worked with photographs of the ca. 1869 fountain. The DMAAH's casting workshop prepared a model that would ultimately be approved by Cárdenas.[40] The new fountain reused fragments of the original base, a large stone ring of acanthus leaves that had remained in place, and re-created its central pavilion with four upended fish under a neoclassical canopy (figure 2.11).[41] Such changes reflected a larger rejection of Porfirian cosmopolitanism (evoked by the Victorian kiosk) and a return to early nineteenth-century neoclassical and independence era values, both

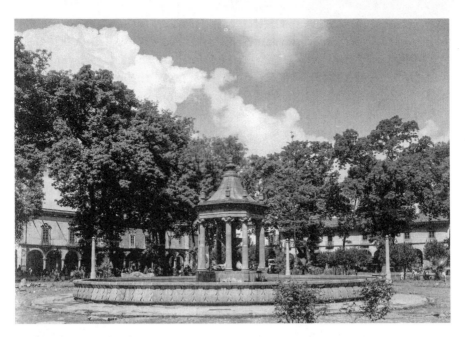

Figure 2.11. "Fuente de los Pescaditos. Plaza principal" (Fountain of the Little Fish. Main Plaza). From Enrique Cervantes, *Pátzcuaro el año mil novecientos treinta y seis* (Mexico City, 1949).

aesthetically and functionally. No longer would the central point of the plaza be an elevated platform for political and cultural performances; such activities were reoriented to the municipal palace end of the plaza. Instead, in a democratizing move, the plaza returned to being a space for walking and interacting at ground level, now in orderly, symmetrical patterns. This return to order was resonant with various ideologies; in this case it arguably linked the postrevolutionary period to the mid-century Reforma and its association with neoclassical liberalism, effectively excising the Portfiriato. Interestingly, this blurring of the line between colonial and neoclassical nineteenth-century art and architecture was also seen in the institutional structure of the DMAAH, which had a single office overseeing monuments of the colonial and republic periods. *Lo típico*, in this context, became more about order and the exclusions needed to maintain such order.

Town maps manage to capture the plaza's symmetrical design, and subsequent photographs of the new plaza certainly project that sense of order and calm. Enrique Cervantes, Mexican engineer, photographer, and key figure in the conservation of colonial Mexico, photographed the town in 1936 for an album celebrating the reconstruction (*Pátzcuaro en el año del mil novecientos treinta y seis*, 1948). His photos create that sense of order and structure by

emphasizing the plaza's architectural features and minimizing human presences. Many are taken from within the plaza's surrounding porticos, which then frame the few people, animals, plants, or wares for sale (figure 2.10). Cervantes's photo of the new fountain highlights the ordered symmetry of the circular base, with a ring of plantings on the far side (figure 2.11). Photographers (including Foto Valdés, which operated from an arched portico on the plaza's north side) often followed these principles as well, which ultimately served to reinforce the neoclassical essence of the town previously commented on by visitors such as the Mexican-born Jewish American anthropologist and author Anita Brenner.[42] This is also the aesthetic captured in the *Mapa* article that praised Cárdenas's leadership in the town's historical preservation. In fact, the opening image was a favorite of professional photographers: the view of Portal Aldama from the Portal Hidalgo, with trees and the arches containing clusters of local inhabitants in the distance (figure 2.1).

Yet the idea of an orderly plaza perhaps overstates the power of the governing elites' architectural choices to shape the lived experience of a space. Other images postdating the new fountain show the crowded throngs that filled the plaza *tianguis* on Friday, the traditional weekly market day when indigenous vendors from towns around the lake and the hills still bring their produce and wares to Pátzcuaro for trade and sale. Unlike Modotti's image of 1926 (figure 2.8), most photos are taken from pedestrian level: little essential structure emerges. We see the vendors sitting at the edge of pathways, sometimes in rows, other times alone, while milling indigenous and mestizo crowds barter and inspect the goods. Notably, however, when the plaza itself fails to contain the crowds, the photographers continue to either uncover or impose an order. One of the 1934 preservation photographs, for example, uses its view from above to capture and isolate a cluster of market women and their children, who have seated themselves in a circle (figure 2.3). Such images work to control and mediate the image of the indigenous market woman—with her elaborately pleated skirt and distinctive rebozo—for the consuming gaze of the tourist or government official. In fact, this conflicted history of images of the plaza and its Friday *tianguis*—which has since been moved to the Plaza de San Francisco—just hints at a more protracted struggle in Pátzcuaro over the control of its urban markets and its vendors, who for some were the epitome of *lo típico*.

MARKET WOMEN, INDIANS, AND THE PUBLIC MARKET

For many, the sober, stoic-looking market woman with great pleats of skirt gathered in back and a blue rebozo covering her head, with fish and produce

in baskets arranged on the ground before her, preserved in a mere fragment of a long-hidden mural (perhaps by Juan O'Gorman), epitomizes typical Pátzcuaro in the 1930s (figure 2.12). Such images built on the nineteenth-century *costumbrismo* tradition, or regional type, in which traveler artists and others created images displaying the distinctive clothes, customs, and produce to represent the region. Ramón Alva de la Canal's image of a Purépecha fish-seller overlooking the lake within the *Monumento a Morelos* and Arturo Gómez's *Mujeres de Pátzcuaro* (Women of Pátzcuaro) (1936, figure 2.13) continue the tradition of the "type": a generic image that uses a basic series of signs — the clothing, Lake Pátzcuaro's famed whitefish, the custom of selling goods while seated on the ground — to stand for a category of people. Note how the excessive treatment of the pleated skirt arguably threatens to eclipse the person represented. For many realist artists, however, the image of the market woman could go beyond the type to stand as a social document of the time. The photographer who in 1934 captured the circle of vendors discussed above clearly carefully composed the image to highlight the women's distinctive clothes, yet also captured their activities, camaraderie, curiosity, and what John Mraz refers to as a "density of detail" characteristic of realist photographers.[43] Meanwhile, the local photographer producing Foto Valdés postcards makes us part of the scene, in which a vendor offers her catch of fish and interacts with the photographer/viewer and her companion (figure 2.14). Notably, the recently uncovered mural showing a vendor seated along a wall may in fact speak to a contested category of market woman — represented by various visiting artists — seated on the fringes of Pátzcuaro's streets rather than within the main plaza's famed *tianguis*. Likely painted a few years after the construction of Pátzcuaro's modern new public market, which brought with it new conflicts about who was to offer goods for sale in which space, O'Gorman's hidden work suggests that such images also entered into the negotiations over regulating street and market commerce in Pátzcuaro.

For many, the streets, plazas, and markets were the exemplar of *lo típico*. At the same time, they were also arguably some of Pátzcuaro's most important "contact zones," a term invoked by Mary Louise Pratt to discuss the spaces where travelers and locals met and interacted, most often across relations of unequal power.[44] This concept can also be applied to contact between the region's urban and lake populations. These spaces of commerce represented the center of the regional economy. Linda Seligmann describes Andean markets, noting that "the marketplace itself . . . constitutes the border marking the separation between the urban and rural spheres and the

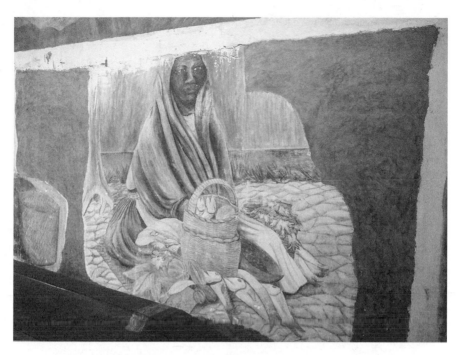

Figure 2.12. Covered mural at the Biblioteca Pública Gertrudis Bocanegra, Pátzcuaro, ca. 1938–1942. Photograph by author.

Figure 2.13. Arturo Gómez, *Mujeres de Pátzcuaro* (Women of Pátzcuaro), color lithograph, 1936.

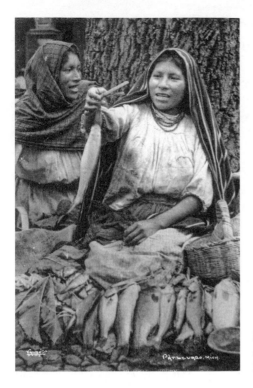

Figure 2.14. Foto Valdés, "Pátzcuaro, Mich." postcard. Courtesy of the David Haun Postcard Collection.

nexus in which they intersect."[45] By the 1930s the market and its vendors had also become central to Pátzcuaro's touristic image, and all guidebooks made note of the Friday *tianguis* in the main plaza. In her *Motorist Guide to Mexico* (1938), Frances Toor went so far as to assert that Pátzcuaro's market was "one of the most picturesque and interesting markets in Mexico."[46] While the weekly *tianguis* was a favorite with tourists and artists, however, street vendors more broadly were met with ambivalence and even hostility from local business owners. Such vendors sold their goods daily in the Plaza Chica, along the streets, and under arches around the squares. The social and economic importance of markets—both formal and informal—accounts for the various attempts made to regulate their spaces and subjects, from the creation of new architecture to house vendors to their reproduction in a myriad of images. Such attempts to govern and regulate were all the more important in contact zones, given the tendency that Pratt describes for such unmapped areas of contact to become spaces of inversion, reversal, and negotiation.[47]

While modern Pátzcuaro is now imagined as a mestizo town, and historically was split evenly between Spanish and *mulato*/mestizo populations, the frequency of depictions of indigenous figures in public spaces is worth re-

marking upon. A photograph by French photographer Abel (Alfred) Briquet from his album *Vistas mexicanas* (ca. 1880) clearly stages his shot down Calle Ramos toward the Santuario de Guadalupe, arranging three bodies evenly across the street: to the left, a figure in dark clothes (perhaps a *mulato* cargo handler); to the right, a field-worker in white; and in the center an Indian water vendor.[48] While additional figures punctuate the background and sides of the images, this highly strategic staging highlights the ways in which artists and photographers self-consciously worked to define the city of Pátzcuaro in relationship to the region's diverse working-class population. Images regularly stressed the variety of classes and races that together defined the city — even if typically divided by lighting or space. But the frequency with which seeming Indians serve as props to define the urban space is notable, given that by the eighteenth century the city residents were largely Spanish, *mulato*, and mestizo, along with certain elite Indian families, and given the regularity with which commentators noted that the local indigenous populations lived around the lake. While we can in part understand the regular posing of indigenous figures as part of a photographic tradition of picturesque and *costumbrismo* images, I suggest that something more is going on here: from Pátzcuaro's early foundations the city was necessarily defined through laboring Indian bodies. While indigenous peoples were considered part of the natural world (they were, after all, called *los naturales*), Indian bodies were simultaneously defined in and by cities. In fact, the very category of Indian was created in the urban context as a regulated and governed body, defined vis-à-vis the colony's other populations. Over the centuries the terms with which this took place adjusted. In the 1930s the modernization of this urban Indian was particularly vulnerable to the dramatic reconstruction of Pátzcuaro's built environment.

It is crucial to recall that the very invention of the "Indian" as a social, political, and economic category took place during the colonial period, as part of the conquest, and thus during the creation of colonial Pátzcuaro. On one hand, chroniclers describe Don Vasco de Quiroga's move to establish Pátzcuaro as involving the translocation of a group of Spanish and elite indigenous families from Tzintzuntzan. For those elite Indians, the emerging definition of *el indio* included a preservation of specific lineage rights and obligations. It also involved a claim to privileged spaces in the new colonial city: elite sons of noble indigenous families received a religious education at Don Vasco de Quiroga's Colegio de San Nicolás. The Palacio de Huitziméngari, for example, was built on the prestigious main plaza of Pátzcuaro and housed the indigenous governor and descendants of the last Purépecha

ruler. At the same time, the outskirts of Pátzcuaro—technically part of the municipality—included many barrios with Indian populations: communities held by the *encomenderos* (later *hacendados*) who lived in Pátzcuaro's main square.[49] These Indians also had specific rights and obligations and were, for example, expected to pay tithes and submit to the indigenous governor and colonial authorities. For our purposes, it is especially important to note that market vending was defined as the exclusive prerogative of Indians from early in the colonial period.[50] Throughout the colony, in order to make cities viable, rural Indians were required by law to bring their food and wares to cities and in exchange received the right to sell their goods.[51] Spanish municipal authorities had the power to regulate and control when and where the markets operated and tightly curtailed attempts to sell goods outside of markets. They also set standards for local weights and measures, hygiene, and refuse disposal and collected taxes from vendors.[52] Notably, barter in the *tianguis* has long been important for transactions between indigenous people, but market transactions by design brought New Spain's varied inhabitants together. The market plaza became the defining contact zone of the early modern world, and its indigenous vendors were its cultural and economic brokers. Thus the construction of indigenous identity from early in the colonial period included the Indian market vendor, a figure defined by her regulated presence in the city and by her negotiated relationship to various other urban social groups.

Indian dominance in the market was destabilized even during the colonial period. Mexico's markets became some of the most racially diverse spaces in New Spain. By the 1930s Pátzcuaro's Indians had certainly lost their monopoly. The *tianguis*, Pátzcuaro's celebrated Friday marketplace, remained known as the Indian market but was just one option for buying and selling wares in the city. David Kaplan describes mid–twentieth-century Pátzcuaro as a city of "middlemen," where mestizos and *indios* alike sold goods in a daily market, regardless of whether they or their family had produced them.[53] Yet, in the context of the developing tourism industry, indigenous status did once again carry a certain currency, both in the Friday *tianguis* and in the daily markets. In this modern world, however, mere status as market vendor was not sufficient to assign—or claim—indigenous identity. Rural communities, while typically assumed to be indigenous, were likely in fact populated by people of a mixture of Spanish, indigenous, and African heritage. In this context, the vendors and their recorders created physical, material, and cultural signs to signify "indigenous." It was in the business interest of market women to claim such distinctiveness and to play their part.

Kaplan described mid-century indigenous vendors as selling food and goods that their own families produced or caught (unalienated labor), marked by their elaborate dress (pleated skirts and rebozos covering their heads), bare feet, and seated position on the ground, all of which differentiated indigenous vendors from mestizos. These characteristics, along with braided hair, are the markers that artists depicting indigenous vendors stressed in their representations of market women, which became so popular in postcards, paintings, calendars, and murals. Manuel Toussaint evoked the market's allure for artists and painters, noting that in the *tianguis* "we find the life of the people painted in living color, which a painting cannot match."[54] The Friday traditional *tianguis* was advertised as one of Pátzcuaro's chief tourism draws. These images both preserved and regulated the open-air market, as they helped determine who counted as an indigenous vendor.

Certainly many of these images resonated with visitors because they spoke to a larger context: a Mexico, and a world, in which modern public markets—steel and glass structures with large open naves, running water, and electricity that embraced the rhetoric of progress, hygiene, and capitalism—were expanding.[55] By contrast, the precapitalist *tianguis* increasingly represented the marketplace of the past.[56] In the economy of modern tourism, its allure resided in that difference. It is in this context that the regulation of Pátzcuaro's vendors became intensely racialized and politicized: between 1934 and 1937 Pátzcuaro's municipality planned and constructed a modern new public market building on the Plaza Chica. Plans for the market began with private fund-raising efforts in 1934; the state expropriated a city block on the Plaza Chica in 1935; and by January 11, 1936, following a city official's December visit to Mexico City to meet with Cárdenas, the Banco Nacional Hipotecario Urbano y de Obras Públicas, S. A., had promised a loan of up to Mex$93,800.[57] Cárdenas helped the municipality secure this large public loan from the National Bank.[58] The construction project was long and drawn out; there were problems with securing materials and funding and with repaying the loan.[59] Along the way, Leduc and the DMAAH weighed in on the building's plans. Unspecified modifications were made, presumably under the leadership of engineer Armando Carrano, who had finished work on the project by February 2.[60] On March 31, 1937, the new market opened (figure 2.15).[61] This initiated a transformation in the regulation of market commerce and culture in Pátzcuaro, as street vendors were required to relocate from the daily markets in the Plaza Chica, under the arches, and along the streets to rented spaces where they paid higher taxes for the privilege of access to permanent shelter, running water, and electricity.

Figure 2.15. "El Mercado, Pátzcuaro, Mich." Public Market, Plaza Chica, Pátzcuaro, 1935–1937. Archivo Histórico Municipal de Pátzcuaro.

Progressive municipal leaders around Mexico embraced such new markets as signs of the country's postrevolutionary new order.[62] Such markets offered, it appeared, modern solutions for the public good, including hygienic facilities, a solution to dirty, crowded streets clogged with vendors, and even educational and social programming. As such, Alberto Híjar has suggested that such projects served as a "condensation" of the postrevolutionary urban project, with its goal of creating a new modern and progressive subject, in political and economic terms.[63] In the case of Pátzcuaro's new market, daily vendors would be regulated, confined, organized, and framed in a thoroughly modern manner.

Notably, however, every attempt was made to couch this modern, national project in highly traditional and local terms, thanks to the efforts of municipal authorities, who led the project, and Leduc, acting as the representative of the federal DMAAH. The public market engaged the rustic end of the spectrum of colonial style deemed typical in Pátzcuaro. Such a vernacular style was coded by intellectuals like Dr. Atl in his *Artes populares de México* (1922) as "indigenous architecture," described as colonial-era architecture that was overseen by the Europeans but supposedly built by Indi-

ans.[64] Like the Casa del Portal Chaparro (figure 2.10), the oldest residence on the Plaza Principal, the market's portal was squat, with heavy, bulging Doric columns and capitals, set underneath double-stepped rectangular capitals, all of wood. On the second story, a balcony replicated the lower portico in the center third of the building, its balustrade harkening back to pre-nineteenth-century preference for wooden rather than iron railings. Effectively, then, the style of the architecture was designed to preserve the ideological association between indigenous identity and market commerce, while in fact increasingly serving the needs of a much broader range of middlemen (and -women) vendors and marginalizing those smaller-scale vendors who tended to sell their own goods. While the structure did not share the refined architecture of many of the Plaza Chica's buildings, its whitewashed adobe walls, red-tiled roof, and elevation helped the market harmonize with other structures on the plaza. And municipal authorities required that local materials and local workers be used for its construction.[65] Thus was this radical intervention in Pátzcuaro's commercial world—and the embrace of capitalist market relations that favored middlemen and -women—integrated into the city's built environment.

Of course such reworkings of Pátzcuaro's built environment also had implications for customers and the ways in which they interacted with vendors. The public market was built with counters, and vendors were to stand rather than sit on the floor. This modern reframing of social relations served, once again, to "elevate"—as Cárdenas often intoned—indigenous and mestizo vendors, putting them face to face with their customers. The realignment of the customers' habitual market behavior—looking directly at, not down at, their vendor—was further regulated by the monumental figure at the center of the Plaza Chica, freshly cleared of its daily marketers. In 1938 Guillermo Ruiz constructed a new monument dedicated to Gertrudis Bocanegra, the independence-era heroine who provided a role model of civic virtue for the women of and in Pátzcuaro (plate 7). While I discuss her historical significance as a martyr to Mexican Independence and model of female civic virtue in chapter 4, here I want to address her role overseeing the new market and its plaza.

According to Claudio Lomnitz, "the most basic element in the construction of a regional culture is the development of an idiom and a mythology for interaction between the groups that are being pulled together. I have called this conjunction of idiom and mythology the 'culture of social relations.'"[66] Bocanegra, I suggest, provided just such a mythology for Pátzcuaro's "culture of social relations," as she was publicly celebrated as a champion of the

region's indigenous people. In a historical anecdote included in the newly published biography of this heroine, Bocanegra is described visiting the *tianguis*, always treating the Indians with kindness.[67] It is curious to have such an explicit and anecdotal detail of daily life in a biography containing scant historical details about the life of its subject. Arguably, this detail was inserted in a book released in the year of the monument's inauguration in order to connect Bocanegra more emphatically to the new market plaza and to charge readers to emulate such behavior in Pátzcuaro's key contact zone. As such, female customers (visitors and locals) are also given an image to live up to. We might recall Fanny Calderón de la Barca's experience in Pátzcuaro, where she noted how she herself was carefully regulated, constantly looked after by attentive hosts, and watched by locals in the streets.[68] Female customers and vendors alike were imparted with consciousness of seeing and being seen, of having to live up to idealized images. One thing the two classes shared was a larger culture that expected women to be on display, self-regulating their appearance and behavior.

Architectural harmony and aesthetic emulation did not produce social harmony, however, and conflicts emerged soon after the market's opening. As discussed above, the goal of such markets, though not explicitly recorded in Pátzcuaro, was typically about hygiene and social regulation: to remove vendors and their detritus from the streets and plazas and send them into the controlled interior space of the market, with its drains, running water, and electric lighting. But municipal and federal records note that Pátzcuaro's vendors continued to set up outside the market, causing problems both with other vendors and with local businesses.[69] Again, this contact zone proved difficult to regulate.

The relationship between ambulant vendors and tourism was particularly ambivalent. Recognizing the importance of the *tianguis* to the town's "typical" image and tourism trade, the Friday market continued in the main plaza until at least the mid-1940s. Visitors and artists often did not make a distinction, however, between the *tianguis* vendors and the daily vendors. *Mapa*'s 1936 article on Pátzcuaro was illustrated with a photograph of vendors in the Plaza Chica. American photographer Paul Strand famously photographed rebozo-covered women selling tortillas along sidewalks in 1933 (figure 1.10). Writing about his project, he claimed to be capturing a world that would soon cease to exist (see chapter 1).[70] In this case, he likely did not realize how soon his monumental and stoic tortilla vendor would be threatened with displacement. Diego Rivera likewise painted a watercolor of an indigenous mother (marked as such by her rebozo, full skirt, bare feet, and pose)

and child with a sack encamped along a city street in 1938, when he and Frida Kahlo hosted André Breton, Leon Trotsky, and their wives in the city. Further, it appears that the original murals in Pátzcuaro's Biblioteca Pública Gertrudis Bocanegra (formerly San Agustín church) were dedicated to indigenous fish and vegetable vendors, again along a city wall, not the *tianguis* (figure 2.12). The limited viability of such murals perhaps stemmed from their location low on the wall in a library needing shelf space (the murals were covered by bookcases until the late 1980s) but may also point to the controversial nature of such indigenous street vendors. The staff of the Hotel Concordia on the Plaza Chica complained about vendors spilling into its portals, even after construction of the new market.[71] So much for showing kindness to vendors. As studies of *ambulantes* (street vendors) in other parts of Mexico note, the beneficiaries of new market regulations tended to be local businesspeople, including those involved in the tourism trades.[72] Meanwhile, town officials complained that they were having trouble collecting sufficient fees from vendors in the new market and were struggling to pay back their loan.[73]

For some, indigenous vendors were an intrinsic part of picturesque and *típico* Pátzcuaro, while for others they were a nuisance or even a hazard. Attempts to regulate and control them met with mixed success.[74] Yet what emerges from this conflict appears to be two competing possibilities and strategies, hidden within the guise of *lo típico*. On one hand, the market offered vendors (and consumers) a new, modern setting for conducting their business, masking its transformation of the institution of market vending and vendors within its indigenous façade. Here, of course, the cost of doing business included new fees and modes of regulation. As an alternative, vendors could choose to continue to participate in the *tianguis* and even continue to operate in the streets—if they were able to maintain the image of *lo típico* indigenous market vendors. On some level, market women themselves clearly played a role in establishing this image—after all, to a large extent their own organization, dress, and performance of their role as market vendors formed the basis of the 1934 photographs taken for the preservation archive (figure 2.3) and informed the urban mestiza models reenacting this role for calendar artists like Gómez. However, future generations making a claim to *lo típico*, and by extension the right to operate in the traditional way, needed to negotiate this image. Thus in this space of contact and exchange one set of possibilities for *lo típico* emerged, generated by competing interests: an indigenous Pátzcuaro.

THE PLAZA CHICA FROM SAN AGUSTÍN
TO GERTRUDIS BOCANEGRA

The new public market was just one part of the Cardenista project of radical modernization and "urban editing" taking place in Pátzcuaro's Plaza Chica under the guise of enhancing or restoring Pátzcuaro's typical physiognomy. The plaza's succession of names speaks to the changes underfoot: originally known as the Plaza San Agustín, for its early Augustinian monastery and church, the plaza was secularized and renamed for independence heroine Gertrudis Bocanegra, to whom its monument was erected and for whom the new public library in the former Augustinian church was named. Locals sidestepped the proliferation of ideologically loaded names by referring to the space as the Plaza Chica, smaller and a block away from the town's Plaza Principal (dedicated since the 1960s to Don Vasco de Quiroga). If the changes in the Plaza Principal discussed earlier reveal a kind of truce—to remove a Porfirian symbol and restore something older but neutral—the changes in Plaza Chica reveal the Pátzcuaro project's stakes: colonial and neocolonial façades would put a familiar face on a radical program of secularization and modernization, while simultaneously serving as a new tool with which to engage long-standing local power struggles.

The first dramatic sign of the impact of the new policy was the March 1932 destruction of the Teatro Apolo. This local theater had existed in the Plaza Chica across from the San Agustín church in two renditions. The original Salón Apolo was a low, orientalizing structure with *mudéjar* arches and short towers topped with squat onion domes, and served as a gathering place for local businesspeople (figure 2.16). The taller Teatro Apolo was a curious neogothic and Renaissance-revival hybrid, constructed in wood, used for movies and gatherings (figure 2.17).[75] Prominent *hacendado* and businessman Luis Ortiz Lazcano, who had a grand house on the Plaza Principal in addition to the family's Casas Blancas hacienda, owned the Apolo.[76] According to Teresa Castelló Yturbide, Cárdenas himself ordered its destruction.[77]

Cárdenas and Lazcano arguably had a complex relationship. Lazcano, known locally as the "Count of Casas Blancas," was an opponent of agrarian reform in the 1920s and conspicuously held political power in Pátzcuaro in the 1910s and 1940s, but not during the height of Cardenismo.[78] At the same time, he remained closely involved in Pátzcuaro's redevelopment, facilitating its electrification (he financed the region's hydroelectric plant) and water distribution projects and designing the pavilion at the Mirador Tariácuri—projects that were also important to Cárdenas.[79]

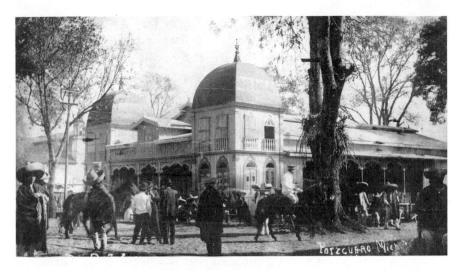

Figure 2.16. Salón Apolo (I), Plaza Chica, Pátzcuaro, ca. 1910s. Colección Gerardo Sánchez Díaz, Archivo Fotográfico, Instituto de Investigaciones Históricas, UMSNH.

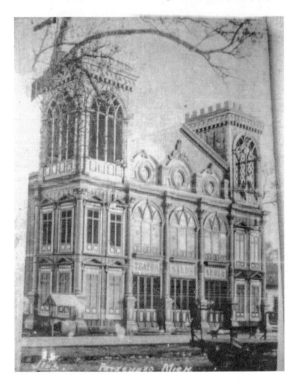

Figure 2.17. Teatro Apolo (II), Plaza Chica, Pátzcuaro, destroyed 1932. Archivo Histórico Municipal de Pátzcuaro.

The theater itself was also associated with the history of Cardenismo in the region. In January 1929 it hosted the first meeting of the Confederación Revolucionaria Michoacana del Trabajo, an organization founded by Cárdenas to bring together workers and *agraristas* (agrarian workers who embraced land reform) and raise the visibility of leftist politics in Michoacán.[80] The theater was part of an international trend of designing theaters as grand palaces for their middle- and working-class publics, even as they preserved and reinforced hierarchies through the division of the interior into orchestra, balcony, and boxes. Ultimately, while there is limited evidence to give us a full understanding of the decision to disassemble this early twentieth-century theater, it is possible that it went beyond purely aesthetic justifications. The move potentially spoke directly to long-standing tensions between the powerful Lazcano family and local *agraristas* and Cárdenas supporters. But the succession of styles seen here is suggestive: from exotic or orientalist to neogothic internationalism, both popular during the Porfiriato. In couching the destruction as a consequence of an aesthetic search for a "typical style," Cardenistas effectively censured ideological associations with Porfirian cosmopolitanism, the theater's use of space to enforce social hierarchies, and a powerful local leader. The destruction of the theater provided a dramatic beginning for the plaza's transformation, which became the centerpiece of President Lázaro Cárdenas's Pátzcuaro project, complete with a new library, monumental sculpture, market, and theater.

Aesthetically, the Apolo's destruction meant that the plaza could be reconstituted as *típico*, marking a break with the Porfiriato's cosmopolitan culture and couching modernization and secularization under Cárdenas's watch in explicitly traditional and local terms (despite his own internationalism). In many ways, the plaza typified the eclectic range of "colonial" styles that made Pátzcuaro famous. To the north sat the San Agustín church and convent, originally dating from 1571 (and rebuilt in the mid-eighteenth century), with simple ornamented flat façades—an example of what Toussaint would refer to as Mexico's "pure" Renaissance style (figures 2.2 and 2.4). The convent façade's ornamental arches and doors harmonized with the church's two-tiered portal, with its arched entrance, rectilinear pilasters, and entablature surrounding doorway and window above, which in turn was overlaid with curved moldings and volutes. The religious structures anchored the plaza with their stone façades and tall baroque bell towers (a later addition).

On the plaza's east side, two-storied houses with iron balconies lead to a structure, now commercial, displaying some of the portals that made Pátzcuaro famous: in this case, a single-storied rustic portal, with tiled overhangs

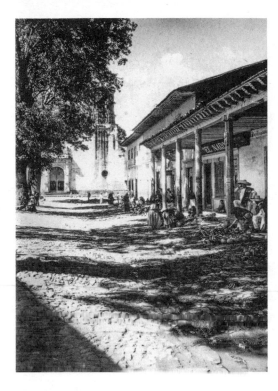

Figure 2.18. "Plazuela y templo de San Agustín" (Little Plaza and the St. Augustine Church). From Enrique Cervantes, *Pátzcuaro en el año mil novecientos treinta y seis* (Mexico City, 1949).

supported by tall, slender wooden columns (figure 2.18). A single-storied house on the far southern end of this side contrasts the rustic portico with its own refined Renaissance style: tall raised veranda windows with iron balustrades surmounted by decorative architraves and a simple entablature, molding, and cornice.

To the south the famous La Pila del Toro (or Torito), reconstructed in the nineteenth century and restored again by the state in 1934, long served as the neighborhood's main water source and still stands today before a simple set-back, single-storied commercial structure with a red-tiled roof (figure 2.19).[81] The large building on this stretch—housing the Hotel Mercado at the turn of the century, Hotel Guizar in the 1920s, Hotel Ocampo by 1936 is one of three hotels on the square. Doric columns support its portico; its tall, graceful veranda windows and doors are edged with a simple decorative molding; and its upper-story balconies, shaded by a tiled overhang, are iron.

Finally, the west side of the plaza is home to two more elegant grand hotels, the Concordia and the Plaza, with its arched portico, iron balconies, and alternating triangular and arched cornices. The Italianate Concordia, owned by Luis Solchaga, was one of the city's earliest hotels (founded by

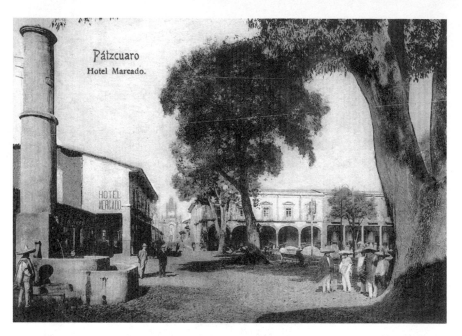

Figure 2.19. "Pátzcuaro: Hotel Marcado [*sic*] [with La Pila del Toro and the southern end of Plaza Chica]" postcard, ca. 1910s. Courtesy of David Haun Postcard Collection.

1908), and expanded to the north in 1935–1936.[82] Completing the west side of the square at the northern end and opened in 1937, the public market, with its bank of steps and new rustic façade, was set back from the street (figure 2.15). Thus a combination of porticos, the regular play of windows and doors, red-tiled roofs, and largely white stucco façades facing the square provided a semblance of unity restored after the removal of the sharply contrasting wooden, neogothic, cathedral-like Teatro Apolo.

While architecturally the Plaza Chica displayed an eclectic range of traditional styles, historically it has been central to Pátzcuaro's modernization. Not only was it home to Pátzcuaro's first movie theater, but it was also the site of Pátzcuaro's first gas station and public phone office.[83] Even as the gas station was displaced to the outskirts of town, the plaza was crisscrossed with power lines, and additional electric lighting was added in the 1930s. Furthermore, in 1934 the municipality added a taxi stand in front of the hotels, which themselves testified to the growing importance of the tourism industry.[84] Clearly, then, the city was experimenting to find the right balance between making modern conveniences available and preserving — or *creating* — the semblance of a place that could be described as "typical" and "colonial."

On the plaza's north end, the creation of the Teatro Emperador Caltzon-

tzin and Biblioteca Pública Gertrudis Bocanegra (1935–1938) epitomized Cárdenas's use of colonial façades to mask the material and ideological transformations taking place in Pátzcuaro (figure 1.18). The project required the permanent conversion of the Augustinian monastery and its church—originally built in 1571 and expropriated by the state in 1927 at the height of the enforcement of the anticlerical laws and the Cristeros Rebellion—into a secular public theater and library for Pátzcuaro's masses: spaces that defined the cultural side of the SEP's socialist education program under Cárdenas. The DMAAH's architect, Alberto Leduc, was in charge of the complex and shared plans for a new theater with Cárdenas in fall 1935.[85] The sixteenth-century convent (figure 2.4), which in a dilapidated state had served as a jail, rectory, government offices, and even a museum, was torn down (with the state government's approval). Leduc designed a new theater in its stead, using *spoilia*—colonial-era arches and architectural detailing appropriated from the original building—to decorate the façade.[86] Reusing the original structure's ornamentation and installing locally produced wooden screens (a regional handicraft) gave a local spin to the rage for neocolonial architecture found in Mexico's metropolitan centers and in southern California in the 1920s and 1930s. Its ample arched entrances and windows, refined stonework juxtaposed with white stucco walls, wooden screens, and red-tiled roof blended harmoniously with the city's architecture (even if the result was much blockier than its neighboring former church). Yet while the new structure presented a pair of symmetrical towers evocative of mission architecture and preserved the convent's finials and triple-arch façade, its use of airy wooden screens across the arches presented a comparatively open, welcoming face to the public, compared to the limited access offered to the secluded monastery. The effect was quite distinct from *lo típico* presented by the new market, under construction on the northwest corner of the plaza; this *típico* was a reinterpretation of Spanish Renaissance religious architecture for a new secular context.

While Leduc's neocolonial façade created the illusion of tradition preserved and restored, the interior—the public theater—was entirely modern in its structure and function. As one contemporary commentator pointed out, the hall was only one large room, without private boxes or privileged sections.[87] This seemingly harmonious architectural synthesis of traditional aesthetics and modern purpose masks what was in fact a revolutionary project that sought a radical redefinition of the conditions under which a community would come together, spend its leisure time, and experience art and culture. This transformation was not lost on its patrons. As Hilario Reyes's newspaper claimed: "This center for spiritual recreation is the product of the

blood lost in the fields of struggle, it is a sacred temple made with the remains of our parents; for this reason it has the respect . . . of every one of its spectators."[88] The visual and rhetorical language of colonial church architecture was thereby mobilized for the Cardenistas' secular agenda.

In concrete terms, the theater was and continues to be home to a range of activities, from music, dance, and theater performances to lectures and films. The theater opened on October 3, 1937, to a rave review and a crowd of 1,600. It initially had a contract with the Empresa Cinematográfica, which drew movie audiences of over a thousand people a day and presented Mexican films, true to the revolutionary spirit in which Cárdenas commissioned the theater, according to one reviewer.[89] Muralists were hired to decorate the interior. Roberto Cueva del Río's murals of life on the lake (discussed in chapter 1; figure 1.19) and huge medallions imitating local decorative *bateas* (lacquer platters) enveloped the audience within the unified new theater space. Ricardo Bárcenas painted a pair of murals commemorating Cárdenas's political, economic, and cultural program in the theater's upper foyer and reception hall (the subject of chapter 3; plates 5 and 6). And Cueva del Río added a historical mural to the upper foyer, depicting the *Encuentro del Rey Tanganxuan II y el conquistador Cristóbal de Olid en las cercanías de Pátzcuaro en el año de 1522* (see chapter 4; plate 3). Audiences—rebozo-covered women from around the lake, local urbanites, and tourists alike—were treated to a combination of entertainment and political art supporting the Partido Nacional Revolucionario (PNR) and the SEP's regional and national programs.

It is worth noting, however, that questions arose early on about who would oversee the theater: the municipality, the state of Michoacán, or the federal government?[90] Despite local desire to maintain control, in November 1940 Cárdenas used the "Ley sobre clasificación y régimen de los bienes inmuebles federales" (1902) to decree that the Teatro Emperador Caltzontzin would be dedicated to serving the State of Michoacán and controlled by the federal Secretaría de Hacienda y Crédito Público. Henceforth the federal government would be responsible for its maintenance.[91] In October of that year Cárdenas had also approved the finance secretary's plan to redirect funds from the theater's cinema program to support stalled work on Pátzcuaro's hospital project.[92] Clearly, the federal patrimony laws could serve as a tool to promote formal centralization of Mexican culture, trading local autonomy for an institutional mechanism to sustain state support beyond Cárdenas's tenure as president.

Likewise, transforming the church of San Agustín into a library marked a profound and permanent move toward secularizing Pátzcuaro's community.

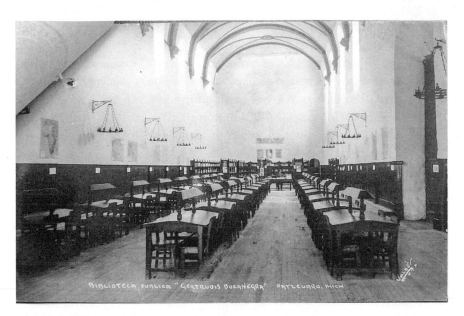

Figure 2.20. Foto Valdés, "Biblioteca Pública Gertrudis Bocanegra, Pátzcuaro, Mich" (Gertrudis Bocanegra Public Library, Pátzcuaro, Mich.) postcard, ca. 1938–1941.

The church, closed during the height of the Cristeros conflict, had reopened but was closed again in 1936, ostensibly for safety reasons: with work beginning next door on the new theater, the federal closure order cited safety concerns about the structure's stability and required removing its valuables.[93] Pátzcuaro's municipal government discussed this safety warning at the same time that that they approved a plan to petition the federal Bienes Nacionales for permission to convert the structure into a public library—a discussion initiated with Cárdenas some months earlier.[94] Working with engineer H. Gómez, Leduc renovated the sixteenth-century church to convert it into a library, retaining the exterior architecture but preserving only the interior's vaulting's architectural detailing and the series of hanging iron candelabras along the walls (figure 2.20). The painted walls were whitewashed, bookshelves and desks replaced the pews, maps were hung on the walls in place of the Stations of the Cross, and posters—including a portrait of Cárdenas—were hung above the bookshelves at the apse of the former church. This secular temple to learning, like its neighboring theater, was institutionalized within the federal government, operating under the auspices of the SEP.

The project faced many hurdles, not least of which was that a considerable faction of the local community hoped that the church would reopen for worship.[95] Leduc complained that engineer I. Ramírez Inclan attempted to

avoid him, making it impossible to gain admittance to the library and complete his work.[96] Francisco Leal was originally asked to paint murals in the library, but it is unclear what came of that project.[97] Cárdenas had hoped to populate the library with the generous list of books that he had donated to Pátzcuaro's short-lived Melchor Ocampo Library in 1935, but apparently that collection of international classics and leftist and Mexican contemporary works had made its way into local school libraries. Leduc and the library's new director, Juan E. Noguez Becerril, immediately set to work requesting book and journal donations for the new lending library.[98] The Biblioteca Pública Gertrudis Bocanegra opened its doors to the public in fall 1938 and within a year had collected 3,359 volumes (specializing in local literature) from local and national donors. Yet while the theater was enthusiastically embraced by a community eager to replace its lost movie hall, resistance to the library continued. Noguez reported continuously working to overcome community resentment regarding the closure of this favorite Pátzcuaro church, writing that he had "little by little persuaded them, making them change their minds and prejudices, in a prudent and just manner, without offending decorum or dignity."[99] Finally, in 1941–1942, Juan O'Gorman painted a monumental mural depicting Michoacán history (discussed further in chapter 4; plate 4). Supported by private funds but approved by the now former president Cárdenas and the SEP, the new mural effectively guaranteed the structure's secular status.[100]

SECULAR AESTHETICS, OR THE APOTHEOSIS OF ART AND HISTORY

Notably, both the theater and library projects demonstrate that the aesthetic reification of colonial-era architectural styles belied a larger move away from colonial and Catholic culture, values, and daily practices. While these structures presented colonial façades, they were named after a Purépecha emperor and a War of Independence heroine — figures who marked the violent beginning and end of the colonial period and speak to a larger trend of publicly commemorating extracolonial history (see chapter 4). Beyond the secular repurposing of former religious spaces, two other maneuvers were key to this aesthetic bait and switch occurring throughout the town. First was a process by which religious spaces were represented in historical and aesthetic terms within guidebooks, history books, and architecture studies. Such publications downplayed any contemporary religious use that still existed and instead drew readers' attention to architectural detailing and historical and

aesthetic values—found equally in religious and secular structures. Cárdenas himself approved a request that the federal government publish monographs on notable buildings in order to provide visitors to Michoacán with greater information.[101] Efforts to emphasize the city's aesthetic qualities were aided by the multiple generations of artistic visitors to the city, who had cast Pátzcuaro's derelict architecture in the romantic and formalistic artistic terms discussed above, as well as by the postcard makers who made a living converting the town and its environs into images for purchase and circulation.

This emphasis on the history and aesthetics of religious and secular structures enabled the second and related strategy: the growing insistence that Pátzcuaro's charm lay not in the significance of individual and specific monuments but rather in the unified city. According to Manuel Toussaint, people don't visit Pátzcuaro for single monuments in and of themselves but for the general character of the city as whole.[102] This represents a radical departure from a different kind of tourism, in which pilgrims visited Pátzcuaro to pay homage to specific sites and their cult objects, like Nuestra Señora de la Salud, or the region's oldest cross at the Humilladero chapel. This effort marks Pátzcuaro's conversion into a historical monument in its own right, in the tradition of what the nineteenth-century British preservation advocate John Ruskin described as "urban ensembles."[103] Even as guidebooks and Toussaint's architectural history identify notable monumental structures and present related anecdotes or historical accounts, the accumulation of texts and visual documentation of both religious and secular architecture helps provide a portrait of a larger whole, while never precluding the readers' ability to seek specificity. A state-sponsored guidebook concurs: after brief discussion of a clock on the former Jesuit church, La Compañía (figure 2.21), the author explains that the "enchantment of Pátzcuaro . . . is in the street" and proceeds to discuss the city's plazas, markets, and residential architecture.[104] Thus the creation of Pátzcuaro as a historical monument, a process that mobilized historical and aesthetic criteria and relied on new federal regulatory structures, neutralized its religious spaces by subsuming them into the larger urban whole. In this process, Pátzcuaro's creation also contributed to the foundations of Mexican "colonial" art and architecture.

Clearly the religious significance of the region's historical architecture posed particular tensions for the emerging advocates of urban conservation, as the modernization process in Mexico regularly developed in conflict with the Catholic Church's institutions and authority. In the 1920s regional churches had once again become flashpoints for the church-state contest for regional control. During this period, President Calles enforced the Constitu-

Figure 2.21. "Templo de la Compañía" (The Company of Jesus Church). From Enrique Cervantes, *Pátzcuaro en el año mil novecientos treinta y seis* (Mexico City, 1949).

tion of 1917, seizing church lands and buildings, closing church schools, and outlawing church rites, including Mass. The Cristeros' resistance to these laws—along with tensions associated with regional land reform, secular education, and long-standing local conflicts—exploded in the three-year Cristeros Rebellion (1926–1929), centered in the states of Michoacán and Guerrero, between the secular state and those aligned with the Catholic Church. The Cristeros took up arms, attacked and murdered schoolteachers working on the front lines of the SEP's rural education program, and waged war against Mexico's postrevolutionary government. While the Cristeros were subdued formally in 1929, resistance to secular education, requests to reopen churches, and conflicts over lands continued in parts of Michoacán through the 1930s.

According to Jean Meyer, as part of La Segunda (the post-1932 wave of renewed struggle), 7,500 Cristeros took up arms in 1935; in just three years, 100 teachers were assassinated and 200 mutilated (typically their ears were cut off).[105] In May 1935, two days after a church was closed in Tzintzuntzan, 53 men and women were arrested for attempting to kill the local teachers. Three of the teachers were shot and wounded, one of whom died.[106] At the

1934 Congreso Femenil Socialista (Feminine Socialist Congress) in Pátz-cuaro, revolutionary Pérez H. demanded "schools, rather than churches; workshops, rather than seminaries; cooperatives, rather than saints and alms-boxes."[107] Clearly, the struggle continued.

It was in this context that the state and federal government began to ap-propriate Pátzcuaro's religious structures and their colonial ambience for new secular ends. Mexico's emerging institutions and discourses on histori-cal preservation helped provide this process with moral legitimacy. Numer-ous religious structures were restored and repurposed. Beyond the transfor-mation of the San Agustín complex described above, a number of regional churches were converted at least temporarily into schools, including La Compañía, the former Jesuit church; the church of San Francisco, which temporarily became the Ricardo Flores Magón School; a church in Puáparo (in the municipality of Erongarícuaro), for which its local indigenous com-munity sought federal SEP funds; and a convent in Erongarícuaro that be-came the Escuela Elemental Agrícola.[108] El Sagrario (apparently a hotbed for antisocialist resistance) and El Calvario were both taken out of service, and numerous other churches around the lake were also closed (including those in Jarácuaro, Erongarícuaro, and Parácuaro).[109] In the case of El Calvario, the 1936 closure was ostensibly to enable repairs.[110] By 1936, efforts were under way to convert the Dominican convent, known at that time as Santa Cata-rina or La Josefina (after its founding abbess Doña Josefina de la Señora de la Salud Gallegos, 1688–1750) and since 1955 known as the Casa de Once Patios (House of Eleven Patios, a center and market for *artesanías*), into a home for the elderly, a maternity hospital, and an orphanage.[111] While the convent had been closed and converted into a school under the laws of the Reforma, locals were once again advocating for the nuns to remain in 1936.[112]

The conflict intensified when Leduc was accused of taking tiles from the convent to use in a new school constructed in the "typical" style on Jarácuaro, for which he ultimately apologized. As Françoise Choay has pointed out, those in charge of historical preservation (and re-creation) often are simul-taneously involved in the destruction of historical buildings.[113] One build-ing was restored for a modern version of its original purpose: the Hospital of San Juan de Dios, founded in the seventeenth century in the tradition of Don Vasco de Quiroga's religious hospitals or community support centers, received funds in 1935 for its restoration, which continued sporadically dur-ing the 1930s.[114] While Cárdenas was spending funds for national patrimony work at churches and a hospital,[115] the fates of these structures as religious institutions were in doubt. Smaller religious artworks were also taken out of

Figure 2.22. Interior of Nuestra Señora de Guadalupe, Pátzcuaro, 1926. Photograph by Edward Weston. Collection Center for Creative Photography. © 1981 Center for Creative Photography, Arizona Board of Regents.

commission. The stone statue of Nuestra Señora de la Salud that graced the Don Vasco fountain was removed from its public setting, ostensibly to protect it from potential vandalism, and artworks from various churches were removed for safekeeping.

At the same time as church buildings were being closed to their parishioners, those same buildings were increasingly celebrated for their historical and artistic merits. Edward Weston took photographs at the Santuario de Guadalupe, transforming the church interior from a space of worship into a play of line and volume, light and dark (figure 2.22).

Anita Brenner had hired Weston and Tina Modotti to travel Mexico and document regional *artesanías* for her book in progress, *Idols behind Altars*, which was dedicated to the study of Mexican popular art and the Mexican cultural renaissance. Many of their photographs from Michoacán treat religious works, now appropriated as aesthetic objects that testify to Brenner's premise regarding a tradition of syncretism between indigenous and European forms and values. Perhaps it is thus not surprising that Brenner did not include the Santuario photographs in her book, as the history of the structure—commissioned by a former African slave brought from Havana, Don Feliciano Ramos, as a votive offering for the Virgin in thanks for his ultimate prosperity in mining—might have presented a hurdle for her thesis of *mestizaje*.[116] Weston also photographed carvings at the Capilla de Humilladero in Pátzcuaro and climbed the Santuario's bell tower to photograph the sculptures representing the seven virtues for Brenner.

The aesthetic vision encouraged by projects like Weston's was also practiced by local art students, at the prompting of Spanish artist and Open-Air schoolteacher Gabriel García Maroto (discussed in chapter 1). Launching his Acción Plástica Popular in Pátzcuaro's poorest schools in 1932, he taught locals to look at their surrounding world with a tourist's attention to local beauty and to convert structures into two-dimensional aesthetic patterning

and form. In their images of the city, the children were particularly drawn to representing churches, including the imposing, symmetrical neoclassical façade of the Santuario de Guadalupe. In this print, any suggestion of access to the building is cut off by the play of lines that mark the gated entrance to the structure. Meanwhile, twelve-year-old Salomón Horta, from the Colegio P. A. de Ibarra, presents a view of the Companía church in Pátzcuaro, transformed into a gridded pattern (figure 2.23). The play of illusion is particularly striking, as a pilaster from the far end of the church and ex-convent's yard merges with a church window, creating a dynamic new form. Interestingly, undated photographs show that at one time a pilaster supported a cross in the churchyard. Does its absence here represent artistic license or a change to the plaza, perhaps stemming from the local church-state conflict? While the print retains the cross on the top of the structure, the absence in the courtyard below is rendered hyperinvisible—yet visible—by its replacement with the image's most elaborate decorative motif: an invented fountain-like form, perhaps representing a bouquet of flowers on the denuded pedestal. Regardless of the student's attitude toward the change, its fact is profoundly registered.

Tourist guidebooks equally helped to incorporate the city's religious structures into the modern nation, drawing on the secular practices of tourism. Taking their lead from nineteenth-century travel writers, modern guidebooks provided historical insight into the local religious structures. *Terry's Guide to Mexico*, first published in 1909 and updated over the decades, applied orientalist ideals to Pátzcuaro, comparing the settings to those in Japan, while describing the antiquated town as a quaint reminder of colonial Spanish days. *Terry's Guide* recommends visiting churches for their historical and aesthetic interest, along with shopping for handicrafts, exploring the lake, fishing, and visiting the controversial painting attributed to Titian in Tzintzuntzan.[117] *Los rincones históricos de Pátzcuaro* (discussed earlier) compelled visitors to visit the city's picturesque corners, leading them through town to visit historically significant structures and engaging them with regional history and legends.[118]

Justino Fernández's guidebook, commissioned by the Secretaría de Hacienda y Crédito Público (1936), put the federal government's stamp on the enterprise. A budding art historian, Fernández added an aesthetic and historical layer to appreciating Pátzcuaro. He presents a larger regional history and then discusses local buildings and monuments as well as the people and art connected to them. His book also supplied the first touristic map of the city (along with a lake map, discussed in chapter 1), orienting the touristic experience of Pátzcuaro around its urban heart and effectively placing the

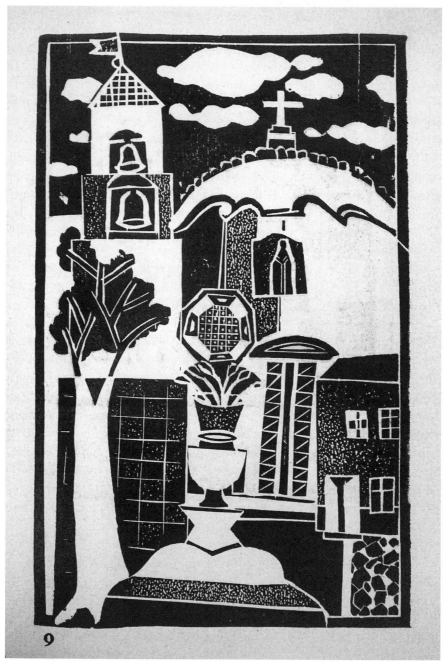

Figure 2.23. Salomón Horta, *La Companía* (The Company of Jesus), 1932.
From Gabriel García Maroto, *Acción Artistica Popular: 24 grabados en madera*
(Morelia, 1932). Photograph by author.

city on a par with the lake in the touristic imaginary (plate 2). Fernández based his map on the 1895 city map and updated the names of streets and plazas. In contrast to the clean lines, pure geometry, typeface, and "scientific" language of the earlier map, Fernández represented Pátzcuaro in a pictorial style inspired by colonial-era maps, which he also deployed for maps of Uruapan, Morelia, and neighborhoods of Mexico City. This approach helped define relationships between spaces while simultaneously identifying local landmarks and hotels. While the occasional white tower or church façade interrupts the flow of the red rooflines, it is the patterns of red (tiled roofs) and green (the plazas and parks) that compete for attention and present the town as a harmonious aesthetic unit.

The historical and aesthetic ascendency of Pátzcuaro's architecture was secured by Manuel Toussaint's publication on the city's architectural history (1942), a project that is instructive on many levels. In 1928 Toussaint published the first of such volumes treating the architectural history of a single town: Taxco, Guerrero, a mining town south of Mexico City that was revived in the late 1920s as an artists' retreat and tourism destination. Toussaint had sent a copy of that book to Salvador Solchaga, his friend in Pátzcuaro, who had contacts with many of Mexico City's artistic elite during this period due to his knowledge of local history and handicrafts, especially lacquer. Solchaga's role in creating Pátzcuaro cannot be overstated; he served on the town's first tourism councils, revived the region's lacquer industry, and helped found a local popular arts museum (see chapters 3 and 5). True to his vision for developing Pátzcuaro as another regional center for art and tourism, Solchaga wrote to Toussaint in 1932, encouraging him to write a book on Pátzcuaro.[119] Toussaint replied that Oaxaca was next on his agenda, but in 1940 he and a team of students from the Instituto de Investigaciones Estéticas (IIE: Institute of Aesthetic Investigations) and the architecture school came to Pátzcuaro to research and coordinate the second volume in this series.

Toussaint's work was decisive in turning Pátzcuaro's churches into part of Mexico's art and architectural history. In addition to providing a regional history and accounts of the town's monuments, the book is filled with plans, elevations, studies, and architectural photographs, isolating architectural details to enhance further study of the structures. In this book and soon afterward in official briefs, Toussaint advocated for identifying a series of local structures as national—not just state—monuments. At the same time, he also consistently argued that Pátzcuaro's architectural heritage was not confined to its religious structures and that they were instead parts of the larger whole that constituted the town.[120] Thus we see how local actors were able to enlist

national figures, resources, and the emerging institution of art history in a campaign to make Pátzcuaro into a national icon.

Furthermore, just as the town leaders learned to use the rhetoric of historical preservation and *lo típico* to leverage their agenda — for example, petitioning the state for urban development funds — locals did the same. Such rhetoric shows up in neighborhood development disputes, calls to get money for local school repairs, and even calls to reopen churches: not because they were centers for worship, but for their historical significance to the city. Thus all was not lost for Pátzcuaro's religious communities and their symbols. The commitment to an aesthetically pleasing town required the municipality to invest in remodeling the gardens in front of La Colegiata, Pátzcuaro's largest church and intended cathedral. It also remodeled a fountain in the small Cruz Verde plaza, traditionally Pátzcuaro's indigenous neighborhood, replacing a wooden canoe-shaped trough with a simple colonial-style basin.[121] Photographs by Raphael García appearing in *Mapa* and a México Foto postcard frame that site as part of *lo típico*. In addition, Cárdenas approved a new Presbyterian church (Evangélica Presbiteriana) in 1937, which represented an alternative to the Catholic Church in the region.[122] And communities that learned to use the language of tourism, art, and history had successes in preserving their churches: for example, parishioners of la Compañía, the former Jesuit church (founded in 1546), detailed the history of their church and appealed for its return to their parish in memory of Don Vasco de Quiroga, its founder.[123] While the Jesuits' former school was converted into a state cultural center, its adjoining church was returned to service. The press in Mexico City picked up on concerns regarding vandalism in El Calvario and the possibility that it and San Francisco might be closed; letters to the INAH evoked the structures' historical and aesthetic values as well as the potential loss of tourist attractions.[124] Meanwhile, as Toussaint noted, the sculpture of the Virgin and child on the Fuente Don Vasco, which traditionally honors Nuestra Señora de la Salud and the site on which Quiroga miraculously found water for his new capital, was restored in the name of aesthetics after having been removed to the new museum to protect it from antireligious fanaticism.[125] Thus the rhetoric of aesthetic and historical value, and the promotion of tourism, could be used to advance multiple interests within Pátzcuaro.

CONCLUSION: "NATIONAL" ARCHITECTURE

Thus *lo típico* was constituted not as a single unified style, nor as a descriptive category, but rather as an ideological tool and aesthetic strategy for nation

building and modernization. As we have seen, *lo típico* was created as much by processes of exclusion as by the selection, preservation, construction, and representation of monuments in Pátzcuaro's streets, artworks, guides, and architectural histories. As such it was constituted as a "useful" category, a set of ideals that could be embodied, articulated, and materialized for specific interests in the ongoing process of creating Pátzcuaro and Mexico more broadly.

Through this process *lo típico* was negotiated by various parties at the local and national levels. Its parameters became increasingly institutionalized within three emerging arenas, all of which worked together within Mexico's larger nation-building agenda. The tourism economy gave impetus and financial incentives to this project and provided mechanisms for amplifying and disseminating the results. Tourism's emphasis on the affective experience of Pátzcuaro and its monuments—now defined in secular terms—provided the emerging middle class with the opportunity to explore Mexico's roots, by visiting and witnessing distinctive elements of Mexican culture. Meanwhile, the federal DMAAH, which in 1939 was subsumed within the INAH, defined *lo típico* through selective architectural preservation and its oversight of new construction. In these institutional contexts two parallel ideas about *lo típico* emerge. On one hand, we see an attempt to define the typical as indigenous, a process particularly pronounced in the development of the image of the indigenous market woman, in the construction of Pátzcuaro's new market in a so-called vernacular style. On the other hand, Leduc's new theater presented a different vision of *lo típico*, derived from an aesthetic appropriation of sixteenth-century Spanish church and convent architecture: San Agustín's monastery, which Toussaint celebrated as "pure" Renaissance style.[126] Together, these versions of *lo típico* became the architectural equivalent of *mestizaje* and allowed the creation of Pátzcuaro as a historical monument to be mobilized in a secular context to do the affective moral work of nation building.

Art history provided a third institutional context for the development of *lo típico* and helped supply a rational, scientific framework to bolster and refine the affective experience of historical monuments promoted in the touristic context. While art history has deep historical roots, and in Mexico had a curricular presence in the Academy of San Carlos (originally the Royal Academy, founded in 1783), in the 1930s the field underwent a major transformation. In 1935 Manuel Toussaint was named founding director of the Laboratory for Art under the National Autonomous University of Mexico (UNAM). In the following year the laboratory was integrated within the new Instituto de Investigaciones Estéticas, which supported research in

music, theater, and literature in addition to the visual arts. As Toussaint noted in his proposal, "The history of our plastic arts is yet to be made. There have been esteemed isolated efforts, but they lack a coordinated and authoritative center. That can and should be our university [UNAM], the greatest cultural center of the country."[127]

Institutionalized as a newly independent field within this structure, art history needed to legitimate itself as a profession and demonstrate its usefulness for the nation. From the start the laboratory framed its research, educational, and outreach efforts as serving national interests, even briefly offering courses for tourist guides (much as did anthropologists and historians working within the Museo Nacional de Antropología, Historia y Etnográfica, which monopolized such education after the IIE had to reduce its funding).[128] As Guillermo Palacios has noted in his study of the history and anthropology fields, such pressure to be useful was formative for Mexico's academic disciplines, as they sought to achieve professional stability and define the terms of their intellectual freedom.[129] In this context, art history, like history, needed to compete with the rise of the social sciences and increasingly sought to systematize itself as a discipline, drawing on ideals of objectivity, documentation, and empiricism, as invoked in its original choice of name.[130] As Justino Fernández wrote in his 1957 account of the IIE, Toussaint's goal was to transform art history into a serious field of study, grounded in documentation and science.[131] Toussaint, his colleagues, and their students mobilized to document and gather data regarding monuments throughout Mexico and continued (in the tradition of the positivists) to borrow models from the sciences to describe social and aesthetic change. The collaboration surrounding Toussaint's *Pátzcuaro* monograph (1942) contributed to this larger effort and sheds light on the foundational concerns and strategies of Mexican art history and the emerging field of colonial art.

As Martha Fernández notes, the founders of the IIE were all specialists in colonial art history, an area that had been marginalized within nineteenth-century positivist histories, which sought the foundations of the modern era in the preconquest past.[132] In recuperating the colonial as more than a mere foil for the pre-Hispanic and independence eras, the idea of the "colonial" had to be redefined not merely as a Spanish importation but also as foundational for the modern nation. Toussaint's efforts to establish the historical, aesthetic, and ideological parameters of colonial art history began in the 1930s and culminated (initially) in the publication of *Arte colonial de México* (1948). In his early work Toussaint mobilized his documentary and empirical study of art and architecture from the time of the conquest though indepen-

dence to propose a theory that would allow colonial art to become national art. Drawing on larger art historical trends that viewed the history of artistic style as the expression of cultural and national identities (for example, Heinrich Wölfflin, *Principles of Art History*, 1915) and sought scientific models for describing change in art, he translated the story of colonial art into the narrative of *mestizaje*. First, he insisted on the postconquest preservation of indigenous culture, which he argued was visible on the level of style within Mexico's art and architecture. Then he framed Renaissance art and architecture as a Spanish importation, imposed on the landscape and people of the future Mexico. Finally, he characterized baroque art as the grand synthesis of these two traditions, able to embody the diversity and exuberance of New World cultures.[133] Thus he applied a social science model to an analysis of artistic style and his rigorous accumulation of data to develop a theory for describing the foundational role performed by art, architecture, and art history within the Mexican nation.

Pátzcuaro was not the only place where these ideas were being worked out, but its creation in the 1930s does draw attention to the process and the stakes involved in this reconceptualization of the colonial as itself the product of *mestizaje*. If the new building construction framed typical Pátzcuaro in terms of either a rustic vernacular coded as indigenous or a reimagined, secularized version of Spanish Renaissance architecture, Toussaint's historical study offers a slightly different solution. His ultimate argument regarding Pátzcuaro—that Pátzcuaro's contribution as a historical monument was not a particular building but rather the synthesis of styles and forms in a single town—anticipates his celebration of the baroque's ability to encompass diversity and variation.

However, we must clarify the limits of this understanding of diversity. While Toussaint did do important work in critically engaging the *mudéjar* tradition in the Americas, acknowledging the artistic and historical presence of Arab and north African traditions within the Spanish art and culture brought to the new world (*Arte mudéjar en América*, 1946), he did not come to terms with (much less acknowledge) the presence of African slaves and their descendants in Mexico or identify any traces their history left in the realm of the architectural or the national. As with many cultural nationalist projects, the limits of what was assumed to be a bicultural *mestizaje* erased large portions of Mexico's population. Yet his embrace of the baroque as a space of diversity has provided ample room for more recent work, like that of Gabriel Silva Mandujano, whose social art history treating Pátzcuaro's baroque houses openly discusses the rise of *mulato* Pátzcuaro and identi-

fies key stonemasons and architects of African descent involved in the city's eighteenth-century re-creation.[134] Yet it remains to be seen whether today's materialist studies have the power to make a claim to visibility in as forceful a way as Toussaint's stylistic and nationalist narrative did, working in tandem with mestizo nationalism.

Of course an inability to see the African heritage in Pátzcuaro, or Mexico more broadly, was not just Toussaint's and art history's shortcoming; rather, it was part and parcel of choices that began with the understandable post-independence dismantling of the caste system and was sealed with the selective racial politics of the postrevolutionary celebration of *mestizaje* and *indigenismo*. The choice to aestheticize indigenous identity, making it visible alongside Spanish and European identity more broadly, spoke to a political strategy seeking legitimacy in Mexico's land or national territory and premised in the notion that its original inhabitants were part of the landscape and thus the source of authentic Mexican identity (discussed further in chapter 3). In the process, the African heritage—imported, largely by force and violence—was seen as a detriment rather than being useful to the nation.[135] Responding to this erasure and the crystallization of European-indigenous *mestizaje*, in 1946 Gonzalo Aguirre Beltrán questioned the binary terms used for racialized nation building in Mexico, arguing that Africans constituted a forgotten "third root" of Mexico—a collective lapse of memory only slowly being rectified.[136]

Key questions remain regarding the visibility of Africanness in Pátzcuaro and art history's ability to contribute to it. Material historians are beginning to make contributions here, and I leave open the question as to whether style might eventually provide a fruitful path of inquiry. Meanwhile, iconography holds potential; in the context of the town's urban spaces, I have suggested that the postcolonial tropical aesthetic, and banana plants, remained in the early twentieth century as a trace of the Atlantic slave trade in Pátzcuaro. One might also consider a compelling photograph from this period, showing a wooden carving of a mermaid (La Sirena) on the corner post of a Pátzcuaro house photographed side by side with a seated dark-skinned and dark-clothed woman, whose pose mimics the mermaid's (figure 2.24). The photographer has framed this woman as La Sirena's human counterpart, and the Fototeca Nacional (or perhaps the original photographer) has labeled her "Mujer purépecha" (Purépecha Woman), despite her divergences from the image of the "typical" Indian woman image discussed above (figures 2.3, 2.12–2.14). This image and title follow the larger coding of Pátzcuaro, its vernacular architecture, and its streets as indigenous. Today La Sirena—seen

Figure 2.24. "Mujer purépecha en una calle de Pátzcuaro" (Purépecha Woman in a Pátzcuaro Street), Pátzcuaro. Fototeca Nacional, Secretaria de Cultural-INAH-MEX. Reproducción Autorizada por el Instituto Nacional de Antropología e Historia.

in Pátzcuaro's *artesanías* and restaurant and store names—is still assumed to be an indigenous survival. Contemporary stories link her to Eréndira, the Purépecha princess who in one account was raped by a conquistador but escaped when the gods took pity on her, converted her tears into nearby Lake Zirahuén, and transformed her into a mermaid. Yet Eréndira is likely a nineteenth-century invention, discussed in very different terms in the 1930s (see chapter 4). The origin of this mermaid story is not clear but likely post-dates this period.[137]

Throughout the Atlantic world, mermaids are historically connected to overseas trade and commerce and have proven a particularly flexible symbol for mediating among European, indigenous, and African cultures, all of which have traditions of female water spirits. In the context of African religions and their diaspora, the figure of Mami Wata is of particular interest.[138] It might be fruitful, for example, to consider whether Pátzcuaro's significant African-descended population might equally be given some credit for La Sirena's sustained presence regionally. This is hardly conclusive, but I intend my question merely to contribute to a larger discussion regarding the place of Africans within Mexico and its art, and the strategies that art history might use to help render these traditions visible.

If early twentieth-century photographs suggest that Africans and their descendants did still constitute a locally recognized "type" (figure 2.25; note the children in blackface on the far left), by the 1930s *lo típico* had been re-invented. Applied in Pátzcuaro and elsewhere as a means to govern architectural preservation and urban development policies, *lo típico* was reinterpreted as explicitly Spanish and indigenous, racialized in narrow terms to make a case for a shared regional and national mestizo identity. As a racial term, *lo típico* made fundamental claims about the "natural" state of things—be it people or architecture—and proved an extremely potent ideological tool to justify the transformation and modernization of urban Pátzcuaro. Remember that *Mapa* claimed that Cárdenas had restored Pátzcuaro's "physiognomy." This process of "restoration" demonstrates how an aesthetic project could contribute both affective and scientific dimensions to nation building, while operating simultaneously within the realms of tourism, academics, and government bureaucracy.

At the same time, this process reveals something of how multiple (though clearly not all) voices did contribute to shaping Pátzcuaro. Pátzcuaro's creators included both local representatives and national officials and authorities and even the city's adopted son, President Cárdenas. The images that they negotiated spanned period, media, and ideological agendas and in-

Figure 2.25. Photograph with racial types, Morelia, 1926. Colección Dr. Jesús García Tapia, Archivo Fotográfico, Instituto de Investigaciones Históricas, UMSNII.

cluded both local and foreign image-makers. Such endorsement of diversity finds a parallel in Toussaint's book, as he creates an argument around the ideal of the whole, which emerges (justified by history and aesthetics) in his account of the city's eclectic colonial architecture. This recipe defines the aesthetics of nation building in modern Mexico and the limited terms in which eclecticism and diversity would be understood.

Creating the Traditional, Creating the Modern

Two colorful murals face off across the upper hall of Pátzcuaro's Teatro Emperador Caltzontzin (figure 1.18). The first presents *Industrias de Michoacán* (Michoacán Industries) within a crowded virtual marketplace, high above Lake Pátzcuaro (plate 6). Various *artesanías* are displayed across the foreground, as one might find in a popular art exposition or shop window: a mask used for the celebrated local Viejos dance and wooden Diablo masks from Tócuaro, brightly painted gourds, copper-work from Santa Clara, carved fish, and a grinding stone. Artisans at work on the celebrated trays and bowls from Uruapan take center stage; stacks of freshly carved wooden *bateas* (platters) are ready for lacquering, while those in the lacquered pile will be incised and inlayed with color. Women covered with blue rebozos work on the painted trays, colored birds, and fishes and visually frame the central white-clad male artisans. In the midground a range of regional specialties abound: pottery jugs and plates from Cocucho and Patambán; guitars, a harp, and a violin from Paracho; baskets and hats from Erongarícuaro; and woven mats from Sahuayo. Above, massive looms weave cloth, a fisherman from Janitzio hangs nets, and Don Vasco de Quiroga — credited with promoting Michoacán's handicraft industries in the sixteenth century — rides a mule up a hill overlooking the lake.

Across the hall, a constructivist-inspired fresco (*El Plan Sexenal*, The

Six-Year Plan) montages diagonal slices of scenes celebrating Mexico's Plan Sexenal (plate 5): the political program articulated by Mexico's Partido Nacional Revolucionario (PNR) that guided Lázaro Cárdenas's six-year presidential term. The lower left corner heaves under subterranean pressure, buoying up the first band, which depicts a scene of oilrigs, anticipating the 1938 nationalization of Mexico's oil industry. Giant hands rise to offer the promise of the industrial age: men in overalls line up to enter a factory, while a heroic electrician controls a hydroelectric dam. In the next band a surveyor assesses a landscape that includes new housing, a bridge spanning a river, and tractors driving up from the Banco Ejidal (the national bank founded to support newly formed collective land holdings). Above, to the left, young students line up for school alongside a row of soldiers' faces. To the right, a new highway, a locomotive, and airplanes flying overhead announce Mexico's growing transportation network. In the center, a hand gripping wheat rises from our very location—Pátzcuaro's new public theater—and links culture to the promised abundance. Across the top, a sea of placards and banners promotes, and ultimately legitimates, the regime's agenda; socialist education, constitutional reform, and land redistribution.

When I first came to Pátzcuaro, in 2001, I was searching for 1930s industrial-themed murals and became curious to understand why there was a critical mass of them in Michoacán (in Pátzcuaro, Morelia, and Jiquilpan). However, Ricardo Bárcenas's 1937 Pátzcuaro murals reminded me of the flaw in considering such imagery of modernization in isolation. Only when approaching these murals as a unit can we understand them as an exceptionally coherent and succinct artistic projection of Cárdenas's official state policy, both for the region and for the nation. Paired within Pátzcuaro's new public theater, itself an embodiment of the state project of radical modernization in the guise of lo típico (see chapter 2), they become the visual manifestation of the ideal that the state drives Mexico's program of radical transformation and modernization while at the same time being the keeper of Michoacán's—and Mexico's—history and tradition.

Activating this tension between modernization and preservation of tradition, the murals materialize a set of paired categories guiding period discourse and articulating, across the hall, a series of binary oppositions: the region and the nation, the past and the future, the traditional and the modern. Far from being mere descriptive categories, these ideological labels were activated historically in order to provide a logic for nation building. As Mary Coffey has asserted, within modernizing nationalism the tradition/modernity dichotomy, among others, organizes postrevolutionary discourses of

philosophy, anthropology, education, and art.[1] If, as Tenorio-Trillo compellingly argues, "what is regarded as modern has never referred to the real world" but is rather a projection of what is optimal and most advanced, generated by a political, economic, and cultural elite, then we need to analyze how such ideas are generated and sustained, and for whose interests.[2] According to anthropologist Nestor García Canclini, the modern was necessarily constituted vis-à-vis the traditional, establishing a pattern mapped to a series of binary oppositions, leading to the binary opposition hegemonic/subaltern.[3] As we shall see, such paired concepts resurface repeatedly in two intersecting arenas during the 1930s: the state-promoted programs of the Secretariat of Public Education (SEP) and the public-private collaboration forming Mexico's nascent tourism industry, effectively creating the ideological foundations that helped define the Mexican nation and its tourism economy.

Thus it should not surprise us that while Cardenistas worked to enact a national agenda of political and economic modernization, they simultaneously articulated a vision of what was traditional and authentic, against which their ambitious modernization programs could be defined. In and around Pátzcuaro, ideas about the traditional, local, and authentic (*lo típico*) coalesced around the figure of the Indian — either in the lake environs (as we saw in chapter 1) or within the city's *tianguis* (as discussed in chapter 2). Both variants regularly evoke Bartra's description of the melancholy inhabitants of a lost Eden, who serve as foils for the modern world — arguably in part because their image remains so tightly bound to outdated colonial regulations that linked Indians (*los naturales*) to the land and to the market.[4] Leftist Cardenistas initially attempted to recast rural Mexicans as campesinos within the agrarian movement of the 1920s.[5] While campesinos — revolutionary in their demand for land reform but backward and needing the help of Cardenistas to modernize and integrate into the nation — dominated discourse at the beginning of Cardénas's term, in the mid-1930s the figure of the Indian emerged, once again, as its own discrete category.

The political usefulness of a *racial* category that naturalizes social and spatial relations within the contexts of nation building and tourism development cannot be overstated. Fundamentally, racial categories are social: they project power relationships, which are codified within institutions and policy and embodied and enacted in daily life. Under colonialism, officials institutionalized and memorialized European-indigenous relations in paternalistic terms, in which personages like "Tata" Vasco (the fatherly nickname for Don Vasco de Quiroga) have been celebrated as the great benefactors of their indigenous flocks. This paternalistic relationship was reenacted in the

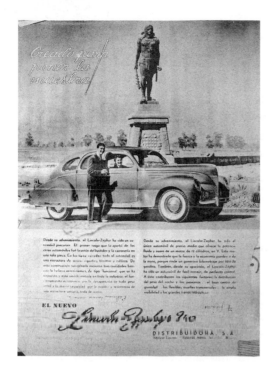

Figure 3.1. Lincoln Zephyr ad from *Hoy* (April 19, 1939). Archivo Fernández y Fernández, COLMICH. Photograph by author.

postrevolutionary revival of indigenous identity and within the ideology of *indigenismo.*

More specifically, it is a spatialized understanding of race, introduced in the colonial period, reinforced by the nineteenth-century scientific language of *lo típico*, and aestheticized within twentieth-century nationalistic discourse, that defines indigenous identity in terms of an essential tie to land (despite the realities of rural migration). In a modern age defined by mobility, spatialized notions of race served to ground the nation in its vast territory and inspired government officials, intellectuals, and tourists to claim a privileged role as those who moved around that territory. This relationship was rehearsed in automobile advertising and in monuments around Mexico, including *Monumento a Tanganxuan* (Monument to Tanganxuan) in a traffic circle outside Pátzcuaro (see chapter 4): Indians would proudly mark local territory, while tourists became modern as they navigated around them in shiny new cars (figure 3.1).[6] It was in this context of modernization and circulation that Cardenistas reanimated Mexico's "Indian" as a figure who could anchor elusive notions of authenticity, tradition, and indigenousness in specific locales around the country.

Bárcenas's murals, facing off as they do across a reception hall, present grand vistas of each side of these dichotomies, from the modern to the tradi-

tional, the benefactor to the beneficiary. On one hand, this pairing projects the national, mobile, modern state as the patron who will preserve *lo típico*: the regional, traditional, and rooted Indian. On the other hand, public art and tourist practices created spaces for constituting identities that democratized such responsibilities. In this context, the mural pair also grants viewers an opportunity to imagine their place within this spectrum. As such the murals function as a technology of governance—part of the "exhibitionary complex" discussed by Tony Bennett that allows citizens to know, understand, and organize the world and to determine their place within it.[7] It is no coincidence that they align with period exhibitions: the Primera Exposición Objetiva del Plan Sexenal (First Objective Exposition of the Six-Year Plan) in Mexico City's Palacio Nacional de Bellas Artes (1937) and the new Museo de Artes e Industrias Populares in Pátzcuaro (founded in 1936). All worked together to define citizenship, nationhood, and state authority in Cardenista Mexico.

BÁRCENAS'S MURALS: *EL PLAN SEXENAL*

As discussed in chapter 2, the creation of *lo típico* in Pátzcuaro (or we might say here, traditional Pátzcuaro) was at the same time the creation of "modern" Pátzcuaro. In particular, we saw that Cardenista programs of modernization were in fact the driving force behind the creation of Pátzcuaro's new public theater, the Teatro Emperador Caltzontzin, its projection of "typical" local values, and thus its creation of a localized and racialized notion of tradition. Yet unlike the theater's aesthetics, which arguably masked Pátzcuaro's radical transformation, Bárcenas's murals highlight the tension found within this project and present Cárdenas's vision for a Mexico that is both modern and traditional. If we accept the premise that each notion is equally ideological, and essentially what Tenorio-Trillo would describe as an "unattainable metaphor,"[8] the questions become: how did the patron and artist conceive of these terms, and to what end? By beginning with the Plan Sexenal (Six-Year Plan), I aim to foreground the extent to which the Cardenista program of radical modernization, its vision of the future, and its quest for legitimacy guided the process.

The Plan Sexenal was the political platform of Mexico's ruling party, the Partido Nacional Revolucionario (PNR), drafted by convention in 1933 under the leadership of former president Plutarco Elías Calles, who continued to control Mexican politics until his 1935 clash with Cárdenas. Prompted by economic challenges exacerbated by the worldwide depression, Calles used the plan to promote greater state intervention in Mexico's economic devel-

opment and modernization. The plan called for renewed land reform, the regulation of large industries, socialist education in schools, restructuring of the army, and national economic investment.

Lázaro Cárdenas ran for president on its social and economic reform platform and promoted his vision of a "modern" Mexico that was secular, democratic, and socially just. Early in his presidency he aggressively pursued this project of economic modernization of the nation, expanding land redistribution programs, promoting *ejidos*, interpreting labor laws in favor of workers, and expropriating key industries. Meanwhile, a modern democratic political system required an educated populace with political access, a goal that involved instituting socialist education and creating new avenues of political participation, like the Confederación de Trabajadores de México (CTM, 1936).

Economic and political fallout from the 1938 nationalization of Mexico's oil industry, however, led to very different policies in the remaining years of Cárdenas's six-year term, as he moved to court investment and repair broken alliances.[9] But until 1938 Cárdenas's policy and the ideology of Cardenismo were developed in relationship to the ambitious Plan Sexenal and its promise to carry the Mexican Revolution forward.

Painted in early 1937 as the plan continued to gather momentum, Bárcenas's constructivist montage-inspired mural represents both its achievements and ambitions. The PNR platform (by its very nature) was a vision for a future Mexico. Bárcenas bends time for ideological ends, as the mural represents both the present and the future. The bottom diagonal, for example, anticipates the 1938 expropriation of the oil industry (as the plan promised), as magma builds up like revolutionary pressure, demanding change and creating the composition's dynamic diagonals. Likewise, to the right, a heroic worker operates controls before a massive hydroelectric dam—a testament to the state's support of local electrification programs and the PNR's promise to develop a national electrical industry. In April 1937—while Bárcenas was already at work on the mural—Cárdenas signed the nascent Federal Commission of Electricity into law, launching a national electrical company. At the same time, many promises of the Plan Sexenal were already guiding policy. Giant hands protect the anonymous male workers arriving at a generic factory, evoking the regime's protection of the right to strike and efforts on behalf of labor. Such policies proved decisive in securing labor's support for Cárdenas in his 1935 face-off with Calles, which ended with Calles's 1936 exile. Thus the mural presents the Cárdenas administration's early achievements and its socialist agenda for the future.

The middle and upper tiers represent the plan's promise for rural Mexico, imaged in the local context. New communities highly reminiscent of state-sponsored housing on Lake Pátzcuaro's shores spring up; a surveyor maps the land; and mechanical tractors climb the incline from the Banco Ejidal to meet the plow in the community fields. Michoacán communities received redistributed lands under Cárdenas, and these *ejidos* were given new opportunities as the government removed legal hindrances to collective ownership and created the Banco Ejidal to provide loans to modernize farming practices. Transportation and communication infrastructure was also promised: the background shows a new bridge, while in the layer above highways (like the one under construction linking Mexico City, Morelia, and Guadalajara), trains, airplanes, and factories traverse the hilly Michoacán landscape and announce industrial networks that would connect the modern country.

To the left, monumental soldiers' faces watch over children lining up for public school, representing the controversial centerpiece of Cárdenas's program to modernize and integrate the country by adding 12,000 new rural schools. The row of soldiers' faces above the students promotes the idea that the army protects the state's revolutionary public education agenda (a theme also celebrated in Diego Rivera's SEP murals in Mexico City) and evokes the new public boarding school for army children founded in Pátzcuaro, the Hijos del Ejército (1931). The school is connected to the SEP's larger cultural programs, represented by Pátzcuaro's new Teatro Emperador Caltzontzin (the site of this mural: figure 1.18). From this intersection of education, culture, and the industrialized countryside springs a hand holding wheat, symbolizing a fruitful merger. Finally, across the top, a host of overlapping banners proclaim their demands and support for the Six-Year Plan's programs and Cárdenas's regime ("Socialist Education," "Constitutional Reform of Article 3," and "Land," to name a few), insisting: "The Revolution Is the Law of the People's Movement." Bárcenas thus codifies Cardenista ideology or Cardenismo, suggesting that the government has heard the people's will, is carrying on Mexico's revolutionary legacy, and is remaking the country in this revolutionary image.

The mural's style suggests the dynamic nature of these changes in national policy, seemingly driven upward from naturally building subterranean pressures. Bárcenas, like many of his colleagues, employed the internationalist and utopian language of constructivism to provide this thrust to his modernization imagery.[10] Although originally montage was deployed to stress the discord, upheaval, and clashes of modern life, by the 1930s it was regularly integrated into the graphic language used by government-supported artists

seeking to represent the constructive (positive) potential of state-guided social and political transformation.[11] At the same time, montage was embraced within the context of modern capitalism, giving dynamic form to modern life, industry, commerce, travel, and communication—especially in the context of the nascent tourism industry. Yet, crucially, Bárcenas's mural defines this industrial promise as Mexican and local—unlike, for example, Grace Greenwood's mural of a generic and universal (male) industry found in her mural in Morelia, *Man and Machine* (1934).

Bárcenas designed his mural in the context of a government-wide effort to prepare the Primera Exposición Objectiva del Plan Sexenal, which opened in Mexico City in May 1937—a month after the mural's completion.[12] This was to be the first in a series of annual exhibitions held at the Palacio Nacional de Bellas Artes to publicize progress toward fulfilling the party's six-year economic plan. In the tradition of promoting national progress more typically reserved for foreign audiences at World Fairs, the DAPP coordinated this event in the nation's capital. The exhibit and accompanying book sought to demonstrate to the public "in an accessible and objective manner" how all facets of the Cárdenas administration worked to fulfill the national party's vision for Mexico and "vindicate the ideology of the Mexican Revolution."[13]

Photographs of the event show a crowded space, where text, photographs, models, plans, new technologies, and charts work in tandem in a veritable montage to synthesize the efforts of each government office (figure 3.2). Graphs quantify and visualize the expansion of communications, photographs document new water systems and hospitals, and models present a futuristic airplane ancient monuments. Large touristic maps give visual form to the national territory that encompasses this variety of programs and projects. Like Bárcenas's mural, the exhibition design evoked constructivism's visual language to present national modernization. This visually aligned the Cárdenas project with economic development plans emerging from the socialist world (especially the Soviet Union), while also creating an uplifting, dramatic, and potentially overwhelming sensorial environment. Slanted walls, together with a barrage of modernist text and images, suggest the dynamism undergirding national modernization, making it palpable for its audience. Of course, whether this would have its desired effect—to excite and inform the audience about Mexico's transformation under Cárdenas—or merely confuse, dizzy, and scare people, as a critic writing for *Hoy* warned, was determined by the individual viewer.[14] As Dafne Cruz Porchini points out, such exposition techniques ask viewers to work actively to read

Figure 3.2. "Primera Exposición Objectiva del Plan Sexenal" (First Objective Exposition of the Six-Year Plan), installation view, Palacio Nacional de Bellas Artes, 1937. Fondo Francisco J. Múgica, álbum III, foto 385, Archivo Histórico de la Unidad Académica de Estudios Regionales de la Coordinación de Humanidades de la UNAM y el Centrol de Estudios de la Revolución Mexicana Lázaro Cárdenas, A.C.

and interpret the texts and images.[15] In lieu of such effort, one might in fact become overwhelmed by the crowded space and onslaught of information.

Importantly, imagery did not solely focus on industrialization. Artists contributed works: Carlos Bracho (1899–1966), for example, combined modernist form and traditional allegory in his sculpture *El pueblo se apodera de la tierra* (The People Seize the Land), in which a standing man grasping a female body allegorizes land expropriation and redistribution (figure 3.3). The National Museum made models of historical structures for the exhibition, its department of anthropology supplied photos and a lecture on the economic and social value of indigenous Mexico, and the Office of Colonial and Republican Monuments produced eighty-eight large-scale monument photographs.[16] Such displays did not, however, merely promote Mexican history and culture alongside the country's industrialization. Together with the office's activity statistics, the photographs provided evidence of the government's ability to become modern by mediating, preserving, and institutionalizing Mexico's past.

The regime's path to modernization was also broadcast to audiences beyond Mexico City. Artists dynamically rendered the Plan Sexenal in prints, artworks, and photomontages. These, in turn, were published in books and journals and sent to teachers around the country. For example, a photomontage on an *El Maestro Rural* cover juxtaposes a new, functionalist school building, Bracho's modernist figural sculpture, modern farming equipment, and grains and bread. Paralleling Bárcenas's mural, the harvest imagery suggests that Mexico's program of socialist education, art, and modern technology will generate prosperity and abundance for Mexico (figure 3.3). The cover of Antonio Luna Arroyo's *Qué hará mi país en seis años*, published by the PNR in 1935, brings together electrified city skyscrapers, oil rigs, a hydroelectric dam, factories, and a tractor (figure 3.4), while other elements of the project are illustrated inside.

Bárcenas's rendition in monumental scale of the Plan Sexenal was clearly part of this larger government-led effort in self-promotion, designed to celebrate the achievements of the revolutionary state in monumental public displays. It used widely circulating iconography to evoke key elements of the program — an oil field, a hydroelectric dam, functionalist school architecture, tractors, workers, hands bearing wheat — and added signs and banners to broadcast familiar revolutionary slogans. The effect was to project Mexico as modern and revolutionary and Cardenismo as an ideology and set of policies that embraced the future, transformation, and progress.

What makes Bárcenas's image particularly distinctive, however, is its re-

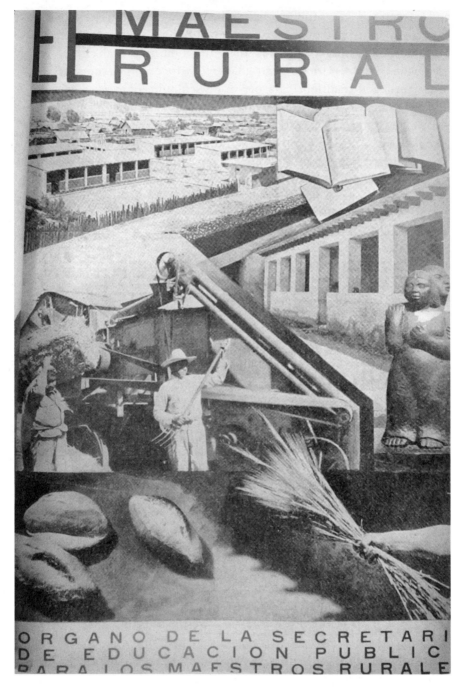

Figure 3.3. Cover, *El Maestro Rural* 6, no. 2 (Jan. 1935). Note Carlos Bracho's sculpture *El pueblo se apodera de la tierra* (The People Seize the Land) (1937) on the right.

ANTONIO LUNA ARROYO

QUE HARA MI
PAIS EN 6 AÑOS

PNR
BIBLIOTECA DE CULTURA
SOCIAL Y POLITICA

Figure 3.4. Cover, Antonio Luna Arroyo, *Que hará mi país en seis anos* (What My Country Will Be in Six Years) (Mexico City, 1935).

interpretation of this national plan through a specific regional lens. As such, it draws our attention to the way that national programs were interpreted and implemented at the local level—as a strategic state project, like those found in the pages of *El Maestro Rural* and other governmental programs of national integration. Furthermore, whereas the exposition in the Palacio Nacional de Bellas Artes threatened to overwhelm, Bárcenas organized his constructivist composition in a dynamic yet controlled manner. Such strategic decisions were given yet greater meaning by the mural's pairing with its mate across the hall.

INDUSTRIAS DE MICHOACÁN: A MODERN TRADITION

Bárcenas conceived of *Industrias de Michoacán* as a foil for and complement to its mate, *El Plan Sexenal*. If the title *El Plan Sexenal* announced a national agenda, *Industrias de Michoacán* announced a regional one. And as *El Plan Sexenal* projected the future onto the present in order to represent an ideal

of progressive modernization, *Industrias de Michoacán* projected the past onto the present in order to frame contemporary *artesanías* as part of an extensive living tradition. But this was no neutral presentation of regional *artesanías*; rather, it was the traditional, or even *lo típico*, as mediated by the state and its modernization agenda. As Rick López has argued, *artesanías*' ascendency as a symbol of authentic Mexican identity wasn't achieved when a true Mexican identity was finally recovered; it only happened once an identity was articulated that could function with Mexico's larger project of economic and political modernization.[17] Bárcenas's mural captures the terms in which this project coalesced under Cárdenas. As spiritual expressions with economic viability in postrevolutionary Mexico, *artesanías* had the potential to integrate Michoacán communities into a national economy. At the same time, they offered an aesthetic and affective potential that could be mobilized for nation building within new institutions and practices, including those of tourism.

Any interrogation of the particular *artesanías* presented by Bárcenas reveals how slippery categories like "tradition" are in reality, as the so-called traditions selected are in fact from a range of historical periods and produced by people of various backgrounds. Certainly scholars have made the case that hand-molded pottery, copper-work, and basket weaving had roots in preconquest Purépecha culture, as did the *maque* tradition of lacquer production from Uruapan. Lacquer had undergone a process of remarkable transformation, however, first in dialog with Asian art during the colonial period and again in the early twentieth century. Thus Bárcenas's coding of its practitioners here as indigenous—by depicting the craft workers barefoot and in white, displaying Uruapan-style *bateas*—is a choice that requires analysis. The guitars and harps are from Spain and North Africa, so Paracho's industry was securely postconquest. While colonial sources indicate that carpentry was an *oficio* (specialized craft) during the pre-Hispanic period, woodworking and furniture making developed as a colonial-era industry to include craftsmen of European and African descent.[18] Likewise, weavers predated the conquest, but the industrial loom-based weaving shown by Bárcenas accelerated in Michoacán during the nineteenth century following the closure of colonial textile mills in other parts of the country. Finally, masks experienced a new demand in the postrevolutionary era, as the SEP's cultural missions promoted the re-creation and staging of Lake Pátzcuaro's "traditional" regional dances, and the anthropological and artistic interest in popular masks began to filter into popular media.[19] While the idea that a rapidly modernizing society might seek to preserve and promote a concrete manifestation

of the past in the present is hardly unique to Mexico, the version of that past preserved there, and specifically the casting of "traditional" as indigenous and male, speaks to the particular needs of the Cárdenas regime and nation building in this part of Michoacán, as well as the artist's own agenda.

Artesanías as Art

Artesanías refer to a range of handmade artisanal goods; while many retain a utilitarian function, they also can be decorative and, in the age of tourism, are regularly marketed as souvenirs. In postrevolutionary Mexico, however, *artesanías* became "art": an aesthetic category worthy of national incorporation, emulation, and investigation, operating within a tradition that promised beauty as a source of moral and spiritual uplift.

From the early 1920s *artesanías* began competing for the title "popular art" in the rhetoric of intellectuals and artists seeking to challenge Eurocentric hierarchies of taste and to validate their own identification with an illusive essence of Mexico, *mexicanidad.* "Popular" suggested "of the people," so successfully claiming and using this label had the potential to establish relevance within the democratic nation. More specifically, the need to represent — to visualize, or materialize — the nation and its people generated conditions under which *indigenistas* (those who promoted and defined indigenous culture) deployed *artesanías* as a symbol of the Indian, to serve alongside ancient archeological objects and sites as the living manifestation of a Mexico that had resisted full assimilation into European society.[20] In *indigenista* rhetoric, such art forms offered access to a precolonial, "authentic" Mexico. Intellectuals argued that adoption of such vernacular aesthetics from various regions within Mexico had the potential to integrate the nation.

By the early 1930s, cultural nationalists had positioned this variant of popular art as central not only to the national redemption of Mexico's Indians, as Marjorie Becker has argued, but also to the redemption of the nation as a whole.[21] Such rhetoric regarding the aesthetic and thus moral (in the humanistic tradition) potential of *artesanías* pervades the pages of *Maestro Rural*, where articles describe handicrafts' role in providing a spiritual outlet for its creators and the nation at large and stress the revolutionary nature of creating a national market for such goods.[22] We are told that the production and consumption of handicrafts by Mexicans could serve the nation by promoting spiritual health and racial unity and that popular arts are able to produce ideological unity because intellectual and ideological unity is generated from emotional unity.[23] The DAPP perpetuated such rhetoric; one

of its catch phrases from 1937 noted: "The simple enchanted form and proportion of our people's art translates their strong and healthy spirit."[24] As Rick López posits in his excellent study of Mexican *artesanía* production and policy, *artesanías* provided an aesthetic—and I would add affective and moral—dimension to nation formation.[25]

Mobilizing the tradition of aesthetics positioned *artesanías* to do this moral, affective, and spiritual work of nation building, yet this aesthetic status was hardly secure: the terms in which *artesanías* could contribute to the nation were subject to debate. For intellectuals like Adolfo Best Maugard, Mexico's popular and folk traditions provided an authentic basis upon which modern artists might build their own aesthetic projects. He designed a method of art education based on such principles.[26] By contrast, Dr. Atl (Gerardo Murillo), Jorge Enciso, and Roberto Montenegro promoted *artesanías* as aesthetic objects in their own right; the task was to train the public to recognize them as such. To this end Atl's influential 1921 Exhibition of Popular Art and its catalog identified, isolated, and celebrated *artesanías'* aesthetic and historical credentials in order to develop the public's taste and promote connoisseurship, and even promoted specific artists along with their work. According to James Oles, by the 1930 exhibit *Mexican Arts* at the Metropolitan Museum of Art, in which *artesanías* and modern painting shared a stage, *artesanías* had been transformed into "art."[27] Following both exhibits, the fashion for collecting and decorating with *artesanías* grew, along with the ideal that one should express nationalism or diplomatic camaraderie with Mexico by displaying handicrafts.[28]

Yet, as many scholars have noted, the display of *artesanías*—even in overtly artistic contexts—often relied on an exhibition style resembling a home or curio shop, effectively promoting the ideal of the domestic and touristic consumption of *artesanías*.[29] The promotion of *artesanías* as commodities within the tourist market was seen as vital for regional economic development. Regional institutions like the Universidad Michoacana de San Nicolás de Hidalgo sponsored fairs in Michoacán explicitly to promote *artesanías* for the tourist market.[30] And *artesanías* found a receptive audience: as we have seen, the *tianguis* (indigenous market) became an essential theme within the touristic picturesque. *Artesanías* and their markets were staples within the pages and on the covers of tourism-promoting magazines and guidebooks (figure 3.5).

Yet while some promoters of *artesanías* embraced the slip between aesthetic and market contexts, others resisted the conflation or even rejected *artesanías* because of this perception that they were mere commodities for

Figure 3.5. F. Urgel, *Market Scene*. Cover, *Mexican Life* 7, no. 1 (January 1932).

the tourist market and thus could not be authentic expressions of Mexican identity.[31] For artists like Tina Modotti and Edward Weston, the solution was to divorce *artesanías* from their market or functional contexts. Their photographs decontextualize and represent *artesanías* as isolated aesthetic objects, described by principles of light, texture, and form (figure 3.6): beauty without purpose, as Immanuel Kant would dictate the credentials for "art." Such artworks, like many inspired by *artesanías*, contributed to the cultural nationalist discourse promoting the aesthetic value of *artesanías* to the nation at the same time that they bolstered the reputations of modernist artists and intellectuals. Ultimately, however, it was those projects that bridged the aesthetic and the commercial—like Bárcenas's mural—that would prove most useful in the state's policy efforts to institutionalize *artesanías* in the 1930s.

Bárcenas overtly situates *artesanías* within the *tianguis*, the marketplace setting that was standard in tourism guides and magazines like *Mexican Life*, to which he contributed illustrations. Yet he also applies the aesthetic lens found in other contexts. Masks, for example, were alternatively promoted as useful elements of popular dances in the pages of *El Maestro Rural* and *Mapa* (both of which promoted Lake Pátzcuaro's Los Viejitos, revived under the SEP in the 1920s and early 1930s; figure 3.7), while being framed as aesthetic objects in *Mexican Folkways* and *El Universal Ilustrado* (figure 3.6). For his part, Bárcenas represents masks displayed helter-skelter on a stand, as one might find in a shop, yet his attention to their formal qualities—dramatic,

Figure 3.6. Tina Modotti, "Two masks, painted in bright colors with feather designs, not intended to be worn: Santa María, Michoacán." Published in *Mexican Folkways* 5 no. 3 (1929).

Figure 3.7. "Artes populares: Danzas mexicanas" (Popular Arts: Mexican Dances). *Mapa* (Feb. 1935). Photographs by Luis Márquez.

shifting planes of contrasting color—helps transform the pile into a quasi-cubist still life.

Further emphasizing their artistic status, Bárcenas pictures the *artesanías* alongside their creators, who work coloring *bateas*, playing guitars, and weaving cloth. This presents the market as an ideal realm of unalienated artistic labor, in pointed contrast to the dealer's curio shop. Artists like Dr. Atl, who included photographic portraits of artisans within his exhibition catalog for *Mexican Popular Art*, clearly recognized that assigning authorship to *artesanías* would help elevate their status. Such imagery of the artists with their wares became typical of attempts to promote the artistry of *artesanías*.

It is worth noting that most typically Michoacán's lacquers were associated with females. In Uruapan, legends specifically speak of the art form's feminine origins.[32] Period postcards, guidebooks, and promotional images regularly showed women artisans holding their lacquered *bateas* (figure 3.8). Often women were posed with *bateas* and other *artesanías* in order to code the works and women as authentic indigenous objects of beauty. One might recall the promotion of the 1921 India Bonita (Beautiful Indian) contest or note examples of "art" photography presenting a female nude, covered with only a *batea*. Such images foreground just how quickly connotations regarding authorship are exchanged for objectifying and sexualizing the female sitter in popular imagery.[33] Thus it is particularly notable that Bárcenas pays homage to the lacquer industry's male artists and effectively skirts such sexualization. Arguably, this was another means to enhance the genre's artistic status (after all, professional female "artists" were still a minority, whereas "craft" has long been cast as women's work).[34]

Furthermore, we might recall that Marion Greenwood had likewise shown artisans at work in her mural treating labor in Michoacán's Lake region (see chapter 1; figure 1.11) and had even signed the female artisan's skirt, as if to suggest an affinity between herself and the female potter.[35] Whether or not Bárcenas likewise identified with the male lacquer artist—a question to which I shall return—both muralists share an interest in the status and labor of local artisans. Bárcenas's rosy portrayal seems to suggest that the unalienated artistic labor that was "naturally" indigenous to Mexico offered an alternative to the alienation of the modern art market. As I discuss at the end of this chapter, this redemptive view of unalienated artistic labor in the marketplace likely speaks to a larger agenda.

The mural's focus on lacquers further elevates the status of *artesanías*, as Michoacán lacquers claimed a privileged position within the cultural nationalist's *artesanías* canon. Since the nineteenth century, lacquerware (includ-

Figure 3.8. "Uruapan, el paraíso de Michoacán" (Uruapan, Paradise of Michoacán). *Heraldo Michoacano* 1, no. 1, November 12, 1938. Above, Señorita Lupita Vázquez; below, Señoritas Consuela López and Rosita Calvillo, at the Casa Calvillo.

ing examples dating to the previous century) had been included in major exhibitions, promoted at home and abroad, and studied by intellectuals in this emerging field. Such elevated status likely was in part practical: *bateas* and lacquered chests and furniture tend to be large and exhibit well. Yet lacquer also had a long history: lacquered gourds were prestige objects under the Purépecha empire, and the craft adapted to European fashions in the sixteenth century. A major center in Peribán, Michoacán, established early stylistic preferences for symmetrical *bateas* with concentric bands of decorative floral, bird, and butterfly motifs, interspersed with medallions.[36] In the eighteenth century, Uruapan and Pátzcuaro emerged as lacquer-making centers. Don Manuel de la Cerda, from a noble indigenous family of Patzcuareños, gained international renown for his Asian-inspired motifs and scenes of leisure during the height of an international chinoiserie, the fascination with things Asian, which became all the rage in Pátzcuaro.[37] Uruapan's style dramatically shifted away from its recognizable flat, stylized floral patterns in 1904, when Uruapan artisans were invited to contribute to the St. Louis World's Fair. Inspired to experiment with a new illusionistic and asymmetrical style fashionable in that context, they brought the popular new style (and earnings) back to Uruapan and applied the region's distinctive inlay technique to new ends.[38] As twentieth-century collectors began to seek out antique lacquers, Michoacan's industry was revived to meet renewed demand. While the industry in Quiroga (on Lake Pátzcuaro's northeastern shore) began to produce mass-market *bateas* using synthetic lacquer and paints for tourists, workshops in Pátzcuaro and Uruapan established claims to produce "traditional" or "authentic" examples of the art form, catering to an emerging class of connoisseurs.

Period scholarship on the lacquer tradition added to its growing status as a "traditional" art form and reveals the specific concerns of connoisseurs: was lacquer authentically indigenous or did it reflect contact with Europe or Asia?[39] How could one identify high-quality, traditional, and authentically Mexican lacquer in a world where techniques and styles were changing in response to global pressures? While authors lament the rise of cheap, industrial lacquer and iconography foreign to the region (like the popular China Poblana), they also reassure potential collectors that a revival was in the works. Frances Toor specifically credits the government with supporting projects in Uruapan (cited as the one place still using "authentic" techniques and styles) and in Pátzcuaro to this end.[40]

Local artist Salvador Solchaga, who led the revival in Pátzcuaro, was not only a key resource for Mexico City–based intellectuals like Roberto Monte-

Figure 3.9. Salvador Solchaga with one of his gold filigree *bateas*. Photograph from his photo album, collection of the Museo de Artes e Industrias Populares, Pátzcuaro.

negro and Anita Brenner as they sought historical lacquer but also learned to produce *bateas* himself. He discovered an old formula for gold-filigreed lacquer and established a workshop to train others in the technique, thus positioning Pátzcuaro's lacquer industry to maintain leadership in a shifting field (figure 3.9). The state named Solchaga a "master of lacquer" for his efforts.[41] Bárcenas's prominent presentation of lacquers in the hands of their male creators asserted the objects' artistic status and taught viewers to imagine themselves as connoisseurs as they approached the market.

Efforts to promote and preserve Michoacán's *artesanías*, including lacquerware, coalesced around Pátzcuaro's new Museum of Popular and Industrial Arts. In 1936 Cárdenas ordered the creation of this new museum within Pátzcuaro's former Colegio de San Nicolás de Hidalgo.[42] Founded by Vasco de Quiroga in 1540 (figure 3.10), the structure served both Spaniards and indigenous men as Mexico's first seminary until 1580, when it was relocated to Morelia with the seat of regional power (where it operates today as the Americas' longest-running university). Since then the building's trajectory has been aligned with the region's fortunes: the Jesuits used the building as a school until their eighteenth-century expulsion, at which point it was abandoned and later reincarnated as a primary school, hotel (*mesón*), and *vecindad*

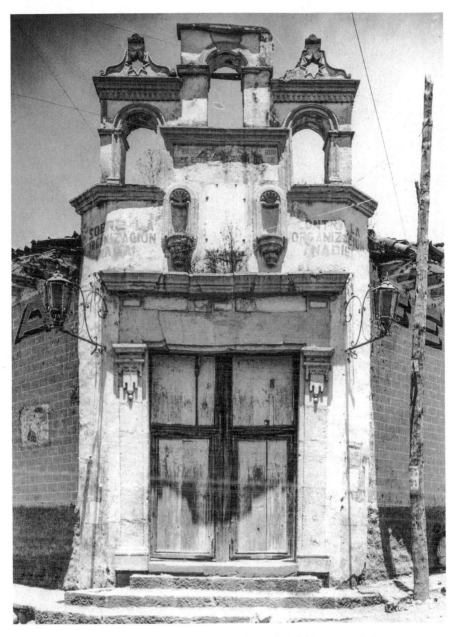

Figure 3.10. "Primitivo Colegio de San Nicolás. Portada" (Primitive College
of San Nicolás. Entrance). From Enrique Cervantes, *Pátzcuaro en el año mil
novecientos treinta y seis* (Mexico City, 1949).

(boarding house), among other uses.[43] While still reproduced at the turn of the century within religious narratives (like the *Álbum de Pátzcuaro*), in 1929 the building was appropriated by Cardenistas and became a center for meetings of the Confederación Revolucionaria Michoacana del Trabajo (Michoacán Revolutionary Labor Confederation), as part of a confrontational strategy of inserting a revolutionary agenda into the state's religious centers.[44] In 1936, however, the project to preserve *lo típico* tempered this confrontation. Restored by Leduc, the building reopened as a museum in 1938. In the estimation of Toussaint, who paid homage to the building in his 1940 project (its 400th anniversary), its new role created one of the nation's most delightful museum experiences.

The federal Departamento de Monumentos Artísticos, Arqueológicos e Históricos (DMAAH) funded the museum's acquisition budget and restoration projects. Control remained under the local leadership of figures including Solchaga, Refugio Cerda, María Teresa Davalos, and Rodolfo Ayala, who served as its first director. It operated as a trust (*patronato*) until 1942, when it was incorporated into the INAH.[45] The museum preserved and promoted "traditional" *artesanías* through the acquisition, restoration, and display of select objects and by sponsoring Solchaga's lacquer and painting workshop. Cárdenas facilitated its early acquisitions, including a stone chacmool excavated at Ihuatzio's sacred center and antique lacquers from a museum in Guadalajara, Jalisco, and a private collection (of Magíster León, professor of Greek and Latin at the Colegio de San Nicolás de Hidalgo) in Morelia. Ayala purchased a range of works, including woven hats and regional textiles, ceramics, and toys.[46] Their display inside the museum speaks to the tensions discussed above, as some rooms featured protective vitrines that celebrated antique and modern lacquers as distinctive works of art, while other objects were arranged within faux domestic interiors, modeling how visitors might use or decorate with *artesanías* in their own homes (figure 3.11). Thus the museum and the mural alike spoke to the cultural nationalists' aesthetic agenda, while using the nascent tourism industry to help cultivate connoisseurs and build a national market for quality *artesanías*.

But the cultural nationalist project's visibility in this regional context, from Bárcenas's mural to Pátzcuaro's new museum and its programs, testifies not to the political ascendency of the cultural nationalists but rather to how the promise of high-quality, traditional *artesanías* was useful at a moment when in fact both demand and state policy were organizing around low-cost tourist souvenirs developed to support regional economies. Mexico City's Museum of Popular Arts, by contrast, was increasingly marginalized

Figure 3.11. Interior view, Museo de Artes e Industrias Populares. Fototeca Nacional, Secretaría de Cultura-INAH-MEX. Reproducción Autorizada por el Instituto Nacional de Antropología e Historia.

and underfunded in the later 1930s, culminating in the removal of its original director, Roberto Montenegro, and its displacement from its exhibition space within the Palacio de Bellas Artes to expand the Primera Exposición Objetiva del Plan Sexenal, discussed above.[47] Even in Michoacán, *artesanías* were equally likely to be promoted in contexts that emphasized their status as local products or commodities: the DAPP-sponsored Regional Exposition of Agriculture in Morelia and its poster (figure 3.12), for example, place lacquers and masks alongside cattle, wheat, and corn.

The name of Pátzcuaro's new museum, the Museo de Artes e Industrias Populares, indicates that its mission was aligned with an understanding of "popular industry" that in fact shaped Cárdenas's *artesanías* policy. The emphasis on the industrial nature of artisanal production emerged under pressure from dealers, market forces, and leftist productivists within the SEP, whose socialist lens emphasized industrial labor. Such rhetoric can be found in pages of *El Maestro Rural*, which in 1936 emphasized industrial arts like glassblowing and do-it-yourself "small industries" like preserves before gradually beginning to reintroduce images of *artesanías* in 1937, if not actually discussing them.[48] The result of this ideological modernization of *arte-*

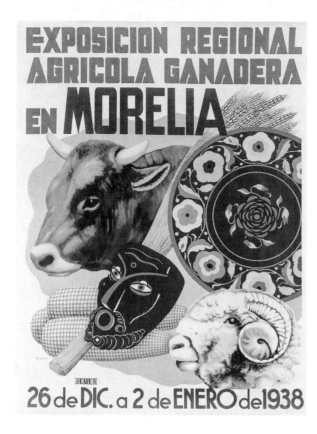

Figure 3.12. DAPP poster: "Exposición regional agricola ganadera en Morelia" (Regional Agriculture Exposition in Morelia), 1938. Courtesy of Swann Auction Galleries.

sanías was hardly revolutionary, however.[49] The state-subsidized Sociedad Impulsora de Industrias Típicas Mexicanas (Society for the Promotion of Mexican Vernacular Industries, originally the Cooperativa Nacional de Industrias Típicas Mexicanas) had reorganized artisanal production and distribution in 1934 to privilege brokers and merchants, effectively marginalizing the artists themselves. As Rick López has argued, the organization succeeded by co-opting the cultural nationalists' aesthetic language and strategies, even as its policies privileged industrial practices, efficiency, and prices set low enough to compete with Asian imports.[50] Under such conditions, producing and promoting inexpensive tourist curios for foreign and national audiences alike became the raison d'être of most artisanal production. The effect was to lower the artisans' status and autonomy.

Bárcenas's mural *Industrias de Michoacán* thus epitomizes the state's appropriation of the cultural nationalists' aesthetic vision, while presenting industrial rows of guitars, piles of *bateas* waiting for lacquer, long swatches of textiles and nets, and the labor of workers within the marketplace. Yet by

emphasizing the individuality and manual labor of key figures and reproducing a world in which the artists themselves sell their materials in the market, the leftist artist effectively idealizes their labor as both unalienated and high quality—a vision very much masking the reality of the administration's new industrial model.

Indigenous Arts and National Geography

To craft this ideal of nonalienated artisanal labor, both Bárcenas and the new museum mobilized racial ideology, specifically the idea that indigenous people were timeless representatives of Mexico's land who could directly channel an essence of Mexico via their artistry. This effort to define *artesanías* as indigenous, and the fictional reinvention of the Indian that accompanied it, served a number of purposes in the context of nation building. First, as many have noted, it provided a visible counterweight to centuries of imported culture, aesthetics, and values, contributing to the materialization of the national ideology of *mestizaje*, which claimed that Mexico was a product of mixing indigenous and European cultures. At the same time, it transposed the idea of national territory onto the bodies of certain citizens and the objects they made—an idea embodied most explicitly in Miguel Covarrubias's 1947 map *México pintoresco* (Picturesque Mexico), which labeled the country's regions with traditionally dressed Indians and *artesanías* and was originally painted for Mexico City's Hotel Prado. While indigenous bodies were expected—given the precarious nature of this process—to remain rooted in place physically and culturally (or to return to home after visiting the capital),[51] their artworks were portable and collectable and thus were traveling symbols of the regional within the larger nation. As powerful as these ideas have remained, they have also obscured a range of historical realities, from the diversity of peoples that have participated in Mexico's *artesanías* economies over the centuries to the movement, autonomy, and cosmopolitan engagements of individuals identifying as indigenous. Crucially, this logic of nation building worked to define not only Indians in terms of a connection to the land but also those who enjoyed the privilege of mobility and claimed responsibility for the well-being of Mexico's Indians. Thus *artesanías* were defined as indigenous art, tied to specific regions and requiring state patronage.

Both the space and exhibitions within the new Museo de Artes e Industrias Populares framed contemporary *artesanías* as indigenous. Its curators originally anchored the collection with a pair of Purépecha chacmools, excavated at the nearby archeological site of Ihuatzio under Alfonso Caso, and

included both historical and contemporary regional objects.[52] In fact, early DMAAH documents often referred to Pátzcuaro's museum as the "Ethno-graphic Museum," applying an anthropological lens that linked ancient civilizations with contemporary indigenous peoples. Most importantly, according to Toussaint, the museum honored "Tata Vasco" as the region's first bishop and promoter of *artesanías*.[53] This was part of a larger effort to appropriate Quiroga's legacy and recast it as part of Mexico's history of visionary social experimentation (see chapter 4). A major part of Quiroga's legacy was the institutionalization and regulation of indigenous identity, which he based in part in artisanal production.

Quiroga's reputation as a social reformer rests in large part on his role in expanding Michoacán's system of communal village-hospitals: living communities that resettled, educated, and converted indigenous populations, while providing social support and moral guidance. To govern communal life, Quiroga wrote a system of *Reglas y ordenanzas para el bien gobierno de los pueblos hospitales* (1532), which defined strict expectations regarding religious instruction and hours worked, clothing (white cotton or wool shirts and pants for men, and long skirts and white rebozos for women), and behavior.[54] Each community had a specific artisanal economy. Today scholars note that such village-specific craft economies predated the colonial period and are found throughout Mexico, but it became popular to assert that "Tata Vasco" established Michoacán's artisanal economies, teaching each community its distinctive craft, which would be bartered in the regional economy.[55] Historians since the 1930s have debated whether such living communities, with their social services and barter of goods, demonstrated a form of primitive communism or whether they represented a protocapitalism, developing within colonial systems of forced labor.[56]

Guidebooks and travel literature also celebrated Quiroga's legacy in the Pátzcuaro region and focused particular attention on his role in the artisanal economy.[57] Alfredo Maillefert, for example, muses on Quiroga's legacy in his impressionistic travel narrative, *Laudanza de Michoacán* (1937):

> From a window as we write these pages, we see the lake and some blue mountains . . . and think about Don Vasco. About Don Vasco, who ran all over the diocese . . . on his white mule. . . . About Don Vasco, who ran around to villages to watch and advise the *artesanos* who carve the wood, paint the platters, polish and decorate the vases, who have been doing these things that he taught them and that fill them still with the fervor of life and of love of *artesanías*, the *tianguis* of the Michoacán people.[58]

It is precisely this image of the *tianguis*, the indigenous artisans, and Don Vasco traveling on his mule that Bárcenas presents to us, as he, like so many of his contemporaries, appropriated both the idea of the great benefactor, Quiroga, and the version of indigenous identity that necessarily accompanied it.

This image of Quiroga as benefactor, traveling to visit artisans, provided a particularly compelling role model for viewers, from everyday tourists to the nation's president. Cárdenas performed this benefactor role publicly (see chapter 5), and comparisons with Quiroga were not lost on the public. Dubbing him "Tata Lázaro," a fatherly term of endearment shared with "Tata Vasco" de Quiroga, journalists and historians alike cast Cárdenas as a modern incarnation of the bishop and celebrated his backcountry horseback rides to tend rural populations, his social vision, and the love he dedicated to and received from indigenous people—all elements shared with the Quiroga myth.

This beneficent subject position was not only available to the president of the Republic. The Primer Congreso Interamericano de Indigenistas (First Inter-American Indigenista Congress), held in Pátzcuaro in 1940, extended this role to all its delegates, as government representatives from throughout the Americas gathered in the Teatro Emperador Caltzontzin to discuss the poor status of the continent's indigenous peoples and unanimously supported proposals promoting indigenous arts as a means of economic and cultural integration. The congress explicitly celebrated Quiroga's legacy (see chapter 4) and distributed a newly published edition of his *Reglas y ordenanzas* to its delegates. At Cárdenas's suggestion, indigenous representatives were included in the congress at the last minute.[59] The guiding assumption was that it was the job of government bureaucrats to save the continent's Indians. The indigenous participants played a central role in discussions of *artesanías* and even organized a follow-up conference (The Day of the Indian) in Mexico City; however, their talks were not recorded in the congress proceedings (as were those of non-indigenous delegates). Furthermore, while the governmental delegations were put up in local hotels and received the full touristic experience, indigenous delegates stayed at the local boarding school, Hijos del Ejército. Meanwhile, as the state created structures and events to codify this benefactor-Indian relationship, the mural extended this patron role to all viewers: cultivate your love, eye, and taste for *artesanías*; travel; and patronize regional artisans.

In creating an image of the Indian that invited viewers to embrace the role of benefactor, Bárcenas preserved a core feature of indigenous identity as conceived during colonization and reinvented by postrevolutionary intellectuals and politicians: the Indian as artisan—enabled, watched over, patron-

ized, and realized by a higher authority. After all, racial categories are fundamentally social and manifest through such regulation of power. In the piece of the colonial system re-created here, to be Indian was to be subservient, indebted, and devoted to beneficent outside authority figures. Thus not surprisingly Bárcenas summons a range of Quiroga's colonial racial codes: many of the men still wear white uniforms, and the women are modestly covered in rebozos (now blue), remain barefoot, and sit humbly on the ground with their *artesanías*. Notably, we are not shown Pátzcuaro's lacquers with their Asian influences and gold filigree (figure 3.9), revitalized by Solchaga, who was Hispanic.[60] Meanwhile, Bárcenas also incorporated more contemporary tools for regulating race, positioning his central lacquer artisan in profile, for example, to quote a typical format used to promote lacquers in postcards and guidebooks, arguably derived from ethnographic photography (used for establishing racial categories). Such profile views—which present the photographic subject as an object of study, seemingly oblivious to the viewer's gaze—were also used to display artists within Dr. Atl's 1922 popular art catalog, where they helped perpetuate the idea that *artesanías* are fundamentally and essentially indigenous, despite centuries of transformation.[61] Arguably the mural should be understood as part of the modern institutionalization and regulation of the category "Indian" that develops within academic institutions, museums, and institutes for preservation, including the Proyecto Tarasco (founded in 1939), the INAH (founded in 1939), and the Department of Indigenous Affairs (founded in 1935).

Ultimately the effect—of the mural, the museum, the larger infrastructure surrounding the "preservation" of indigenous culture, and the visual culture of tourism—was to reconstitute the colonial category "Indian" and its practices of regulation for the modern era. At the heart of this maneuver was a telescoping of the past into the present, a practice that has come to define indigenous identity in the modern world (see chapter 1). Bárcenas's mural makes this explicit: while the image represents Quiroga on the hills above the lake, prior to the arrival of the Morelos statue on Janitzio, it also presents the contemporary moment, artisans, and their objects—including at least one contemporary lacquered gourd acquired for the museum's collection. Moreover, Bárcenas not only highlights Uruapan lacquers but also represents Uruapan's flat, stylized, symmetrical *bateas* rather than the illusionistic style popularized post-1904. Thus Bárcenas—much like the museum's curators—chose to define indigenous and authentic in terms of an illusively "pure" past.[62] This, as we have seen, was the lot of the Indian as a racial category: displaced from history, "naturally" maintaining precapitalist ways, and

invisible as Indian outside this framework. In exchange, the Indian became the privileged bearer of tradition.

It is important, however, to note that this was not a wholesale importation of Quiroga's Indian, who, after all, was a member of a strictly Catholic community. Since the eighteenth century, historians in Mexico had worked to transform Quiroga's legacy to make it fit a liberal humanist model. A key part of that transformation, intensified during the 1930s, was to secularize his memory.[63] It became particularly important that *artesanías* offered a secularized indigenous identity in the context of Michoacán's religious tensions following the Cristeros Rebellion (1926–1929). Around Pátzcuaro, handicraft economies developed in communities that lacked sustainable agricultural economies—communities that for religious and political reasons had rejected state-sponsored land redistribution following the expropriation of local haciendas and the establishment of the *ejidos* (collective land-holding system).[64] Thus Cárdenas's promotion of Michoacán handicrafts offered redemption and integration to those Michoacanos who had explicitly rejected the state's revolutionary agenda. As the state embraced handicrafts as a secular source of spiritual values, they attributed such values to those who resisted the state's anticlerical laws and who continued to demand that their churches be reopened. And Bárcenas's promotion of *artesanías* corresponds to their institutionalization in the regional context, when the state mobilized *artesanías* within its political and economic program of national modernization, secularization, and integration.

Ultimately the images of *artesanías* and Indians projected by Bárcenas's mural succeeded not because they were born of regulation but because these terms appeared useful to various parties in the 1930s—and not just government authorities, intellectuals, and tourists. Many local Purépecha communities came to adopt this role as "heirs of tradition" and learned to cultivate this relationship with their public. Purépecha representatives began to advocate the creation of a federally supported Instituto de Investigación y Cultura Indígenas at the Universidad Michoacana de San Nicolás de Hidalgo in order to propagate and conserve indigenous language, culture, history, and art and educate teachers.[65] Despite the patronized subjectivity built into the very idea of the "Indian," *artesanías* and the visibility they offered to their makers represented not only new economic opportunity for members of rural communities but also the growth of regional indigenous pride—even if, as Luis Vázquez León has argued, such pride is mediated through indirect references, "such that the agency of indigenous actors remains limited to gaining cultural visibility via cultural tourism."[66] Morelia's artisans' union

(one of a series of collectives that would seek to improve the lot of artisanal workers) was opened to artisans around the state in 1938 and began a pro-tracted struggle to make their labor economically viable.[67] Indigenous dele-gates at the 1940 Primer Congreso Interamericano de Indigenistas, or the First Inter-American Indigenista Congress, followed up by organizing their own congress on tourism and produced the Día del Indio (Day of the Indian) the following year at Bellas Artes in Mexico City, speaking to the use that they made of this newfound visibility and path for agency.[68]

Moreover, what made this image of indigenous *artesanías* compelling in the nation-building context was the regionally specific nature of the "Indian." In a modern world often defined in terms of mobility, migration, and ex-change, the mythical ideal that to be indigenous was defined via connection to the land held special power. Again, this element of Indian identity was the invention of colonization, during which indigenous status and tribute guar-anteed people's access to land, and migration worked to destabilize the caste system.[69] The *encomienda* system, which gave Spanish landowners rights to the labor of and moral responsibility for the care of the Indians living on and working their land, realized such principles. In the postrevolutionary world, the ability of the racial category "Indian" to evoke both an essential connec-tion to the land and a timeless connection to the preconquest world was the source of its power, as intellectuals sought a foil to complement Mexico's long identification with imported European heritage, culture, and art.

Artesanías became a portable sign of this racial geography. Describing the beauty of Uruapan, a *Mapa* author likens the city, whose Purépecha name means "place of the gardens," to its famed *artesanías*, noting that "Uruapan is, in reality, an immense *batea*" and presenting Uruapan's *bateas*, artisans (shown in modern dress), waterways, and parks as "nature tamed"—a Chris-tian metaphor for colonial conquest and conversion, translated into the secu-lar world of tourism.[70] This conflation of place, people, and art form—as we see again in *Industrias de Michoacán*—allowed popular art to play a privileged role in representing Mexico's vast geography to the nation, to the world, and to individual collectors.

Such was the context in which Bárcenas created his foil to revolutionary modernization and transformation. As the DAPP's talking points insisted, artesanías served as a "faithful reflection of the artistic spirit of the Mexi-can people" and "preserved purely, they are examples of an important part of our heritage and culture."[71] In short, they were to be a pure and authen-tic aesthetic connection to place, to spirit, to national identity. While the specter of "Asian influence" (and rise of Asian imports) would continue to

haunt the lacquer industry, this image of indigenous *artesanías* worked to re-constitute *artesanías* as the realm of the Indian. This framing came at the expense of artisans with African, Asian, or European heritage, however, and of a cosmopolitan view of indigenous artisans like Manuel de la Cerda or the Uruapan artists preparing works for the St. Louis World's Fair, who actively engaged and exchanged ideas within a global lacquer industry. Instead, at a moment when once again *artesanías* were on display to the world, subject to global pressures, and undergoing a rapid transformation, Bárcenas mobilized racial ideology to fabricate an image of *artesanías* as essentially regional, traditional, and of an unalienated past.

BETWEEN THE STATE AND THE INDIAN

Thus *Industrias de Michoacán* and *El Plan Sexenal* were equally the product of Mexico's modernization. Together, the murals represent the ideological basis of Cardenista policy: presenting both the promise of radical transformation and modernization and a commitment to preserving cultural traditions. At the same time, the murals present the intersection of the national and the regional, with the national Plan Sexenal interpreted through a regional lens, and Michoacán's *artesanías* industry presented as part of a national project of aesthetically based spiritual redemption. Moreover, in this configuration, as the murals face off across the reception hall, the state, along with the PNR and its six-year plan, serves as the noble benefactor that enables, protects, and preserves the Indian. It is in this juxtaposition of political programs, racialized subject positions, and artistic visions of Mexico that the mural pairing's larger significance can be understood.

As we have seen, Bárcenas's visual articulation of binaries can be understood as part of the process of producing the "modern nation." According to structuralist thought, binaries generate meaning through opposition: cultures define tradition in order to modernize; to become a nation requires regions; colonizers create the category "Indian" to colonize. Of course the configuration of those dichotomies and the way in which they are used change over time. Such is the case in Mexico, as we see when we compare the way the cultural nationalists and the leftist productivists used binaries to promote distinct plans of social transformation in the pages of *El Maestro Rural*, the SEP's journal for rural education.

Cultural nationalists sought simultaneously to rediscover and to create a coherent nation through appreciating Mexico's diverse cultures, often deploying a biological metaphor, typically sexualized, to describe the merging

of indigenous and Spanish cultures to create a new mestizo culture.[72] Writing in 1932, Moisés Sáenz evokes Mexico's cultural mixing (Indian, "primitive," mestizo, and Spaniard), alongside an interconnected series of binaries: the complex blending of old and new, traditional and modern, rural and urban cultures, local and universal, which all come together and coexist.[73] When the productivists took over the SEP under Cárdenas (1934), dichotomies were deployed within the logic of dialectical materialism. Juxtapositions of traditional and modern farming equipment in the pages of *El Maestro Rural*, for example, implied that from this opposition a new rural culture would emerge, obliterating the backward, backbreaking ways of the campesinos.[74] After the DAPP took over the journal in 1937, however, a compromise was reached: while images of campesinos and rural industries, like the processing of preserved fruits and vinegar, are increasingly modernized, an image of the Indian simultaneously returns to take its place as a living emblem of a timeless, traditional past.[75] The imagery moves away from the didactic narrative of transformation and liberation and instead presents indigenous people and *artesanías* — a potter with a ceramic pot, a Tehuana, a *batea*, or a folkloric mask — in isolation from the rest of the journal's content.[76] Yet this is a reinvented Indian, presented by virtue of mediation by the Mexican state and its modernist artists and intellectuals: a painting of a Tehuana by Gabriel Fernández Ledesma or a series of articles in which Angelina Beloff provides instructions for making traditional arts, designs, and toys.[77] If the campesino is incorporated through transformation, the Indian is presented as the traditional, regional "Other" for the modern nation and more specifically for the emerging Mexican state, with its institutions, administrators, and professional artists. This is also the dichotomy crystallized in Bárcenas's Pátzcuaro murals, where the Cárdenas administration's program of social transformation and modernization, the Plan Sexenal, is the foil for the traditional Indian.

This strategic contrast between modern and traditional views of Mexico (and Mexicans) became a staple not only in the pages of *El Maestro Rural* but also within the exhibitions and murals presenting Mexico to its publics at home and abroad. At the New York World's Fair of 1939–1940, for example, official displays of Mexican engineering and industrialization were paired with *artesanías*, dancers in regional folkloric costumes, and Márquez's photographs of Lake Pátzcuaro's indigenous fishermen (see chapter 1). Such contrasts were adopted in the tourism industry's rhetoric and visual culture, as hotel and regional promotional materials promised modern conveniences (plumbing, electricity) alongside traditional charm. The regular display of

such ideals to visitors and Mexican citizens alike suggests that we consider the role of such a "culture of display" in nation building and diplomacy. Tony Bennett describes such culture as deploying an "exhibitionary complex": a technique of social administration that transforms the problem of order into "one of culture," in which individual viewers learn to discipline their own bodies and minds by being offered an empowered position from which to view and organize the world. As technologies of nation building, public exhibitions—and I would add murals, monuments, and touristic experiences— stimulate citizen formation. Exhibitions offered

> object lessons in power—the power to command and arrange things
> and bodies for public display—they sought to allow people, and *en masse*
> rather than individually, to know rather than to be known, to become, in
> seeing themselves from the side of power, both the subjects and the ob-
> jects of knowledge, knowing power and what power knows, and knowing
> themselves as (ideally) known by power, interiorizing its gaze as a prin-
> ciple of self-surveillance and, hence, self-regulation.[78]

Similarly, Bárcenas's murals worked alongside exhibits such as the Primera Exposición Objectiva del Plan Sexenal and those in the new Museo de Artes e Industrias Populares, as well as a broad array of visual culture, to structure and organize a rapidly transforming society. As such, they prompted and *empowered* Mexican citizens and visitors alike to examine their place within the modern world.

Standing in the theater's upper reception hall, the viewer can see portions of each mural but must walk into each of the rooms created by the building's twin towers in order to see their full height. There each mural stands as monumental projection of state governance at work, designed to impress and engage. *El Plan Sexenal*'s dynamic lines and agitprop style seek to move and inspire with its upward thrust; *Industrias de Michoacán* seeks to cultivate the viewer as a connoisseur, stirring our passions and uplifting us with its aesthetic display of artists and their art, awaiting an appreciative patron. The viewer moves between these murals, negotiating and organizing the paired worlds, to find a place between tradition and modernity, the region and nation, the Indian and the state. It is up to the individual to resolve such oppositions within his or her own subjectivity. As William Rowe and Vivian Schelling point out, many of us (including those who identify as indigenous) live somewhere in between the poles.[79] While this process was available to any viewer (local or visitor), it is worth reiterating the special

place such binaries are given within touristic practices. In fact, Néstor García Canclini has argued that such oppositions and juxtapositions not only allow tourism to thrive but also are reconciled within the tourist's subjectivity.[80] The mural articulates such subjectivity in terms of race and space, which speaks once again to the ways in which tourism offers its subjects the possibility of a privileged, mobile subjectivity.

A MURALIST IN THE CULTURAL POLITICS OF THE 1930S

Bárcenas's mural pairing also embodied a choice for the artists of the 1930s. On one hand, as a government employee presenting state ideology to Pátzcuaro's publics, Bárcenas was part of the state apparatus and positioned to serve as benefactor to the country's indigenous artisans. On the other, his presentation of unalienated artistic labor in the marketplace may well have addressed concerns felt broadly by Mexico's artists, newly navigating through Mexico's incipient art market. Arguably, the murals' dichotomous structure helps us understand key questions debated within Mexico's highly polemical artistic culture regarding both the artist's fragile position vis-à-vis the state and the marketplace and the future direction of the visual arts.

During the mid-1930s, Mexican artists engaged in a lively and contentious debate about the future of Mexican art, instigated in large part by local artists who identified with the international Popular Front movement (1934–1939). The Popular Front formed as leftists and moderates around the world joined forces to organize against the rise of fascism. In Mexico, this coalition emerged in 1935 to support Cárdenas, when former president Calles sought to reclaim power, and began to dissolve in 1938, as the left became disenchanted (and disenfranchised) by Cárdenas's retreat from radical reform. Artists around the world took leadership roles in the Popular Front, forming organizations like Mexico's Liga de Escritores y Artistas Revolucionarios (LEAR: League of Revolutionary Artists and Writers) to promote art that would combat fascism, in addition to advocating in general for the social necessity of art. The LEAR worked alongside Cardenistas both within and outside the administration, seeking commissions and solidarity and working to expand Mexico's art publics. Like Popular Front organizations worldwide, the LEAR managed to bring together a wide range of artistic tendencies (eventually even Mexico's *arte pura* [pure art] faction).[81] It created a polemical artistic culture that actively debated the state of art in Mexico (engaging in "collective self-critique") and its path forward.[82]

In Mexico that debate coalesced around key personalities, as epitomized

in the "Battle of the Century," a debate staged between David Alfaro Siquei-
ros and Diego Rivera at the Palacio de Bellas Artes (and extended into other
venues) in August 1935.[83] Like many period polemics, the debate was be-
tween leftist factions: Communist sympathizers versus the anti-Stalinist
left. Siqueiros's critique of Rivera revolved around two poles. First, he de-
scribed Rivera as a "political opportunist," uncritically (according to Siquei-
ros) working for the Mexican government at a time when it had outlawed
the Mexican Communist Party (1925–1935) and accepting a series of commis-
sions from leading capitalist industrialists in the United States. Second, he
raised questions about the ideological and stylistic content of Rivera's work,
suggesting that it catered to an art market of bourgeois tourists and for-
eigners, with its emphasis on indigenous themes, folklore, and references to
archeological cultures.[84] Such a critique reflected the left's growing concern
that both the limited private art market and government commissions in-
creasingly catered to tourists—the ultimate symbol of the ascendant middle
class (the bourgeoisie) and their imperialist impact—and that artistic oppor-
tunities remained limited to Rivera and others who favored romantic images
of Indians rather than those who wielded art as a weapon of struggle and so-
cial transformation. At stake were commissions, professional stability within
Mexico's emerging art institutions, and the question of art's social utility.

While it is not clear whether Bárcenas was a member of LEAR or at-
tended this weeklong series of debates in Mexico City, it is hard to imagine
that he, as a young leftist art professor, would completely have missed news
of such a decisive event within Mexico's City's artistic culture. Tellingly, his
paired murals seem to offer competing views of muralism's possibilities, in
styles indebted to both sides of this debate, facing off across the reception
hall. As we have seen, on one side, in *El Plan Sexenal*, Bárcenas has embraced a
version of the dynamic language of constructivism that appeared regularly in
leftist photomontages, posters, and LEAR's journal, *Frente a Frente*. Such art
sought to mobilize for the transformation of society, supporting Cárdenas's
vision for Mexico's future. Across the hall, his style owes much to Rivera's
monumental realism of the 1920s, as he dedicated a mural to celebrating the
supposedly unalienated labor of indigenous *artesanías*. Prior to receiving the
mural commission, Bárcenas illustrated journals like *Mexican Life*, creating
a regular fare of romantic Indians and epitomizing the tourist art criticized
so heavily by Siqueiros's faction. Yet his mural's idealizing vision of artistic
production offers hope to all artists navigating the capitalist marketplace.
Understood in the context of these debates, it is notable that in Pátzcuaro he
balances between two variants of Mexican 1930s art, creating a Mexican *juste*

milieu (happy medium) for his first major state commission. Such an effort to find a middle ground seems to have been appreciated by officials and perhaps by Cárdenas himself. Bárcenas was rewarded with one of the most prestigious positions within the art world: the directorship of the ENAP.

Meanwhile, Bárcenas's translation of programs promoted in a wide variety of media and spaces—from prints and photographs to museums and expositions—into a pair of murals makes a case for the utility of muralism and provides insight into how the Cárdenas administration understood the role of the fine arts within its larger cultural policy. While arguably one of Cárdenas's major contributions (albeit short-lived) to cultural policy was the centralization of government communications under the DAPP, it is important to note that the SEP was the government agency largely responsible for the material transformation of Pátzcuaro, from its historic preservation projects and the new museum to the commissioning of new buildings, murals, and monuments. While in early 1937 some SEP responsibilities were in the process of being usurped by the DAPP (including the realms of film, photography, publishing, graphic arts, and concert and theatrical broadcasts), the creation of a mural celebrating *El Plan Sexenal* can be understood as a defensive move asserting that the SEP and the fine arts could (and should) continue to be responsible for shaping and promoting the nation's transformation. This expanded on the role that the Mexican muralists actively claimed for themselves starting in the 1920s: to make "ideological propaganda for the people" and to use their monumental art form to support those regimes that best served the interests of the revolution.[85] The larger Pátzcuaro project, with its abundance of murals and monuments, not only suggests that Cárdenas's government did still take the fine arts seriously but also represents a resurgence in the vacillating fortunes of the Mexican mural movement, marking the state's affirmation of mural painting as a useful technology of nation building.

Bárcenas's strategy was successful in the short run, as he took over the directorship of the ENAP soon after completing his Pátzcuaro works. Bárcenas forged ahead with reforms at the academy, working closely with the socialist student organization, the Sociedad de Alumnos. His proposals bear reading alongside his murals. On one hand, he proposed a system of cultural missions, which would provide a mechanism to train artists from the start to claim the benefactor role discussed above: students would spend ten months in rural Mexico, working to popularize art for campesinos. In addition to making visual studies of campesino life and the natural world, students would research and study popular arts, exhibit their work, and work

with local authorities to establish art classes.[86] On the other hand, Bárcenas proposed to prepare students for the market by opening a university gallery and introducing a graphic design curriculum (previously only taught at night, targeted to workers). Simultaneously, students learned to be useful to the state, as faculty and students alike entered competitions and won commissions to create monuments around the country. In 1938, however, in the wake of UNAM's reassertion of its political autonomy, the new rector dismissed Bárcenas (and a number of his colleagues) and replaced him with Manuel Rodríguez Lozano. A proponent of the *arte puro* movement, Lozano advocated for the autonomy of the arts and canceled many of these reforms. Alberto Beltrán, a student who left the ENAP and followed Bárcenas to his new school, the Escuela Libre de Arte y Publicidad, explained that Bárcenas's orientation had been criticized for being too commercial.[87] Thus the murals and Bárcenas's vision for Mexico's up-and-coming artists addressed key questions faced by the period's artists during the 1930s institutionalization of the arts and education sectors: In what terms should artists and intellectuals be useful to the nation? Should artists rely on the state? Should state-supported artists and intellectuals be free to pursue their own agendas? How would artists fare within the marketplace? In 1938 at the ENAP, which operated under the UNAM, *arte puro* artists demanded and received state-supported autonomy.

Thus while the Cárdenas administration appreciated Bárcenas's bid for artistic relevance, by 1938 the ties that had brought Mexico's varied artistic factions together with the state were once again beginning to fray. Nonetheless, Bárcenas's mural remains a testament to the possibility, which was still alive in 1937, of a vision that could unite Mexico's polemical artistic voices in a projection of state policy. The premise of this vision—that the Mexican state might reconcile the contradictions and oppositions that threatened to divide the country—was extremely useful to the state and its ruling party and became the centerpiece of national ideology, long after the artistic coalitions of the mid-1930s dissolved. This utopian vision of a Mexico bringing together the traditional and the modern, the regional and the national, and the Indian under the care of the benevolent state was centered in Pátzcuaro.

Creating Historical Pátzcuaro

Whttps... hen guidebooks promised that to visit Michoacán was to visit Mexico, they noted that Michoacán's land embodied the range of Mexico climates and asserted that all periods of Mexican history could be explored while visiting the region. No mere "regional center," Pátzcuaro was constituted as a microcosm of the nation and its history in the 1930s; better yet, it offered an alternative national narrative, purged of discomforts. This chapter traces two strategies that artists and intellectuals used to frame the region's past as national history. First, scholars, intellectuals, artists, and politicians appropriated national myths, narratives, and traditions of hagiography to cast Pátzcuaro's history in national terms. At the same time, they deployed the humanist tradition of using history as a lens through which to frame contemporary issues, providing historical precedents to support the Cardenista agenda. Thus they established Pátzcuaro as the source of an idealized national image and embedded the foundations of modern Mexico in its historical recreation.

Historians and theorists of nationalism have long argued for the past's importance in constituting the modern nation. As nineteenth-century historian Ernest Renan argued:

A nation is a soul, a spiritual principle. Two things, which in truth are but one, constitute this soul or spiritual principle. One lies in the past, one in

the present. One is the possession in common of a rich legacy of memories; the other is present-day consent, the desire to live together, the will to perpetuate the value of the heritage that one has received in an undivided form.[1]

Although scholars have refined the discussion of the contingent and even imagined nature of national and civic identities, the dual roles of memory and history remain at the core of this construction.[2] Pierre Nora discusses the "memory nation" as a phase of nationhood in which memory and history act in a reciprocal manner, symbiotically constituting the nation—an apt description of Cardenista Mexico.[3] Consent and "desire to live together" remained in question in 1930s Mexico, and Cárdenas's administration worked to create and enhance both state institutions and national ideologies that could help manufacture such consent. While the Secretaría de Educación Pública (SEP), its appointed officials, and its teachers and muralists were at the forefront of efforts to shape a shared national history during the preceding decade, Cárdenas mobilized a much larger infrastructure to enable this work. The emergent postrevolutionary state's need to create a mythic imagined nation opened doors for historians, anthropologists, artists, intellectuals, and politicians publicly to remember Mexico's past. Their success in creating Mexico via history is registered in Jean Meyer's assertion that "when we say 'national identity' we are also saying 'history.'" His cautions against a state that depends on national myths instead of social contracts to create the present day consent that Renan evoked speak to the stakes of creating historical Pátzcuaro.[4]

Fueled by Cárdenas's personal interests, the process of remembering historical Pátzcuaro presented opportunities for many. Local leaders, historians, artists, anthropologists, intellectuals, and entrepreneurs appropriated local memories and rendered them consumable as images, structures, and texts. Nora has described this transformation and representation of memory as a process in which rational, critical, disciplined history has come to colonize the realm of spiritual, authentic, and affective memory.[5] While these characterizations of history and memory have their limits, it can be useful to understand Pátzcuaro's creation as including a disciplining process, in which various popular and academic fields (each applying its particular methodology) represent history to stake their claims to relevance within the modern nation. Such efforts resonated during this period in which disciplines were professionalized and institutionalized. Guillermo Palacios frames the founding of the Departamento de Asuntos Indígenas (1935), INAH (1939), and Escuela Nacional de Antropologia (1940–1942) as evidence of the state's

recognition of the usefulness of the competing social sciences, offering intellectuals stability and professional stature while incorporating them into the state structure. Likewise, the administration charged a series of new or revitalized institutes at UNAM (including the IIE, discussed in chapter 2) with solving national problems from all regions of the country—a charge that challenged the liberal arts to reflect on and articulate their social utility.[6] Thus as we go forward in this chapter we should not be surprised to find the names of key members of these institutes and departments, all active in Pátzcuaro: Antonio Caso, Jesús Romero Flores, Silvio Zavala, Edmundo O'Gorman, Manuel Toussaint, and Justino Fernández.

Meanwhile, for artists within the nineteenth-century academy, historical subjects had been the currency of professional legitimacy. While Vasconcelos and the SEP hired muralists in the 1920s to paint public murals as history books for the masses, however, it was not until the 1930s that sculptors like Guillermo Ruiz consistently made their cases for the value of public historical monuments in the postrevolutionary context. In turn, Ruiz's school, the Escuela Libre de Escultura y Talla Directa, received state support and expanded to include a foundry for public monuments during this decade and in 1942 became the major alternative to the academy: the Escuela de Artes Plásticas (later Escuela de Pintura y Escultura), called La Esmeralda In short, the creation of historical Pátzcuaro went hand in hand with the reorganization and creation of academic Mexico and its institutional structures, revealing a professionalization process that was another hallmark of Mexico's modernization.

This process was not without repercussions for the kind of history told in and about Pátzcuaro. First, given that the terms of the "usefulness" debate revolved around history's relevance to nation building, Pátzcuaro's past was often remembered and forgotten according to how closely local history conformed to national models and ideologies. While the larger project celebrated Pátzcuaro's distinctive contributions to the nation and even framed Pátzcuaro's history as an idealized alternative to national history, it was simultaneously beholden to the national narrative and its blind spots—including race (introduced in chapter 2). Second, in creating a new contract with the state for institutional support, artists and intellectuals potentially sacrificed their autonomy, prompting great debate about the extent to which historians and artists can play an autonomous critical role in modern Mexico.[7] As history struggled to remain relevant during the 1930s rise of anthropology, Palacios suggests the state "kidnapped history" and transformed it into "official history," which he describes as "a narrative used to solve the problems

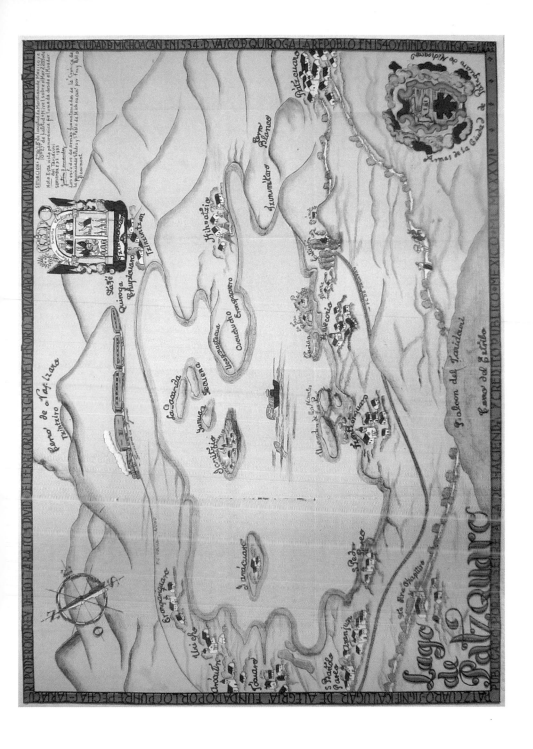

Plate 1. Justino Fernández, Map of Lake Pátzcuaro. From *Pátzcuaro* (Mexico City, 1936). Photograph courtesy of Catherine Ettinger.

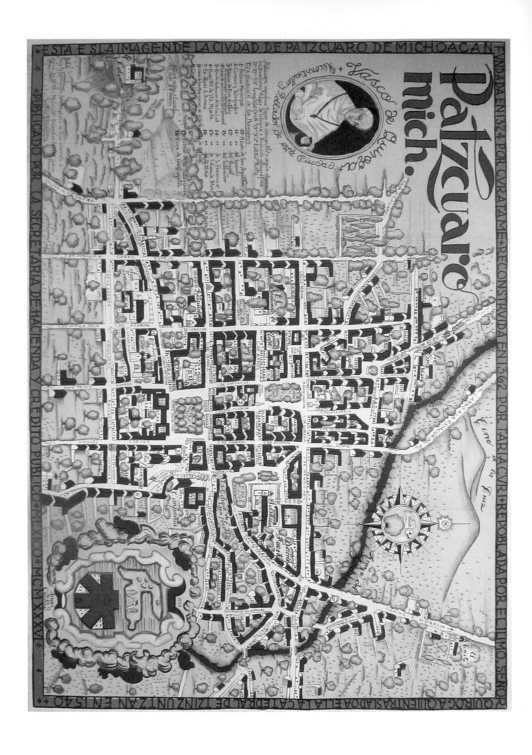

Plate 2. Justino Fernández, Map of Pátzcuaro. From *Pátzcuaro* (Mexico City, 1936). Photograph courtesy of Catherine Ettinger.

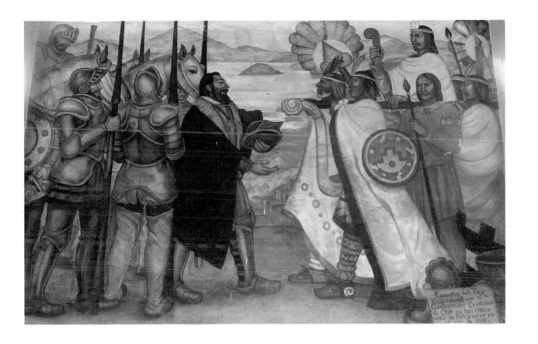

Plate 3. Roberto Cueva del Río, *Encuentro del Rey Tanganxuan II y el conquistador Cristóbal de Olid en las cercanías de Pátzcuaro en el año de 1522* (Encounter of King Tanganxuan II and Conquistador Cristóbal de Olid in the Environs of Pátzcuaro in 1522), Teatro Emperador Caltzontzin, Pátzcuaro, 1937. © Roberto Cueva del Río. Courtesy of Ana María de la Cueva. Photograph by author.

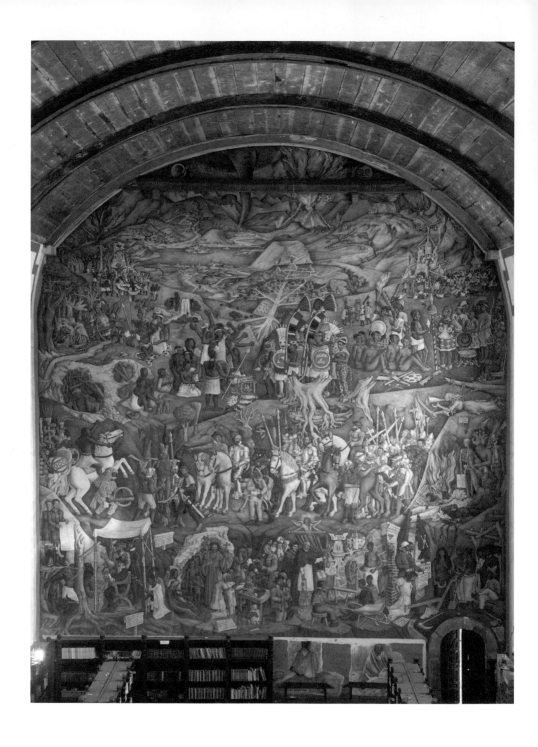

Plate 4. Juan O'Gorman, *La historia de Michoacán* (The History of Michoacán), Biblioteca Pública Gertrudis Bocanegra, Pátzcuaro, 1941–1942. Photograph by author. © 2017 Estate of Juan O'Gorman/Artists Rights Society (ARS), New York.

Plate 5. Ricardo Bárcenas, *El Plan Sexenal* (The Six-Year Plan), Teatro Emperador Caltzontzin, Pátzcuaro, 1937. Photograph by author.

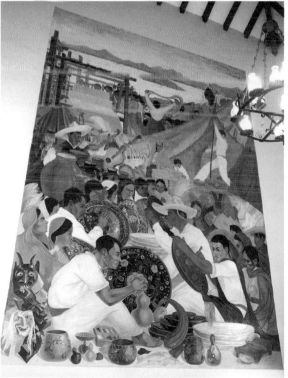

Plate 6. Ricardo Bárcenas, *Industrias de Michoacán* (Michoacán Industries), Teatro Emperador Caltzontzin, Pátzcuaro, fresco, 1937. Photograph by author.

Plate 7. Guillermo Ruiz and Carlos Cruz Reyes, *Monumento a Gertrudis Bocanegra* (Monument to Gertrudis Bocanegra), Plaza Chica, Pátzcuaro, 1937–1938. Photograph by author.

Plate 8. Guillermo Ruiz, with Francisco Zúñiga and assistants, *Monumento a Tanganxuan* (Monument to Tanganxuan), Pátzcuaro, 1937–1938. Photograph by author.

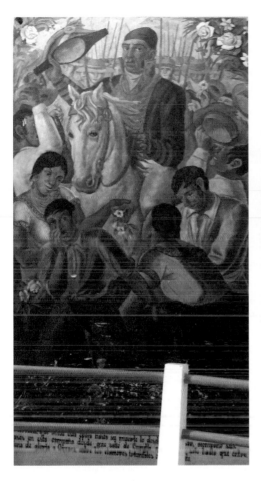
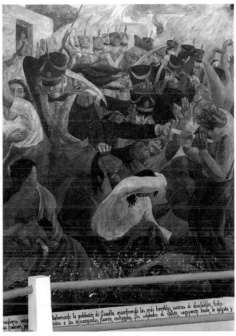

Plates 9a and 9b. Ramón Alva de la Canal, *La Vida de Morelos* (Life of Morelos),
Monumento a Morelos (Monument to Morelos), Janitzio, 1938–1940. Photographs by
author. © 2017 Artists Rights Society (ARS), New York/SOMAAP, Mexico City.

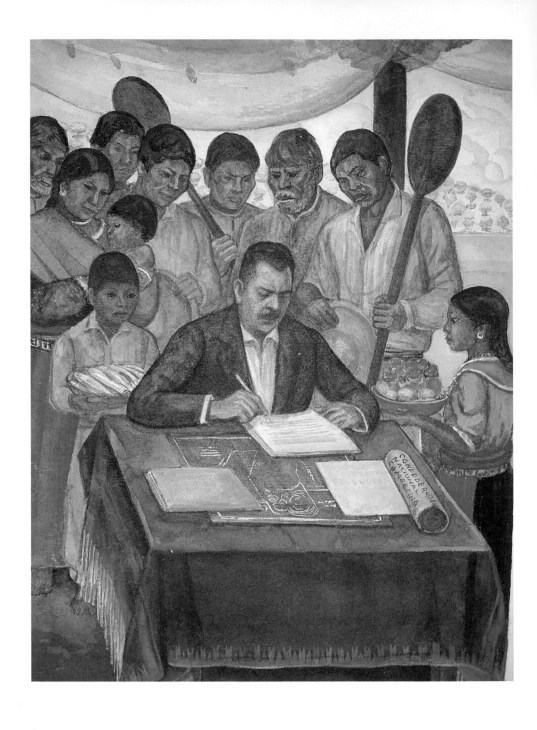

Plate 10. Roberto Cueva del Río, *Lázaro Cárdenas*, watercolor, 1937. © Roberto Cueva del Río. Courtesy of Ana María de la Cueva.

of its legitimacy."[8] Similar charges have been leveled against state-supported artists, most famously by Octavio Paz, who fundamentally questioned how muralists claiming to be revolutionary could simultaneously serve as official state artists.[9] Carlos Monsiváis suggests that monuments reign supreme as vehicles for legitimating authority, testifying to a process that "transforms historical content into governmental action," a charge that leaves him questioning whether an autonomous reading of public monuments is even possible.[10]

This chapter explores how Cárdenas worked with artists and intellectuals to transform memory into official history and back again, in order to constitute Pátzcuaro as an ideal center for Mexico. Such public remembering (and forgetting) was revealing on many levels. First, I note continuity with the nineteenth-century liberal nation-building project, even as the style and scale of representing and writing history change in this period. Such changes mark the recognition of history's relevance as a public phenomenon in the age of mass politics and demonstrate the wide range of tools—from traditional texts to public ceremonies and tourism rituals—that were used to make history memorable. Second, while Cárdenas clearly had a heavy hand in determining monuments built in the region—even after the end of his presidential term—I want to draw attention to competing historical narratives and the ways in which communities helped shape their public histories and thus their identities. Finally, I use the term "appropriation" in describing the process of creating historical Pátzcuaro in order to highlight the ways in which history and memory are used and activated by historical subjects (historians, artists, politicians, and others) in order to empower particular agendas. As such, the process reveals something of history's stakes, both as academic and artistic practice and more broadly within the modern nation.

HISTORY AND SOCIAL SPACE

For the past to be rendered socially useful, history (the institutionalized representation of memory) needed to be made visible in public spaces—the city's schools, museums, libraries, and streets—and integrated into the community's everyday life. In this context Pátzcuaro's 1930s monuments—its new public sculptures and murals, its newly edited built environment—take on special importance. As Françoise Choay has argued, the affective qualities of monuments are particularly important for materializing localized pasts in our present lives: "It is not simply a question of informing, of calling to mind a neutral bit of information, but rather a stirring up, through emotions, a living memory."[11] These aesthetic materializations of the past—or

what Nora might call sites of memory—became bound to the community through a series of rituals as well as by a larger historicizing apparatus (lectures, history books, school assignments, guidebooks) largely controlled by state institutions. Arguably their power is located in their ability to function simultaneously in the realms of memory and history, the individual and collective, the affective and rational.

Focusing on the visualization of history in Pátzcuaro's public spaces draws attention to history's social and spatial dimensions. Magali Carrera describes the "historical-geographic system" activated by state mapmaking and monument-building projects that made history visible in select locales during the mid-nineteenth century.[12] This system extended its reach in the twentieth century as federal and state agencies amplified monument building around the republic and promoted tourism. The emergent tourism industry provided the ritual impetus to travel to visit monuments and museums as well as offering mechanisms of circulation to integrate local histories with national histories. Sites, guidebooks, official plaques, and tour guides (some trained by the state) provided historical contextualization, while maps, postcards, and souvenirs helped materialize and preserve tourists' aesthetic and spatial experience. Such projects became crucial facets of nation building, as monuments not only make history visible in a particular place but also become a collective point of reference around which individuals shape their understandings of social relationships and their place in the world.[13]

Meanwhile, read critically, monuments can help orient us to the production, maintenance, and resistance of social and spatial hierarchies. Thus the production of monuments in Pátzcuaro and around the lake at times reinforced and at other times challenged the ways in which previous generations had been taught to conceive of the region. Given this intrinsic relationship among monuments, power, and visibility—in other words, given that monuments are visible manifestations of someone's authority—they also become the flashpoints for conflict and debate. Thus we might expand Nestor García Canclini's charge that we consider how monuments orient us in space and history, to also ask how they help orient us socially and politically.[14]

Pátzcuaro's History in the Streets

In 1911 the town of Pátzcuaro presented a history parade (figures 4.1 and 4.2) to coincide with the December celebrations honoring Nuestra Señora de la Salud. Eighteen years later the 1929 parade guide preserved in Cárdenas's

Figure 4.1. "Procesion histórica varones y damas ilustres de Pátzcuaro. Pátzcuaro, 8 de dic. de 1911" (Historical Procession: Illustrious Ladies and Gentlemen of Pátzcuaro, December 8, 1911). Colección Dr. Jesús García Tapia, Archivo Fotográfico, Instituto de Investigaciones Históricas, UMSNH.

library presents a different set of historical characters and testifies to how the public presentation of the past served various interests. Their changing contents reveal much about the collective remembering and forgetting of history. As ephemeral art forms, parades can respond to the changing times more effectively than do the monuments and murals discussed below. As such, these glimpses into the past—made possible by the fortuitous preservation of a booklet and a transcript of another as well as select photographs of the event from 1911 and 1922—reveal something of Pátzcuaro's historical self-presentation and provide insight into later choices to monumentalize publicly select figures in stone, bronze, and fresco.

A history parade converts history into spectacle, presenting its viewers with an affect-rich and ideologically loaded version of the past. Little is known about Pátzcuaro's early history parades, although their origin possibly owes something to Mexico's larger 1910 centenary celebrations, which included an elaborate series of parades, each dedicated to a different era of Mexican history: the conquest, the period of colonial domination, and independence. Planning for Mexico's independence celebrations began in 1907 and involved municipalities and districts all over the country; a number of Pátzcuaro's luminaries served on a district commission in charge of organiz-

ing local celebrations.[15] It is unclear whether Pátzcuaro's parades emerged from this national pageant, but the differences between its presentation of history and Mexico City's are revealing. Not surprisingly, Pátzcuaro used a similar structure to present history; however, unlike Mexico City's focus on central Mexico and the Aztecs, local organizers began with the Purépecha world and then presented colonial- and independence-era Pátzcuaro. Furthermore, while Mexico City's liberal organizers (who were working to neutralize the Catholic Church's power) made every effort to diminish religion's place in the spectacle of national history, Pátzcuaro's organizers by contrast celebrated religious history.[16] While hardly surprising, given the 1911 parade's connection to the annual December celebrations for Nuestra Señora de la Salud, this difference is key in understanding the stakes of Pátzcuaro's changing self-presentation.

According to a typewritten "Guía de la procesión histórica de Pátzcuaro" (Guide to Pátzcuaro's Historical Procession) in Toussaint's archive, the parade began with the indigenous ruler (*caltzontzin*) Tanganxuan II, his court, and the conquest period. The guide tells his story as the last Purépecha leader; describes his ill-fated diplomacy with the Spanish invaders, which ended in his torture and death; and reminds readers of the remaining lakeside monuments that testify to Purépecha culture and civilization. The next section celebrates the most "glorious" king of Spain, Carlos V, and his local contributions: sending Pátzcuaro its first bishop (Don Vasco de Quiroga), granting Pátzcuaro its status and coat of arms, and supporting the Hospital of Santa Marta and the Primitive Colegio de San Nicolás. The third contingent represented Quiroga and his committee, responsible for moving the seat of the Michoacán bishopric to Pátzcuaro from Tzintzuntzan in 1540, commissioning the cane-paste image of Nuestra Señora de la Salud, and founding the Royal Hospital of Santa Marta. Fourth came Pátzcuaro's government representatives from the viceroyalty and three priests, including the region's first indigenous priest, Don Pablo Siriani. Next came three locally significant popes: Paul III, for approving Pátzcuaro as the seat of the bishopric; Leo XIII, for crowning Nuestra Señora de la Salud in 1899; and Pius X, for dedicating La Colegiata as the Virgin's new home in 1907. The final section presented illustrious ladies and gentlemen of Pátzcuaro, many celebrated for contributions to the city's religious life: Don Antonio Huitziméngari (the brother of the final *caltzontzin*), the Spanish friar Don Francisco de Lerín, Doña María Manuela de Heyzaguirre, the abbess Doña Josefa Antonio Gallegos (La Beatita), pastor Don Eugenio Ponce de León, pastor Don Perdo Ahumada, former Afro-Cuban slave Don Feliciano Ramos (who

Figure 4.2. Vasco de Quiroga, from Pátzcuaro's History Parade, 1911. Colección Dr. Jesús García Tapia, Archivo Fotográfico, Instituto de Investigaciones Históricas, UMSNH.

founded the Santuario de Guadalupe), and priest and poet Don Manuel de la Torre Lloreda. In addition, the businessman, *hacendado*, and captain Don Pedro Antonio de Ibarra and the martyr to the cause of Mexican independence, Doña Gertrudis Bocanegra Mendoza de Lazo y de la Vega, were recognized. While the parade began with an overt parallel to Mexico City's parade, clearly the priority revolved around publicly remembering and honoring Pátzcuaro's religious history and its patrons.

Parade photographs set in the Sagrario churchyard present some of our "Illustrious Ladies and Gentlemen of Pátzcuaro" and document that in fact children dressed and performed in these roles (figures 4.1–4.2). The tiny abbess Doña Josefa Antonio Gallegos (La Beatita), Doña María Manuela de Heyzaguirre, and Gertrudis Bocanegra stand out as the three ladies present. Many of the ecclesiastical male figures blur together with historical distance; however, some are identifiable. Ramos, the former slave, is shown holding the plan for his church, La Guadalupe; he carries a cane and wears short pants, a bandana, and a top hat that mark him as Afro-Mexican.[17] A sixteenth-century gentleman (a dark-skinned child) holds a plume and document, perhaps representing King Carlos V and the city's charter. And a bearded clergyman

with a tabernacle, who was additionally singled out for a solo studio portrait, likely represented Vasco de Quiroga. Notably, two members of his retinue, girls in decorative skirts carrying *bateas* filled with fruits and Quiroga's standard, pose for a studio portrait and remind us that Quiroga was remembered in relationship to the indigenous communities that he served and vice versa. Posed for posterity, the children perform characters fittingly, from cocky self-assurance (King Carlos) and divine inspiration (Quiroga) to the Beatita's humility and the ladies' elegance and modesty.

We can recognize the names of Pátzcuaro's streets (Quiroga, Ponce de León, Ahumada, Ibarra, Ramos, Lloreda, and Lerín—added in the 1930s), plazas (Gertrudis Bocanegra and Vasco de Quiroga by 1965), and monuments (the Teatro Emperador Caltzontzin, *Monumento a Tanganxuan*, Biblioteca Pública Gertrudis Bocanegra, Casa Huitziméngari on the main plaza, and the Josefina Convent). Yet, while some of these figures remained visible in Pátzcuaro, others began to disappear. Not surprisingly, the Spanish king and the popes were not included in the 1929 parade—staged in the wake of the Cristeros Rebellion (1926–1929)—even as religion remained central to the event. And the 1929 published parade guide preserved by Cárdenas reveals the arrival of new priorities for remembering local history.[18]

Most notable is the range of newly recovered indigenous figures included in 1929. The first group was dedicated to the Purépecha god Curicaveri and his priests. Perhaps assuming that Curicaveri would be new to readers, the guide quotes an eighteenth-century author, Friar Matías Escobar, who compares Curicaveri to the Aztec Huitzilipochtli and Roman Jupiter and describes his worship, mountaintop shrine, and sacrificial regime.[19] The second group is dedicated to the Princess Eréndira, along with her father, Timas, and the Purépecha general Nanuma. The legendary (if modern) Purépecha heroine is celebrated for her beauty, patriotism, and talent, which helped her lead the resistance against the Spanish conquest and famously elude capture by learning to ride a horse, before eventually being baptized a Christian. The third group celebrates the final Purépecha *caltzontzin* (Tanganxuan II), this time focusing on his baptism rather than his defeat and humiliation, and again quotes Escobar, who calls the *caltzontzin* the Constantine of his kingdom (strategically evoking the first Roman emperor to convert to Christianity). A 1922 photograph preserves a float presenting the baptism.[20] Next came a group representing the founders of Pátzcuaro's churches, a list that includes both familiar and new names—Quiroga, Friar Martín de la Coruña, Friar Francisco de Villafuerte, Bishop Marcos Ramírez del Prado, priest and doctor Juan Meléndez Carreño, Ponce de León, Ibarra, and Ramos—as well

as reference to anonymous Indians responsible for constructing chapels for which history did not record a specific founder.

The changes suggest that the history parade was an important vehicle for contemporary political and ideological concerns. We see that Catholicism remained central to local values—after all, the parade was part of a religious festival—even as the authority of the pope and Spanish Crown faded from public view in the postrevolutionary context. Yet the interest in promoting indigenous history and legend on par with European history suggested a newfound *indigenista* consciousness—albeit framed within a Catholic value system that celebrated the transition from human sacrifice to the baptism of individual leaders to the building of churches by the indigenous masses. And a figure supposedly drawn from local memory and legend is included—Eréndira, who resists before converting to Christianity. She will be granted a crucial ideological role in creating a distinctive local narrative of *mestizaje*. As we compare these ephemeral versions of local history with the 1930s public monuments, it is notable that, while Pátzcuaro's illustrious figures were taken from both parades' ensembles, religious history was overtly marginalized in the 1930s.

We don't know the parade's route through the city, but we can imagine it circling the plazas and traveling streets named for these illustrious figures, reminding participants and audiences that the names encountered daily—those words that organize and orient our spatial experience in Pátzcuaro—were connected to real people who had once walked these very streets themselves. Information on the parades is limited. It is unclear how regularly the parades occurred and how long they continued. We might guess that they were organized by a committee (like the festivities of 1910), were overseen at least in part by the municipality (whose name appears on the photography), and to some extent represented a view of local history curated by Pátzcuaro's political and religious elite. The audience grew to include tourists, as such festivities (including the annual releasing of large decorated silk *globos* [hot-air balloons] and the appearance of the giant farcical Mojigangas puppets) were recognized as tourist attractions. By 1932 even secular guidebooks recommended the December Nuestra Señora de la Salud festivities, along with the Noche de los Muertos (Night of the Dead) and Semana Santa (Holy Week).[21] The efforts to place local history on a par with European traditions suggest a foreign audience but would have been equally important to locals educated within a Eurocentric system. Ultimately the parades evolved as a homegrown phenomenon—locals were not only the primary audience but also the ones given the task of performing history. And experiencing

their spectacle became an important mechanism for converting history—long the domain of an educated elite—into a public phenomenon and ultimately into collective memory. The organizers published booklets to accompany the parades, and children were the main performers, which indicates self-consciousness regarding the events' social and educational value. And Manuel Toussaint had a copy of the 1911 version in his archive, suggesting just one way in which these popular projects helped inform later historical endeavors.[22] For these reasons, comparison with the local history presented by Pátzcuaro's federally supported public artworks of the 1930s provides important insight into the stakes of public history.

PURÉPECHA PÁTZCUARO

As changes to Pátzcuaro's history parade indicate, by 1929 local leaders were already working to integrate an indigenous, precolonial, and conquest-era regional history into local historical narratives. To this end, they focused their attentions on the people of the Purépecha Empire and their descendants (then called the "Tarascans")—asserting the local indigenous civilization's high status and rivalry with the Aztecs. Such ambitions had parallels in *indigenista* intellectual circles around Mexico, which sought to identify indigenous contributions to Mexico's larger cultural and racial *mestizaje*, and in limited federal efforts to promote such contributions. These most typically came in the form of state support for the archeological preservation of ancient ruins, the academic study of historical and contemporary indigenous communities, and the promotion of *artesanías*.[23] Notably, we find in this promotion of Purépecha history and culture a resurrection of Humboldt's assertion that the Purépechas were the most appealing of Mexico's indigenous cultures.[24] As such, they offered an alternative to the Aztecs—long an ambivalent, if central, touchstone within Mexico's national genealogy[25]—and became an essential ingredient in claiming Pátzcuaro's national relevance.

During the 1930s a variety of *indigenista* projects developed around Lake Pátzcuaro, as the SEP and new institutes founded under Cárdenas focused attention on pre-Hispanic Michoacán. The SEP's early cultural missions sponsored the collection, reconstruction, and promotion of regional *artesanías*, music, and folklore. In 1937 archeologist Alfonso Caso began excavating and reconstructing key Purépecha sites around Lake Pátzcuaro: the *yacatas* (massive rounded temple platforms) of the ceremonial center of the Purépecha Empire at Tzintzuntzan, and those at the nearby site of Ihuatzio. This project came under the auspices of the new Instituto Nacional de

Antropología e Historia (INAH) upon its founding in 1939. So did a number of other anthropological projects, including the Proyecto Tarasco, a linguistic study launched in 1939 under Mauricio Swadith, and George Foster's study of Purépecha communities, co-sponsored by the Smithsonian Institution.[26] Meanwhile, even as anthropologists and archaeologists increasingly led efforts to study the indigenous past and present, historians and art historians added their expertise: the National Museum posthumously published Nicolás León's *Los indios tarascos del Lago de Pátzcuaro* in 1934 and Manuel Toussaint published a book and article on the *Relación de Michoacán* in the inaugural issue of the IIE's journal, *Anales.*[27] Building on the momentum surrounding excavations of ancient art from western Mexico—and the interest that Mexican intellectuals like Diego Rivera had in collecting it—the INAH began planning for an exhibition of Rivera's so-called Tarascan art, which opened to critical acclaim at the Palacio Nacional de Bellas Artes in 1946.[28] This erroneous lumping together of all ancient western Mexican art under the "Tarascan" label speaks to Pátzcuaro's privileged position in the period's national imaginary.

While these projects were associated with communities around the lake, the rise of tourism and local *indigenismo* drove efforts to uncover the city's indigenous roots, even if a living presence of Indians in Pátzcuaro remained largely limited to the *tianguis.*[29] Historians and guidebooks remind us that Pátzcuaro's name originated from the Purépecha "Petátzecua" (place of the stones) and that the colonial town grew up on the foundations of a sacred site with a temple dedicated to Curicaveri, an axis mundi marked by four stones and an entrance to the heavens.[30] We are also told that the site was the "place of happiness," a retreat or recreational site for indigenous royalty— effectively granting modern tourists the privilege of continuing in an ancient noble tradition.[31] Architectural histories and guides reconstituted the historical significance of the Casa Huitziméngari, on the main plaza, in which the region's first indigenous governor, Don Antonio, and descendants of the Purépecha nobility lived (albeit in a sixteenth-century version of the extant eighteenth-century house). Cárdenas's major cultural project, the new public theater, paid homage to indigenous history with its name, the Emperador Caltzontzin, and murals. And Juan O'Gorman's 1941–1942 mural in the new library (discussed further below) began its regional narrative with an indigenous creation myth and history (plate 4).

Yet the most extensive public representations of indigenous history and culture were again on the outskirts of town, toward the lake. This was perhaps not surprising, given the region's spatial politics, which since colonial

times had oriented regional power and authority around the Europeanized town center. Such spatial patterns mapped ideology: as noted, period geographic essentialism naturalized indigenous marginalization by racially associating *los naturales* (the Indians) with the lake. While major excavations were under way at Tzintzuntzan and Ihuatzio, effectively focusing scholarly and touristic attention on the lakeshores, only later did excavation begin within the city of Pátzcuaro itself. At the same time, the sites chosen for new works—Cárdenas's new estate, the traffic circle on the new main highway into town, the Tariácuri *mirador* (discussed in chapter 1), and a faux-Purépecha *mirador* at San Jerónimo—were available specifically because of Cárdenas's regional development project.

La Quinta Eréndira

Cárdenas's house at La Quinta Eréndira (figure 4.3) sits on a low hill at the head of the Avenida de las Américas, a boulevard that visually links the estate with the island of Janitzio. Cárdenas began constructing his estate in 1928

Figure 4.3. La Quinta Eréndira, Pátzcuaro, 1928–1929, 1935–1938. Photograph by author.

while he was Michoacán's governor; it was the home to which he first brought his new wife, Amalia Solórzano, in 1932. As Ana Cristina Ramírez Barreto has pointed out, the legendary Purépecha princess Eréndira became wildly popular under Cárdenas, in part thanks to his own embrace of the heroine.[32] Historical photos and advertisements show that clothing stores and regional specialty shops claimed the name, integrating it into daily regional life.[33] At his Pátzcuaro estate Cárdenas commissioned murals dedicated to Purépecha history in 1930 and again in 1938. When the exterior was remodeled to enhance its colonial aesthetics in 1935, Guillermo Ruiz and his local assistant Juan Tirado Valle added a fountain with an indigenous mother and child and a relief featuring the heroine on horseback, while garden benches with neo-indigenous symbols (temples, geometric patterns, and sun and moon imagery) were constructed nearby.[34] While the estate was technically private, Cárdenas opened it for local celebrations, for diplomatic activity and guests, and even as a public school and library while he resided in Mexico City. His personal embrace of indigenous symbols and history lent symbolic weight to his public campaigns to elevate the status of Mexico's indigenous peoples.[35]

The original murals in the estate's library demonstrate how the region's indigenous past was transformed into national history, a process aided by engagement with the eighteenth-century text of Fray Pablo de Beaumont and the nineteenth-century writings of Eduardo Ruiz, both of whom used history to make contemporary political claims. Jesús Ernesto López Argüelles has reconstructed the history of these lost murals, now known primarily through a series of original studies and reproductions made in 1938. In 1930 Cárdenas hired Fermín Revueltas to execute a series of historically themed murals for the Biblioteca Eréndira.[36] It appears they were destroyed when the library was remodeled in 1938, at which point Roberto Cueva del Río made copies on a panel for Cárdenas in addition to painting new murals (discussed in chapter 5).[37] The original murals treat the rise and fall of the Purépecha Empire and frame local history as national history—a strategy that López Argüelles notes was common in art promoted by Cárdenas.[38] Specifically, the murals, like the texts they reference, appropriate national historical narratives in order to supplant the national myths and locate Mexico's ideal foundations in Michoacán.

The first scene demonstrates clear engagement with the work of Michoacán author Eduardo Ruiz (1839–1902), who was a liberal politician and prolific novelist, poet, historian, and journalist credited with linking the past and the present, bringing a nationalist lens to his writing, and celebrating the historical role of the individual. A well-worn copy of his *Michoacán: Paisajes,*

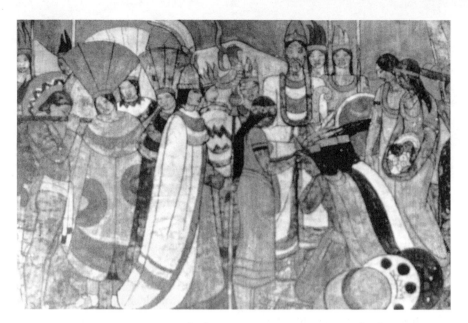

Figure 4.4. Fermín Revueltas, *El valiente y generoso Rey Tariácuri . . . dividió su territorio* (The Valiant and Generous King Tariácuri. . . Divided His Kingdom). Original from La Quinta Eréndira Library, 1930. Archivo Histórico Municipal de Pátzcuaro.

tradiciones y leyendas (1891) remains in Cárdenas's library, with the spine broken at the story of Eréndira. In this two-volume tome Ruiz adopts a "legendary" voice, self-consciously complementing information drawn from well-respected regional histories with local stories, legends, and the traditions from his childhood as well as his own literary inventions—regional collective memory, rather than what he refers to as "true history."[39] Drawing on Ruiz's account, Revueltas represents the origins of the Purépecha Empire, as King Tariácuri divides his lands into three kingdoms, each represented by a feather: green for Tzintzuntzan, white for Pátzcuaro, and red for Coyuca. As Ruiz asserts, these feathers would later be reunited in the liberated Mexican nation (figure 4.4).[40] This account has been popularly invoked in regional histories and guidebooks to represent Michoacán as Mexico or, more literally, as the source of the Mexican flag and has been translated into a range of media.[41]

In other scenes, Revueltas promoted the region as a site of *mestizaje*, the national ideology that claimed that the foundations of Mexico came from the combination of indigenous and Spanish blood and culture—a myth that erased descendants of Africans in Mexico, who by the eighteenth century accounted for a significant portion of Pátzcuaro's population (see chap-

ter 2). Revueltas invoked this privileged racial mixing by depicting the meeting of the conquistador Cristóbal de Olid and King Tanganxuan II, a scene that Rafael Heliodoro tells us was inspired by Fray Pablo de Beaumont's eighteenth-century images and text, *La crónica de Michoacán*.[42] While the sixteenth-century *Relación de Michoacán* leaves open the question of whether (much less where and on what terms) such an encounter ever happened, the scene has been reinvented over the years in various configurations and locales, arguably inspired by representations using the meeting of Hernán Cortés and Moctezuma II to allegorize the encounter between European and indigenous cultures.

Revueltas's reimagined scene additionally evokes precedents found in works like an anonymous later seventeenth-century *Meeting of Cortés and Moctezuma*, showing both men on foot (today at the Library of Congress) or Juan Corea's eighteenth-century folding screen with Moctezuma in a litter and Cortés on horseback. In La Quinta Eréndira, a retinue carries King Tanganxuan on a litter as he greets the conquistador Cristóbal de Olid, shown on foot and with head bowed, accompanied by his soldiers. Notably, Revueltas presents this scene as a moment of Spanish supplication (and his drawing was still more extreme, with Olid kneeling) rather than one of indigenous humiliation. In the nineteenth century, by contrast, Eduardo Ruiz claimed that the *caltzontzin* was forced to kneel before the Spaniard.[43]

Additionally, while the eighteenth-century *Crónica* strategically located this encounter (with both men on foot) in the environs of Valladolid (the ecclesiastic seat of power, now Morelia), Revueltas sets the 1523 scene in an indigenous power center marked by temples, likely Tzintzuntzan, on the shores of Lake Pátzcuaro. Notably, in his 1937 Teatro Emperador Caltzontzin murals, Cueva del Río relocated the scene yet again, to the "environs of Pátzcuaro" or specifically to the Mirador Tariácuri (see chapter 1: plate 3) and Ruiz's monument of 1937–1938 (figure 4.5) set the scene at Pátzcuaro's Capilla de Cristo or Humilladero. The repeated appropriation and relocation of this scene of a possibly invented encounter speaks to the powerful resonance it held as a symbol of *mestizaje*, both nationally and locally, and to the ideological importance of geography and history.[44]

Further appropriating and rewriting the national narrative of *mestizaje*, Revueltas represents the story of Eréndira, whom Ana Cristina Ramírez Barreto refers to as Mexico's first anticolonial heroine and an untainted foil for the infamous La Malinche (figure 4.6).[45] National narratives focus on La Malinche, an indigenous woman who translated for and bore a child to Hernán Cortés, who in the 1930s was still remembered as a traitor and sexu-

Figure 4.5. Francisco Zúñiga, *Monumento a Tanganxuan* (Monument to Tanganxuan), rear relief [Meeting of King Tanganxuan II and conquistador Cristóbal de Olid], bronze, Pátzcuaro, 1937–1938.

Figure 4.6. Fermín Revueltas, *Eréndira*, Library of La Quinta Eréndira, 1930 (original). Archivo Histórico Municipal de Pátzcuaro.

ally tainted mother (*la chingada*) of Mexico's *mestizaje*. In contrast to the historical La Malinche (christened Doña María), however, Eréndira was a legendary Purépecha princess (likely invented by Eduardo Ruiz, according to Ramírez Barreto), who learned to ride a horse to escape from the Spaniards, led her people to resist the conquest, and ultimately spiritually (chastely) fell in love with a Spanish monk and was baptized a Christian. In this way the story of Eréndira gave a name and story to an ideal represented by Michoacán artist Félix Parra, in his academic history painting *Fray Bartolomé de las Casas* (1875), where an anonymous indigenous woman's chaste embrace of the priest embodies an asexual reconciliation of Spanish and indigenous cultures.[46] Again, Michoacán's history embodies a core element of Mexico's nation-building ideology: *mestizaje*; but this time Eréndira is able to provide a pure (unconquered and virginal) possibility within *mestizaje*. Thus it appears that in commissioning such murals, Cárdenas sought to position Purépecha history—Michoacán's history—as an alternative to national narratives focused on the Aztecs. Quite simply, the Purépecha past is presented as the ideal origin of the Mexican nation.

Monumento a Tanganxuan

Cárdenas's promotion of a Purépecha foundation for Mexico was given public form in 1937, when he commissioned Guillermo Ruiz to create a bronze *Monumento a Tanganxuan* (plate 8, figures 4.5, 4.7–4.9), the name given two Purépecha *caltzoni* (the plural of *caltzontzin*) at the new traffic circle uniting the two routes into the city.[47] Such a monument to indigenous emperors clearly pays homage to Francisco M. Jiménez and Miguel Noreña's *Monumento a Cuauhtémoc* (which also commemorates Cuauhtémoc's predecessor Cuitlahauc) in a Mexico City traffic circle, dedicated to leaders who resisted the Spanish conquest of Tenochtitlan. Ruiz modernizes the monumental form, however, simplifying its ornamentation and structure. At the circle's center stands a low and wide temple-like platform, with talud-like, sloped corners, five long steps along each side, and a tripod brazier in each corner. An art-deco pedestal decorated with saguaro cacti and bronze reliefs supports a monumental sculpture of Tanganxuan, cast as an anti-imperialist hero. While both monuments share the purpose of establishing publicly the high status (an empire) achieved by preconquest cultures and celebrating anticolonial resistance, the conflation of the national and local was problematic.[48]

The reliefs represent episodes from the lives of both Tanganxuans, adapted from the mural scenes in Cárdenas's estate, and the Purépecha lin-

eage that unites the two. The replication of earlier murals reveals the sedimentation of a local historical iconography. Two reliefs are the work of Francisco Zúñiga (who together with Juan Cruz Reyes and others assisted Ruiz), who had a growing state-supported studio through the Escuela Libre de Escultura y Talla Directa. The largest relief faces the highway arriving from Tzintzuntzan, Quiroga, and Morelia, where we see the genealogical tree showing Tariácuri and the Purépecha lineage (figure 4.7): a naturalistic reinterpretation of a stylized drawing from the sixteenth-century *Relación de Michoacán*.[49] The remaining three reliefs are all in horizontal format and include text to orient the viewer to regional history and space. To the east, Tanganxuan I is shown as Tariácuri divided his kingdom into three portions, giving the feathers to his son and nephews, who kneel before the emperor and receive a blessing from a female figure (figure 4.8)—a representation that pays homage to Revueltas's mural at La Quinta Eréndira. While the feathers here are all bronze, the accompanying text explicitly names their colors to rehearse the national origin story. Both these reliefs are relatively shallow and patterned, creating a hazy effect, which in a *modernista* mode evokes an era long past.

By contrast, the two reliefs treating Tanganxuan II are classical in their well-defined and articulated forms, which stand out from *schiacciato* (extremely shallow relief) background details. To the south, Tanganxuan II (Caltzontzin), carried in a royal litter, encounters the conquistador Cristóbal de Olid, on foot looking up; each has his own retinue, including mounted Spaniards (figure 4.5). The compression of the figures makes it hard to identify Olid. It is tempting to assume he is elevated on horseback, but this leading figure among the Spaniards quotes Revueltas's and Beaumont's supplicating conquistador. The text below maps the encounter to the Humilladero (Chapel of Christ), locating the event within Pátzcuaro's touristic landscape, above town in the Barrio Fuerte. Local guidebooks claim that the early chapel's name referred to the humiliation of indigenous surrender, although Toussaint reminds us of Spanish public crucifixes, so named to honor the passion of Christ. In effect, this historically loaded geography effectively likens the Purépecha emperor to Christ.[50]

Furthering such hagiography on the west side, Ruiz depicts the eventual torture of Tanganxuan II, whose exposed, nearly nude body reflects his courage despite being pulled over a fire, demonstrating heroism and stoicism while suffering and again evoking Miguel Noriega's monument in Mexico City (figure 4.9). In effect, Tanganxuan II is represented and remembered as enacting two seminal historical narratives: he both performs the original

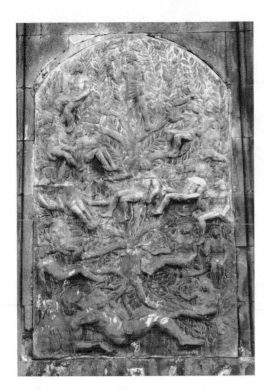

Figure 4.7. Francisco Zúñiga, *Monumento a Tanganxuan* (Monument to Tanganxuan), front relief [Lineage of the Tarascans], Pátzcuaro, 1937–1938. Centro Documentatión e Investigaciones Artísticas, Morelia.

diplomatic role typically granted to Moctezuma II in his early, still heroic, encounter with the Spanish conquistadors and is shown as the resistant and suffering leader, like Cuauhtémoc. Such a conflation conveniently forgets that Tanganxuan allied with Cortés against the Aztecs and that his execution under Nuño de Guzmán was arguably part of a larger power struggle between Guzmán and Cortés rather than the consequence of any consistent opposition to Spanish imperialism.[51]

This historical remembering of Tanganxuan recast arguably *redeemed* — as resistant leader is secured by the proud and ready Indian ruler who stands atop the pedestal. Gazing toward the lake, with his feet spread and hypermuscular chest bared, the ruler holds his sword at his side in one hand, while the other clenches in a fist. This heroic male nude represents a return to academic values that insisted that the (nearly) nude male body had the potential to represent not just physical perfection but moral and spiritual perfection as well. In embracing this element of the classic tradition, this work should be paired with the photograph discussed in chapter 1 entitled "An Adonis of the Lakes, Proud and Virile" by Luis Márquez, published in *National Geographic* (figure 1.6). Here Emilio "El Indio" Fernández, playing the lead male role in

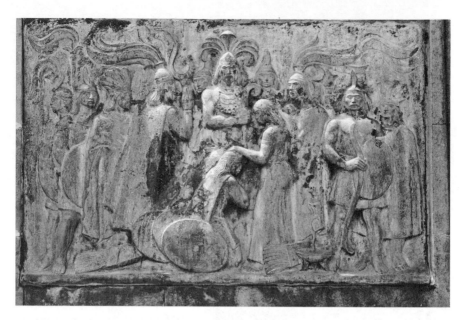

Figure 4.8. Guillermo Ruiz, *Monumento a Tanganxuan* (Monument to Tanganxuan), lateral relief [Tariácuri divides the kingdom], bronze, Pátzcuaro, 1937–1938. Courtesy Centro Documentatión e Investigaciones Artísticas, Morelia.

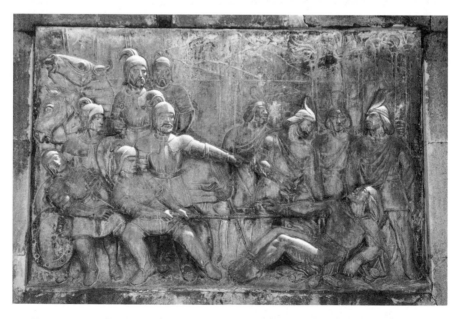

Figure 4.9. Guillermo Ruiz, *Monumento a Tanganxuan* (Monument to Tanganxuan), lateral relief [Torture of Tanganxuan II], bronze, Pátzcuaro, 1937–1938. Courtesy Centro Documentatión e Investigaciones Artísticas, Morelia.

the 1934 film *Janitzio*, strikes just such a pose on the prow of a canoe, paddles in hand. The film-still monumentalizes the mestizo actor as Zirahuén, who leads his fellow islanders in resisting the arrival of an urban capitalist who sought to exploit local fishermen. Both works posit the male, supposedly Purépecha body as embodying a new ideal for Mexico. In both, heroic stances are used to represent anticolonial resistance.

Of course, while both works share a monumentality, only one is a projection of the Mexican state, cast in bronze and erected in the environs of Pátzcuaro as a public monument. In this regard, as Agustín Arteaga has argued, Ruiz's Tanganxuan bears comparison with contemporary totalitarian works, like those of Josef Thorak in Germany. Thorak devised a modernist, stylized version of the classical tradition to give form to the ideals of his patron, Adolf Hitler, and the National Socialist regime. Likewise, Ruiz's work returns to classical principles while remaining resolutely modern; from the stylized folds of the loincloth and cape to the use of a physical prototype that rejects classical proportions, facial types, and references in favor of a stylized indigenous model, it is grounded in the Mexican modernists' search for a distinctly national mode of representation. Yet this return to the monumental male nude and its traditional public role — not to mention the return to working in bronze rather than the direct carving that made Ruiz's name as a modernist in Mexico — is significant and speaks to the political needs addressed by such monumental sculpture. As Arteaga points out, for both Ruiz and Thorak, the nationalist rhetoric of the body is highly racialized. In addition to evoking ideals of virility, it creates a model of strength, health, and discipline — a prototype of what the nation should produce: its "new man." Ultimately, he argues, "Ruiz looks to the past for prototypes of stoicism and heroism to justify the present and the destiny of the new regime."[52] Furthermore, its maleness — and the regular use of the male Purépecha body to represent Pátzcuaro in promotional materials, in sharp contrast to the traditional emphasis on female indigenous figures — cements the analogy of Tanganxuan, Pátzcuaro, the Cárdenas regime, and Mexico.

While such a monumental public sculpture speaks to shared expectations regarding both the potential of a race and gender to represent a nation and the role of art in the age of mass politics — from providing figures to emulate to projecting authority and legitimacy — it is well worth pursuing the comparison to evaluate its durability. In both countries such monumental projects disrupted the lives of ordinary — and often marginalized — citizens. As Paul Jaskot has described, Albert Speer used the reconstruction of Berlin as an opportunity to implement Hitler's anti-Semitic housing policy, dis-

placing and ghettoizing Jewish families.[53] Not entirely unlike Hitler's architect, Speer, architect Alberto Leduc was given instructions to evict the Orta family from their home as he developed the monument's traffic circle and its planned indigenous artisans' houses and workshops. Yet José Orta was comfortable in directly contacting Cárdenas to request that he hear this order from the president.[54] Equally notably, the newspaper *La Vida*, published in Pátzcuaro by Professor Hilario Reyes, a teacher and Cardenista, felt comfortable publicly criticizing the monument and the events surrounding its dedication on May 25, 1938.[55] This suggests that in Pátzcuaro, at least some citizens felt safe to criticize and hold their leader accountable for his cultural policy.

Reyes's published criticism not only suggests something about the state of local democracy but also demonstrates the limits of conflating local and national historical narratives and agendas. First, the account lays bare the disjuncture between the regime's ambitions and local desires. As was typical, the monument's inauguration was a political event; such unveiling rituals are tools for legitimization and provide a public opportunity to enact social relationships and activate monuments' varied meanings. *La Vida*'s critic notes that officials used the event to celebrate Mexico's recent expropriation of foreign oil companies and laments that an opportunity was lost to bring together regional indigenous residents, public officials, and townspeople, to pay homage to the history, music, and folklore of the Purépechas. While it is not surprising that the administration would use a local symbol of foreign and colonial resistance as an opportunity to celebrate Cárdenas's revolutionary nationalization of Mexico's oil fields, it is notable that a local observer found this ideological posturing troubling and said so publicly. The administration's narrative linking Purépecha history to national history, up to the present expropriation, was not accepted wholesale even by local Cardenistas.

Second, the essay complains about the choice to commemorate Tanganxuan II. The author describes Tanganxuan I as glorious and victorious in his conquering and uniting of Michoacán but asserts that Tanganxuan II hid away and capitulated to the Spanish. Rather, he proposes that Tariácuri should be honored. While the figure of Tanganxuan provided an opportune parallel to Moctezuma II and Cuauhtémoc for those who sought to project his memory on a national or even international stage, for others the conflation was at best confusing and at worst a misrepresentation of history.

Public rituals still today reactivate *Monumento a Tanganxuan*: every February 14 a self-appointed group of local teachers and women gather to honor the emperor.[56] The rituals performed at the site in April 1940, however, were part of an official effort to secure Cárdenas's international repu-

tation as a leading proponent of indigenous peoples. That month Cárdenas and Pátzcuaro hosted the Primer Congreso Interamericano de Indigenistas (First Inter-American Indigenista Congress), inviting government delegates from all over the Americas (see also chapter 3). On the final day, a ceremony was held at the *Monumento a Tanganxuan*, in which a copy of the conference agreements was buried at the monument, accompanied by tributes and a speech by the Argentinean ambassador. Two members of an (unspecified) indigenous group interred the documents in an urn at the monument's feet. Conference participants had been treated to a full touristic experience of Pátzcuaro: beyond meetings and lectures at the new public library, conference proceedings included multiple performances and a film at the Teatro Emperador Caltzontzin, tours and receptions at the new Museo de Artes e Industrias Populares, and a visit to Janitzio. And the memories and documents of their experience were then ritually bound together with *Monumento a Tanganxuan*.

Thus we see that the presentation of local indigenous history provided a key element in creating historical Pátzcuaro and in representing the region as foundational to Mexico. But the terms of this appropriation were largely designed to serve a narrow set of interests. The indigenous past not only was transformed into a format that would be memorable for tourists but also served a Cardenista agenda that sought to elevate this region as exemplary within Mexico. As Tanganxuan II was recast as a national hero, redeemed by Cárdenas's revolutionary agenda (from the local economic revitalization program to the oil expropriation to the Primer Congreso Interamericano de Indigenistas), however, the complexity of his story was forgotten.

COLONIAL PÁTZCUARO

We could describe the entire city of Pátzcuaro as a monument to the colonial period. As discussed in chapter 2, Cárdenas, Leduc, Toussaint, and city leaders worked to transform Pátzcuaro into just such a historical monument. Yet, when it came time to commemorate specific historical individuals in monumental form, none of the heroes selected represented the colonial period. In fact, while planners considered a public monument to city founder Don Vasco de Quiroga, it was not realized until 1965.[57] This can be interpreted in various ways. It perhaps reflected an effort to constitute Pátzcuaro as a site containing the broad sweep of Mexican history—a goal that required new monuments that complemented rather than reiterated the town's colonial core. At the same time, this choice mimics a larger trend

from the liberal, secularizing Porfiriato period, during which an 1877 decree governing monument building along Mexico City's grand Paseo de la Reforma advocated forgetting the dark colonial period and focusing on the pre-Hispanic and independence periods.[58] Furthermore, as we have seen, Pátzcuaro's colonial history and memory were politically fraught in the wake of the Cristeros Rebellion. Arguably this effort to reorient Pátzcuaro's collective memory was part of the secularizing agenda discussed in chapter 2 and was not a neutral decision.

Nevertheless, Pátzcuaro's new monuments of the 1930s did not completely neglect the colonial period. As discussed above, works commemorating indigenous history also addressed the conquest in order to frame Pátzcuaro as a font of *mestizaje*. Such stories set in the colonial period were encouraged, as they enabled Pátzcuaro's claim to embody Mexico's foundational nation-building mythologies. What is most remarkable, however, are the terms in which Don Vasco de Quiroga, the colonial era's most lauded figure, was remembered. To parallel both national and international prototypes, including Fray Bartolomé de las Casas and Sir Thomas More (canonized in 1935), historians, politicians, and intellectuals reworked Quiroga's memory to serve their respective agendas.

Don Vasco de la Quiroga

Quiroga, who studied secular and canonical law, came to New Spain in December 1530 to serve as a judge for the Second Audiencia (New Spain's five-person governing body from 1531 to 1535). It was charged with reforming the *encomienda* system and reviewing (and ultimately prosecuting) the First Audiencia (1528–1530) and its president, Nuño de Guzmán. Quiroga is celebrated for bringing harmony to Michoacán following the violence and destruction wrought during the conquest under Nuño de Guzmán as well as for his roles as a social visionary who created at least two of Michoacán's communal "village-hospitals," as the founder of Pátzcuaro, and as the first bishop of Michoacán (1538–1565). Central to his legacy is the idea that he loved, and was loved by, the Indians.[59]

Recent scholarship provides a welcome critique of Quiroga's legacy, noting that the mythology generated around his memory transcended ideological position. James Krippner argues that "Don Vasco's posthumous ability to straddle the ideological divides that frame understandings of the Mexican past has been his most significant legacy."[60] Krippner describes how Quiroga's memory has been strategically mobilized and contested over time.

While both anticlerical intellectuals and practicing Catholics lay claim to Quiroga, during the 1930s proper his person appeared only as a marginal figure in a public artwork: riding his mule in the upper right corner of Bárcenas's *Industrias de Michoacán* mural (plate 6; see chapter 3). While public monuments to Quiroga were proposed, no new public portraits were dedicated to this important figure.[61] It was not until the early 1940s that he began to receive artists' attentions: he was included in Juan O'Gorman's mural *La historia de Michoacán* (1941–1942) and in a portrait painted by Cueva del Río at La Quinta Eréndira (1943; see chapter 5); his remains were moved to a new tomb in the basilica; and Miguel Bernal Jiménez composed an opera to commemorate his legacy (1940–1941). Yet the skirting of his memory and the contest over the terms in which he would be remembered are testament both to his continued significance and to the perceived power of public memorials in shaping contemporary realities.

While Quiroga's portrait did not grace Pátzcuaro's central plazas, his name and memory remained ever present. Scholarly and popular accounts of Don Vasco tied his memory to sites in the city, and sightseeing and civic rituals activated them. The name "Vasco de Quiroga" graced a local school and a street along the main plaza, remaining part of everyday local life. The main plaza's new fish fountain was also associated with him.[62] The 1930s guidebooks inevitably mention that Quiroga founded the colonial city in 1540, when he relocated the Episcopal seat from Tzintzuntzan to Pátzcuaro. According to Bay Pisa, the author of *Los rincones históricos*, Quiroga brought with him 30,000 Indians and 28 Spanish families to reconstitute the city after its depopulation under Nuño de Guzmán.[63] Yet period guidebooks and histories worked to secularize the myths surrounding Quiroga. Bay Pisa, for example, qualifies the account of Quiroga's miraculous discovery of a spring at Pátzcuaro—typically used as divine legitimation of his political and logistical decision to relocate the regional capital—by noting that this was the story he heard as a child. Toussaint warns us not to be "lulled" by this lovely tale.[64] Likewise, Frances Toor notes that while the *Nuestra Señora de la Salud* (ca. 1538) was said to have miraculously emerged out of the lake's waters, in reality Quiroga commissioned an Indian to make the corn-paste statue.[65] Scholars pieced together the statue's commission and history.[66] Local memory was being appropriated and legitimated as secular history, even as guidebooks preserved the story's affective elements concerning Quiroga's role as a loving benefactor of Indians.[67]

Leading us through Pátzcuaro's streets and sights, guides explain that Quiroga founded the city's early institutions: the Hospital of Santa Marta

(1540), now El Sagrario; the Colegio de San Nicolás (1540; figure 3.10), the continent's longest-continuously-operating institution of higher education; the original cathedral, La Compañía de Jesús (1546; figure 2.21), built on the main Purépecha temple;[68] the Capilla de Cristo or Humilladero (1553), enclosing the region's oldest cross; and the basilica (1573–1580), intended as an ambitious new five-nave cathedral. The renovated Colegio de San Nicolás, reopened as the Museo de Artes e Industrias Populares (1936–1937), was arguably the closest Pátzcuaro came during this period to a monument to Don Vasco (chapters 2 and 3).[69] The new museum cemented that connection between Quiroga and *artesanías*. Guidebooks still perpetuate this idea — despite evidence that village-specific crafts reflected preconquest social and economic organization and are found elsewhere in Mexico.[70] Meanwhile, while Quiroga's original plan for the cathedral was never completed, its image still graces the shield of Pátzcuaro (plate 1, lower right corner) and remains bound to the city's identity. While numerous guidebooks discuss this history, Toussaint reminds us how controversial this project once was. In fact, Krippner-Martínez points out that the community of Tzintzuntzan successfully sued Quiroga over being excessively taxed and drafted into the cathedral's labor force, which pointedly challenges Indians' universal love of Quiroga.[71] Thus we note how histories and guidebooks charged with preserving and activating local memories strategically remember and forget.

Quiroga's legacy appeared throughout Michoacán. During the previous century travelers paid homage to Quiroga in various settings: a site in the sierra of Nahuachín is named Obispo Tirecua ("the place where the bishop ate"), and a longtime travel ritual near Paracho involves sticking one's right foot into a hole that preserved the celebrated bishop's footprint.[72] In 1852 the town of Cocupao on the shores of Lake Pátzcuaro changed its name to Quiroga in honor of Tata Vasco; a monument was dedicated to him there in 1950. Beyond the hospital-village of Santa Fe de Laguna, the lakeshore site most associated with Quiroga was the original seat of the bishopric, Tzintzuntzan. The Department of Monuments designated the San Francisco church and monastery there as a national monument in 1937, and architect José Gorbea Trueba oversaw its restoration for INAH.[73] Guidebooks noted Quiroga's introduction of olive trees to the region in addition to his religious work in the Purépecha capital.[74] Yet not all attempts to honor Quiroga were fulfilled. Historians credit him with introducing bananas to Mexico from Santo Domingo, but when Tomás Martínez Rubio wrote to Cárdenas, requesting that he endorse a plan for Ziracuaretiro's banana producers to honor Don Vasco with a statue at Mexico's first banana plantation, nothing apparently

came of that project at the time.[75] Rather, the memorialization of Quiroga in the 1930s focused on his legacy overseeing indigenous Mexico, not a Mexico tied to the greater Caribbean.

Meanwhile Quiroga's legacy on the national stage was determined by historians, who in 1937 tied his memory to the recently canonized Sir Thomas More (1935) and to President Cárdenas. They launched a debate about whether Quiroga's social experiment, the communal village-hospitals, should be viewed as a homegrown proto-Marxist social reform. The village-hospitals were Catholic indigenous communities organized around a hospital, orphanage, school for adults and children, music-making, and communal religious ritual. These communities of up to 30,000 people lived under the rules established by Quiroga's *Reglas y ordenanzas para el buen gobierno de los pueblos hospitales* (1532), which specified equal expectations of labor (six hours a day), regular shared schedules, dress and behavior codes, and support for the infirm and others in need.[76] In 1937 Silvio Zavala published his seminal essay *La "Utopía" de Tomás Moro en la Nueva España*, locating the origins of Quiroga's village-hospital system founded at Santa Fe de México in 1532 in Thomas More's *Utopia* (1516).[77] The essay's introduction by Genaro Estrada explicitly linked More and Quiroga to Cárdenas's revolutionary social programs—an assertion against which historians Edmundo O'Gorman and Justino Fernández vociferously protested. They argued that humanistic monastic "communism" was fundamentally different from contemporary socialist projects (considered heretical by the church) and questioned unsupported assertions like the idea that Quiroga funded the hospitals out of his own wages.[78] This link became popular, however, and appeared in various contexts. Reviewing Bárcenas's new frescos in *Hoy*, Salvador Ortiz Vidales credits Bárcenas with looking to the past to understand the present, criticizes Soviets who ignore the past, and claims that the "Marxist ideals of the hospitals anticipate communism," positing Quiroga, and thus Pátzcuaro, as the source of a distinctively Mexican proto-Marxism.[79]

The stakes in this debate within Mexico's left were not simply communism versus anticommunism or antichurch versus orthodox Catholic.[80] First, they related to history's purpose and autonomy at a moment when historians were re-creating their discipline and debating its institutionalization vis-à-vis the state.[81] While Zavala and Estrada worked in the humanistic tradition to use history to reflect present concerns, O'Gorman and Fernández effectively questioned whether history should be a vehicle for contemporary politics and carefully guarded their intellectual autonomy. Notably, all the historians in question (except Estrada, who passed away in 1937) came out of the

dispute with prominent positions, reflecting the compromise that characterized education reform during this period. O'Gorman received a position in the Department of Philosophy and Letters in 1938, and Fernández joined the Instituto de Investigaciones Estéticas in 1937. These two institutions were both part of the National Autonomous University of Mexico (UNAM), which reasserted its academic autonomy in 1938. By contrast, Zavala, with Cárdenas's support, was named the first director of the Center for Historical Research at the new Colegio de México in 1940, which was state-funded but external to the UNAM.

Further, coming soon after Cárdenas had insisted on Mexico's difference from Stalinist communism by granting Leon Trotsky asylum in Mexico, a second key debate asked how Mexico's left should imagine its relationship to variants of Marxism and raised the possibility of a distinctive Mexican socialism. In this context, historians and critics channeled Quiroga's historical legacy as a reformer into Cárdenas's larger social and political agenda. Once again, Pátzcuaro's past was reshaped to establish the city as the site of a Mexican origin story. With this revolutionary remembering of Quiroga and Pátzcuaro, we can perhaps even better understand why Diego Rivera brought the revolutionary leader of the Fourth International, Leon Trotsky, and leading surrealist André Breton on a Pátzcuaro retreat to pen their manifesto, "For a Free and Revolutionary Art" (1938). Pátzcuaro and its lake not only were home to an "authentic" indigenous culture (of particular appeal to surrealists) and an ideal region for Rivera and Breton to collect ancient "Tarascan" art but also were cast as a crucible of utopian social experimentation.

Don Vasco de Quiroga's image as a friend and loving benefactor of indigenous peoples was also projected into an international context at the 1940 Primer Congreso Interamericano de Indigenistas. In a telling conflation, the ceremonial burial of the conference proceedings at *Monumento a Tanganxuan* discussed above was part of a larger day honoring Quiroga's memory.[82] While Quiroga had prosecuted Nuño de Guzmán, Tanganxuan's executioner, and thus could by a bit of a stretch be considered the emperor's redeemer, privileging Quiroga's memory here suggests that conference organizers largely identified with Quiroga as an ideal benefactor for indigenous people, their handicrafts, and their history (as discussed in chapter 3). Prior to the ceremony, delegates gathered at the new popular art museum, where they enjoyed a presentation on Quiroga's legacy while indigenous delegates stood guard in front of Quiroga's ashes.[83] Don Vasco's name was ubiquitous throughout the congress: proceedings largely took place at the Posada Don Vasco, and references to the Terraza Don Vasco and Sala Don Vasco dot the program. This new hotel

and conference center (founded in 1938), owned and operated by Mexico City–based Hoteles Regionales, had been constructed in a regional style and equipped with modern conveniences. Its opening arguably enabled Cárdenas to host the Congress in Pátzcuaro.[84] In addition, congress organizers printed a facsimile edition of Quiroga's rules for the social organization of communal life, *Reglas y ordenanzas*, formally aligning his utopian social vision with that of the congress.[85] Thus in this diplomatic setting Don Vasco, the cause of indigenous welfare, Cárdenas, and Pátzcuaro were further bound together.

Of course Cardenistas did not monopolize Don Vasco's memory in Pátzcuaro. In 1940 Michoacán's archbishop commissioned Miguel Bernal Jiménez to compose an opera in belated commemoration of the anniversary of the bishop's arrival in New Spain. The result, *Tata Vasco: Drama sinfónico en cinco cuadros* (Tata Vasco: Symphonic Drama in Five Acts), combines an ambitious and innovative musical melding of Western and vernacular traditions with a libretto by Manuel Muñoz to tell the story of young indigenous lovers and celebrate Quiroga's role in bringing forgiveness, harmony, and the arts to the region.[86] Music historian Leonora Saavedra frames Jiménez within Michoacán's religious conflict as part of a pro-Catholic faction who resisted the state's anticlericism and notes the emphasis placed in the libretto on forgiveness and conformity.[87] Arguably, this theme suggests that we should understand the work as part of an agenda of the moderate archbishop Luis María Martínez ("the peace-making Bishop") to use culture to smooth church-state relations.[88] Yet while Cárdenas and Martínez had managed a truce of sorts by 1940, the opera's Mexico City premiere was canceled out of concern regarding religious controversy. Instead the opera premiered in Pátzcuaro on February 15, 1941, in the Templo San Francisco, accompanied by the National University's Symphonic Orchestra.[89] Bernal Jiménez and Muñoz published *Tata Vasco* in Pátzcuaro in 1941. This suggests, on one hand, that significant local support for such a religiously oriented memorial to Quiroga remained and, on the other, that the project to celebrate Quiroga locally as a figure of reconciliation had been successful.

While the Quirogas memorialized in these coexisting visions— conservative man of faith, radical utopian social reformer, benefactor to regional Indians—resonated for very different constituencies, their shared qualities reveal the important work that his legacy accomplished in the present. Above all, the Quiroga mobilized was a patron of the arts and bringer of harmony to the region, who could address the region's most pressing needs: economic development and ideological reconciliation. He was reconstituted as a perfect model for Cárdenas, the contemporary leader. Thus it should not

Figure 4.10. Roberto Cueva de Río, *Don Vasco de Quiroga*, Reception Room, La Quinta Eréndira, 1938. Photograph by author.

surprise us that the mythic tropes used to discuss Tata Vasco were likewise embraced by Tata Lázaro and his supporters: from his rides into the backcountry on horseback (alas, not on a white mule) to encouraging artisanal production and serving as benefactor of indigenous Mexicans. Promoting such a resonant version of history was key for the period's historians, who were advocating for the development of Mexico's education institutions. As Cárdenas's policies late in his *sexenal* turned increasingly moderate and multiple readings of Quiroga were in circulation, official recognition of Quiroga was possible and even desirable. In 1943, no longer in office, Cárdenas had Cueva del Río paint a fresco portrait of Don Vasco guiding the Purépechas to Pátzcuaro in La Quinta Eréndira (figure 4.10). By 1945 he was investing in and promoting a Michoacán olive industry, introduced by Quiroga. As discussed in chapter 5, it seems that Cárdenas and his supporters alike found this history useful.

INDEPENDENCE PÁTZCUARO

In contrast to colonial history, which had long been part of collective memory in Pátzcuaro, local independence-era history still needed to be self-

consciously recovered and brought to both scholarly and public attention. Professional historians, like Jesús Romero Flores (a Michoacán intellectual in charge of the history department at Mexico City's Museo Nacional), private citizens, and even Cárdenas himself contributed to this effort to uncover, share, and ultimately map local history to the city and region. In recent years Mexican historians have drawn our attention to the artifice and politics surrounding the creation of the independence pantheon, a project begun in the nineteenth century by liberal politicians and intellectuals, deploying a rich tradition of hagiography to realize period political agendas.[90] Likewise, for Cardenistas working in Pátzcuaro, history provided an ideological basis for their contemporary agendas: creating continuity between the independence period and the present proved to be particularly useful for reconstituting the postrevolutionary nation.

The Passion of José María Morelos de Pavón

Notably, the region's first monument constructed under Cárdenas's patronage was dedicated to the independence-era hero and revolutionary priest José María Morelos de Pavón (1765–1815) and seemingly involved just such an act of historical recovery (figures 1.13–1.15). Cárdenas began discussions with sculptor Guillermo Ruiz for a Lake Pátzcuaro project by 1932. They considered various locations, including the Tariácuri Mirador or the summit of Janitzio, and multiple historical subjects, including the early Purépecha Emperor Tariácuri and Don Vasco de Quiroga. According to Juan Tirado Valle, Morelos was selected after Cárdenas and a group visited Janitzio to select a site and found a cross that locals claimed Morelos left there while hiding from royalists during the War of Independence.[91] Thus the choice to dedicate the statue to Morelos transformed local memory into official history and narrated a kind of secular hagiography, celebrating Cárdenas's recovery of this memory. This discovery narrative helped naturalize what has long been seen as a controversial and out-of-place monument.

While today Mexicans might take for granted Morelos's status as one of Mexico's founding fathers, Morelos has been controversial historically, speaking to long-standing social tensions and Mexico's church-state conflict. Morelos was born in Valladolid (called Morelia since 1828 in his honor) to parents of mixed indigenous, Spanish, and African heritage and studied to be a priest at the Colegio de San Nicolás.[92] He served poor populations throughout the state before joining the revolutionary forces in Mexico's War of Independence, taking command of the insurgents following Miguel Hidalgo's death. He convened the Congress of Chilpanzingo (in Guerrero) in 1813 to

declare independence and form a revolutionary government and contributed to Mexico's 1814 Constitution of Apatzingán (in Michoacán). Morelos called for ending the racial caste system, abolishing slavery, restoring indigenous land and water rights, and redistributing the country's wealth and ecclesiastical treasures—a legacy that Romero Flores tells us was foundational for 1930s Mexico and debated as protosocialist.[93] Morelos was captured in battle, excommunicated, and executed in 1815. His excommunication has made him volatile politically: the religious elite resisted his apotheosis as a martyr to the War of Independence, while nineteenth-century liberals identified him as an ideal secular hero.[94] Despite a decree of 1823 ordering monuments to independence martyrs, Morelia did not construct a monument to its namesake until 1842–1843.[95] One might also ask to what extent his racial heritage contributed to his tentative apotheosis, specifically an early reluctance to sanction his portrait.[96]

This iconographic reticence changed under Cárdenas, whose artistic patronage greatly expanded the hero's celebration by liberals. As a governor aligned with antichurch factions, Cárdenas had already identified Morelos as an important Michoacán hero and in 1931 commissioned Fermín Revueltas to create a large-scale easel painting, *El Congreso de Apatzingán* (1932), for the Salon de Actas in Morelia's Palacio de Gobierno. Guillermina Guadarrama Peña argues that this work emphasizes the mixed race of Morelos and the spectators.[97] Over the course of his presidency Cárdenas was linked rhetorically with Morelos and facilitated that association by commissioning Ruiz to make multiple statues and busts of the figure, in both bronze and stone, to be donated to communities in Mexico and abroad.[98] He also authorized the creation of a museum and monument in Apatzingán dedicated to this independence hero, in a bid to raise Morelos to a stature on a par with Padre Hidalgo.[99] The embrace of Morelos by Cárdenas speaks to a regional nationalism—the desire to celebrate a fellow local son and promote Michoacán as a crucible of independence. But at the same time it raises interesting questions about how the selective remembering and forgetting of this excommunicated priest-turned-revolutionary functioned during a time of continued religious controversy.

The Janitzio monument grew in scale and scope between 1932 and 1940 and today epitomizes the assertion of art historians Enrique Franco and Agustín Arteaga that "the large-scale sculptural works of the 1930s worked to link charismatic personalities with the power of the state."[100] Governor Cárdenas hired Guillermo Ruiz, who was working in Morelia in 1932, to design and oversee the project. Cárdenas used his long-standing military ties to mobilize

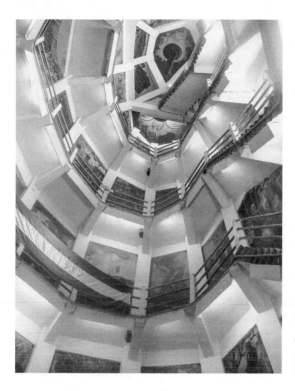

Figure 4.11. Interior, *Monumento a Morelos* (Monument to Morelos), Janitzio, 1938–1940. Photograph by author.

the engineering know-how of Capt. Antonio Rojas García and the labor of the federal 22nd Regiment and the 1st Battalion of Zapadores to ferry 15,000 blocks of stone to the island and construct the 40-meter edifice in stone and reinforced concrete.[101] The collaboration between Ruiz, his assistant Juan Tirado Valle, and Rojas García resulted in a starkly modern statue (sword in hand and fist raised) that stands atop the island's summit, from which visitors can view the lake's panorama. After completing the main sculpture and its base in 1935, work continued on various fronts. Ruiz hired Ramón Alva de la Canal to paint Morelos's life story in a series of fifty-five vignettes along the winding interior staircase leading to the monument's lookout (figure 4.11). On its base he cast an open book and quotation in bronze, and he sought a means to maintain a permanent flame at the site. Working on Cárdenas's behalf, he acquired relics connected to the independence martyr, including his death mask and handkerchief, which were originally housed behind a cast bronze door in the sculpture's head.[102] Furthermore, the project expanded to include new infrastructure on Janitzio, including electric lighting, water and sewage systems, a garden with pavilions to surround the monument, and an infirmary.[103] Cárdenas gave the monument to the island in a peculium (a land

grant held in trust). The islanders organized a collective system to maintain the monument and develop concessions, although it was not maintained and a class hierarchy emerged.[104] Ultimately the monumental statue of the revolutionary priest, with its raised-fist *mirador*, five-tiered mural cycle, and park, was merely the most spectacular part of a project that transformed the island for visitors and locals alike.

To make the controversial figure of Morelos viable as a hero in the 1930s, the sculpture and its murals appropriated and transformed traditional iconography and form in telling ways. Ruiz's sculpture was a departure from previous images of Morelos. Unlike Morelia's more typical 1913 monument to the hero, which appropriates royal equestrian iconography in order to glorify the leader, Ruiz uses the Statue of Liberty as a point of departure — not just for its scale and composition but also for its republican iconography of freedom.[105] By transforming the torch into a fist, he aligns Mexican liberty with the left and anticipates the Popular Front fist of the mid-1930s. Thus the statue is not merely a portrait sporting Morelos's iconic garb (high-collared jacket, cape, and bandana) and sword but also a transcendent allegory of Mexican democracy.

Meanwhile, Alva de la Canal carefully presents the hero in his five-tiered mural cycle, and his crafting speaks to the changing dynamic of church-state relations in the 1930s. As historian Carlos Herrejón notes in examining Morelos historiography, heroization required not just the embrace of mythic tropes to glorify a subject but also the ability to ignore and remain silent about elements that detract from the desired image.[106] With regard to the former, Alva de la Canal performs an act of hagiography so bold as to cast this excommunicated priest as a modern-day Christ; the result is not known only as *La vida de Morelos* (The Life of Morelos) but also as *La vida y pasión de Morelos* (The Life and Passion of Morelos). He appropriates Catholic iconography throughout, presenting scenes straight out of the lives of the Virgin Mary and Christ: the birth of Morelos (like the birth of the Virgin; figure 4.12), Morelos as a child with carpentry tools (as the Christ child in the workshop with Joseph), his youthful education (disputing with scholars), and his family's "flight" on horseback to Pátzcuaro (rather than Egypt). As the local story turns national and Morelos joins the independence struggle, scenes recast Spanish soldiers as Romans slaughtering the innocent (plate 9). Morelos appears on horseback welcomed by crowds in "Entrada triunfal de Morelos en Oaxaca" (Morelos's Triumphal Entry into Oaxaca), as if he is triumphantly entering Jerusalem. During the Congress of Apanzingán he speaks to twelve men seated at a supper table (figure 4.13). Ulti-

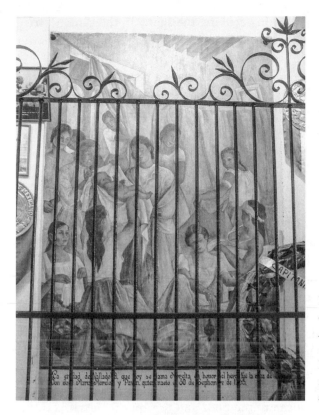

Figure 4.12. Ramón Alva de la Canal, *Vida de Morelos: Nacimiento de Morelos* (Life of Morelos: Birth of Morelos), Janitzio, 1938–1940. Photograph by author.

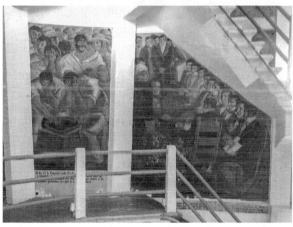

Figure 4.13. Ramón Alva de la Canal, *Vida de Morelos: Rendición de Valladolid y Congreso de Apanzingán* (Life of Morelos: Surrender of Valladolid and Congress of Apanzingán), *Monumento a Morelos* (Monument to Morelos), Janitzio, 1938–1940. Photograph by author.

mately he is captured (in a setting evoking the agony in the garden), tried and excommunicated, and executed by Spanish soldiers as a modern martyr to independence.

While Catholic iconography renders Morelos a heroic martyr, it is also worth noting Cárdenas's initial response when the artist sent him his initial project plan in the summer of 1935, which demonstrates a careful navigation of religious themes at what was the high point of 1930s religious tension.[107] Cárdenas's redacted copy of the proposed narrative shows that Cárdenas reworked the text in key places where Alva de la Canal evoked Catholicism — in either a positive or negative light — in the life story of this priest turned revolutionary: reference to Morelos constructing a church alongside workers becomes Morelos speaking with and listening to campesinos (figure 5.8; see chapter 5); Morelos kneeling before the bishop to receive his sentence is replaced with onlookers who are fascinated by the spectacle and the incredible calm of the sentenced prisoner. Interestingly, by the time Alva de la Canal painted the final mural in situ (1938–1940), religious tensions had lessened and various elements of Morelos's religious life were remembered. The scene of Morelos excommunicated by the clergy was restored, and Morelos appears in his cassock. This gauging of changing church-state relations is perhaps also seen in Cárdenas's delayed 1939 decision to quote Morelos on the bronze book at the monument base: "The goods of the rich and the treasures of the church should be given to the poor and to support the costs of the insurgency" — a popular anticlerical sentiment that was highly relevant after the state's effective claim to all religious property ("Ley de nacionalización de bienes," 1935) and the church's support for the expropriation of Mexican oil in 1938.[108] The quotation was ultimately included. Morelos's legacy was securely tied to Cárdenas as he fulfilled this promise of the independence struggle.

The selective remembering and forgetting of Morelos also is highlighted when considering the ways in which Cárdenas and Alva de la Canal tied together individual, regional, and national history, from his use of local models to tell this national story to the selection of content and the development of narrative. Childhood scenes focus on Michoacán and specifically evoke Pátzcuaro. But, as the mural rises higher and higher, the story becomes national as Morelos joins the fight for Mexican Independence, until we find Morelos's apotheosis as the torch of liberty itself. Morelos's Michoacán origins surface three times more. Cárdenas inserted into the 1935 plan a scene treating the drafting of the 1814 Constitution at Apatzingán to compete with the more-often-cited Congress of Chilpancingo in Guerrero (1813) as the

seat of Independent Mexico. Alva de la Canal also treats the surrender of Valladolid (now Morelia; figure 4.13). Just before his death, the imprisoned Morelos drinks from a regional-style mug.

Race was also used to constitute Morelos as a national symbol within the discourse of *mestizaje*. Relying on phenotypical difference to represent race, Alva de la Canal repeatedly codes Morelos as mestizo: his brown skin is neither the lightest nor the darkest in the cycle, his nose is of medium proportion, and his hair is kept tightly controlled under its bandana.[109] In fact, he is explicitly coded as *not* Afro-Mexican: in *La huida de sus tropas* he holds his ground in contrast to a black man's flight; in the scene anticipating the surrender of Valladolid, he and his troops paint their faces black before launching their successful attack (figure 4.13). And family scenes explicitly code the women as indigenous, marked by braided hair, clothes, and activities like grinding meal (figure 4.12). Meanwhile, his ideal mestizo status is expressed through social relations: Morelos recruits *criollos* (like the Hermanos Galeano), works with Indians, and leads people of all races. In these ways the mural cycle anticipates a phenomenon that Gonzalo Aguirre Beltrán describes in his landmark book *La población negra de México* (1946). African slaves, who represented between 71 percent and 65 percent of migrants to New Spain (the rest largely European) during the colonial period, had been forgotten and assimilated into a supposedly Euro-Indian *mestizaje*.[110] Thus the specificity of Morelos's racial identity—as well as the substantial *mulato*, Afromestizo, and African populations of Pátzcuaro and Michoacán—is again subsumed within the larger demands of postrevolutionary mestizo nationalism.

While the monument left plenty of room for controversy, published concerns have been couched largely in aesthetic terms. What were such objections really about, beyond taste? As discussed in chapter 1, early commentaries described the work as a modernist and Yankee invasion (evoking the Statue of Liberty comparison) in what was traditionally celebrated as a region of quintessential picturesque natural beauty.[111] Guidebooks and tourism promoters who objected on picturesque grounds perhaps were uncomfortable with the challenge that history and struggle presented to the picturesque promise of ahistorical, Edenic nature. Objections to the clash between the work and its "typical" setting perhaps registered how the avant-garde Ruiz used aesthetics to challenge to the status quo, including the church (figure 1.14).[112] We also see discomfort with the work's scale, its unabashed display of power, and even Cárdenas's deployment of army labor—today's revisionist art historians liken the monumental project to those carried out by the

era's dictators in Germany, the Soviet Union, and Brazil.[113] Endorsing the monument in the 1930s, Justino Fernández delicately registers the audacious nature of this "work of the greatest magnitude made in the Republic during the revolutionary period," suggesting that a view from the side subdues its "arrogance."[114] We might further ask: to what extent is such a reading tied to the audacious challenge that Morelos offered to Mexico's class and race hierarchies?

Notably, the objections do not appear to come from islanders themselves. While in part this reflects access to the public record, it is worth noting that correspondence from Janitzio recorded during Cárdenas's presidency was favorable, seeking assistance with the island's further transformation into a tourism destination and support for a new cooperative concessions system, including shops to sell "typical items" and a restaurant.[115] One might imagine that Cárdenas did the footwork necessary to get local buy-in and that objections came from constituencies whose interests—ideological and material— were left out. As Lilia Zizumbo Villareal has demonstrated, however, Janitzio's transformation into a tourism center profoundly changed the island. It promoted acculturation through regular engagement with tourists and their expectations and created a divided economy of underpaid, unstable service workers and elite business owners, whose sojourns in the United States in the late 1930s earned them capital to invest in *artesanías* shops and restaurants and who also typically had additional professions. The goal of using *artesanías* and tourism to improve the Indians' status, she charges, has failed.[116] Thus the controversies, superficial as they may be, make visible one undisputable fact: the memorial to Morelos irrevocably transformed Lake Pátzcuaro for locals and visitors alike.

In the end the monumental project arguably helped establish and entrench the status of both Morelos and Cárdenas. The monument not only created an indelible image of Morelos but also contributed to his cult, complete with relics, pilgrimage, and rituals that continue today. At the same time the project's ambition and scope demonstrated Cárdenas's ability to mobilize manpower (the military, no less), resources, favors, and popular support, in addition to developing the region's infrastructure and economy.

Ladies of Liberty

Morelos was not the period's only local representative of independence-era history. Guillermo Ruiz created two statues dedicated to female heroes of the War of Independence in the region: the well-known statue of Gertrudis Bocanegra in Pátzcuaro's Plaza Chica (plate 7, figure 4.14), and a bust of

María Luisa Martínez in nearby Erongarícuaro (figure 4.15). As historian Alicia Tecuanhuey has noted, the celebration of female heroes of the independence struggle proceeded slowly. While the nineteenth-century liberal search for heroes combined with the emerging possibility of women's self-emancipation to allow select heroines to be identified, it was not until the 1930s and 1940s that the number of heroines multiplied. They began to be understood as representative of Mexican female virtue, not just exceptional individuals.[117] Pátzcuaro's heroines bear out her observations: Bocanegra was "discovered" and celebrated as early as 1905, Martínez already in 1893, and both became part of a 1930s effort to define heroism as a typical trait of Mexican women.[118] Books and newspaper articles, lectures, and Ruiz's monument especially amplified Bocanegra's memory during this period, both locally and nationally.[119] Both women would also become visible nationally as school names in a period that saw the expansion of educational opportunities for girls. The celebration of both heroines drew on the example set nationally by liberal historians writing on Josefa Ortiz de Domínguez and Leona Vicario, who emphasized feminine virtues (motherhood, wifely duty, emotion), in addition to love of liberty, patriotism, and decisive action.

While Bocanegra was already recognized in Pátzcuaro in the 1930s (she appeared in the history parade, her name graced the garden in the Plaza Chica, and she was featured in local guides), texts and artworks of the period transformed her into a national symbol of Mexican womanhood. We are told that María Gertrudis Bocanegra Mendoza de Lazo y de la Vega (1765–1817) was born in Pátzcuaro to a Spanish family and married a *criollo* soldier only after he agreed to leave what she considered the imperialist royal army.[120] Historians describe her contributions to the independence struggle as stemming from her domestic role. She convinced her son and husband to join the insurgency, and she herself ran messages for the rebels. Jesús Romero Flores (historian and politician from Morelia, who headed the history department of Mexico City's National Museum) describes Bocanegra's house in Pátzcuaro as a center of the insurgency. After the death of her husband and son, she continued the struggle, working to subvert the royalists and rallying resources and supporters to the cause. Her seduction of royalists led to her arrest and execution. Romero Flores notes that she was one of a number of Mexican women shot during the struggle, including María Luisa Martínez in Erongarícuaro two years earlier. Bocanegra's final acts — refusing to betray the rebels, asking the priest to give her pendant and watch to her daughters, pulling down her blindfold to look her executioners in the eye, and exhorting the gathered crowd to continue the struggle — have been immortalized in historical texts and in Ruiz's monument.[121] Through these works she has

been remembered, Romero Flores suggests, as an example of civic virtue for women and girls, constant in her strength, stoic in her sacrifice, and willing to offer her life for others.[122]

While the terms of Bocanegra's hagiography closely parallel those of Domínguez and Vicacio, which emphasize patriotism, domesticity, and action, Ruiz's sculpture is a marked departure from their commonly reproduced nineteenth-century portraits. According to convention, these are tightly confined profile busts or, in the case of the 1909–1910 monument by Enrique Alciati in Mexico City, present Domínguez calmly seated, scroll in hand. However, one finds an interesting precedent in the 1910 monument to the Corrigiadora (Domínguez) monument in Querétaro, poised high on a column as an individualized rendition of a refined Lady Liberty carrying her torch. Ruiz likewise mixes allegory and portrait. He began work in 1937, along with his collaborator Juan Cruz Reyes. The monument was erected after Leduc finished its base in 1938.[123] Far from being a confined bust or refined lady high above the plaza, however, Ruiz's full-length statue shows Bocanegra striding forward, hair loose, breast nearly bare, calling out, not unlike an image of Minerva or Victory (e.g., Antoine Le Nain, *Allegory of Victory*, ca. 1620–1648). The hand at her side opens to her audience, while the other hand grasps her breast, as if to offer her body to the nation. Fermín Revueltas's painting *El fusilamiento de Gertrudis Bocanegra* (The Execution of Gertrudis Bocanegra, 1932, Palacio de Gobierno, Morelia, also commissioned by Cárdenas to celebrate Michoacán's contribution to national history) represents her with her daughters, in the long-sanctioned role of mother, but here she stands alone. Yet maternal gendering is present here too: by offering her breast Ruiz likens her to an allegory of charity, whose milk nourishes those in need (figure 4.14). Too indecorous for a true portrait, Bocanegra's statue presents an allegory idealizing Mexican womanhood, not the exceptional heroine. Ruiz innovatively conflates the individual with the idea, even as he perpetuates the traditional notion that the heroine must be maternal.

On the statue's base, a narrative bas-relief depicts Bocanegra on the verge of her execution. Raised on a platform in a condensed Pátzcuaro plaza, she kneels, bound, yet has dropped her blindfold to challenge her executioners and face her mourners. This scenario is replicated in a watercolor-style lithograph on the cover of Romero Flores's 1938 book. Both the martyrdom scene and the evocation of *caritas* (charity) evoke Catholic values to celebrate this secular hero and provide a patriotic female role model during a time when many women in Michoacán resisted the state program of secularization.[124]

The highly anticipated Bocanegra monument likely inspired Elías García Rojas of Morelia to contact Cárdenas in 1938 to request that a monument

Figure 4.14. Guillermo Ruiz, *Monumento a Gertrudis Bocanegra* (Monument to Gertrudis Bocanegra) (detail), Plaza Chica, Pátzcuaro, 1937–1938. Photograph by author.

to his grandmother-in-law, María Luisa Martínez, be erected in Erongarí cuaro. It is interesting to note what constituted a successful petition of this nature. García Rojas sent Cárdenas a well-developed documentation of the heroine, noting the plaque in Erongarícuaro's cemetery dedicated to her and quoting articles and historians (including Romero Flores) regarding her role in the independence struggle and her execution.[125] When Cárdenas sent Ruiz to the town, the agrarian and indigenous community in the area joined town leaders in thanking Cárdenas for his "donation." This suggests that multiple local constituencies mobilized around the project and hints at the diplo-matic role performed by such monuments-cum-gifts.[126] Ruiz received assis-tance from Lic. Gabino Vázquez and Luis Valencia (likely Col. Luis Valencia Madrigal, an assistant from the army). While the monument is not signed and dated, it was completed in November 1940 and originally installed in the churchyard where Martínez was shot.[127] Unlike the Bocanegra monument, the portrait bust of María Luisa Martínez conformed to earlier prototypes, presenting a modest and moderate woman, with her blouse buttoned to her neck and wavy hair in a loose, braided bun, even as Ruiz's rustic modern style energized her (figure 4.15). While clearly a project on a much smaller scale, it speaks to a citizen's ability to mobilize resources to transform familial and

Figure 4.15. Guillermo Ruiz, *María Luisa Martínez*, Erongarícuaro, 1940.
Photograph by author.

regional memory into state-supported monumental form and to the state's growing interest in promoting female heroes.

In all the monuments discussed here, independence history was mobilized to express contemporary concerns and ideals associated with the recent Mexican Revolution (1910–1917). In effect, the monuments make the case that the revolution was the continuation of independence-era struggles, from the anticlerical struggle to property reform and racial justice. Yet, notably, the mechanisms for making history and its heroes memorable were borrowed from the Porfiriato and from the Catholic Church. It was only when a project stepped outside that familiar sphere (the giant Morelos) and radically changed local social and economic dynamics that both critics and supporters alike began to register their concerns—if largely in what appeared to be aesthetic and affective terms.

REVOLUTIONARY PÁTZCUARO

The Mexican Revolution and its aftermath clearly had a profound effect on Pátzcuaro's urban environment, from the growing investment in secular public spaces and structures to choices made about which histories would

be visible. Yet while the revolution and its consequences were arguably the major factor driving the projects discussed throughout this book, revolutionary history in its own right was a delicate topic for the region. Note, for example, that the history parade discussed above changed dramatically between 1911 and 1929; yet even its 1929 version did not extend forward in time beyond references to independence-era history. By 1936 Pátzcuaro had renamed one street near the center of town "Calle Obregón" and transformed the Plaza San Francisco into the Plaza Revolución (a name that did not stick); but the revolution's relative invisibility near the city center must be noted. Thomas Benjamin's comment that "state and national governments proclaimed that their social improvements and public works—schools, sports parks, *ejidos*, and irrigation works—were the real monuments to the revolution" arguably holds true for Pátzcuaro.[128] What's more, as we have seen, these public works—the public market, theater, and library in the center and even the schools and new housing on the outskirts—were all designed to blend with the town's long-standing architecture and were not visibly marked as a radical departure. By contrast, one new neighborhood in Pátzcuaro overtly celebrated the revolution. Built on land formerly belonging to the Hacienda Ibarra, the neighborhood of La Revolución and its monument were part of the new developments built between Pátzcuaro and the lake on former hacienda land.

As Carmen López Núñez has pointed out, aerial photography is particularly effective at registering the loaded spatial transformation that takes place at expropriated haciendas.[129] In the case of Pátzcuaro's Colonia Revolución, its regular streets, large central plaza, and adjoining school filled in preexisting roads and marked the land with its newly ordered urban grid (figure 1.22, between city and lake). The school—the most important symbol of the new postrevolutionary order—combined modern functionality with aesthetic details evoking local typical architecture: tiled roofs, white adobe walls, and rustic wood columned porticoes. The surrounding homes follow suit, though at times their neocolonial constructions give a nod to art-deco stylization. At the west side of the park, with its crisscrossing paths, Cárdenas and the SEP commissioned Guillermo Ruiz to create a monument to the Mexican Revolution—his first in the city proper, dedicated on November 20, 1936 (figure 4.16).

A Monument to the Revolution

Stylistically, Ruiz's *Monumento a la revolución* (Monument to the Revolution) represents the meeting of modern and traditional ideals. The monument is

Figure 4.16. Guillermo Ruiz, *Monumento a la revolución* (Monument to the Revolution), Colonia Revolución, Pátzcuaro, 1936. Photograph by author.

a wide, pentagonal plinth, made of stone blocks with bas-relief carving on the side facing the park. As in other local projects, the 22nd Regiment assisted Ruiz, likely constructing the stone monument's three-stepped base, the high bench along its façade, and its overall form. Presumably Ruiz directly carved the relief himself. Ruiz founded his school of direct carving in 1927, La Escuela Libre de Escultura y Talla Directa in Mexico City (a parallel school in Morelia, La Escuela Libre de Pintura y Escultura de Michoacán, was founded in 1928). Ruiz and his contemporaries celebrated direct carving—an approach to sculpture that privileged the immediate experience of the material and rejected formal academic planning and modeling—as a more authentic and spontaneous alternative to imported academic ideals. Such a seemingly naive approach to sculpture sought to align itself with the masses, being revolutionary in both its anti-academic style and its populist ambitions. Notably, however, while preserving the rustic style of such experimental work, Ruiz appears to have made a model for this major commission.[130] Furthermore, the monument's pentagonal form evokes traditional funerary and war memorials from previous generations.

At the center the relief presents an allegory promoting the embrace of revolutionary ideals. Ruiz carved four figures within a simple rectilinear molding: the "revolutionary trinity" introduced in the muralist's iconog-

raphy (campesino, proletarian, and soldier) and a female figure with long hair, necklace, and bare feet, who personifies "La República Mexicana." The well-armed soldier and the Republic present a banner to a worker and a campesino, who grasp her hand and clasp her shoulder to accept her charge. The banner's text reads: "Worker, the Revolution waits for your loyalty to your class brothers." Thus the soldier on the battlefield (cannons and more guns stand ready behind him) and the nation hand off responsibility for the revolution to the worker and peasant (backed by factories and rolling hills), as the new day dawns. More than being the war memorial suggested by the monument's funerary profile, the work mobilizes the memory of the fallen to charge the new community to perpetuate the Mexican Revolution.

Perhaps it is not surprising to see that Pátzcuaro's most overt celebration of the Mexican Revolution—and one of the nation's early monuments to it—is located on the outskirts of town on the land of a former hacienda, in a community made possible by that very revolution. In other words, it is set in a context primed to support the revolution and the controversial land reform that followed. While the revolution clearly marked a major turning point for Pátzcuaro and the lake region, however, overt references—visual and otherwise—to its legacy outside of this specific neighborhood are few. While the revolution made possible and effectively helped launch the changes discussed here, what is significant is that revolutionary ideas and history were disguised in Pátzcuaro. They largely spoke through a series of historical references to other periods and ideals as well as through historical erasures and ellipses.

CODA: THE RETURN OF THE HISTORY PARADE

The monuments and murals described in this chapter worked cumulatively, each memorializing its piece of historical Pátzcuaro, until Pátzcuaro became a microcosm of historical Mexico, just as its regional tourism promoter would have hoped. The potential of this epic ideal was given its full visual form in 1942, with Juan O'Gorman's mural in the new Biblioteca Pública Gertrudis Bocanegra (plate 4). La historia de Michoacán (The History of Michoacán) presents a veritable parade of the region's historical personages, from its mythical origins through the Mexican Revolution, winding across a panoramic landscape of Michoacán. Whether O'Gorman saw Pátzcuaro's history parade is unclear, but the prototype would have been familiar and arguably inspired a new approach to depicting history. O'Gorman has taken Rivera's strategy from the National Palace murals (1929–1934)—to as-

semble portraits of notable Mexicans in historical clusters—but has instead stretched the characters out in a line to create a dialectical historical narrative. This epic approach to history combines with its sublime point of view (discussed in chapter 1) to summon the framework of the national whole, even as its content and landscape are specific to Michoacán.

Painted in 1941–1942, after the Cárdenas presidency, this work was *not* a state commission; rather, Theodore Kaufman, the North American department store magnate, funded it after he canceled O'Gorman's mural cycle for the Pittsburgh Young Men's Christian Association. Kaufman gave O'Gorman 8,000 pesos to paint a mural in Mexico. O'Gorman chose the site in consultation with Cárdenas and Dr. Enrique Arreguín Vélez, subsecretary of the SEP.[131] O'Gorman worked with the library's director, Juan E. Noguez, who gave the artist excerpts of classic regional texts, including works by Pablo de Beaumont, Nicolás León, and A. Salas León, the *Crónica de Michoacán*, and Eduardo Ruiz's *Michoacán: Paisaje, tradiciones y leyendas*.[132] While Cárdenas approved the project, however, and while O'Gorman engaged with what was now a familiar range of sources, he created a monumental history that departs in significant ways from the ideal of a "national" history projected by the monuments discussed above.

Working in the tradition of Ambrogio Lorenzetti (and Diego Rivera), O'Gorman uses the landscape to stage a moral allegory, in which the terrain and its trees structure the plot.[133] Across this terrain, O'Gorman presents a historical panorama of real and fantastic figures in order to comment on the long-standing oppression of indigenous peoples and the contemporary rise of totalitarianism.[134] Across the top, far away from the contemporary viewer, we see the mythical origins of Lakes Pátzcuaro, Cuitzeo, and Zirahuén, and the eruption of El Estribo. Shelves of land support layers of history below. First, we see the ancient settlements and temples at Naranxhán and Tzacapu (at the lake's north end), integrated by tree-like paths in the landscape. Below to the rich green left, the newly arrived Purépechas worship their gods and establish elements of their culture still celebrated today, including the arts, hunting, the *tianguis*, and marriage rituals. A hint of discord is found in the cave-form to the left, where a miner has collapsed due to poisonous gases.

As Ida Rodríguez Prampolini points out, O'Gorman deploys historical materialism to analyze and organize Michoacán's history of suffering.[135] In the pre-Hispanic world, the conflict between the Purépechas and Aztecs culminates on the far right in warfare and sacrifice. At the center, between the base of the tree connecting the Purépecha communities and the severed

stump dividing their world and legacy from the next tier of history, the *caltzontzin* rules with his court.

In the next band, the Spanish conquest is led by the central figure of Nuño de Guzmán, who leaves bodies and a pile of burning codices in his wake (right) and invokes (through O'Gorman's fantastic characters and portrait of Hitler) the Nazis' contemporary bonfires and deaths (labeled "The Paradise of Rats"). On the left, backed by a volcano, Eréndira rears her horse and resists the conquest; in antithesis, King Tanganxuan II is tortured and executed, before a deep chasm connecting him to the Purépecha world.

The final band suggests that independence and the revolution are the synthesis of a history of struggle. O'Gorman condemns the oppression of "indigenous slaves" under the *encomienda* system, represented through an appropriated photograph from *Life* magazine of an African American chained to a tree, tortured with a blowtorch, and murdered (lynched).[136] O'Gorman's valid concern with treating the subject of indigenous oppression misses an opportunity to address the regional history of African slaves, once again erasing the black body from the historical mix that becomes the Mexican nation. In antithesis to the *encomienda* system and the brutality of Nuño de Guzmán, hope is offered indigenous populations by the Franciscan Fray Juan Bautista Moya and the central Don Vasco de Quiroga, shown overseeing local industries (figure 4.17). The portrait of Sir Thomas More and the "Utopia" sign over the (tree) roots of a new community in Michoacán visually suggest that Quiroga offers a renewal of the region's indigenous roots, at the same time evoking the debate that O'Gorman's brother Edmundo engaged in regarding Quiroga's legacy in contemporary Mexico. Synthesizing oppression and utopianism, the parade ends with independence and the revolution. Gertrudis Bocanegra, José María Morelos, and Emiliano Zapata are brought together, along with other revolutionary figures, to suggest that the revolution continues the legacy of Mexico's War of independence.

Critics and art historians have lauded O'Gorman's exacting and detailed style. Writer Elena Poniatowski goes so far as to claim O'Gorman could not tell a lie, much less paint one, and suggests that children should learn their history from O'Gorman's murals.[137] Some have credited O'Gorman's historical sensitivity to his relationship with his historian brother. Beyond O'Gorman's careful and epic construction of Michoacán's history, however, I am most struck by the degree of irony and self-consciousness that he brings to the telling of history. The distance created by an aerial perspective as well as by the overwhelming use of meticulous detail enforces an urge to step back and distance oneself from the image and history. The odd figures that

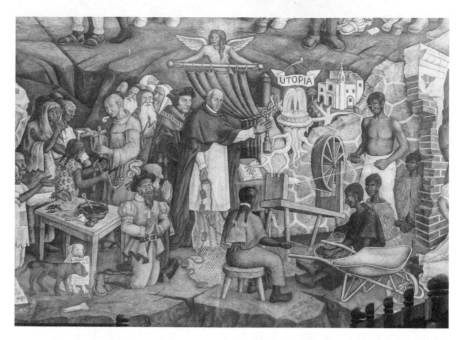

Figure 4.17. Juan O'Gorman, *La historia de Michoacán* (The History of Michoacán) (detail: Don Vasco de Quiroga), Biblioteca Pública Gertrudis Bocanegra, Pátzcuaro, 1941–1942. Photograph by author.

populate the landscape carrying signs to orient us—the rigged-up, half-dead allegory of war over the "Paradise of Rats"; the artist himself telling us explicitly that his point is to celebrate the Indians who have endured hardship and will someday achieve freedom, like an exploding volcano; O'Gorman's alter-ego rat-man telling us "así es la vida" (that's life) (figure 1.23)—lend a distance, perhaps satirical, to the telling of history. How seriously should we take a monstrous hand hiding Hitler, in a sixteenth-century scene of the conquest? More than anything, the image of Don Vasco, singled out with a curtain backdrop supported by a little angel, says: look how we have idealized him! These gestures remind library patrons that history is constructed, fabricated—through art and texts alike—with intentionality. At the same time O'Gorman draws attention to the subjective viewing (or, in his wife's case, not viewing: figure 1.23) and interpreting of history.

Notably, this self-consciousness is precisely the legacy that Edmundo O'Gorman is said to have left Mexican historians. As discussed above, Edmundo O'Gorman had challenged Estrada and Zavala's humanistic efforts to use the history of Quiroga's utopian social experiments as a lens through

which to understand Cardenas's social reform. When Jorge Alberto Manrique eulogized the historian, he argued that O'Gorman promoted reflection within the process of writing history and worked with the premise that "the interpretation of the facts—and there are no facts that are not, necessarily, interpretations—is also a historical process, dependent on the subject that makes them and his [or her] time and circumstance."[138] Himself the product of an age that sought to transform history into a science, Edmundo O'Gorman challenged the possibility of that project.

As we consider Juan O'Gorman's mural, then, it is worth asking to what extent we see the painter in dialog with his historian brother. Arguably, the mural demonstrates an ambivalence regarding the changing nature of public history. The painter's lining up of meticulously rendered historical personages in this historical parade allows them to be systematized into the professional logic of historical materialism, while the distancing effects of the texts and outsider's aerial point of view provide the professional historian's ideal critical distance (and even repudiate a view from the east, from Mexico City). Meanwhile, O'Gorman's insertion of farcical images (the rat-man, the hand hiding Hitler, the angel presenting Quiroga) satirizes the use of history for ideological ends in the present, while not letting us forget contemporary politics. Finally, the self-portrait of the historian-artist suggests self-consciousness about the historian's subjectivity, lack of disinterest, and the distortions that may result. Thus the mural's style, composition, and use of farce encapsulate the debates that will be central to the disciplines of history and art in the twentieth century, as they endeavored to find professional security, relevance, and autonomy within modern Mexico.

In the process, memory—the local, individual, and informal version of the past, told and retold in the history parades—was rendered as official history in a grand-scale, state-sanctioned monument. This remarkable fact, that such a self-consciously critical (and self-critical) mural, implicitly questioning the ends to which we use public history, can be found within the walls of a public library, speaks to both the continuing radical potential of muralism and the range of actors participating in the creation of Pátzcuaro.

Pátzcuaro's history parade was resuscitated in 2005, though it is now framed in secular terms and held in September to celebrate the city's anniversary.[139] A newspaper account of 2009 tells us that key personages that we have discussed continue to be remembered in Pátzcuaro: "King Tanganxoán" [sic], Vasco de Quiroga, and Gertrudis Bocanegra are mentioned by name and briefly explained.[140] The version that I saw in 2010 was a spectacle celebrating local traditions—young girls with braided hair and painted bateas, primary

school children dressed as fishermen chasing a great silvery white fish (now extinct), high school students dressed as indigenous elite, Los Viejitos and Los Moros dancers, *charros* in broad hats and women in long ruffled skirts on horseback—though I can't claim I was able to identify any specific historical figures. But the crowds testified to its appeal for both locals and visitors. A federally sponsored temporary historical marker told the story of the Purépecha origins of the Mexican flag and provided a smart-phone QR (Quick Response) code for more information. Finally, a display of children's art honoring the Mexican Bicentennial in the Teatro Emperador Caltzontzin visually quoted monuments around town, and school groups appeared regularly within the Biblioteca Pública Gertrudis Bocanegra to visit O'Gorman's murals. Such civic rituals continue to integrate local history into the lives and memories of Patzcuareños.

Creating Cárdenas, Creating Mexico

A giant statue of Cárdenas in a tree-lined park greets today's travelers entering Pátzcuaro from the Morelia highway. Cárdenas permeates local memory; he has become synonymous with the creation of modern Pátzcuaro. When asked who was responsible for any regional project or change of the 1930s, a local will probably answer: "Lázaro Cárdenas." Of course this also holds true, to a great extent, for the way in which many understand the creation of modern Mexico.

Cárdenas is foundational to the study of Mexico, both for his statecraft (the policies and institutions that he helped establish and lead) and for the ideas and myths attached to his legacy. While revisionist scholars have initiated a crucial debate on Cárdenas's political legacy within modern Mexico, much recent discussion considers how he has been popularly remembered, heroized, and mythologized. Adolfo Gilly identifies the myth of Cardenismo (together with Zapatismo) as one of the great myths of twentieth-century Mexico. This ideological tradition suggests that Cárdenas's *sexenal* was the culmination of the Mexican Revolution and that the underclasses finally had their day under him.[1] Furthermore, Cárdenas stands for the possibility of social justice in Mexico as well as for the government's ability to represent the will of the people. According to Verónica Vázquez Mantecón, the myth of Cárdenas has been instrumental in Mexican politics, used to consolidate

and legitimate Mexico as a nation-state and, more recently, to challenge its legitimacy.[2]

The rehearsing of myths surrounding Cárdenas clearly was not confined to Pátzcuaro; nor was the Cárdenas myth created solely there. In fact, one of the most salient elements of the Cárdenas myth was that he was *everywhere*, in person, meeting people, listening, discussing and resolving problems. That said, the creation of Pátzcuaro gives us a privileged vantage from which to explore selected elements of the creation of Cárdenas, the ideology of Cardenismo, and, by extension, the creation of modern Mexico.

A 1937–1938 watercolor study by Roberto Cueva del Río paints a portrait of Cárdenas that crystallizes Cardenista ideology (plate 10). Cárdenas, informally dressed in a brown gabardine suit and open collar, works at a table overlooking Lake Pátzcuaro. He studies documents, including a scroll attributed to the Confederación Nacional Campesina (National Campesino Confederation) and a blueprint, which lies before him on the sarape-covered table, and prepares to sign a stack of papers. The lake's fishermen with their familiar paddles and faces and a mother with her child in a blue rebozo stand and watch over his shoulders. A young boy and girl offer up whitefish and local produce. The iconography lifted from earlier artistic demands for land reform (like Xavier Guererro's print *La tierra es de quien la trabaja con sus manos* [The Land Belongs to Those Who Work It with Their Hands]) tells us that now Cárdenas is the figure who fulfills the revolution's promise of land redistribution and accountability. He travels to the people, works for the people, and receives their thanks and devotion; seated, he is their patriarch, their savior, their leader. The watercolor encapsulates the heroic image of Cárdenas and suggests paths for investigation.

First, it presents Cárdenas as the lone advocate of the region's Indians — it does not show the entourage of assistants, local politicians, and journalists that accompanied him on his typical journeys.[3] One key element of the Cárdenas myth suggests that Cárdenas alone was responsible for the transformations that took place during the 1930s — for better or worse. Luckily, historians have begun to question this myth of the all-powerful, all-responsible Cárdenas. As Luis Anaya Merchant, Marcos Águila, and Alberto Enríquez Perea argue in their recent study of Mexican politicians and intellectuals, the postrevolutionary project was a collective one.[4] Collaboration among Mexico City–based politicians, intellectuals, and regional actors enabled the distribution of revolutionary agendas, as Mary Kay Vaughan demonstrates in her foundational study of rural education.[5] In fact, Rick López suggests that ultimately it was the participation of divergent voices (albeit from a limited so-

cial sector) that gave the postrevolutionary project its semblance of inevitability.[6] Alan Knight proposes that we view Cárdenas as neither a demagogue nor a utopian visionary but rather as a pragmatic delegator.[7]

With these cautions in mind, I want to highlight some of the individuals who helped carry forward and transform Cárdenas's regional vision as well as the art world institutions that intersected it. Historians have discussed institution building under the Cárdenas regime as fundamental to the twentieth-century consolidation of state power in Mexico. Art institutions profoundly shape both the production and experience of art, in addition to its meanings, and studies of the institutionalization of Mexico's art world under Cárdenas have been limited.[8] By considering the effects of participation in Cárdenas's project on artists' professional trajectories, I seek to understand the extent of Cárdenas's influence over the art world and especially its academic institutions. Ultimately, it appears that Cárdenas's influence within Mexico's art world was surprisingly limited, especially after 1938.

Second, the watercolor draws upon familiar heroic iconography. Not only is Cueva del Río quoting works by Xavier Guerrero and Diego Rivera that demand or celebrate land reform,[9] but we also see here the patriarch at the head of the table, working miracles, Christ-like, as others pay witness. As Vázquez Mantecón discusses, the mythic discourse used to transform Cárdenas into a heroic figure is part of a rich tradition of hero-making in Mexico, much of which combined Christian hagiography with a nationalist narrative.[10] As we have seen, the creation of Pátzcuaro included such heroization of figures like Tanganxuan, José María Morelos, and Don Vasco de Quiroga in projects patronized by Cárdenas himself. With this in mind, I suggest that Cárdenas's involvement in creating Pátzcuaro helped shape his own public persona. Various scholars and commentators have posited Cárdenas's complicity in constructing his own myth.[11] Like any early twentieth-century politician grappling with the dawning of mass media, Cárdenas needed to be acutely aware of how he presented himself publicly, and it should not surprise us that photographers and journalists documented his travels and engagements with constituents in far-flung regions of the country or that his earliest authorized biography was written by a pair of American journalists who were invited to tour with him in 1939.[12] In examining the resulting images of Cárdenas, it is clear that he not only modeled his public persona on the heroes of Mexico's (or more specifically, Pátzcuaro's) mythic pantheon that he helped construct but also framed their history as fundamental to his own patriotic biography.

Third, at the heart of Cardenismo and its deployment to legitimize the

state is the assertion that Cárdenas embodied the will of the Mexican people. This watercolor, along with countless images showing Cárdenas before massive crowds in the Zócalo or seated listening to rural Mexicans' petitions, has helped materialize this ideal. Referring to Cárdenas as Mexico's greatest populist president, scholars have studied how his famed accessibility, policies, and image worked to create his popular ethos, and have debated its veracity.[13] Beyond helping to define our notion of a "populist style," however, I would like us to consider how the Pátzcuaro project sheds light on what was to become Mexico's modern body politic, wherein experiencing Cardenista visual culture and engaging in touristic practices enabled citizens to *see* and *act* like Cárdenas. In this framing, we see the potential of art and visual culture as a technique or technology of governance. Cárdenas pledged to elevate the Mexican people, and especially the indigenous and working populations. How did Cardenista art participate in this project, and whom did it really serve?

INDIVIDUALS AND INSTITUTIONS

In one photo, architect Alberto Leduc guides Amalia and Lázaro Cárdenas (dressed in his iconic gabardine suit) around Lake Pátzcuaro's island of Jarácuaro to show them the progress on his new school building (figure 5.1). In another, Cárdenas (again in tan gabardine) poses with dark-suited officials at the Mirador Tariácuri. To celebrate the construction of the Morelos monu-

Figure 5.1. Alberto Leduc, Amalia Solórzano de Cárdenas, and Lázaro Cárdenas touring Jarácuaro school, *Arquitectura y Decoración* (January 1938).

ment, a worker, with his face in shadows, dumps dirt and rocks from an up-turned wheelbarrow, as Cárdenas grasps one handle and a man in pinstripes holds the back of the barrow to assist. Several men—some in suits, many in overalls and broad-brimmed hats—crowd around Cárdenas and Pedro Tala-vera in Tzurumútaro (neighboring Pátzcuaro), bearing signs thanking Cár-denas for leading their confederation on the path to freedom. Cárdenas's engagement with the region's transformation is undeniable. The photos and reports of his presence publicly insisted on his regional investment—not merely financial but personal. Today, of course, we recognize the products of a photo-op; perhaps some were even coordinated by Cárdenas's short-lived DAPP, responsible for coordinating, creating, and distributing information for the government, including photographic publicity. Furthermore, ac-counts of Cárdenas's personal investment in transformations all around the country form part of the standard narrative of Cardenismo, or Cardenista ideology.[14] So what was the nature of his role in creating Pátzcuaro, and who were these other key players on the ground? Was Cárdenas's local involve-ment personal and idiosyncratic, or part of a systematic program for Mexico? Following the activities of key individuals involved in creating Pátzcuaro provides insight into the extent of Cárdenas's role in the larger creation of Mexico, especially in the understudied field of Cárdenas's artistic patronage, on which I focus.

My premise is that Cárdenas's regional involvement began as personal and idiosyncratic but became institutionalized over the course of his six-year term. Remember that Cárdenas's local patronage began with murals for his Pátzcuaro home and only later extended into the public sphere. His early efforts in the region became models for institutional changes; using the army to build the monument to Morelos, for example, arguably inspired what was to become a policy of deploying the army in civil projects.[15] Further, the minutiae of Cárdenas's interactions with his artistic team demonstrate his direct involvement: holding meetings (notoriously at all hours), correspond-ing, managing funding requests, and approving and commenting on plans testify to this engagement.

Yet even as we trace Cárdenas's close contact with specific artists, it is worth noting that scholars like Raquel Tibol argue that work for artists under Cárdenas—often channeled through the antifascist and pro-Cárdenas LEAR—did not offer them stability or security.[16] Moreover, while the Cár-denas administration employed some artists and photographers in the new DAPP,[17] the SEP remained the state's major institution for coordinating art and artists, who joined cultural missions, taught in state-supported art

schools, worked for various museums, and received mural, monument, and illustration commissions. Even what to contemporary eyes might seem the most stable of these fields—teaching—was in flux during this period, with turnover due to power struggles at the Escuela National de Artes Plásticas (ENAP) and uncertainty for the relatively young, avant-garde Escuela Libre de Escultura y Talla Directa (which would expand and reorganize under Antonio Ruiz in 1942–1943 to become the Escuela Nacional de Pintura, Escultura y Grabado, or La Esmeralda). Judith Alanís challenged Tibol's assessment of the fine arts' marginal status under Cárdenas, pointing to the range of art institutions that were established under his *sexenal*, which she argues gave institutional form and operational practice to the revolutionary process.[18] I suggest that looking at the intersection of the careers of specific artists with Cárdenas's attention and these emerging institutions provides insight into the Tibol-Alanís debate by highlighting the terms under which institutionalization happened, the instability of these early institutions, and the limits of Cárdenas's authority in this arena.

The contrasting careers of two key figures in the Pátzcuaro project, sculptor Guillermo Ruiz and architect Alberto Leduc, are a case in point. Guillermo Ruiz was at the height of his authority during the 1930s; his reputation as an avant-garde artist preceded Cárdenas, his productive career slowed in the 1940s but continued into the early 1960s, and his work has recently been the subject of multiple studies. Ruiz came to attention in Mexico in the 1920s for his avant-garde works and promotion of "direct carving," which was recognized by the state when the SEP opened the Escuela Libre de Escultura y Talla Directa (1927–1942) under Ruiz's leadership. Ruiz's Pátzcuaro works were just part of his production during the 1930s, although Ruiz worked extensively in Michoacán with Cárdenas's patronage (dating to his time as governor) and coordinated the efforts of a large team of artists and assistants. He not only continued in his directorship but also was paid for commissioned work and awarded a monthly stipend for his efforts. Federal support for Ruiz additionally included granting him use of the Mexican army's foundry, where he cast his sculptures, and army labor, including stipends for assistants from the army. As Agustín Arteaga astutely notes, the army's participation made the monumental-scale works of the 1930s possible.[19] Ruiz's remarkable level of production during this period was also aided by artist collaborators from the Escuela Libre, including Francisco Zúñiga, Juan Cruz Reyes, and Juan Tirado Valle (who was apparently unsatisfied with the level of recognition that he received).[20] In addition to regular correspondence and meetings to develop plans and receive funding, Ruiz generally kept Cárdenas apprised

of his efforts and movements; in fact, when he lost contact for a month, Cárdenas sent Núñez to investigate his whereabouts.[21] Thus we must note Cárdenas's personal attention to Michoacán's monuments project, begun while he was secretary of war, as well as the collective effort that Ruiz directed to enable its realization.

It is also worth noting, and is not surprising, that Ruiz's amassing of such powerful support and important commissions did not go unchecked; nor was it sustained when Cárdenas left office. In March 1938 the Escuela Libre relocated and was able to open its own foundry workshop; the high costs of working in the army's foundry required that Ruiz's team relocate their own efforts to the school's new space. That same year the executive committee of the Unión de Artistas Plásticas opened an investigation of Ruiz, whose competing roles as school director and monument-builder to the president were perhaps now more visible. Complaints included the charge that he did not respect the hours fixed by the SEP for professors, that students at the Escuela Libre were not remunerated for works sold, that he allowed professors to be despotic with students, and that only four teachers were really present to teach, the rest being busy with personal projects.[22] Ruiz's position at the school was rethought in 1942, as the SEP placed painter Antonio Ruiz in charge of the newly expanded and renamed Escuela de Artes Plásticas and refocused Guillermo Ruiz's duties around one of three sculpture divisions. The following year Antonio Ruiz restructured the school's curriculum and transformed the school into the Escuela Nacional de Pintura, Escultura y Grabado (called La Esmeralda after its alley location). Guillermo Ruiz left teaching; though he received some commissions, he did not regain the security of an academic teaching position until 1949.[23]

In contrast to Guillermo Ruiz, architect Alberto Leduc is virtually unknown in Mexican architectural history, which largely has celebrated modernist architecture. Furthermore, his trajectory as a practicing architect appears to be narrowly tied to Cárdenas's patronage. Leduc, together with Col. (later Gen.) José Manuel Núñez, who seems to have overseen the regional public works projects, was Cárdenas's key figure on the ground in Pátzcuaro as well as in Jiquilpan, Cárdenas's hometown. Nearly all of the traces that I have found of Leduc's original architectural work are from the 1930s: schools in Jarácuaro, Uruapan, Tzintzintzan, and Jiquilpan; Pátzcuaro's new public theater and *casas de artesanías*; traffic circles, monument bases, and church-to-library conversions in Pátzcuaro and Jiquilpan; and hospitals in Jiquilpan and Sahuayo, not to mention restoration projects to convert colonial buildings into museums in Pátzcuaro, Jiquilpan, and Zamora.[24] Later, it ap-

pears, his career was more closely linked with the growing field of preservation and restoration of colonial monuments. Throughout the period in question he was working for the Departamento de Monumentos Artísticos, Arqueológicos e Históricos within the SEP and doing monument and building inspections in addition to this architectural design and preservation work for Cárdenas. His growing expertise on colonial architecture was also clearly recognized. He collaborated with Roberto Álvarez Espinoso and Jorge Enciso on a book, *Una casa-habitación del siglo XVIII en la ciudad de México*, published by the Departamento de Monumentos Coloniales in 1939. These interests eventually led him to the emerging profession of architectural conservation and restoration. By the 1950s he was working in the Bienes Inmuebles de la Secretaría de Patrimonio Nacional, serving as its subdirector and, later, director general.[25] He maintained a close friendship with the Cárdenas family, traveling with them to Europe in 1959 and visiting regularly.[26] Leduc returned to architectural design briefly in the 1950s, constructing a house for Cárdenas on Calles de Andes in Mexico City and a primary school in Apatzingán.[27] The record is sketchy, but it appears that he did find stability and helped institute the emerging field of architectural preservation, although he never received fame and recognition within the world of contemporary architecture (as did his younger brother Carlos Leduc Montaño).

The trajectory of Ricardo Bárcenas (ca. 1907–1960) is likewise revealing, as it even more clearly shows a figure who was appreciated by Cárdenas but unable to effect change in Mexico City's artistic culture. It also suggests that art institutions experienced the retrenchment seen in other arenas of Cárdenas's administration and policy. Working-class Bárcenas began as a scholarship student at the Academy of San Carlos in 1925. In the early 1930s Howard Phillips (writing as "G. Rivas") singled him out in the pages of *Mexican Life* for showing great potential. Bárcenas periodically provided illustrations for the magazine. How he received his mural commission is unclear, though he had begun teaching at the ENAP and had won a "Central Airport Mural Contest" in 1931. Yet more remarkably, shortly after finishing his work in Pátzcuaro, at age thirty Bárcenas became director of the Escuela Nacional de Artes Plásticas, during a period of great turmoil.[28] While his tenure lasted only a year, his experiments speak to the potential of a distinctive Cardenista vision for Mexico's artistic culture, which greatly appealed to leftist students associated with the ENAP's Sociedad de Alumnos.

In spring 1937 sculptor Carlos Dublán left the ENAP directorship. The university rector stepped in as acting director, closed the metal sculpture program, expanded the graphic arts, and launched a plan to reorganize a

school suffering from effects of a long-term power struggle, involving teachers and students alike.[29] The plan included creating a master's degree in fine arts, integrating studio and open-air work, increasing opportunities for professor and student exhibitions, and expanding outreach.[30] Bárcenas stepped in as director and likely penned a social services program for the school, inspired by his time in Pátzcuaro. Working with the supportive Sociedad de Alumnos, he proposed to integrate cultural missions into the school curriculum, whereby students would spend ten months in rural Mexico, working with campesinos, studying *artesanías*, sketching, and developing exhibitions and art classes (see chapter 3).[31] At the same time, according to Bárcenas's student Alberto Beltrán, Bárcenas proposed to expand graphic design—coursework previously accessible to workers in night classes rather than fine arts students.[32] Such projects engaged the larger Cardenista agendas at the SEP and the DAPP, including socialist education and publicity management, and reflect the larger cross-disciplinary trend to make academics useful to the Mexican state.[33] To this end, Bárcenas filled government requests for artists to work on official projects and launched a student contest for monuments for rural towns around the republic, while resisting a SEP suggestion that all the students enroll in psychology courses to prepare them for teaching.[34]

These new programs largely did not have an opportunity to develop, and Bárcenas encountered resistance from those claiming his programs commercialized art. While Francisco Goita launched a cultural mission in Xochimilco working with the Liga Nacional Campesino and ENAP faculty and students, and the monument contest went forward, Bárcenas and a core group of faculty and students lost their positions in the June 1938 university shake-up, following the ousting of rector Luis Chico Goerne.[35] The university was insisting on its political autonomy. In part of a larger institutional turn away from socialist education, Manuel Rodríguez Lozano, an *arte puro* proponent, was given the directorship and in the early 1940s successfully managed to stabilize the institution. Notably, he also systematized graphic design within the 1939 curriculum.[36] Bárcenas meanwhile established a new design school, the Escuela Libre de Arte y Publicidad (1938–1948), on Calle Uruguay, bringing many of his leftist students with him.[37] Today Bárcenas is largely remembered as a teacher.

Roberto Cueva del Río has likewise received little critical attention in recent years, despite the range of work that he did for Cárdenas between 1937 and 1940 in Pátzcuaro and Jiquilpan and a very active career as a muralist in the 1950s and 1960s. Cueva del Río was trained at the Escuela Nacional de

Bellas Artes and began working as a muralist for the SEP in 1926.[38] In 1930 Diego Rivera recommended him for the commission to paint murals in the Mexican Embassy in Washington, DC. Cueva del Río painted there on and off between 1933 and 1940.[39] His murals for Pátzcuaro's public theater, the Mirador Estribito on the Cerro Colorado, La Quinta Eréndira, and a public school in Jiquilpan suggest Cárdenas's particular support for the muralist, though notably he does not appear in Mexico City's artistic culture of the 1930s. It is unclear whether he was a member of the LEAR, which held sway there. Instead in 1943 he became director at the Escuela de las Bellas Artes at the Universidad Michoacána de San Nicolás de Hidalgo, in Morelia.[40] If Cárdenas did not maintain influence at Mexico City's ENAP, perhaps he did with his long-time collaborator, historian Jesús Romero Flores, who just two days earlier had begun his five-month term as interim rector of the Universidad Michoacána San Nicolás de Hidalgo.[41]

It is also useful to consider the trajectory of a Pátzcuaro local who played a central role in aesthetically recreating Pátzcuaro, without whom the region might not have been rediscovered in the 1920s. Serving as a regional "culture broker," Salvador Solchaga performed a critical role in making Pátzcuaro culture and art legible and accessible to outside audiences. Solchaga came from a Spanish landowning family that settled in the region in the late eighteenth century, although the Mexico City intellectuals who befriended him persisted in thinking of him as an *indio*, likely because of his association with regional *artesanías*.[42] Like many, Solchaga manipulated his self-image: photos in his family album present him alternatively as a cosmopolitan and modern dandy, with suit and cravat, or as a traditional *ranchero*, with embroidered jacket, broad-rimmed hat, and sarape (figures 5.2 and 5.3). The *ranchero* photo later was presented alongside photos of his *bateas*, suggesting its importance to his artistic identity.[43] Not unlike the popular images of Spaniards and mestizos dressed as *indios*, such a multivalent identity was key to his visibility, success, and ability to introduce urban elites to the region's art and culture.

In fact, it appears that Solchaga reinvented himself as an artist during the 1920s and 1930s: a *hacendado* whose family lost its land, he began studying the craft and history of lacquer-making after finding old papers with information regarding gold-leaf work.[44] Cultivating ties with Roberto Montenegro, he became the key local expert who guided urban visitors like Toussaint, Brenner, Weston, Modotti, and René d'Harnoncourt, as well as Rivera, Breton, and Trotsky when they visited. He also helped assemble the collection for Pátzcuaro's new museum.[45] His regular involvement with visiting intellectuals made him an ideal founding member of Pátzcuaro's Pro-Tourism Com-

Figure 5.2. Salvador Solchaga,
photo album, Archive of the
Museo de Artes e Industrias
Populares, Pátzcuaro.

Figure 5.3. Salvador Solchaga,
photo album, Archive of the
Museo de Artes e Industrias
Populares, Pátzcuaro.

mittee in 1936 and also directly contributed to his family's new business: his father, Luis Solchaga, owned the Hotel Concordia on the Plaza Chica.

While López suggests that we view a figure like Solchaga as a "silent partner" in a middle-class project carried out by his intellectual urban peers, viewed from Pátzcuaro the picture is more complex.[46] I would describe Solchaga as a member of a disintegrating regional elite who found a way to make himself, his family, and his city viable in the postrevolutionary new order. He parlayed his connections, knowledge, and experiences of the 1920s and 1930s into a professional career in the regional context. In addition to establishing a respected *artesanías* and painting studio and being recognized as a "Master of Lacquer," he oversaw the restoration of the Tupátaro chapel and El Calvario.[47] In 1944 Solchaga was named an investigator in the folkloric section of the Museo Michoacano under the INAH in Morelia.[48]

Even such brief sketches of some of the key artistic figures in Pátzcuaro's creation highlight the range of institutions and individuals working with Cárdenas to transform the region. Many of them used this participation in the president's personal project to transform themselves, their professions, and their careers. Notably, unlike intellectuals collaborating in Pátzcuaro from other fields—history, anthropology, art history—who were more consistently able to parlay their efforts in Pátzcuaro into long-term and prestigious academic positions, Cárdenas's artists did not fully achieve professional prestige and security as a result of their collaborations in Pátzcuaro. Like many, they were subject to jockeying for power and position and did not consistently weather the period's political turmoil and polemics. Their mixed fates and paths toward institutional success are suggestive of the limits of Cárdenas's power in the arts and present a more nuanced view than the mythic, omnipotent Cárdenas. Instead a picture emerges of Cárdenas working relatively closely with select figures in the arts—especially Ruiz and Leduc (and Cueva del Río, Bárcenas, and Alva de la Canal to a lesser extent)—in addition to Núñez, municipal authorities, and the Michoacán governors Rafael Ordorica and Gen. Gildardo Magaña to coordinate public-works efforts on the ground. While originally idiosyncratic, his great investment in the region arguably led Cárdenas to institutionalize the project at the end of his term—much to the frustration of local authorities, who had hoped to control the city's new institutions. The theater came under the jurisdiction of Secretaría de Hacienda y Crédito Público and the museum formally joined the INAH in 1942; each exchanged a degree of autonomy for long-term institutional stability.[49]

The individuals involved likewise gained some professional stability, al-

though not at the center of Mexico's art world. Meanwhile, while Cárdenas's artists were briefly given positions of authority from which to launch ambitious new projects, their efforts were not well received. The art world's divergent factions coalesced around Mexico City's two major teaching institutions: the Escuela Libre de Escultura y Talla Directa (later la Esmeralda) and the ENAP, with smaller institutions like Bárcenas's ten-year venture providing socialist alternatives. The UNAM's institutions, from the ENAP to the IIE and IIH (discussed in chapters 2 and 4), had struck an uneasy balance: they proved their social relevance but simultaneously insisted on their autonomy, as the removal of Cárdenas's man Bárcenas directly demonstrated. Thus we observe that what historians have described as a turn to more conciliatory values, accompanied by institutionalization, likewise took place in the arts beginning in 1938.

MYTHMAKING

Cárdenas's Popular Image

If Cárdenas's omnipotence was a myth, then we should consider its generation. While Cárdenas was notoriously humble (for example, rejecting the idea that Pátzcuaro's new public theater be named after him, as Leduc's original sketches suggest),[50] he was arguably very self-conscious about the presentation of himself and the government. After all, he created the state's first communications agency, the DAPP, to manage government information and images. Cárdenas did not control his image absolutely, however; as photo-historian John Mraz has pointed out, under Cárdenas the press enjoyed a freedom that disappeared in the 1940s.[51] Image-makers worked for various publications, from *El Nacional*, the daily of the National Revolutionary Party, and labor journals to a growing field of private newspapers and magazines, including *Rotofoto* and *Hoy*, owned by conservative José Pagés Llergo. Notably, these images in unofficial publications made a particular impact, as their drive to expand audiences encouraged the departure from traditional leadership imagery, which ultimately helped facilitate a new leadership paradigm. Furthermore, the mythical quality of Cárdenas's memory—as a savior who traveled the nation, preaching to the people—suggests a substantive engagement with both the rhetoric of tourism and the tradition of hagiography, both grounded in his Pátzcuaro project.

While some images of Cárdenas certainly fit into traditional models, most significant are those that challenged expectations of decorum and

HOMENAJE
A MICHOACAN

GENERAL DON LAZARO CARDENAS
PRESIDENTE ELECTO DE MEXICO

Figure 5.4. "General Don Lázaro Cárdenas, presidente electo de Mexico" (General Lázaro Cárdenas, president-elect of Mexico). *Homenaje a Michoacan*, 1934, COLMICH archives.

helped forge the twentieth-century populist ideal of the leader, a product of the modern democratic age. More traditional photographs appearing in early campaign literature and continuing in official channels most typically presented Cárdenas as a "visionary" (figure 5.4). They depict his well-lit face in full or three-quarters profile, gazing off into the future. However, those images for which Cárdenas is most remembered cast him as a "man of the people," a staple for the twentieth-century populist politician, also developed in the context of his presidential campaign. Such images resonate within the international visual culture of the 1930s—especially those images that materialize the ideal of popular support for the leader. Prints and photographs show a monumental Cárdenas speaking before the masses, surrounded by supporters (figure 5.5) or even in a virtual dialog with them.[52] Seas of figures swell to buoy Cárdenas's image in photomontages appearing in the PRN paper, *El Nacional*—dubbed "Débussy" moments by Renato González Mello (see figure 5.7 below).[53]

It was the images appearing in *Rotofoto*, an irreverent Mexico City–based weekly photojournalism magazine, especially photographs by Antonio Carrillo Jr. (who also worked for the DAPP and *El Nacional*), that defined some of the most iconic Cárdenas moments. *Rotofoto* launched in May 1938 with a photograph of Cárdenas seated on the ground, sharing a meal with campesinos—perhaps innocuous by today's standards but apparently viewed as unpresidential by those of the 1930s (figure 5.6). Soon afterward, a formal prohibition on publishing photographs of the president eating was announced.[54] In June *Rotofoto* retaliated against this censorship by publishing covers first with Luis I. Rodríguez (head of the Partido de la Revolución Mexicano, founded by Cárdenas in 1938) eating tacos and then with a raunchy image of Senator Padilla shoving a huge burrito into his mouth. *Rotofoto* would repeatedly test the limits of photographing and reporting on public figures. Its images of labor leader Vicente Lombardo Toledano eventually led to a Confederación de Trabajadores de México strike against

Figure 5.5. Cover, *¡Cárdenas habla!* (Mexico City, 1940).

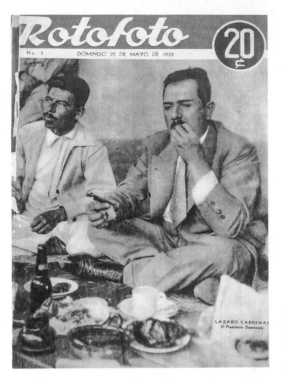

Figure 5.6. "Lazaro Cardenas, el presidente demócrata" (Lázaro Cárdenas, democratic president). *Rotofoto* 1 (May 22, 1938).

the journal, threats and attacks, and the magazine's collapse.[55] However, as much as *Rotofoto* selected and captioned images in ways that worked to challenge authority, its photographers clearly had been given access to politicians as never before—photographing them in their homes, in formal and informal meetings, and smiling on the beach. This suggests that Cárdenas and his cohorts were cognizant of a need for a colloquial and humanizing approach to political imagery, even if they didn't always like the results. And as controversial as the magazine's published photos (and captions) were, they worked in tandem with official images to present the president as a man of the people, which proved highly effective in shaping the Cárdenas myth.

Decisive in defining Cárdenas's populist reputation, Cárdenas's travels around Mexico—and their representation in the contemporary media—established the claim that he spoke and listened to people in every corner of the country reached by train, plane, car, and horseback.[56] This reputation was built in reality—in fact, Cárdenas spent 489 days of his six-year term on the road[57]—yet was enhanced by publicity generation. The DAPP generated a range of images, including a film short dramatizing the heroic combination of modern and traditional technologies (his official car loaded on a train or

pulled though rivers by horses) used to enable Cárdenas's ventures. Cárdenas also encouraged photographers like Antonio Carillo Jr. of *El Nacional* and *Rotofoto* and journalists like Sylvia and Nathaniel Weyl to travel with him and distribute their impressions to the reading and viewing publics. In fact, Vázquez Mantecón notes that Salvador Novo, writing his regular column in *Hoy*, was the first to label Cárdenas the "traveling president."[58]

As Knight points out, populism is about style, and I would argue that Cárdenas's style resonated because it drew on both traditional and modern values and cast the leader as equal parts exceptional hero and everyman.[59] Arguably, this style was inspired by the liberal humanist recasting of Don Vasco de Quiroga (discussed above). It also reflected a larger appropriation of hagiographic traditions dedicated to messianic teachers and disciples. Renato González Mello examines a remarkable photomontage produced in *El Nacional* (the PRN's periodical) as emblematic of such mythmaking (figure 5.7). Waves of people form an ocean that surrounds a map of Mexico, with the president's travels inscribed. The masses surge to support Mexico's traveling president: "36,801 kilómetros a través de México realizando un go-

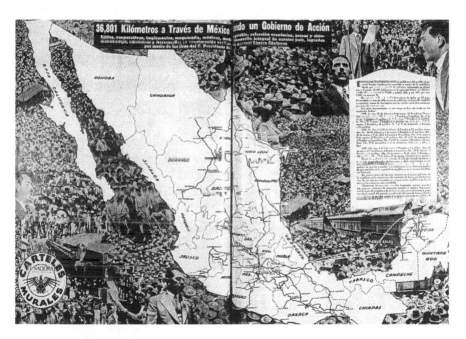

Figure 5.7. "36,801 kilómetros a través de México realizando un gobierno de acción" (Traveling 36,801 Kilometers through Mexico Creating an Active Government). *El Nacional*, September 12, 1937.

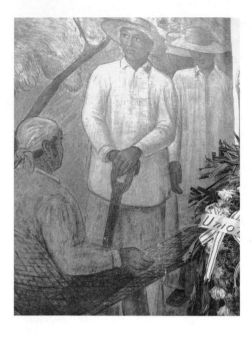

Figure 5.8. Ramón Alva de la Canal,
Vida de Morelos: Parroquia de Parácuaro
(Life of Morelos: The Parish of
Parácuaro), detail, Janitzio, 1938.
Photograph by author.

bierno de acción" (Traveling 36,801 Kilometers through Mexico Creating an
Active Government). Photographs of Cárdenas listening and speaking to the
crowds are inserted throughout the montage to insist on his perpetual pres-
ence. González Mello frames this image (and this reputation for travel) as a
manifestation of the messianic quality in Cárdenas iconography, comparing
such images of Cárdenas listening with an anonymous contemporary paint-
ing of Jesus preaching to Mexico's multiclass masses.[60]

This heroic image of the populist leader listening to his constituents,
teetering on the edge of religious iconography, also directly engaged with
the re-creation of the independence-era leader José María Morelos and his
Christ-like presentation on Janitzio. As discussed in chapter 4, Cárdenas re-
dacted Alva de la Canal's early plans for the murals dedicated to the hero's
life, in particular editing scenes addressing the contentious topic of religion
(even as Alva de la Canal ultimately presented Morelos as a modern-day
Christ figure). In one instance, a scene of Morelos building a church was to
be replaced by a scene of Morelos "amicably chatting with a group of campe-
sinos, who listen to him with great admiration."[61] The resulting scene dedi-
cated to his work as priest and judge in the community of Parácuaro (1798)
shows Morelos seated on a hammock, as three campesinos cluster before
him, listening, while a woman (not visible in figure 5.8) sits behind him. The
religious work of Morelos is secularized—he is a local arbiter, friend, and

resource—and made available for appropriation by Cárdenas. Yet in such a scenario the lines between model and appropriator are blurred, as Alva de la Canal has equally cast Morelos in the image of Cárdenas—arguably at Cárdenas's behest.

While the administration tended to celebrate the exceptional messianic or heroic traveler, Novo's "traveling president" moniker arguably was used ironically, or even derisively, playing on elite and intellectual efforts to distance themselves from mass tourism. Yet the idea of Cárdenas as tourist and the embrace of the rhetoric and imagery of mass tourism arguably became one of the most compelling means to transform the leader into an everyman. In the "36,801 kilómetros" photomontage, Cárdenas was figured as the modern man on the road; complete with route map, he becomes valid as the Mexican president by traveling the country. Coverage of Cárdenas's travels includes pictures of local monuments and *artesanías*, turning the political expeditions into virtual vacations for national readers of periodicals like *Hoy*.[62] His administration followed this lead: in *El Maestro Rural*, for example, images of the secretary of public education, Gonzalo Vázquez Vela, traveling in the Yucatán document his visits to schools, along with visits to archeological sites—the gold standard of tourist destinations.[63] Notably, even Cárdenas's "vacations" were reported on. *Rotofoto* went so far as to publish photographs of Cárdenas in swim-trunks lounging on the Acapulco beach (figure 5.9), along with members of his cabinet, his assistant Colonel Núñez (in one case, buried in the sand), and Luis Rodríguez. Its publication of images of Cárdenas and his cohorts stripping to bathe in a river apparently lost Antonio Carillo Jr. his job at *El Nacional*.[64] (We might ask if Alva de la Canal's images of Morelos and his men stripping fully nude to bathe, which evokes Antonio Pollaiuolo's print *Battle of the Nude Men* [1465–1475], sought in any way to redeem the act or the scandal.) Ultimately, though, while such images of politicians at leisure worked as slurs in Weimar Germany (as Hannah Hoch's photomontage *Heads of State* [1918–1920] attests), in Mexico they arguably helped reinforce Cárdenas's populist claims. Cárdenas's populist style relied on being part traditional, part modern; part visionary messianic leader, part everyman.

The tension between the political work that Cárdenas did all over Mexico and the notion that he was participating in the rituals of tourism was not lost on contemporary readers. In his column for *Hoy*, Salvador Novo leveled his notorious irony at this blending of work and leisure, noting that government employees were now expected to work on vacation, in the spirit of doubling down on progress.[65] On one level this was about Cárdenas and his

Figure 5.9. "Sobre esos cuatro pies se sustentan dos distinguidos personajes políticos" (Two distinguished politicians are supported by these four feet). *Rotofoto* 1 (May 22, 1938).

administration's constant travels. Yet at the same time it reflected a broader institutional pairing of labor and leisure. Professional labor unions, like the teachers' union, increasingly sponsored vacations to special resorts — a trend facilitated in the early 1930s by then governor Cárdenas, for example, when he founded a guesthouse for government employees at Chupícuaro, his favorite beach on Lake Pátzcuaro.[66] Such trends involved both newly won opportunities for leisure and attempts to help structure and inculcate very particular, solidarity-building leisure experiences for classes just learning to go on vacation. In short, Cárdenas was figured as a modern president (and a Mexican president) by virtue of his travels, much as his citizens were likewise being taught the art of being Mexican through tourism.

The Man and His House

As much as Cárdenas's legitimacy to represent the nation became tied to the idea that he was Mexico's "traveling president," his homes are also connected to his public image. On one hand, Cárdenas's decision to relocate the president's Mexico City residence from the Castle of Chapultepec to La Horminga ranch, renamed Los Piños (in honor of his wife's childhood home), was widely understood as a rejection of the castle's ostentation and embrace of a comparably humble presidential image.[67] One widely circulated image

of Cárdenas shows him seated on a tiled bench at Los Piños with Amalia and his son, Cuauhtémoc, presenting him as the proud paterfamilias—a role extended within publicity shots to the nation's children as well.[68] Although less often discussed, La Quinta Eréndira, his home in Pátzcuaro, can equally be considered to be a space that functioned to help shape Cárdenas's public image and tie his biography to both local and national history. In this sense, La Quinta Eréndira and its murals should be read as another portrait of Cárdenas.

If we consider La Quinta Eréndira to be a portrait of its patron,[69] then its remodeling in the 1930s effectively stands as a makeover, as it sharpened Cárdenas's public presentation in a forum that was at once intimately personal and yet regularly open to the public. La Quinta Eréndira was originally constructed in 1928–1929 as a modern lake house on a bluff overlooking Lake Pátzcuaro (figure 5.10). Its innovative ground-plan was a sharp departure from colonial estates: rejecting the local tradition of the enclosed private patio, Cárdenas's elevated house had an open porch and hall, leading to a grand *sala* (originally imagined as a dining room). In 1930 Cárdenas hired Fermín Revueltas to paint murals in the central ground-floor *sala*, as it was being converted into a public library that became known as La Biblioteca Eréndira. After the end of his time as state governor, Cárdenas and Amalia

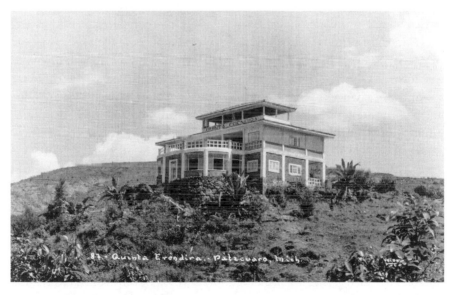

Figure 5.10. "La Quinta Eréndira" (original), Pátzcuaro, ca. 1929. Fondo Pátzcuaro, Archivo Fotográfico, Instituto de Investigaciones Históricas, UMSNH.

Solórzano married and moved into the house, although Cárdenas's work as secretary of war and the navy kept him away from Pátzcuaro for extended periods. Plans for new decorations and remodeling began in 1935 and continued though 1943 and aligned the house with Pátzcuaro's larger stylistic and historical reinvention.[70] Leduc took what was a spare rectilinear structure with a modern floor plan, gridded balconies and windows, and dark walls with light accents and transformed its exterior into an elegant neo-colonial estate with white walls and baroque stonework accents (figure 4.3). Ruiz and his team of sculptors added a fountain decorated with a relief showing Eréndira on horseback, topped with an Indian mother and child, to the front porch's supporting wall, in addition to developing a garden with a round colonial tiled fountain and a series of benches carved with indigenous symbolism.[71] Its most public space, the Biblioteca Eréndira, which had also served as a local school, received a major renovation: one wall was opened up with a series of three arches (closed with window glass), the former mural frieze by Fermín Revueltas was copied in oil on panel and removed to Jiquilpan, and Cuevas del Río painted a new set of murals (1938–1943).[72] Like Pátzcuaro, a modern proposition—a private home, whose ground-level rooms off an open porch and hall served the community as a public library and school—was dressed up in traditional veneer.

The new library murals were designed for the newly remodeled space, yet they also seem to address a growing self-consciousness about Cárdenas's own self-presentation that finds parallels in other contexts. Both mural cycles include a similar set of what we have seen become the region's iconic subjects: Tariácuri dividing his kingdom, the meeting of Tanganxuan and Cristóbal de Olin, the conquest, and the resistance of Eréndira. But there are a number of changes of both content and style. For one, the drama and violence of the earlier scenes are toned down, in part aided by the new murals' monochromatic palette. This might reflect Cárdenas's recognition of a new audience of international diplomats for the space originally decorated for a local library and school. As journalists Sylvia Weyl and Nathaniel Weyl noted, the Spanish ambassador had been deeply offended when he saw the room's depiction of the conquest.[73] In the meeting of the *caltzontzin* and Olid, the two are presented as equals (Cárdenas was, after all, highly supportive of the Spanish Republic) (figure 5.11). The torture of Tanganxuan shows the defiant Purépecha king tall and proud (and intact), before his execution. It is notable that such scenes are preserved; they were not only central to casting regional history in national terms (see chapter 4) but also amplified as part of Cárdenas's biography. The Weyls' 1939 publication (which serves equally

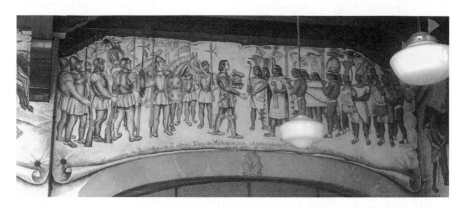

Figure 5.11. Roberto Cueva del Río, *El encuentro de rey Tanganxuan II y el conquistador Cristóbal de Olid* (The Meeting of King Tanganxuan II and Conquistador Cristóbal de Olid), Salon, La Quinta Eréndira, 1938–1943. © Roberto Cueva del Río. Courtesy of Ana María de la Cueva. Photograph by author.

as a biography of Cárdenas and introduction to Mexico's history) tells us that learning the history of Tanganxuan's torture and Michoacán's conquest as a student was formative for the future president. These episodes were scripted into the president's patriotic biography and into his home, becoming part of his claim to revolutionary consciousness.

In this context the new murals' monochromic style is relevant: the murals treating history and legend alike are made to appear as illusionistic parchment documents, tacked onto the walls. Further, one wall was now newly dedicated to reproducing parts of an actual historical document: the sixteenth-century Purépecha-origins manuscript, the "Lienzo de Jucutacato," which in the summer of 1938 had been the subject of an article by Jesús Romero Flores.[74] Thus the new murals make a nod to the ideals of historical authenticity and documentation—key within the newly professionalizing discipline of history (discussed in chapter 4)—as support for Cárdenas's historical consciousness.

Furthermore, Cueva del Río added two key scenes to the cycle: portraits of Don Vasco de Quiroga and José María Morelos now flank the central windows with their view of Janitzio (figure 4.10). As discussed in chapter 4, Cárdenas and his supporters appropriated these figures, recast them using secular hagiography, and promoted them in publications, rituals, and memorials. Both were also rhetorically linked with Cárdenas. Morelos (along with Zapata) was regularly held up as Cárdenas's precursor in the struggle for agrarian rights, racial justice, and anticlericism (despite having been a

priest). Cárdenas's alignment with Quiroga was more complex and had first required Quiroga's recasting as social visionary. As Vázquez Mantecón discusses, the collective imaginary has regularly linked the two men, assigning Cárdenas messianic, redemptive, Christian values, in addition to associating both with ideals of justice. Historians regularly point to the Purépecha title of endearment shared by "Tata Vasco" and "Tata Lázaro" and the mythic love and support claimed by each. According to a friend, Raúl Noriega, Cárdenas was genuinely interested in and influenced by the biography of Vasco de Quiroga.[75] As discussed in chapter 3, both men rode around the countryside to visit far-flung communities, promoted *artesanías* as the basis of the regional economy, and proposed communal organization as an alternative to a dystopian world. Furthermore, Cárdenas worked to create an olive industry in Michoacán, materializing a modern version of a piece of Quiroga's memory (guidebooks remind us that Quiroga brought olive trees to the region). By including portraits of Morelos and Quiroga at La Quinta Eréndira, Cárdenas's new library murals extend history into the modern era and frame the terms in which Cárdenas himself would be remembered.

How well, and how truly, did these images resonate on a national level? This process of secularizing and appropriating the memory of Catholic figures from the colonial period had a precedent in friar Bartolomé de las Casas. Secularized in the later nineteenth century, the friar had been mobilized within the pages of *El Eco Revolucionario* to promote the candidate Cárdenas as a modern-day apostle from the mountains, who preached the just treatment of indigenous populations.[76] Yet the extent to which this conflation of religious and secular values was accepted or viewed with skepticism is suggestively addressed in the version of Antonio Carrillo's well-known photograph of "Tata Lázaro" published in *Rotofoto* in 1938 with a revealing caption (figure 5.12):

> Eyes fixed on the leader; the gesture of simple men that arrive believing that they are meeting someone who will understand them. On Carrillo's photo, which synthesizes an entire epoch of Mexican life, one could engrave the legend that accompanies the monument to friar Bartolomé de las Casas: "Reader, pause and contemplate: this is Lázaro Cárdenas, protector of the Indians."[77]

This casting of Cárdenas in the guise of a secularized sixteenth-century proto-*indigenista* social reformer clearly was sufficiently well rehearsed nationally that it was fit to be the target of *Rotofoto*'s irony and efforts to foster

Figure 5.12. Antonio Carrillo, "Los ojillos proyectados sobre el líder" (Eyes Projected on the Leader). *Rotofoto* 2 (May 29, 1938).

viewers' critical engagement with authority. In this case, readers are implicitly warned to not be "simple" and instead to reflect on Mexico's president and his presentation in the media. Notably, while *Rotofoto*'s editors framed this image critically in 1938, in 1947 Carrillo was given a photojournalistic award for the photo, presented simply and nostalgically as "Tata Lázaro."

It is also interesting to contemplate how Cárdenas at La Quinta Eréndira and in Pátzcuaro was imagined and read nationally. Not only did Cárdenas open his home to locals and invite diplomats to visit him, but journalists also interviewed him there. In December 1938 José "Pepe" Rojas visited Cárdenas in Pátzcuaro and published an article in *Excelsior*, asserting: "The government will not enact more expropriations."[78] Illustrated with an image of a relaxed Cárdenas leaning on the dockside railing and speaking with the journalist, the interview sets the scene on the twilit shores of Lake Pátzcuaro and then clarifies that Cárdenas does not plan to expropriate the mining and electrical industries during his final year in office, so long as companies follow Mexican law. Salvador Novo's commentary in *Hoy* critically deconstructs this photo-op and interview, suggesting that the president in Pátzcuaro exhibited a contemplative and retreating persona and a foil to the man

of action. Set in this "romantic" locale, the resulting article creates a calming image, effectively reassuring readers that the period of turmoil—the revolutionary January 1938 oil expropriation—was over.[79] Thus Roja, Novo, and arguably Cárdenas all acknowledge the power of the picturesque, mobilizing it in the interests of the political moment, returning us to the lakeshore, and in effect decentering Pátzcuaro once again as a mere regional retreat.

As much as Cárdenas manipulated his image (even via his own home), he was not alone in controlling and framing its public reception. The competing images of Cárdenas and Pátzcuaro were subject to criticism, recasting, and reinterpretation by actors in a range of contexts. Notably, however, during this period in which ideas about what it meant to be a nation's leader were dramatically changing, even those images and ideas initially used to critique Cárdenas in the pages of *Hoy* and *Rotofoto* ultimately served to enhance his populous image. A new range of possibilities was laid out in the 1930s, and the issues raised then still resonate today.

A MODERN BODY POLITIC

In this chapter, and in this book more broadly, I have argued that the creation of Pátzcuaro was not an isolated project but was part of the larger process of creating modern Mexico as well as the myth and image of its major patron, President Lázaro Cárdenas. These interests arguably crystallized around the creation of a new version of Mexico's body politic and provided a new way of thinking about the relationship between the leader and the masses. It goes beyond the image of the undifferentiated masses' surging support for their leader, or of the leader seated, listening and acting on behalf of his constituents. The tradition of the "body politic" describes metaphorical relationships and asks us to image that the leader and the masses could share the same body and thus will. In the case of Cardenista Mexico, the core of this new body politic centers on President Cárdenas's vision for Mexico and the question of whether he could persuade others to share it. This is the essence of the exhibitionary complex described by Tony Bennett: that the public might

> identify with power, to see it as, if not directly theirs, then indirectly so, a force regulated and channeled by society's ruling groups but for the good of all: this was the rhetoric of power embodied in the exhibitionary complex—a power made manifest not in its ability to inflict pain but by its ability to organize and co-ordinate an order of things and to produce for the people in relation to that order.[80]

The Pátzcuaro project demonstrates both the limits and possibilities of how art, tourism, and history might be used to manufacture a shared viewpoint, enabling such identification with power and thus serving as a technology of governance.

If intellectuals shared a common cause, if not agreement, with Cárdenas in the desire to expand and stabilize Mexico's educational and research institutions, tourism provided the mechanism for aligning the masses with Cárdenas. The idea that touring the nation would enable one to become a better Mexican predates Cárdenas. Nineteenth-century nation-building projects, such as the *Átlas pintoresco e histórico de los Estados Unidos Mexicanos* (1885) discussed by Magali Carrera, anticipated this idea by tying statistical, historical, ethnographic, and topographical knowledge to the spatial system of cartography.[81] When Mexico's twentieth-century artists and intellectuals began traveling the nation—we might recall secretary of public education José Vasconcelos sending Diego Rivera to the Tehuantepec region in the early stages of the muralism movement—they built on and expanded such nineteenth-century precedents for nation building, further entrenching the idea that to realize oneself fully as a Mexican artist, one must travel Mexico. Likewise, the travels of early art historians like Manuel Toussaint and Justino Férnandez, we are told, established a key professional prerogative of the Mexican art historian, as they sought to identify and document the nation's artistic treasures.[82] Yet no one had so publicly demonstrated the legitimating and authenticating power behind the idea that to travel Mexico was to become Mexican as Lázaro Cárdenas did. With the president's highly publicized travels, he became the country's leading tourist, setting the standards for the nation-building potential of tourism. And his publicly celebrated example—remodeling his house to align it with *lo típico*, incorporating Mexican history into his personal consciousness-raising journey, giving *artesanías* as gifts to leaders around the world—was to be made accessible to modern tourists and citizens.

Travel, the 1936 *Mapa* article treating Pátzcuaro tells us, has the potential to transform the modern Mexican into a more authentic and fully realized citizen who understands that his or her nationality emerges over generations, revealing Mexico's distinctive "character" and "soul" and creating a loyalty to Mexico's "lands and blood."[83] Such narratives made their way into popular culture on multiple fronts. Ismael Rodríguez Ruelas's 1942 film *¡Que lindo es Michoacán!* (How Beautiful Michoacán Is!) makes the restorative nature of such narratives explicit. The film opens as a cosmopolitan female heiress drives home to Pátzcuaro to oversee her father's business interests

following his death, bringing her French cook, pantsuits, fancy appliances, and modern attitudes with her. From the start, her modernity conflicts with everything around her, including the film's leading man, a local lumberjack. Yet as she grudgingly falls in love with this man (in charge of logging on her father's estate), she seemingly Mexicanizes. She dresses in traditional regional clothes, sings and dances to traditional music, and learns to be a particular version of feminine, Mexican, and traditional—much as Adriana Zavala describes in *Becoming Modern, Becoming Tradition*.[84] The romantic climax of the film reconciles the film's range of class, culture, and gender conflicts, as the woman acquiesces (or even "domesticates," on multiple levels), agreeing to let her working-class romantic lead run her logging business.

Notably, *¡Que lindo es Michoacán!* is a story not about tourism but rather about the travel and transformation of the landed elite. This class difference is key, however, because it speaks directly to the promise of mass tourism to grant the middle classes and the organized working class a semblance of class mobility and access to luxury, knowledge, and service. Tourists could buy the *huipiles* and *bateas* that helped transform the film's upper-class heroine and hire canoes to explore the lake, as she does. Pages of history previously shut away in private libraries were now available to the public, both in Pátzcuaro's public lending libraries and as monuments in its streets. This seeming potential for class mobility is also found with the transformation of Pátzcuaro's architecture. Former elite residences were being opened as hotels, whose middle-class guests would enjoy a few days of the settings and service once associated with Mexico's eighteenth- and nineteenth-century elite. Meanwhile, the former Colegio de San Nicolás, once a school for Spanish aspirant priests and Indian nobles, was transformed into a public museum, and the private convent San Agustín was replaced by a public theater: the transformation of Pátzcuaro opened up elite spaces to a middle-class culture of leisure and travel.

In short, tourism helped create a middle-class identity that included the illusion of social mobility and privilege. Arguably, its visual culture played a particularly important role in constituting middle-class privilege, which operated in large part via technologies of seeing. As demonstrated in chapter 1, the vision of nineteenth-century foreign travelers defined the touristic picturesque along with its complex negotiation of access, distance, and desire. The antimodernist challenge to the picturesque might be understood as offering a route "off the beaten track" and more specifically as a means of negotiating an alternative identity for those seeking to refute middle-class, and touristic, identity.

Most tellingly for a modern body politic, however, we might return to the virtual views offered from high above the lake. Ricardo Bárcenas's 1937 mural *Industrias de Michoacán* presents a virtual marketplace overlooking Lake Pátzcuaro (plate 6). As discussed in chapter 3, this representation of regional *artesanías* pays homage to their historical and contemporary role in the local economy as well as to the ideal promoted by the SEP and institutionalized with the creation of Pátzcuaro's Museo de Artes e Industrias Populares: that *artesanías* represent an authentic spiritual and aesthetic manifestation of indigenous Mexico. What I want to explore here, however, is the vantage point from which we view the lake.

Bárcenas perhaps had read Alfredo Maillefert's recently published book, *Laudanza de Michoacán* (1937), as part of his stay in Pátzcuaro, as the mural's imagery is closely linked to Maillefert's impressionistic description of viewing the lake:

From a window as we write these pages, we see the lake and some blue mountains . . . and think about Don Vasco. About Don Vasco, who ran all over the diocese . . . on his white mule. . . . About Don Vasco, who ran around to villages to watch and advise the artisans who carve the wood, paint the platters, polish and decorate the vases, who have been doing these things that he taught them and that fill them still with the fervor of life and of love of *artesanías*, the *tianguis* of the Michoacán people.[85]

As discussed in chapter 3, Bárcenas's mural, with its blue hills, lake view, artisans crafting *artesanías* in the *tianguis*, and Don Vasco on his white mule, arguably embodies this passage. The question raised here, however, is, to whom does this window view belong?

Notably, this view of Lake Pátzcuaro and the island of Janitzio is closely connected to the view from Cárdenas's estate. As discussed above, Cárdenas opened his house to locals and visitors and apparently to photographers as well. Postcards offering lake views from Cárdenas's estate were sold during this period (as were images of his house, elevated on its bluff) and offered tourists a transportable virtual reality replicating Cárdenas's view of Lake Pátzcuaro. Yet the mural's vantage point is higher than the view from Cárdenas's house. Bárcenas's market is nearby, above and behind the estate on the Cerro Colorado, where Governor Gildardo Magaña constructed another new *mirador* between 1936 and 1938.[86]

This neocolonial-styled *mirador*, El Estribito, includes multiple pavilions, multitiered platforms, and baroque decorative accents (figure 5.13). The

Figure 5.13. El Estribito Mirador (The Estribito Overlook), Pátzcuaro, 1938. Photograph by author.

main pavilion includes two folkloric-themed murals by Cueva del Río and originally housed a market. Designed to offer views in multiple directions, the once deforested site is now overgrown. Yet in imagining its original grandeur, we might ask whether this *mirador* represents a democratizing effort, wherein the view from the president's house is replicated yet superseded by a collective, public view and by Bárcenas's mural. And while the viewpoints do not perfectly align—Cárdenas's is farther to the left—creating a desire to compensate for such differences has long been a (the?) key task of virtual reality, art, and visual culture.[87] Thus we are presented with the modern body politic, wherein the viewer—a local, a tourist, or a visiting diplomat—might virtually align with the president's point of view and is invited to identify with power and with Mexico.

CONCLUSION

Even as Cárdenas's vision continues to resonate, it is worth noting that his project neither was ultimately fully successful nor dominated the lake region absolutely. If the Pátzcuaro project provides a political and cultural micro-

cosm in which to study the emergence of modern Mexico, it does so because intellectuals, artists, locals, and Mexico's cultural elite believed that it would be mutually beneficial to align their projects with Cárdenas's vision for the region. Further, as a microcosm of Mexico, the Pátzcuaro project equally reveals the extent to which there was space within this vision for alternative projects and for individuals and groups to negotiate their own relationship to Mexico's people, history, and land.

In a final reflection of the coherence of the Cardenista project, especially with regard to the arts, it would be useful to recall that in July 1938, in the midst of the re-creation of Pátzcuaro, Diego Rivera and Frida Kahlo brought Leon and Natalia Trotsky, André Breton, Jacqueline Lamba (his wife), and Jean van Heijenoort on a retreat to Pátzcuaro. The party was hosted at La Quinta Tzipecua, the lakeside home of Cárdenas's longtime friend and secretary of public works, Gen. Francisco Múgica, which suggests a degree of official support (and protection) for the visit.[88] They ate whitefish, visited local sites, and went on a nighttime excursion to Janitzio (where, upon being recognized, they were serenaded in Purépecha by schoolchildren). Rivera, Van Heijenoort, and Breton hunted for ancient Chupícuaro artifacts (much to Trotsky's displeasure).[89] They very much acted as tourists, although perhaps most importantly Pátzcuaro became the setting in which Trotsky and Breton began planning their landmark manifesto: "For a Free and Revolutionary Art."[90] While the group's stay arguably reflects their sympathetic relationship with Cárdenas (who had granted Trotsky asylum in Mexico the year before), their efforts to define a "free and revolutionary" art speak to the larger problem of cultural autonomy.

As Robin Greeley points out, the encounter and resulting manifesto reveal two distinct approaches to this problem.[91] In the manifesto the revolutionaries reflect on the rise of totalitarian states in Germany and the Soviet Union and their damaging effects on artistic production. The capitalist world, they note likewise, is not viable for the arts, imposing its own restraints. Breton originally proposed a paragraph (born in praxis) in which he describes art as subordinate to the material condition of its creation while simultaneously being able to critique these conditions. This would acknowledge the possibility that socialist art made for a socialist government like Cárdenas's would be shaped by such patronage, while remaining free to critique the system. By contrast, Trotsky's language, which was ultimately published, asserts a need for socialism in politics (so that society's and artists' basic needs are supported) and anarchism in the arts (so that artists can pursue fully free and revolutionary art, unhindered by political and

economic censorship). As Greeley notes, Trotsky was unable to imagine art fully within the system of socialist production and instead projected culture into the realm of anarchism (without providing any road map for what this would look like, apart from a lack of control from above). Such a debate was to the point in Mexico of 1938, as Cárdenas stepped back from his more radical proposals, and state-supported artists and intellectuals debated these questions and sought autonomy. That such a manifesto was launched in Pátzcuaro, under the roof of Gen. Múgica, remains both a reminder of the Mexican state's role during the 1930s in creating the conditions of cultural production and a testament to the possibility of creative and intellectual autonomy within Cárdenas's Mexico.

The legacy of these ideals remains active in Pátzcuaro, which has been home to a diverse range of artists, artistic agendas, and funding sources for cultural production and promotion. Artists have continued to visit Pátzcuaro, where formal and informal artist retreats have been established over the years. Surrealists Gordon Onslow Ford and Jacqueline Johnson made a home, dubbed "The Mill," in an abandoned hacienda in Erongarícuaro and hosted a succession of surrealists along Lake Pátzcuaro's shores. As anthropologist Ruth Hellier-Tinoco has demonstrated, both the private sector and government officials alike still evoke the dance of the Viejitos and the Noche de los Muertos as iconic symbols of Mexico. Notably, Alva de la Canal, who sketched tourists with cameras at the Noche de los Muertos, also saw fit to critique the commodification of such rituals and their transformation into spectacle. Both state and federal funds continue to support cultural activities in Pátzcuaro, from the INAH-controlled public theater and recently remodeled Museo de Artes e Industrias Populares to a cultural center created within the halls of the former Colegio de la Compañía, which operates under Michoacán's secretary of culture.

If Cárdenas and intellectuals guided the creation of Pátzcuaro, its realization and persistence owe much to its reception locally. Local leaders—including those like Luis Ortiz Lazcano, who historically had been at odds with Cárdenas's policies—used the president's interest in regional economic development to buoy their own private ventures, from founding hotels to establishing a new local electrical company.[92] Locals formed tourism-promotion groups and debated the best ways to organize their efforts to serve tourists. Ongoing tensions surrounding vending and markets in Pátzcuaro, short-lived experiments with cooperatives on Janitzio, and Pátzcuaro's boat-launch operators efforts to dominate the emerging transportation industry on the lake suggest both a growth of economic opportunity and the persis-

tence of long-standing social divisions and hierarchies. As Zizumbo Villa-real has discussed, the local tourism economy has been especially helpful for those who already had resources and a degree of economic stability but has proved to be a fickle source of support for its service workers.[93] Yet many clearly learned to work with the demands of the new service economy: dress-ing in regional attire to serve dinners, selling goods, performing, and posing for pictures. By contrast, however, the historically indigenous community of Ihuatzio—like the legendary Purépechas who threw stones to scare away the Aztecs' prophesied eagle that attempted to land on the shores of Lake Pátz-cuaro—violently rejected a proposal in the 1940s to develop a museum at the site newly excavated by INAH archeologists.[94] Responses to the changes clearly varied and reflected long-standing divisions.

If on one hand I have described the structural and institutional changes that aligned to create Pátzcuaro and Mexico, on the other I have suggested that the practices of touring, seeing, and experiencing Pátzcuaro also have profoundly shaped the social relationships that govern the region and define the nation. While the incredible diversity of images produced in this con-text suggests something of the variety of individual responses to the area and tourism, together they helped generate the terms for belonging within the nation. What the images share is that they offer their viewers the opportunity to identify with power: the power of consuming, of gazing, of differentiat-ing, of patronizing, of identifying. Images and touristic practices alike gen-erate a sense of privilege, which becomes a key ingredient within the mythic foundations of citizenship. While that on-high view is fleeting, its appeal remains persistent.

Locals also embraced this opportunity. Artist Gabriel García Maroto's charge to see and represent the region and thereby reclaim it resonated be-yond his students. While the local visual records remain fragmentary, we have seen that local professionals and amateurs alike negotiated the new spaces of tourism to create their own images of the region. Family albums, photographic archives, and stories attest to the role that tourism plays in Patzcuareños' lives: local families relax at the *miradores*, integrate local post-cards into their family albums, and participate in the rituals of tourism.[95] Even as locals learned to see their region through tourists' eyes, they also added their own ways of seeing and understanding the region to the mix.

Even those who clearly differed with elements of Cárdenas's modern-ization program used art as a means to claim the changes to their town as their own, as a local newspaper illustration from 1943 demonstrates (figure 5.14). Jorge Servín González founded *Colega* as the newspaper for a local

Figure 5.14. G. Cerda M., cover illustration with Tanganxuan. *Colega* 2 (April 15, 1943). Courtesy Servín González Family.

Catholic secondary school in 1942. For the cover of the April 15, 1943, issue, G. Cerda M. created an image integrating many of the region's key touristic sights. Tanganxuan stands guard over the lake, its islands, and La Pila del Toro in the Plaza Chica—a composition that effectively projects a unity between the lake and the town, with their very different constituencies. Cerda converted Tanganxuan's pedestal into a view of a church (Compañia de Jesús), Calle Lerín, and the dome of the Sagrario. In this reconfiguration of time and space, Catholic Pátzcuaro provides the foundation for the heroic image of Pátzcuaro's Indians. The state built its monuments, postcard makers teach us what to look at and how to see, but individuals and communities still assemble the pieces to suit their own agendas.

Ultimately, the process of creating Pátzcuaro was one of negotiation. It reveals that as much as Cárdenas's interest cast Pátzcuaro as a microcosm of power in Mexico, there remained space to contest and reframe such power. Furthermore, while the state established policies and institutions during the 1930s, the result was not a perfectly stable, centralized state but rather one with multiple centers, which found ways to serve multiple (though far from all) interests. Attention to the art and visual culture of Pátzcuaro makes some of those competing voices visible again, granting us insight into the state's projection of its collective national vision as well as its blind spots. At the same time, the rituals and visual culture of tourism helped establish the practices and social relationships that allowed citizens and foreigners alike to see and experience their positions vis-à-vis the history, lands, and cultures of Mexico. Working together as technologies of nationalism, art and tourism helped create Mexico.

Notes

AGHPEM	Archivo General e Histórico del Poder Ejecutivo de Michoacán, Morelia
AGN	Archivo General de la Nación, Mexico City
AHIBNAH	Archivo Histórico Institucional, Biblioteca Nacional de Arqueología e Historia, Mexico City
CAM	Compañía Aerofoto Mexicana
CERM	Centro de Estudios de la Revolución Mexicana Lázaro Cárdenas, Unidad Académica de Estudios Regionales de la Coordinación de Humanidades de la UNAM, Jiquilpan
CMT/IIE	Colección Manuel Toussaint, Archivo Histórico y de Investigación Documental, Instituto de Investigaciones Estéticas, UNAM, Mexico City
COLMICH	El Colegio de Michoacán, Zamora
CREFAL	Centro de Cooperación Regional para la Educación de Adultos en América Latina y el Caribe, Pátzcuaro
DAAP	Departamento Autónomo de Prensa y Propaganda
DMAAH	Departamento de Monumentos Artísticos, Arqueológicos e Históricos
ENAP	Escuela Nacional de Artes Plásticas (1929 to present, formerly ENBA)
ENBA/AP	Escuela Nacional de Bellas Artes (1857–1929, formerly Academia de San Carlos)/Artes Plásticas
IIE	Instituto de Investigaciones Estéticas, UNAM, Mexico City

IIH	Instituto de Investigaciones Históricos, Universidad Michoacana San Nicolás de Hidalgo, Morelia
INAH	Instituto Nacional de Antropología e Historia
IPN	Instituto Politécnico Nacional, Mexico City
LCR/AGN	Fondo Lázaro Cárdenas del Río at the Archivo General de la Nación
LEAR	Liga de Escritores y Artistas Revolucionarios
SEP	Secretaría de Educación Pública
UMSNH	Universidad Michoacana de San Nicolás de Hidalgo, Morelia
UNAM	Universidad National Autónoma de México

INTRODUCTION

1. Teresa Castelló Yturbide, *Pátzcuaro: Cedazo de recuerdos*, 29.

2. December 31, 1931, *Libro de actas*, Archivo Histórico Municipal de Pátzcuaro.

3. Jesús Romero Flores, *Lázaro Cárdenas: Biografía de un gran mexicano*, 44–45.

4. *Memoria de la Secretaría de Educación Pública, septiembre de 1935–agosto de 1936*, 212.

5. Múgica became secretary of public works; Jesús Romero Flores became a historian at the National Museum.

6. Romero Flores suggested to Cárdenas that the Chapultepec Castle become a national history museum. Romero Flores, *Lázaro Cárdenas*, 108.

7. See Maurice Tenorio-Trillo, *Mexico at the World's Fairs*; William H. Beezley and Linda A. Curcio-Nagy, eds., *Popular Culture in Latin America*; Mary Kay Vaughan and Stephen E. Lewis, *The Eagle and the Virgin*.

8. "En defense de Pátzcuaro," *Mapa* (December 1936): 33. All translations are my own, unless otherwise noted.

9. See, for example, Leonard Folgarait, *Mural Painting and Social Revolution in Mexico: Art of a New Order*; David Craven, *Art and Revolution in Latin America*; Mary K. Coffey, *How a Revolutionary Art Became Official Culture*; Alejandro Anreus, Leonard Folgarait, and Robin Greeley, eds., *Mexican Muralism: A Critical History*.

10. See Craven, *Art and Revolution*, 34.

11. Henri LeFebvre, *Everyday Life in the Modern World*; Claudio Lomnitz-Adler, "Concepts for the Study of Regional Culture," 195.

12. Alan Knight, "Cardenismo: Juggernaut or Jalopy?"; Alan Knight, "Revolutionary Project, Recalcitrant People"; Mary Kay Vaughan, *Cultural Politics in Revolution*; Marjorie Becker, *Setting the Virgin on Fire: Lázaro Cárdenas, Michoacán Peasants, and the Redemption of the Mexican Revolution*; Verónica Oikión Solano, ed., *Historia: Nación y región*.

13. Most typically, art outside Mexico City is approached within an individual artist's trajectory. Increasingly, the spread of Mexican muralism is being studied in its own right. On muralism's international diffusion, see Laurance Hurlburt, *Mexican Muralists in the United States*; *Territorios de diálogo: México, España, Argentina, 1930–1945*; and Ana Indych-López, *Muralism without Walls: Rivera, Orozco, and Siqueiros in the United States, 1927–1940*. On muralism in Michoacán, see James Oles, "Walls to Paint

On: American Muralists in Mexico, 1933–36"; Sofía Irene Velarde Cruz, *Entre historias y murales: Obras ejecutadas en Morelia*; Jesús Ernesto López Argüelles, "Fermín Revueltas: Roberto Cueva del Río en Jiquilpan," and "Resimbolización del espacio público en la etapa posrevolucionaria: De Santuario de Guadalupe a Biblioteca Pública"; as well as essays in Leticia López Orozco, ed., *Escenas de la independencia y la revolución en el muralismo mexicano*; and Ida Rodríguez Prampolini, *Muralismo mexicano, 1920–1940*, vol. 2.

14. Vaughan and Lewis, *The Eagle and the Virgin*, 13; James Oles, *Art and Architecture in Mexico*, 290; Dafne Cruz Porchini, "Proyectos culturales y visuales en México a finales del Cardenismo," 15. On period ephemera, see *Arqueología del régimen, 1910–1955*.

15. Alex Saragoza, "The Selling of Mexico: Tourism and the State, 1929–1952," 96–98.

16. Hurlburt, *Mexican Muralists*; Jennifer Jolly, "David Alfaro Siqueiros's Communist Proposition for Mexican Muralism"; Oles, *Art and Architecture*, chapter 8; María Fernández, *Cosmopolitanism in Mexican Visual Culture*, 194–220.

17. See Olivier Debroise, "Mexican Art on Display"; Adriana Zavala, *Becoming Modern, Becoming Tradition*; Rick López, *Crafting Mexico: Intellectuals, Artisans, and the State after the Revolution*; Ruth Hellier-Tinoco, *Embodying Mexico: Tourism, Nationalism, and Performance*.

18. Raquel Tibol, "El nacionalismo en la plástica durante el cardenismo," 245; David Alfaro Siqueiros, "New Thoughts on the Plastic Arts in Mexico."

19. The most relevant works here include Becker, *Setting the Virgin on Fire*; William H. Beezley, Cheryl English Martin, and William E. French, eds., *Rituals of Rule, Rituals of Resistance*; Vaughan, *Cultural Politics*; Jennie Purnell, *Popular Movements and State Formation in Revolutionary Michoacán*; Verónica Oikión Solano, *Los hombres del poder en Michoacán, 1924–62*; Christopher Boyer, *Becoming Campesino*; Vaughan and Lewis, *The Eagle and the Virgin*.

20. On the nation as a social construct, see Benedict Anderson, *Imagined Communities*.

21. López, *Crafting Mexico*, 79, 76–94.

22. Marxist Henri LeFebvre emphasizes spatial elements of capitalism and state planning in *Everyday Life*.

23. Knight, "Cardenismo"; Knight, "Revolutionary Project"; Vaughan, *Cultural Politics*.

24. Claudio Lomnitz-Adler, *Exits from the Labyrinth*, 4. See Vaughan and Lewis, *The Eagle and the Virgin*, 9.

25. Folgarait makes a revisionist argument in *Mural Painting and Social Revolution*, arguing that Mexican muralism contributed to the consolidation of authoritarianism in Mexico. In *How a Revolutionary Art Became Official Culture*, Coffey provides a nuanced account of how muralism, with its claims to revolutionary opposition, was gradually institutionalized during the mid-twentieth century. See also Mary Kay Vaughan, *The State, Education, and Social Class in Mexico*, 265; and Anreus, Folgarait, and Greeley, *Mexican Muralism*. Exceptions include *Misiones culturales, los años utópicos, 1920–1938*.

26. Cárdenas asked that "indigenous" schools around Lake Pátzcuaro be federalized in 1937: Lázaro Cárdenas to the SEP, Feb. 4, 1937, 533/20, Fondo Lázaro Cárdenas del Río at the Archivo General de la Nación (LCR/AGN).

27. See *Misiones culturales*. On efforts in Michoacán, see Hellier-Tinoco, *Embodying Mexico*; and Marco A. Calderón Mólgora, "Festivales cívicos y educación rural en México."

28. Guillermo Palacios, "The Social Sciences, Revolutionary Nationalism, and Interacademic Relations: Mexico and the US, 1930–1940," 70.

29. Vaughan, *Cultural Politics*.

30. Juan E. Noguez to President, Oct. 30, 1939, and Nov. 3, 1938, 531.2/460 LCR/AGN; letters dating from 1936 to 1937 regarding secularization of churches, 545.2/15 and 2/342(13)14246, exp. 26 LCR/AGN. Leduc was challenged in his efforts to inspect and restore churches (see above), use old tiles from the convent for his new school on Jarácuaro, and pursue development on the outskirts of town. See letters in 609/210, 568/9 LCR/AGN.

31. "Cronología compartida," in *Guillermo Ruiz y la Escuela Libre de Escultura y Talla Directa*, 39–40; "Historia," *La Esmeralda.edu.mx*, http://www.esmeralda.edu.mx/presentacion.html. On art education, see Laura González Matute, "A New Spirit in Post-Revolutionary Art: The Open-Air Painting Schools and the Best Maugard Drawing Method, 1920–1930," 28–43; and Aurelio de los Reyes, ed., *La enseñanza del arte*.

32. See *Memoria del Departamento Autónomo de Prensa y Publicidad, septiembre 1937–agosto de 1938*; Fernando Mejía Barquera, "Departamento Autónomo de Prensa y Publicidad (1937–39)."

33. Rafael López González, "Departamento Autónomo de Prensa y Propaganda (DAPP): La experencia del estado cardenista en políticas estatales de comunicación" (thesis de licenciatura en Ciencias de la Comunicación, Ciudad de México, UNAM, Facultad de Ciencias Políticas y Sociales, 2002); Tania Celina Ruiz, "El Departamento Autónomo de Prensa y Publicidad: Construyendo la nacion a través del cine documental en México (1937–1939)," dissertation (Universidad Michoacana de San Nicolás de Hidalgo, Morelia, 2010); Cruz Porchini, "Proyectos culturales."

34. Cruz Porchini, "Proyectos culturales," 29–30, 40–49.

35. Cited in ibid., 29.

36. On visual artists and DAPP, see Cruz Porchini, "Proyectos culturales." For a list of employees petitioning for back pay following its dissolution, see Aurelio Bueno Jr. to Carlos Merida, Álvarez Bravo, and other signatories, Oct. 25, 1940, 545.3/252, LCR/AGN.

37. Cruz Porchini, "Proyectos culturales," 15.

38. Esther Gabara, *Errant Modernism: The Ethos of Photography in Mexico and Brazil*, 16.

39. Fernández, *Cosmopolitanism*, 2.

40. Néstor García Canclini, *Transforming Modernity*, 64–68.

41. See essays in "The Tehuana" issue of *Artes de México* 49 (2000), especially Aída Sierra, "The Creation of a Symbol."

42. Jeanne L. Gillespie, "The Case of the *China Poblana*," 32–34.

43. Ibid., 36; Covarrubias, "A Southward View" (1946), reprinted in *Artes de México*.

44. Tom Demott, *Into the Hearts of the Amazons: In Search of a Modern Matriarchy* (Madison: Terrace Books/University of Wisconsin Press, 2006), 58–61.

45. Hellier-Tinoco, *Embodying Mexico*, 67 (emphasis added).

46. Dina Berger, *The Development of Mexico's Tourism Industry*, 15, 58; Saragoza, "Selling of Mexico," 91.

47. Saragoza, "The Selling of Mexico," 91 (see also 92–98).

48. Gabara, *Errant Modernism*, 169.

49. See Medina Lasansky, *The Renaissance Perfected*.

50. Dennis Merrill, *Negotiating Paradise*, 8–12.

51. Dina Berger and Andrew Grant Wood, *Holiday in Mexico*, 9–10, 21–53. On tourism and the Mexican Railroad, see Douglas A. Murphy, "Mexican Tourism, 1876–1940: The Socioeconomic, Political, and Infrastructural Effects of a Developing Leisure Industry" (MA thesis, University of North Carolina, 1988).

52. Berger, *The Development of Mexico's Tourism Industry*, 7.

53. On the emergence of domestic tourism, the key source is Barry Carr, "Issues and Agendas in Writing the Tourism History of Mexico (1940–2008): A Comparison of the Acapulco and Cancún Development Paths" (unpublished manuscript, June 6, 2014), especially 36–41.

54. John Urry and Jonas Larsen, *The Tourist Gaze, 3.0*, 31.

55. "Low Fares for Mexican Workers," *Labor Conditions in Latin America: Latin American Series No. 5* (Washington, DC: Department of Labor, June–July 1940), p. 16, cited in Carr, "Issues and Agendas," 44.

56. Berger, *The Development of Mexico's Tourism Industry*, 110–111. See also the guidebooks published by the Secretaría de Hacienda y Crédito Público in Mexico City, including *Pátzcuaro* (1936), *Morelia* (1936), *Uruapan* (1936), and *Chapultepec* (1938) by Justino Férnandez, and *Tasco* (1932) by Manuel Toussaint.

57. Eugene D. Owen, "Paid Vacations in Latin America," *Labor Conditions in Latin America (from Monthly Labor News)*, March, April, May 1940 (Washington, DC: 1940), 8–9, cited in Carr, "Issues and Agendas," 37.

58. For example, the Mexican Electricians' Syndicate used its journal to promote travel to Michoacán and regularly promoted art and archeology of different regions in Mexico. see, for example, *Lux* 10, no. 4 (April 1937); Carr, "Issues and Agendas," 38.

59. Merrill, *Negotiating Paradise*, 10–13.

60. David Kaplan, "The Mexican Marketplace in Historical Perspective"; Gunther Dietz, Kirsten Stolley de Gámez, Gerrit Höllmann, and Frank Garbers, *Las artesanías en la cuenca del Lago de Pátzcuaro: El caso del tallado de madera y la alfarería*, 45–46

61. December 31, 1931, *Libro de Actas*, 240–241, Archivo Histórico Municipal de Pátzcuaro.

62. "Una vista al Estado de Michoacán: Sus carreteras, su importancia, sus bellezas naturales," Gobierno 1928–31, Caja Michoacán, Archivo Fernández y Fernández, Colegio de México (COLMICH), Zamora; Amalia Solórzano de Cárdenas, *Era otra cosa de vida*, 37.

63. Fernández, *Pátzcuaro*, 21–23.

64. Esperanza Ramírez Romero, *Catálogo de monumentos y sitios de la región lacustre*, 47, 55, 268–271.

65. Michiel Baud and Annelou Ypeij, "Cultural Tourism in Latin America: An

Introduction," in *Cultural Tourism in Latin America*. According to Baud and Ypeiji, cultural tourism in Latin American privileges indigenous culture and history above all others (1, 8–10).

66. May 30, 1936, *Libro de Actas*, 54, Archivo Histórico Municipal de Pátzcuaro; "Quedo constituido el comité pre-turismo en la CDAD. de Pátzcuaro," *Heraldo Michoacano* (November 10, 1938), 3, 13.

67. See Baud and Ypeiji, "Cultural Tourism"; R. Tripp Evans, *Romancing the Maya*; Lisa Breglia, *Monumental Ambivalence*; Fernando Gómez Goyzzueta, "Análisis del desarrollo disciplinar de la arqueología mexicana y su relación con el patrimonio arqueológico en la actualidad."

68. Krista Thompson, *An Eye for the Tropics*, 1.

69. Quoted in Cruz Porchini, "Proyectos culturales," 51.

70. David Crouch and Nina Lübbren, "Introduction," in *Visual Culture and Tourism*, 12.

71. Hellier-Tinoco, *Embodying Mexico*, 28, 38–39.

72. Nelson Graburn, "Tourism: Sacred Journey," 22.

73. See Urry and Larsen, *The Tourist Gaze*, 12–16, for an overview; Berger and Wood, *Holiday in Mexico*, 3.

74. Victor Turner, "The Center Out There: Pilgrim's Goal," *History of Religions* 12, no. 3 (Feb. 1973), cited in Urry and Larsen, *The Tourist Gaze*, 12.

75. Alma Gottlieb, "Americans' Vacations," *Annals of Tourism Research* 9 (1982): 165–187, cited in Urry and Larsen, *The Tourist Gaze*, 13.

76. Carr, "Issues and Agendas," 43–44. In 1895 Pátzcuaro had two "hotels" and nine *mesones*: *Plano de la ciudad de Pátzcuaro*, Michoacán, 1895. Archivo General e Histórico del Poder Ejecutivo de Michoacán (AGHPEM), Morelia.

77. On class in Latin America, see D. S. Parker, *The Idea of the Middle Class*, ix, 3–8.

78. Baud and Ypeij, "Cultural Tourism," 1.

79. Ma. de Guadalupe Mendoza, and others, from Vecinas 6a, Manzana 20., Pátzcuaro to Pres., June 25, 1937, 568/9 LCR/AGN.

80. Lilia Zizumbo Villareal observes the development of a new class hierarchy on Janitzio and the lack of stable employment in the tourism industry in "Pátzcuaro: El turismo en Janitzio," 163–164.

81. Gabriel García Maroto, *Seis meses de Acción Artística Popular*, 31; Gabriel Garcia Maroto, *Acción Artística Popular: Veinticuatro grabados en madera*, preface.

82. Susannah Joel Glusker, ed., *Avant-Garde Art and Artists in Mexico: Anita Brenner's Journals of the Roaring Twenties*, 116–119; Margaret Hooks, *Tina Modotti: Photographer and Revolutionary*, 130; Hellier-Tinoco, *Embodying Mexico*, 96.

83. Luis Vázquez León, "Noche de Muertos en Xanichu: Estética del claroscuro cinematográfico, teatralidad ritual y construcción social de una realidad intercultural en Michoacán," 342–343, 377.

84. R. A. M. Van Zantwijk, *Los servidores de los santos*, 87–88.

85. Tony Bennett, "The Exhibitionary Complex."

86. Ron Broglio, *Technologies of the Picturesque*, 51, chapter 3.

87. Rob Shields, *Places on the Margin*, 60.

88. *Morelia, Pátzcuaro, Uruapan*.

CHAPTER 1. SEEING LAKE PÁTZCUARO, TRANSFORMING MEXICO

1. Magali Carrera, *Traveling from New Spain to Mexico*.

2. Rob Shields, *Places on the Margin*, 60; Hellier-Tenorio, *Embodying Mexico*.

3. See Eder García Sánchez, "Turismo en Pátzcuaro (México)."

4. Urry and Larsen, *The Tourist Gaze*.

5. Ibid., 1–3, 15–16.

6. Broglio, *Technologies*, 58–59.

7. Carrera, *Traveling*, 17.

8. Baron Alexander von Humboldt, *Political Essay on the Kingdom of New Spain*, 57, 209–226.

9. Mary Louise Pratt, *Imperial Eyes: Travel Writing and Transculturation*, 4.

10. Humboldt, *Political Essay*, 57, 299.

11. Frank Holl notes that Humboldt was unconcerned with originality and cited his sources; rather, his contribution was to compile the larger whole: "Alexander von Humboldt's Expedition through Mexico," in *European Traveler Artists in Nineteenth-Century Mexico*, 56.

12. Carrera, *Traveling*, 68.

13. See Xavier Moyssen, "The Revelation of Light and Space," in *El México luminoso de Rugendas*, 130.

14. Nigel Leask, "'The Ghost in Chapultepec': Fanny Calderón de la Barca, William Prescott and Nineteenth-Century Mexican Travel Accounts," 178.

15. Madame Calderón de la Barca, *Life in Mexico during a Residence of Two Years in That Country*, 389, 400–404.

16. Marie Robinson Wright, *Picturesque Mexico* (Philadelphia: J. B. Lippincott, 1897), 324.

17. Pratt, *Imperial Eyes*, 4.

18. On the literary parallel to this, see ibid., 120–125.

19. Humboldt quoted in ibid., 124.

20. Calderón de la Barca, *Life in Mexico*, 389.

21. Broglio, *Technologies*, 57–58.

22. Berger, *The Development of Mexico's Tourism Industry*, 15.

23. *Morelia, Pátzcuaro, Uruapan*, last page.

24. Kye-Sung Chon, "The Role of Destination Image in Tourism: A Review and Discussion."

25. James Buzard, *The Beaten Track*.

26. John Mraz, *Looking for Mexico*, 79.

27. Ibid., 80.

28. García Sánchez, "Turismo," 482–483.

29. Urry and Larsen, *Tourist Gaze*, 2–3.

30. Mraz, *Looking for Mexico*, 81.

31. Roger Bartra, "Paradise Subverted: The Invention of the Mexican Character," 3–5.

32. Mraz, *Looking for Mexico*, 80.

33. Dean MacCannell, *The Tourist*, chapter 5.

34. Susan Stewart, *On Longing*, 133.

35. Ibid., 137–144.

36. See also García Sánchez, "Turismo," 482–483.

37. Fischer would later publish *Die Jünger und Fischer am Pátzcuaro-See: Ein Bildbericht* (Leipzig: n.p., 1939).

38. Hellier-Tinoco, *Embodying Mexico*.

39. Mraz, *Looking for Mexico*, 108–109.

40. Ibid., 7.

41. Mauricio Tenorio Trillo, "Of Luis Márquez, Mexico, and the New York Fair, 1939–1940," 181, 182.

42. "A Mexican Land of Lakes and Lacquers," 637.

43. Carrera, *Traveling*, 133, engages Tony Bennett's work on museums and display culture as she discusses citizenship formation; see Tony Bennett, *The Birth of the Museum: History, Theory, Politics*. Carrera links nineteenth-century visual culture and exhibition culture: 66, 98–103, 155, 233.

44. Tenorio-Trillo, "Of Luis Márquez," 180, 182.

45. Paul W. Murphy, director of the Pan-American Union at the Fair, to Márquez, Oct. 21, 1940, Luis Márquez Archive, reprinted in *Luis Márquez en el mundo del mañana*, 66. Itala Schmelz's catalog essay, "*Indians Are Chic*: Cronografía de Luis Márquez Romay en Nueva York, 1940," in this volume also notes the Mexican Pavilion's popularity in the context of a vogue for things Mexican (42–50).

46. Tenorio-Trillo, "Of Luis Márquez," 184–185.

47. Ibid., 178.

48. It is unclear whether he won for "Los patriarcas" or for a new photo of his model in folkloric dress posed with the fair's modern architecture: Schmelz, "*Indians Are Chic*," 189.

49. Arturo Guevara Escobar, "Fotógrafos y productores de postales," "Letra: C, Letra: D, Letra: M, Letra: R, Letra Z."

50. See photos from Familia Arías y Martínez archive, Archivo Fotográfico, Instituto de Investigaciones Históricas, Universidad Michoacana de San Nicolás de Hidalgo (AF-IIH-UMSNH), Morelia.

51. *Lux* 13, no. 3 (Mar. 1940): 6. On workers' culture at the Mexican Electricians' Syndicate, see Jennifer Jolly, "Art for the Mexican Electricians' Syndicate: Beyond Siqueiros."

52. Quoted in Roberto Kolb Neuhaus, "Leyendo entre líneas, escuchando entre pautas: Marginalia paleográfica de Silvestre Revueltas," 76–78.

53. Hellier-Tinoco, *Embodying Mexico*, 83–87.

54. Merrill, *Negotiating Paradise*, 10–13.

55. On 1930s hotel murals, see Jeffery Belnap, "Caricaturing the Gringo Tourist:

Diego Rivera's *Folkloric and Touristic Mexico* and Miguel Covarrubias's *Sunday Afternoon in Xochimilco*"; and James Oles, *Hermanas Greenwood*, 14.

56. David Alfaro Siqueiros, "New Thoughts on the Plastic Arts in Mexico," 31.

57. Ibid., 32–33.

58. Patricia Albers, *Shadows, Fire, Snow: The Life of Tina Modotti*, 160–161; *The Daybooks of Edward Weston*, 172–181.

59. *Daybooks*, 177–178.

60. Mraz, *Looking for Mexico*, 81.

61. Amy Conger, *Weston in Mexico*, 56.

62. Buzard, *Beaten Path*, 4.

63. "Gabriel García Maroto," in *Diccionario de escritores mexicanos, siglo XX: Desde las generaciones del Ateneo y novelistas de la Revolución hasta nuestros días*; García Maroto, *Acción Plástica Popular: Educación y aprendizaje a escala nacional, con ciento cinco reproducciones*, 16.

64. Gabriel García Maroto, *Seis meses de Acción Artística Popular*; García Maroto, *Acción Artística Popular: 24 grabados en madera*; and García Maroto, *Acción plástica popular*.

65. Maroto, *Seis meses*, 31.

66. García Maroto, *Acción Artística Popular*, 1.

67. On Strand in Michoacán, see James Krippner et al., *Paul Strand in Mexico*.

68. Strand praised Julio de la Fuente's 1939 exhibit in these terms: see Krippner et al., *Paul Strand*, 54.

69. Gerald Sykes, in *P. M.*, July 28, 1940, quoted on publicity material for *Photographs of Mexico*, in Krippner et al., *Paul Strand*, 18.

70. See James Oles on Strand taking photos surreptitiously: *South of the Border*, 93–95.

71. Katherine Ware, "*Photographs of Mexico*, 1940" (1990), reprinted in Krippner et al., *Paul Strand*, 271–272.

72. Krippner et al., *Paul Strand*, 59–62. He critiques art education that promotes copying designs from Guadalajara, referring to the Best Maugard technique of art education.

73. Strand quoted in ibid., 59.

74. Excerpt from Stand's commentary accompanying his 1945 retrospective at the Museum of Modern Art, New York, quoted in ibid., 56.

75. On closing of San Francisco, Uruapan and its conversion into a school, see Miguel Esquihua Campos, to Cárdenas, Feb. 16, 1937, 545.2/15 LCR/AGN; on Calvario (repairs), see Leduc to Cárdenas, Feb. 15, 1936, 568/9 LCR/AGN.

76. Strand to Irving Browning, Sept. 29, 1934, quoted in Krippner, *Paul Strand* et al., 61.

77. Informe draft, exp. 11, caja 34 (1933), AGHPEM, Morelia.

78. James Oles, "Walls to Paint On: American Muralists in Mexico, 1933–36," 126, 131, 135–136. Oles's dissertation contains a thorough account of Greenwood's time in Michoacán.

79. Ibid., 149.

80. Marion Greenwood to Josephine Herbst, June 22, 1933, quoted in Oles, *Las hermanas Greenwood*, 17.

81. As Oles argues, "if the mural transcends the purely folkloric, it is because she does not idealize or ignore the difficulty of labor": *Las hermanas Greenwood*, 19.

82. Ibid.

83. Marion Greenwood to Herbst: Oles, *Las hermanas Greenwood*, 17.

84. Roger Bartra, "Paradise Subverted: The Invention of the Mexican Character," 9.

85. Oles, *Las hermanas Greenwood*, 19.

86. Frances Toor, *Frances Toor's Motorist Guide to Mexico*.

87. See Roland Barthes, "Myth Today."

88. Harold Clurman, letter, Oct. 4, 1940, quoted by Ware in Krippner et al., *Paul Strand*, 273.

89. Bartra, "Paradise Subverted," 3, 5.

90. Eduardo de la Vega Alfaro, *El primer cine sonoro mexicano: Siete décadas de cine mexicano*, 6–7, 9. The film was finished at the Nacional Productora studios.

91. James Ramey, "La resonancia de la conquista en *Janitzio*," 54.

92. Vázquez León, "Noche de Muertos en Xanichu," 335–400, 345. His larger argument concerns islanders' growing self-consciousness regarding the performance of traditions. His argument that this film's chiaroscuro aesthetic inspired the nighttime Noche de los Muertos is not sustainable, as descriptions of nighttime rituals predate the film. See Carlos González, "La ceremonia de la ofrenda a los muertos en el cementario de la Isla de Janitzio."

93. See Hellier-Tinoco, *Embodying Mexico*.

94. "Exhibición de la cinta 'Janitzio,'" *El Nacional* (May 30, 1935), section 2, 4.

95. Manuel Toussaint, *Pátzcuaro*, 192; Fernández, *Pátzcuaro*, 54–55; "Lagos: Pátzcuaro"; Thomas Phillip Terry, *Terry's Guide to Mexico*, 505–507.

96. Zizumbo Villareal, "Pátzcuaro," 157; Ángel Guzmán, José Campos, and Silverio Silvestre to Cárdenas, July 25, 1940, 568/9, LCR/AGN.

97. Hellier-Tinoco quotes Nicolas León (1934) on their abhorrence of cameras and tourists: *Embodying Mexico*, 96; see also Hooks, *Tina Modotti*, 130.

98. *Geografía, economía, agrícola del estado de Michoacán* (Mexico City: DAPP, 1938), cover; untitled Michoacán guidebook, front cover, Caja Michoacán, Archivo Fernández y Fernández, COLMICH, Zamora; "Mexico Builds Her Own 'Statue of Liberty,'" *Popular Science* (Feb. 1936); "Sección dominical," *La Prensa*, San Antonio, Jan. 24, 1937; "A Mexican Land of Lakes and Lacquers," *National Geographic*, 71, no. 5 (May 1937): 642.

99. Zizumbo Villareal, "Pátzcuaro," 160–161.

100. Debates over conceiving the region as a coherent unit have a long history; on the sixteenth-century politics, see Angélica Jimena Afanador-Pujol, *The* Relación de Michoacán *(1539-1541) and the Politics of Representation in Colonial Mexico*, chapter 3.

101. Jean Meyer, "La segunda Cristiada en Michoacán"; Van Zantwijk, *Los servidores de los santos*, 87–88.

102. T. Yamashita, *Investigaciones en el Lago de Pátzcuaro; Crónica de cincuenta años de ecología y desarrollo en la región de Pátzcuaro, 1936–1986*, 11–15.

103. *El Maestro Rural* 1, no. 4 (Apr. 15, 1922); "Danza de los Viejitos," *El Maestro Rural* 1, no. 5 (May 1, 1932); Calderón Mólgora, "Festivales cívicos." Hellier-Tinoco provides the most extensive study of SEP's cultural engagement here in *Embodying Mexico*, especially chapters 3–5.

104. Leonora Saavedra, "Danza de los Moros de Michoacán," *El Maestro Rural* 2, no. 6 (Jan. 1, 1933): 25–28.

105. For comparison, see Catherine R. Ettinger, *Jaime Sandoval*, 19–26.

106. Anthropologist Aida Castellaño introduced me to the *miradores* and suggested their potential to unite the region in the eyes of locals (conversation, Nov. 29, 2010, Morelia, Michoacán).

107. Fernández, *Pátzcuaro*. He also published guides to Morelia and Uruapan.

108. "Ley número 45: De la protección y conservación de monumentos y bellezas naturales," June 17, 1931, Secretario de Gobierno, Gobernación, Gobernadores, exp. 5, caja 31, 1931, AGHPEM, Morelia; "En defensa de Pátzcuaro."

109. Fernández, *Pátzcuaro*, 15. Repairs at the site began in 1933: Secretario de Gobierno, Gobernación, Gobernadores, exp. 11, caja 34, 1933, and exp. 1, caja 36, 1934, AGHPEM, Morelia; Inauguration invitation, Sept. 5, 1936, 568/9, LCR/AGN.

110. *Libro ideal para el hogar: Primera edición cultural pro-estado de Michoacán*, 44.

111. Stephan Oettermann, *The Panorama: History of a Mass Medium*, 12.

112. John Manson (the translator) notes that the version found in *Carnets* (Actes Sud 1985, 79) included "J'ai pensé à un vague sentiment de domination du monde" and reinserted "[for power]"

113. Victor Serge, "Earthquake."

114. Pratt, *Imperial Eyes*, 201–208.

115. Oettermann, *The Panorama*, 40.

116. Eduardo Ruiz, *Michoacán: Paisajes, tradiciones y leyendas*, 112–113, 120–121.

117. Alfredo Maillefert, *Laudanza de Michoacán: Morelia, Pátzcuaro, Uruapan*, 135.

118. Ruiz, *Michoacán*, vol. 2, 83; Toor, *Frances Toor's Motorist Guide*, 177. Mónica Pulido Echeveste is writing a thesis (UNAM, Morelia) on the spatial politics underlying colonial era representations of this encounter.

119. Simon Schama, *Landscape and Memory*, introduction.

120. Mark Dorrian and Frédéric Pousin, "Introduction," in *Seeing from Above: The Aerial View in Visual Culture*, 1.

121. Marie-Claire Robic, "From the Sky to the Ground: The Aerial View and the Ideal of the *Vue Raissonnée* in Geography in the 1920s."

122. Eugenia Macías, "ICA Foundation Historical Archive: History, Technology and the Specific Nature of the Aerial Gaze in Mexico," 213.

123. Possibly Norman Struck and Sons established this franchise. See Macías, "ICA," 212. In 1965 the Ingenieros Civiles Asociados (ICA) acquired the CAM. Fernando Osirio and Nareni Pliego, "Captura de la imagen: Testimonio impreso," 28.

124. Anita Brenner, *Your Mexican Holiday*, 3.

125. See issues of *Mapa*: Jan. 1939, New York City and Mexico City; Mar. 1939, Mexico City; May 1939, Portugal; Aug. 1939, Grand Canyon; May 1940, Mexico and New York.

126. Fernández, *Pátzcuaro*, 15; Crescenciana Gutiérrez C. to Private Secretary of Sr. Presidente, July 15, 1936, 609/210, LCR/AGN.

127. Godofredo F. Beltrán to Cárdenas's private secretary, June 27, 1939, 562.2/72 LCR/AGN.

128. Héctor Mendoza Vargas, "La geografía mexicana del siglo XX: Ensayo de una periodización para su estudio," in *Lecturas geográficas mexicanas: Siglo XX*, xxv.

129. Previously, in 1933, the department of Ciencias Geográficas had been established within the Facultad de Ciencias y Letras. Ibid., xxii, xxvii.

130. "Trabajos geográficos de México," *Revista Mexicana de Ingeniería y Arquitectura* 19, nos. 1–2 (Jan.–Feb. 1941): 1–14, cited in ibid., 81.

131. Antonio Luna Arroyo, *Juan O'Gorman: Autobiografía, antología, juicios críticos y documentación exhaustiva sobre su obra*, 94–95; James Oles, "Industrial Landscapes in Modern Mexican Art," 148–149.

132. Consider the opening sequence in the Emilio "El Indio" Fernández's film *Maclovia* (1948) or murals by Federico Cantú, *Los jinetes del apocalipsis* (Morelia, 1953), and O'Gorman, *El crédito transforma a México* (Mexico City, 1964–1965).

133. "There will be no more expropriations": *Excelsior* (Dec. 2, 1938). Such strategic manipulation was not lost on contemporary observers. Salvador Novo critiqued the reporter's romantic imagery in his *Hoy* column (Dec. 10, 1938), reprinted in Salvador Novo, *La vida en México en el periodo presidencial de Lázaro Cárdenas*, 280.

134. Ray Craib, *Cartographic Mexico: A History of State Fixations and Fugitive Landscapes*, 227.

135. "En defensa de Pátzcuaro," 33.

136. "Pátzcuaro," *Mapa* (July 1938): 23–25.

CHAPTER 2. CREATING PÁTZCUARO *TÍPICO*

1. García Sánchez notes that picturesque images of the city's streets and markets date to the nineteenth century ("Turismo," 484–486); however, I wish to emphasize the major changes that come with Pátzcuaro's designation as a site for preservation.

2. "En defensa de Pátzcuaro," 34, 63.

3. Toussaint, *Pátzcuaro*, 187–188.

4. For the various processes that go into creating a historical monument, see Françoise Choay, *The Invention of the Historical Monument*.

5. Choay draws on the work of Alois Riegl as she makes this distinction: ibid., 12–13.

6. Ibid., 15, 39, 88–93, and chapter 4.

7. "En defensa de Pátzcuaro," 63.

8. "Ley número 45: De la protección y conservación de monumentos y bellezas naturales," June 17, 1931, exp. 5, caja 31, 1931, AGHPEM, Morelia.

9. María Teresa Cortés Zavala, *Lázaro Cárdenas y su proyecto cultural en Michoacán, 1930–1950*, 54.

10. Choay, *Invention*, 88–93.

11. Gabriela Lee Alardin, "Apuntes sobre la conservación y restauración del patrimonio en México," 9.

12. "Ley sobre monumentos arqueológicos" (1897) and "Ley de bienes nacionales" (1902), cited in Alardin, "Apuntes," 9–10. On the photographic projects of Espino Barros and Guillermo Kahlo during this period, see Cristina Cuevas-Wolf, "Guillermo Kahlo and Casasola: Architectural Form and Urban Unrest," 197–198.

13. Lasansky, *The Renaissance Perfected*, xxvii.

14. Elizabeth Grosz, "Bodies—Cities," 507–513 (quotation on 512).

15. *Programa de desarrollo urbano de centro de población de Pátzcuaro, Mich., 2007–2027*, 119.

16. On character and architecture in the eighteenth century, see Lily H. Chi, "On the Use of Architecture: The Destination of Buildings Revisited," 24, 31–32. Heinrich Wölfflin, in *Principles of Art History* (1915), discusses style as a manifestation of the Zeitgeist and racial character of individuals, people, and epochs (138). As Georges Bataille puts it, "Architecture is the expression of the very being of societies, just as human physiognomy is the expression of the being of individuals"; "Architecture" (1929), 19.

17. Toussaint, "A Defense of Baroque Art in America," 164. Toussaint states in the introduction to *Colonial Art in Mexico*: "One of the cardinal aims of this book . . . is to show at every step the persistence of the indigenous spirit, casting a sort of soft tinge of melancholy over the works of the proud conqueror" (4).

18. "Relación de Pátzcuaro," in Isabel González Sánchez, ed., *El Obispado de Michoacán en 1765*, 292–295. Another interpretation of this census reported the numbers as 1,628 "mulatos" and 9 "mestizos y coyotes": *Programa de desarrollo*, 38.

19. Gabriel Silva Mandujano, *La casa barroca de Pátzcuaro*, 26–27.

20. Note that even today the language of architectural and aesthetic harmony is used as a proxy for social harmony: see *Programa de desarrollo*, 119.

21. Thompson, *Eye for the Tropics*, 94.

22. García Sánchez, "Turismo," 484–486.

23. Calderón de la Barca, *Life in Mexico*, 402, 404.

24. *Álbum de Pátzcuaro*; *Noticia histórica de la venerable imagen de Ntra. Sra. de la Salud de Pátzcuaro*; *Apuntes históricos de Pátzcuaro*.

25. Frances Hopkinson Smith, *A White Umbrella in Mexico*, 219.

26. Thompson, *Eye for the Tropics*, 5, 12 15.

27. Fernández, *Pátzcuaro*, 30; Gonzalo Aguirre Beltrán, *La población negra de México*, 148–149.

28. Judith Carney, *In the Shadow of Slavery: Africa's Botanical Legacy in the Atlantic World*, 34–45.

29. Thompson, *Eye for the Tropics*.

30. Jorge Bay Pisa, *Los rincones históricos de la ciudad de Pátzcuaro*, 26–28.

31. Fernández, *Pátzcuaro*, 49; Pablo Macía, *Pátzcuaro*, 297. Both refer to "gente de mal vivir" (people who live badly) in this neighborhood.

32. [Informe draft], exp. 11, caja 34, 1933; and "Contestación al 2nd informe de Ganiguo del Gerl. Benigou, leído ante el legislativo de 15 sept. de 1934," exp. 1, caja 36, 1934,

AGHPEM, Morelia. Note that many projects are comparable to those carried out in other parts of Michoacán; what is distinct is that in Pátzcuaro the projects are framed explicitly in terms of tourism.

33. Informe draft and "Contestación," AGHPEM, Morelia. See also Mar. 8, 1928, Aug. 4, 1931, Apr. 1, 1932, Oct. 8, 1932, Mar. 28, 1933, Mar. 8, 1934, Mar. 16, 1934, Dec. 6, 1935, *Libro de Actas*, Archivo Histórico Municipal de Pátzcuaro.

34. May 19, 1931; Aug. 4, 1931; Mar. 8, 1934; Oct. 1, 1936; July 9, 1940, *Libro de Actas*, Archivo Histórico Municipal de Pátzcuaro.

35. Jorge Enciso, OMCR, "Informe mensual," June 1937, Gobierno, Dirección General, vol. 11, 1937, sección 1, exp. 209, Archivo Histórico Institucional, Biblioteca Nacional de Antropología e Historia (AHIBNAH), Mexico City.

36. *Guía de arquitectura y paisaje: Michoacán*, 224–225.

37. Silva Mandujano, *La casa barroca*, 43, 109–110.

38. [Informe draft], exp. 11, caja 34, 1933; and "Contestación al 2nd informe de Ganiguo del Gerl. Benigou, leído ante el legislativo de 15 sept. de 1934," exp. 1, caja 36, 1934.

39. *Morelia, Pátzcuaro, Uruapan*, 3.

40. Departamento de Monumentos Artísticos, Arqueológicos e Históricos (DMAAH), "Se informe," Aug. 15, 1937, Gobierno, Dirección General, vol. 11, 1937, sección 1, exp. 209, AHIBNAH, Mexico City.

41. The kiosk was donated to Tzurumútaro with Cárdenas's approval. Dec. 6, 1935, *Libro de Actas*, Archivo Histórico Municipal de Pátzcuaro, 49. Engineer Ruiz (the sculptor?) was given photos of an older fountain to reconstruct, in agreement with Cárdenas. Municipal President to Cárdenas, Jan. 17, 1935, 568/9 LCR/AGN. Toussaint (*Pátzcuaro*, 173) explains that the original fountain was elaborate and lauded as one of the most exquisite in Mexico. This was replaced in the early nineteenth century with a neoclassical fountain, which in turn was removed, saved, and replaced with a kiosk. The current fountain, with its sculpture of Don Vasco de Quiroga by Francisco Zúñiga Chavarría (Costa Rica, 1912–1998), dates from 1965.

42. Glusker, *Avant-Garde Art and Artists in Mexico*, Pátzcuaro, May 1926.

43. Mraz, *Looking for Mexico*, 34.

44. Pratt, *Imperial Eyes*, 6–7.

45. Linda J. Seligmann, "To Be In Between: The Cholas as Market Women," 698–703.

46. Toor, *Frances Toor's Motorist Guide*, 178.

47. Pratt, *Imperial Eyes*, 43–44, 53–55.

48. On Briquet, see Rachel Little, "Abel Briquet Photograph Collection," Benson Library, University of Texas, 2009 (http://www.lib.utexas.edu/benson/briquet/index .html).

49. David Kaplan, "The Mexican Marketplace in Historical Perspective," 186. *Encomenderos* received rights to control (but not own) land and tribute (including labor) from indigenous people living on that land; in turn they were responsible for those living on that land. The controversial *encomendero* system formally ended in the eighteenth century. *Hacendados* owned large estates called haciendas, which served as po-

litical and economic centers in rural Mexico and relied on a paid (if often trapped by debt) labor force.

50. Ibid., 254–255, 270.

51. Ina R. Dinerman, "Patterns of Adaptation among Households of US-Bound Migrants from Michoacán, Mexico," 486–487; Kaplan, "Mexican Marketplace," 254–255.

52. R. J. Bromley and Richard Symanski, "Marketplace Trade in Latin America," 9, 11.

53. Kaplan, "Mexican Marketplace," 199, 215–216.

54. Toussaint, *Pátzcuaro*, 162.

55. Helen Tangires, *Public Markets*, 21–22.

56. Alberto Híjar, "Tésis por los treinta," 11.

57. Dec. 6, 1935, and Jan. 11, 1936, *Libro de actas*, Archivo Histórico Municipal de Pátzcuaro; "Informe de los trabajos desarrollados en la sección de expropiación y fraccionamientos," exp. 7, caja 37 (1935), AGHPEM, Morelia. Pátzcuaro was required to pay the owners of the expropriated city block 50 percent of the funds raised from municipal water. Decree 47, exp. 3, caja 38, 1935, AGHPEM, Morelia.

58. Minutes in Pátzcuaro's *Libro de actas* and documents in the AGN document an elaborate exchange and meetings between municipal leaders and Cárdenas both before and after the market construction: Dec. 6, 1935; Jan. 11, 1936; Feb. 2, 1927; Feb. 27, 1938, *Libro de actas*, Archivo Histórico Municipal de Pátzcuaro and 13982/14389, Mar. 29, 1937; 35325/37607; 31505 Apr. 4, 1938, 568/9 LCR/AGN.

59. Apr. 4, 1938, 568/9 LCR/AGN; May 17, 1939–May 27, 1939, *Libro de actas*, Archivo Histórico Municipal de Pátzcuaro.

60. Feb. 2, 1937, *Libro de actas*, Archivo Histórico Municipal de Pátzcuaro.

61. Pedro Talavera to Cárdenas, Mar. 29. 1937, 568/9 LCR/AGN.

62. Among other locales, Mexico City, Morelia, Jiquilpan, and Zaragosa also all constructed new markets during this period.

63. Híjar, "Tésis," 11.

64. Cuevas-Wolf, "Guillermo Kahlo and Casasola," 201–202.

65. May 30, 1936, *Libro de actas*, Archivo Histórico Municipal de Pátzcuaro.

66. Lomnitz-Adler, "Concepts for the Study of Regional Culture," 205.

67. Jesús Romero Flores, *Gertrudis Bocanegra do Lazo de la Vega: heroína de Pátzcuaro*, 11–12.

68. Calderón de la Barca, *Life in Mexico*, 389.

69. Municipal President to Cárdenas, Apr. 1938, 568/9 LCR/AGN.

70. Strand, letter to Irving Browning, Sept. 29, 1934, quoted in Krippner et al., *Paul Strand*, 61.

71. Jan. 13, 1939, *Libro de actas*, Archivo Histórico Municipal de Pátzcuaro.

72. Gareth A. Jones and Ann Varley, "Contest for the City Center," 28.

73. May 17, 1939–May 27, 1939, *Libro de actas*, Archivo Histórico Municipal de Pátzcuaro; to Cárdenas, Apr. 4, 1938, 568/9 LCR/AGN.

74. This struggle continues today: see Carlos Alberto Hiriart Pardo, cited in Catherine R. Ettinger, ed., *Michoacán: Arquitectura y urbanismo*.

75. Aug. 17, 1931, *Libro de actas*, 231, Archivo Histórico Municipal de Pátzcuaro; Gloria Blancas López, *Pátzcuaro*, 61.

76. José Manuel Martínez Aguilar, *El Pátzcuaro de ayer en el imaginario*, 145–146. He does not discuss the two versions but rather describes one and illustrates the other.

77. Teresa Castelló Yturbide, *Pátzcuaro: Cedazo de recuerdos*, 61; Martínez Aguilar, *El Pátzcuaro*, 147.

78. Christopher Boyer, *Becoming Campesinos: Politics, Identity, and Agrarian Struggle in Postrevolutionary Michoacán, 1920-1935*, 200–202; interview, Gloria Blancas López, Nov. 25, 2010.

79. Martínez Aguilar, *El Pátzcuaro*, 61, 67.

80. Eitan Ginzberg, *Lázaro Cárdenas: Gobernador de Michoacán (1928-1932)*, 63, 75–76.

81. Blancas López, *Pátzcuaro*, 54; "Bonador original del 2nd (y último) informe del gabienete gral. BS (Beningo Serrato), Gobernador Constitutional del Estado de Michoacán," Sept. 16, 1934, exp. 1, caja 36, AGHPEM, Morelia.

82. Martínez Aguilar, *El Pátzcuaro*, 83; Julian Bonavit and Carlos Treviño, *Breve guía histórica de la ciudad de Pátzcuaro*; Dec. 6, 1935, *Libro de actas*, Archivo Histórico Municipal de Pátzcuaro.

83. Oct. 13, 1933, *Libro de actas*, Archivo Histórico Municipal de Pátzcuaro.

84. Mar. 16, 1934, *Libro de actas*, Archivo Histórico Municipal de Pátzcuaro.

85. Leduc to Cárdenas, Oct. 25, 1935, announcing the completion of his plans; Cárdenas receives them on Dec. 5, 1935. Interestingly, in his plans Leduc originally named the theater in honor of Cárdenas himself. The state of Michoacán approved the use of the ex-convent for this new purpose. R. Ordorica Villamar, Gob. de Mich., to Cárdenas, Aug. 28, 1935, 609/210 LCR/AGN.

86. Toussaint, *Pátzcuaro*; Anita Brenner's guidebook, *Your Mexican Holiday*, is the one source that mentions San Agustín's role as a museum (170); Aug. 28, 1935, R. Ordorica Villamar, Gob. de Mich. to LC [Lázaro Cárdenas], authorization to use the annex of the Templo Agustín for a popular theater, 609/210 LCR/AGN.

87. "El Señor Presidente de la república en Michoacán," *Surco*, Oct. 15, 1937, 3.

88. "Teatro 'Emperador Caltzontzin,'" *Vida* (Pátzcuaro) 1, no. 3 (July 1938), no pagination.

89. Ibid.; Leduc to Cárdenas, 568/9 LCR/AGN. In 1940 Cárdenas agreed that the money used to support showing films in Pátzcuaro needed to be redirected to work on the hospital. A new movie theater named Michoacán was built in 1955: see Martínez Aguilar, *El Pátzcuaro*, 149–150.

90. Norberto Alceantar and other signatories, Pte del Ayuntamiento Constitutional, Pátzcuaro to Cárdenas, Nov. 11, 1937, 56398, 609/210 LCR/AGN.

91. Acuerdo Presidencial, No. 488, Nov. 28, 1940; Agustín Lanuza to Dir. General de Información, Aug. 7, 1940, 609/210 LCR/AGN.

92. Private secretary Lic. Agustín Leñero to the Secretaría de Hacienda y Crédito Público, Oct. 30, 1940, 609/210 LCR/AGN.

93. Mar. 14, 1936, *Libro de actas*, 52, Archivo Histórico Municipal de Pátzcuaro, Extraordinary.

94. Municipal President Talavera to Cárdenas, Apr. 6, 1936; and Leduc to Cárdenas, Apr. 13, 1936, 609/210 LCR/AGN.

95. Lauro M. Mercado et al. May 19, 1939, 609/210 LCR/AGN; Alberto Leduc to Sr. General José Manuel Núñez, May 6, 1938, 568/9 LCR/AGN; Juan E. Noguez to Cárdenas, Oct. 30 1939, 531.2/460 LCR/AGN.

96. Leduc to Sr. General José Manuel Núñez, May 6, 1938, 568/9 LCR/AGN.

97. Leal asked for an appointment with Cárdenas to discuss the offer made by Ruiz. Telegram from Fernando Leal to Cárdenas, Sept. 21, 1938, 568/9 LCR/AGN.

98. 531.2/112 and 531.2/460 LCR/AGN.

99. To Cárdenas, Nov. 3, 1938, 531.2/460 LCR/AGN.

100. It was funded by Edgar Kauffman in payment for the failed project that O'Gorman undertook in Pittsburgh: O'Gorman, "Autobiografía," in Luna Arroyo, *Juan O'Gorman*, 140. Most other churches closed and expropriated during this period eventually returned to service. O'Gorman is explicit that Cárdenas's goal in adding a mural was to avoid this (140).

101. Soledad de Moral V de Iturbide to Cárdenas, Aug. 16, 1936, 548/19 LCR/AGN.

102. Toussaint, *Pátzcuaro*, 187–188: "Los monumentos de Pátzcuaro no son monumentos artísticos de primer orden que por sí solos ameriten una visita a esta ciudad: es el conjunto, el character, la supervivencia del espíritu colonial íntegro en casas, calles, plazas y templos lo que le da su atractivo."

103. Cited in Choay, *Invention*, 94.

104. *Morelia, Pátzcuaro, Uruapan*, 24.

105. Jean Meyer, "An Idea of Mexico: Catholics in the Revolution," 290–291.

106. "Municipios donde han verificado cambios de Regidores," exp. 7, caja 37, 1935, Secretaría de Gobierno, AGHPEM, Morelia.

107. Marjorie Becker, "Black and White and Color: *Cardenismo* and the Search for a *Campesino* Identity," 458.

108. On La Compañía: Rosendo Ortega et al, to Cárdenas, Apr. 8, 193[?]; Policarpo Sánchez to Cárdenas, Feb. 17, 1936; and Antonio Sánchez to Policarpo Sánchez, Mar. 11, 1936; on San Francisco: Pedro Talavera to Cárdenas, June 23, 1936, 545.2/15 LCR/AGN; and June 19, 1936, *Libro de actas*, Archivo Histórico Municipal de Pátzcuaro; Talavera to Cárdenas and Cárdenas to Talavera, Feb. 1936, 545.2/15 LCR/AGN; Lázaro Cárdenas to Professor Sánchez, Feb. 4, 1937, 533/20 LCR/AGN; Toussaint, *Pátzcuaro*, 176; *Mexico's Western Highways*, p. 63.

109. Policarpo Sánchez to Cárdenas, Feb. 17, 1936; Antonio Sánchez to Policarpo Sánchez, Mar. 11, 1936; Simeon Valdez and signatories to Cárdenas, May 27, 1937; Parácuaro Residents to Cárdenas, Oct. 15, 1937, 545.2/15 LCR/AGN.

110. Leduc to Cárdenas, Feb. 15, 1936, 568/9 LCR/AGN.

111. See a series of documents between Leduc and Cárdenas, Heladio V. y Vargas and Cárdenas, and Cárdenas and Pedro Talavera, Feb. 1936, 609/210 LCR/AGN.

112. Toussaint, *Pátzcuaro*, 114–118; Becker, "Black and White and Color," 139.

113. See note 111 above; Choay, *Invention*, 37–39.

114. There are various references to work on a Pátzcuaro hospital. See José Ramos

Chávez, Pres. Mun., to Cárdenas, Oct. 18, 1935, 568/9 LCR/AGN; and Agustín Lanuza to Dir. General de Información, Aug. 7, 1940, 609/210 LCR/AGN. Toussaint, researching in 1940, tells us that the Hospital de San Juan de Dios had recently been restored: *Pátzcuaro*, 118. Photos of the restored hospital are kept in the Fototeca Nacional archive.

115. José Ramos Chávez, Pres. Mun., to Cárdenas, Oct. 18, 1935, 568/9 LCR/AGN.

116. The local guidebook by Jorge Bay Pisa, *Los rincones históricos*, does tell Ramos's story. Toussaint discusses the structure in aesthetic terms, however, without discussing its patron, thus avoiding mention of African Pátzcuaro.

117. Thomas Phillip Terry, *Terry's Guide to Mexico*, 209–213.

118. Bay Pisa, *Los rincones históricos*.

119. Solchaga to Manuel Toussaint, Nov. 25, 1932; Manuel Toussaint to Solchaga, Dec. 13, 1932, Colección Manuel Toussaint, Archivo Histórico y de Investigación Documental, IIE, UNAM, Mexico City (CMT/IIE).

120. Exp. 460, caja 10, CMT/IIE.

121. Aug. 4, 1931, *Libro de actas*, Archivo Histórico Municipal de Pátzcuaro, 229. Regarding Cruz Verde, see Castelló Yturbide, *Pátzcuaro*, 85, 96.

122. October 12, 1937, 545.2/15 LCR/AGN.

123. Rosendo Ortega to LC, exp. 547.4/133 LCR/AGN. See also Becker, "Black and White and Color," 138–142, for a larger discussion of tactics deployed by regional women in advocating for the reopening of their churches—from striking revolutionary bargains to evoking the need to protect government property.

124. Abraham J. Navas to Director General de Monumentos, May 7, 1938; Departamento Autónomo de Prensa y Público, May 7, 1938; Gobierno, Dirección General, 1939, vol. 14, sección 7, exp. 265, AHIBNAH, Mexico City.

125. Toussaint, *Pátzcuaro*, 169.

126. Ibid., 130–131; Toussaint, *Colonial Art in Mexico*, 115. Note that in a more recent account, Gabriel Silva Mandujano shows that the church was rebuilt in the eighteenth century: *La casa barroca*, 46.

127. Toussaint, "Plan para establecer un 'laboratorio del arte' análoga al que existe en Sevilla" (1934), reproduced in *Una memoria de 75 años, 1935-2010: El Instituto de Investigaciones Estéticas*, 250.

128. María del Carmen Sifuentes Rodríguez, "El archivo documental, memoria del Instituto de Investigaciones Estéticas," in *Una memoria de 75 años*, 214, 217, 219. On the Museo National's classes, see Alfonso Toro to Secretaría del Ramo, Informe, June 16, 1936; Castillo Ledón to Jefe DMAAH, June 10, 1936, in Gobierno, Dirección General, 1936, vol. 10, sección 48, AHIBNAH, Mexico City.

129. Guillermo Palacios, "The Social Sciences, Revolutionary Nationalism, and Interacademic Relations: Mexico and the US, 1930-1940," 58–59.

130. The Laboratorio del Arte named itself after the institute of the same name at the university in Sevilla in Spain. Dr. Fernando Ocaranza to Señor Decano, Mar. 6, 1935, published in *Memoria de 75 años*, 254.

131. Justino Fernández, "Dos décadas de trabajo del Instituto de Investigaciones Estéticas: Catálogo de sus publicaciones, índice de sus Anales," supplement 2 de *Anales de Instituto de Investigaciones Estéticas* 25 (1957): 7. See also *Memoria de 75 años*, 48, 52.

132. Martha Fernández, "Las políticas editoriales de 1935 a 1990," 76.

133. See, for example, Toussaint, "Defense of Baroque Art," 162–63.

134. Silva Mandujano, La casa barroca, 55–62.

135. See, for example, José Pavia Crespo, "La zona negra," El Maestro Rural 8, no. 5 (Mar. 1936): 7–9.

136. Aguirre Beltrán, La población negra.

137. The earliest step toward linking Eréndira and La Sirena that I have found appears in a 1942 book on Don Vasco de la Quiroga, in which Michoacán ("the land of Eréndira") is likened to a siren tempting Quiroga to settle in the region: Benjamín Jarnés, Don Vasco de Quiroga, obispo de Utopia (Mexico City: Carabella, 1942).

138. Henry John Drewal, "Mami Wata: Arts for Water Spirits in Africa and Its Diaspora," 60; see also Henry John Drewal, Marilyn Houlberg, Bogumil Jewsiewicki, Amy L. Noell, John W. Nunley, and Jill Salmons, Mami Wata: Arts for Water Spirits in Africa and Its Diaspora.

CHAPTER 3. CREATING THE TRADITIONAL,
CREATING THE MODERN

1. Mary K. Coffey, "The 'Mexican Problem': Nation and 'Native' in Mexican Muralism and Cultural Discourse," 44.

2. Tenorio-Trillo, Mexico at the World's Fairs, 3.

3. Néstor García Canclini, Hybrid Cultures, 145. See also Zavala, Becoming Modern.

4. Bartra, "Paradise Subverted," 5–12.

5. See Boyer, Becoming Campesinos; and Guillermo Palacios, "Postrevolutionary Intellectuals, Rural Readings and the Shaping of the 'Peasant Problem' in Mexico: El Maestro Rural, 1932–34."

6. Lincoln Zephyr ad from Hoy (April 10, 1939), Plan Sexenal folder, Ramón Fernández y Fernández Archive, Colegio de Michoacán, Zamora.

7. Bennett, "The Exhibitionary Complex," 76.

8. Tenorio-Trillo, Mexico at the World's Fairs, 3.

9. Don M. Coerver, Suzanne B. Pasztor, and Robert Buffington, Mexico: Encyclopedia of Contemporary Culture and History (Santa Barbara, CA: ABC-CLIO, 2004), xvii, 158, 299.

10. Raquel Tibol discusses the internationalist current in Cárdenas era art in "El nacionalismo en la plástica durante el cardenismo," 249. See also Adrián Villeseñor Soto, "Ricardo Bárcenas." While critic Salvador Ortiz Vidales evokes Filippo Tommaso Marinetti and describes Bárcenas's mural as futurist—evoking both dynamism and promises for the future Mexico—the constructivist label is both ideologically and stylistically closer to the mark: Ortiz Vidales, "Los frescos de R. Bárcenas," Hoy (June 3, 1937): 26.

11. Consider, for example, El Lissitzky in the Soviet Union, Josep Renau in Republican Spain, Giuseppe Terragni in Italy, and Enrique Gutmann in Mexico.

12. "Primera Exposición Ojectiva del Plan Sexenal," Hoy (May 19, 1937). See Dafne Cruz Porchini, "Proyectos culturales y visuales en México a finales del Cardenismo."

13. DAAP, *Memoria de Departamento Autónomo de Prensa y Propaganda* (Jan.–Aug. 1937), 115, quoted in Cruz Porchini, "Proyectos culturales," 66.

14. *Hoy* 14 (May 29, 1937): 14, 63, quoted in Cruz Porchini, "Proyectos culturales," 67–68.

15. Cruz Porchini, "Proyectos culturales," 66.

16. Castillo Ledón, Museo Nacional, Informe, June 1, 1937; Informe Mensual, OMCR, May 1937, Gobierno, Dirección General, Vol. 11, 1937, sección 1, exp. 209, AHIBNAH, Mexico City.

17. López, *Crafting Mexico*, 7.

18. On *Los oficios en la Relación de Michoacán*, see Diana Isabel Mejía Lozada, *La artesanía de México*, 26, 28. On African slaves as carpenters, see M. L. Wortman, *Government and Society in Central America, 1680–1840*, 74.

19. See Hellier-Tinoco, *Embodying Mexico*. See also essays in *El Universal Illustrado*, Mar. 4, 1926, in Gabara, *Errant Modernism*, 184–185.

20. David Brading, "Manuel Gamio and Official *Indigenismo* in Mexico."

21. Becker, *Setting the Virgin on Fire*.

22. Salvador Novo, "Curiosidades mexicanas."

23. Narciso Bassols, "Plática del Secretario de Educación Pública a los miembros de las Misiones Culturales, sustentada en el Teatro Orientación la noche del 4 de marzo de 1932"; Moisés Sáenz, "La escuela y la cultura."

24. Gabriel Fernández Ledesma, "15 frases cortas para publicidad," Feb. 11, 1937, AGN, Dirección General de Información–DAPP, caja 50, cited in Cruz Porchini, "Proyectos culturales," 56.

25. López, *Crafting Mexico*, 14–17.

26. González Matute, "A New Spirit in Post-Revolutionary Art," 38.

27. Oles, "Business or Pleasure," 28.

28. Dr. Atl's exhibition catalog notes changing fashions following the 1921 exhibit, as does Oles, who also cites the fad for Mexican *artesanías* in New York City department stores: "Business or Pleasure," 20, 28. On *artesanías* and diplomacy, see Rick López, "The Morrows in Mexico: Nationalist Politics, Foreign Patronage, and the Promotion of Mexican Popular Arts."

29. Oles, "Business or Pleasure," 19–28; Indych-López, *Muralism without Walls*, 88–128.

30. Luis Vázquez León argues that regional tourism was the true patron of *artesanías*, not the state—an argument that I find somewhat overstated: "Noche de Muertos en Xanichu," 354–355.

31. Some of the most damning critiques of such "folkloric" popular arts came from David Alfaro Siqueiros: "New Thoughts" and "Rivera's Counterrevolutionary Road."

32. Laura América Pedraza Calderón, "Manos maqueadoras."

33. On the sexualization of the India Bonita, see Zavala, *Becoming Modern*, chapter 4.

34. See, for example, Griselda Pollock and Roszika Parker, "Crafty Women and the Hierarchy of the Arts"; Tatiana Flores, "Strategic Modernists: Women Artists in Post-Revolutionary Mexico."

35. Oles, *Las hermanas Greenwood*, 19.

36. Ruth Lechuga, "Origins and Forms of Lacquerwork," 66–67; Isabel Medina González, "Pre-hispanic Lacquerwork: A Long-Standing Debate," 68–70; Sonia Pérez Carrillo and Carmen Rodríguez de Tembleque, "Oriental and European Influences," 71.

37. Pérez Carrillo and Rodríguez e Tembleque, "Oriental and European Influences," 71–73; Gustavo Curiel, "Perception of the Other and the Language of 'Chinese Mimicry' in the Decorative Arts of New Spain," 23, 29.

38. Eva-María Thiele, *El maque: Estudio histórico sobre un bello arte*, 46–52.

39. Gerardo Murillo (Dr. Atl), *Las artes populares en México*, 219. R. Molina Enríquez, "Las lacas de México."

40. Frances Toor, *Mexican Popular Arts*, 82–83; E. M. Gómez Millefert, "Lacas."

41. Daniel F. Rubín de la Borbolla, *Artesanías de Michoacán*, 14.

42. Departamento de Monumentos Artísticos Arqueológicos e Históricos, "Actividades," Apr. 1936, p. 9, in Gobierno, Dirección General, Apr. 9, 1936, to Sept. 9, 1936, vol. 9, sección 20, exp. 179, AHIBNAH, Mexico City.

43. Pátzcuaro website: "Museo de Artes Populares," *Pátzcuaro su lago y su tradiciones* (2001): http://patzcuaro.pagesperso-orange.fr/mx/03/mx/03cumu01.htm.

44. Ginzberg, *Lázaro Cárdenas*, 63, 75–76.

45. Interview, Aida Castellano, Morelia, Nov. 29, 2010; "Museo de Artes e Industrias Populares," CONACULTA, INAH (Jan. 19, 2016): http://www.inah.gob.mx/es/red-de-museos/299-museo-local-de-artes-e-industrias-populares-de-patzcuaro; Rodolfo Ayala, "Memorandum," June 12, 1936; Alfonso Toro to Subjefe de la Oficina de Monumentos Prehispánicos, June 13, 1936, Gobierno, Dirección General, Mar. 14, 1936–Dec. 11,1936, vol. 9, sección 31, exp. 120, 121, 190; Dept. de Monumentales y de la República to Secretario del Ramo, Feb. 25, 1936, Gobierno, Dirección General, 1936, vol. 10, sección 48, exp. 208; Oficina de Monumentos Coloniales, Informe, Mar. 1937 and Apr. 1937, Gobierno, Dirección General, vol. 11, 1937, sección 1, exp. 209, AHIBNAH, Mexico City.

46. Thiele, *El maque*, xiii; Departamento de Monumentos Artísticos Arqueológicos e Históricos, "Actividades," Apr. 1936, p. 9, in Gobierno, Dirección General, Apr. 9, 1936 to Sept. 9, 1936, vol. 9, sección 20, exp. 179; Rodolfo Ayala, July 12, 1937, Gobierno, Dirección General, vol. 9, sección 33, exp. 192; Alfonso Caso to Dir. del Museo Nacional de Arqueología, Historia y Etnografía, Apr. 15, 1939, Gobierno, Dirección General, 1939, vol. 17, sección 8; exp. 298, AHIBNAH, Mexico City.

47. Rick López, "Lo más mexicano de México: Popular arts, Indians, and Urban Intellectuals in the Ethnicization of Postrevolutionary National Culture, 1920–1972," 256.

48. "Industria de vidrio," *El Maestro Rural* 8, no. 5 (Mar. 1, 1936): cover, 17–19; "Conservas alimenticas," *El Maestro Rural* 8, no. 11 (June 15, 1936): 18–22. The domestic industry articles continue through 1939.

49. López, *Crafting Mexico*, 146–147.

50. Ibid., 163–170.

51. Various regional performers were brought to the capital and returned home after performing and teaching; on musician and Viejitos performer Nicolás Bartolo Juárez

from Jarácuaro in Lake Pátzcuaro, see Hellier-Tinoco, *Embodying Mexico*, 76–78. Films like John Steinbeck's *El pueblo olvidado* (1941) likewise promoted a narrative linking travel and modernization, in which the indigenous man travels to the big city to learn about Western medicine and then returns to his people to spread the word.

52. Alfonso Caso to Dir. del Museo Nacional de Arqueología, Historia y Etnografía, Apr. 15, 1939, Gobierno, Dirección General, 1939, vol. 17, sección 8; exp. 298, AHIB-NAH, Mexico City.

53. According to Toussaint, the museum was an important means of "honoring Don Vasco's memory": *Pátzcuaro*, 33.

54. James Krippner-Martínez, *Rereading the Conquest: Power, Politics, and the History of Early Colonial Michoacán, Mexico: 1521–1565*, 93–99; Fernando Gómez, *Good Places and Non-Places in Colonial Mexico*, 34–39.

55. Justino Fernández, "Semblanza de Don Vasco de Quiroga," 10.

56. Silvio Zavala and Genaro Estrada, *La "Utopía" de Tomás Moro en la Nueva España y otros estudios*; Alfonso Teja Zabre, "Biografías críticas, 'Tata Vasco,'" *El Maestro Rural* (Mar.–Apr. 1940): 13–15. Critiques include Edmundo O'Gorman and Justino Fernández, *Santo Tomás More*; and Gómez, *Good Places*, 31. On the debate, see chapter 4 and Krippner-Martínez, *Rereading the Conquest*, 172.

57. See, for example, Toor, *Frances Toor's Motorist Guide to Mexico*; and *Morelia, Pátzcuaro, Uruapan*.

58. Maillefert, *Laudanza de Michoacán*, 136: "Desde una ventana, ahora que vamos escribiendo estas páginas, vemos la laguna y unas montañas azules . . . y pensamos en don Vasco. En don Vasco, que recorriendo la vasta diócesis . . . cabalgando en su mula blanca . . . En don Vasco, que recorría los pueblecillos y se pondría a mirar y a aconsejar a los artesanos que torneaban la madera, que pintaban las bateas, que pulían y decoraban las vasijas, que iban haciendo esta mil cosas que él les enseñaba y que llenan hoy aún, de un fervor de vida y de un amor de *artesanías*, los *tianguis* de los pueblos michoacanos."

59. Vázquez León, "Noche de Muertos," 354.

60. It is worth noting as we discuss the conflation of *artesanías* and indigenous identity that many Mexico-City-based colleagues assumed that Solchaga was in fact indigenous. López, *Crafting Mexico*, 115. To clear up this misconception, Solchaga's family member Salvador Garibay published a book about the family's Spanish lineage: *Nuestra sangre: Apuntes genealógicos de la familia Solchaga*.

61. Murillo (Dr. Atl), *Las artes populares*. See López, "Noche Mexicana," 34–39.

62. The indigenous legendary origins of Uruapan's *maque* tradition would be cemented by Francisco León and Fernando Ledesma's 1939 book, *Esmaltes de Uruapan*.

63. See Krippner-Martínez, *Rereading the Conquest*, chapter 5.

64. Kaplan, "Mexican Marketplace"; Dietz et al., *Las artesanías en la cuenca*, 45–46.

65. Equihua to the Congreso Indígena in Uruapan, Jan. 29, 1938, 533/20 LCR/AGN.

66. Vázquez León, "Noche de Muertos," 352–353.

67. "Los artisanos de Michoacán se organizan," *Tierra y Libertad* (Dec. 25, 1938): 3.

68. Vázquez León, "Noche de Muertos," 354.

69. Robert H. Jackson, *Race, Caste, and Status: Indians in Colonial Spanish America*, 117–119.

70. "Uruapan," *Mapa* 63 (July 1939): 47–48.

71. Cruz-Porchini, "Proyectos culturales," 54.

72. Numerous scholars discuss the ideology of *mestizaje*; for recent analyses of its various manifestations, see Coffey, *How a Revolutionary Art Became Official Culture*, 6–12; and Zavala, *Becoming Modern*.

73. "La escuela y la cultura," *El Maestro Rural* 1, no. 5 (May 1, 1932): 6–9.

74. "El ciudad y el campo," *El Maestro Rural* 6, no. 8 (Apr. 15, 1935); "Hay que mejorar," *El Maestro Rural* 6, no. 4 (Feb. 1935): back cover. See Guillermo Palacios for a discussion of the SEP intellectuals' dialectical framing of campesino identity: "Postrevolutionary Intellectuals."

75. "Small Industry" articles become regular; see, for example, *El Maestro Rural* (Aug. 1939 and Sept. 1939).

76. *El Maestro Rural* 3–4 (1937): cover; *El Maestro Rural* 1 (Jan. 1938): 39; *El Maestro Rural* 2 (Feb. 1938): cover; *El Maestro Rural* 1 (Jan.–Feb. 1940): cover.

77. *Cabeza de la Tehuana*, *El Maestro Rural* 5 (1937): cover. Beloff's essays appear regularly between 1937 and 1939.

78. Bennett, "The Exhibitionary Complex," 76.

79. William Rowe and Vivian Schelling, *Memory and Modernity: Popular Culture in Latin America*, 2.

80. García Canclini, *Transforming Modernity*, 42.

81. Lordes Quintanilla, *Liga de Escritores y Artistas Revolucionarios (LEAR)* (Mexico City: UNAM/FCPyS, 1980), 39.

82. Roberto Berdecio, quoted in Maricela González Cruz Manjarrez, *La polémica Siqueiros-Rivera*, 28.

83. Emanuel Eisenberg, "Battle of the Century."

84. Siqueiros, "Rivera's Counterrevolutionary Road." See González Cruz Manjarrez, *La polémica Siqueiros-Rivera*, 34–35; and Coffey, *How a Revolutionary Art Became Official Culture*, 38–42.

85. David Alfaro Siqueiros et al., "Manifesto of the Union of Mexican Workers, Technicians, Painters, and Sculptors," *El Machete* (1923), translated in Dawn Ades, *Art in Latin America: The Modern Era* (New Haven: Yale University Press, 1993), 324.

86. "Programa de Servicios Sociales" [no date], exp. 20, caja 19, Archivo de la Escuela Nacional de Bellas Artes/Artes Plásticas (ENBA/AP), UNAM, Mexico City.

87. Marcela del Río, "Alberto Beltrán habla de Ricardo Bárcenas, la ELAP y otros temas." Bárcenas was also promoting a curriculum in Graphic Design, a version of which was instituted in 1941.

CHAPTER 4. CREATING HISTORICAL PÁTZCUARO

1. Ernest Renan, "What Is a Nation?" (1882), 19.

2. For a seminal example, see Anderson, *Imagined Communities*; regarding Mexico,

see Thomas Benjamin, *Revolución: Mexico's Great Revolution as Memory, Myth, and History.*

3. Pierre Nora, "Between Memory and History: Les Lieux de Mémoire," 11. On Mexico's example, see Benjamin, *Revolución*, 22.

4. Jean Meyer, "History as National Identity," 33.

5. Nora, "Between Memory and History."

6. Palacios, "Social Sciences," 58–72.

7. Ibid., 64–65; Meyer, "History as National Identity," 35; Octavio Paz, "Re/Visions: Mural Painting," in *Essays on Mexican Art*, 115, 131–136.

8. Palacios, "Social Sciences," 64.

9. Octavio Paz, "Re/Visions," 115. See Coffey, *How a Revolutionary Art Became Official Culture*, for an analysis.

10. Monsiváis, "On Civic Monuments and the Spectators," esp. 107–108.

11. Choay, *Invention*, 6–7.

12. Carrera, *Traveling from New Spain to Mexico*, 133.

13. Henri LeFebvre, "Production of Social Space," 139; Kristin Ross, *The Emergence of Social Space*, 8.

14. Néstor García Canclini, "Modos de mirar los murales."

15. "Michoacán: Pátzcuaro," in *Memoria de los trabajos emprendidos y llevados a cabo.*

16. Michael J. Gonzales, "Imagining Mexico in 1910: Visions of the Patria in the Centennial Celebration in Mexico City," 512–513, 520.

17. For comparison, note the Afro-Mexican racial type presented in figure 2.25 (AF-IIH-UMSNH).

18. "Guía del desfile histórico de la ciudad de Pátzcuaro, 8 de diciembre de 1929," CREFAL, Pátzcuaro.

19. Friar Matías de Escobar, *Americana Thebaida*, quoted in ibid., 2.

20. Reproduced in José Manuel Martínez Aguilar, *El Pátzcuaro de ayer en el imaginario*, 159.

21. Brenner, *Your Mexican Holiday*; Toor, *Frances Toor's Motorist Guide*, 177–178; *Morelia, Pátzcuaro, Uruapan*, 26.

22. Toussaint's first publications are dated 1914, so likely he is not its author; arguably he received this copy while researching Pátzcuaro.

23. David Brading, "Manuel Gamio and Official *Indigenismo* in Mexico."

24. Humboldt, *Political Essay*, 299.

25. See Benjamin Keen, *The Aztec Image in Western Thought* (New Brunswick, NJ: Rutgers University, 1990).

26. Alfonso Toro to Secretario Particular del C. Secretario del Ramo, Apr. 30, 1937, Gobierno, Dirección General, vol. 12, 1937, sección 14, exp. 222, AHIBNAH, Mexico City; Mauricio Swadish to Felix C. Ramírez, Nov. 1, 1939, Gobierno, Dirección General, 1939, vol. 17, sección 9, AHIBNAH, Mexico City; "Actividades antropológicas en Michoacán durante el año de 1945," *Anales del Museo Michoacáno* 4 (1946): 7–10; George M. Foster, *Tzintzuntzan: Mexican Peasants in a Changing World.*

27. *La relación de Michoacán: Su importancia artística.*

28. Daniel Rubin to Antonio Arrieta, July 1, 1943, in "Relación de volúmenes empas-

tados," vol. 25, and newspaper coverage in vol. 29, CERM, Fondo Lic. Antonio Arrieta, Centro de Estudios de la Revolución Mexicana Lázaro Cárdenas (CERM), Jiquilpan; Barbara Braun, "Diego Rivera's Collection: Pre-Columbian Art as a Political and Artistic Legacy," 254.

29. Carolina Escudero Luján (General Múgica's wife) notes the division between the lake and city communities: see *Una mujer en la historia de México*, 185.

30. Fernández, *Pátzcuaro*, 21–22; Bay Pisa, *Los rincones históricos*, 7–8; Antonio Arriaga Ochoa, "Don Vasco de Quiroga and the City of Pátzcuaro," *Artes de México* 120, no. 16 (Jan. 1969): 59.

31. Fernández, *Pátzcuaro*, 22.

32. Ana Cristina Ramírez Barreto, "'Eréndira a caballo': Acoplamiento de cuerpos e historias en un relato de conquista y resistencia," 1–2.

33. See ads in *Vida* (Pátzcuaro, July 1938).

34. Ruiz to Cárdenas, Mar. 10, 1935, Nov. 12, 1935, 562.2/14 LCR/AGN.

35. Writing in 1936, Fernández refers to the "former estate" of Cárdenas, now a school (*Pátzcuaro*, 14).

36. Cortés Zavala, *Lázaro Cárdenas y su proyecto cultural*, 54.

37. Jesús Ernesto López Argüelles, "Fermín Revueltas: Roberto Cueva del Río en Jiquilpan: Breves apuntes." The copies are now at the Centro Interdisciplinario de Investigación para el Desarrollo Integral de la Comunidad Rural del Instituto Politécnico (CIIDIR-Michoacán) in Jiquilpan.

38. Ibid., 22.

39. Moisés Guzmán Pérez, "Eduardo Ruiz y su historia de la Guerra de Intervención en Michoacán," *TzinTzun* 20 (July–Dec. 1994): 21, 23, 24, 25–26 (quotations).

40. Eduardo Ruiz, *Michoacán: Paisajes, tradiciones y leyendas*, 319. The sixteenth-century *Relación de Michoacán* describes red, green, and white feathers as spoils of war, divided by the heirs themselves—not by Tariácuri. *Chronicles of Michoacán*, translated and edited by Eugene Craine and Reginald C. Reindorp, 218–222.

41. *Morelia, Pátzcuaro, Uruapan*, 5.

42. Rafael Heliodoro, "Portico," in Jesús Romero Flores, *Michoacán histórico y legendario*, 8.

43. Ruiz, *Michoacán*, vol. 2, 83. By contrast, the sixteenth-century *Relación* mentions an embrace but minimizes the actual encounter between the *caltzontzin* and conquistadors: *Chronicles of Michoacán*, 82.

44. Mónica Pulido Echeveste is writing a thesis on the politics of colonial-era representations of this encounter for the History Department at UNAM, Morelia.

45. Ramírez Barreto, "'Eréndira a caballo,'" 1.

46. Thanks to James Oles for suggesting this work.

47. Note various transliterations: Tangaxuhan, Tanganxuan, Tangaxoan, and the other names given to Tanganxuan II: Caltzontzin (or Cazonci) and Don Fernando.

48. Monsiváis argues that the Cuauhtémoc monument is about imperial status, not ethnic pride: "On Civic Monuments," 118.

49. On the original, see Angélica Jimena Afanador-Pujol, "The Tree of Jesse and the 'Relación de Michoacán,'" *Art Bulletin* 92, no. 4 (Dec. 2010): 293–307.

50. Toor, *Frances Toor's Motorist Guide*, 175–178; Toussaint, *Pátzcuaro*, 119.

51. See Krippner-Martínez, *Rereading the Conquest*: chapter 2, 16–21.

52. Agustín Arteaga, "Guillermo Ruiz: Estoicismo y heroicidad," 39.

53. Paul C. Jaskot, "Anti-Semitic Policy in Albert Speer's Plans for the Rebuilding of Berlin," *Art Bulletin* 78, no. 4 (Dec. 1996): 622–632.

54. José Orta to Cárdenas, Mar. 7, 1940, 568/9 LCR/AGN.

55. Hilario Reyes, "El Monumento a Tangaxuhan."

56. Vázquez León, "Noche de Muertos," 356.

57. According to Gerardo Díaz, his photograph of a fountain showing Quiroga embracing a kneeling Indian records a monument on the outskirts of Pátzcuaro, to the southwest. Interview, Pátzcuaro, October 11, 2013. Today monuments to Quiroga can be found in various Michoacán cities, including Quiroga (1950), Pátzcuaro (1965), Santa Fe de Laguna, Santa Clara del Cobre, and Tzintzuntzan, as well as in some Guanajuato cities, including Irapuato, Salamanca, and Pueblo Nuevo. See http://vamono salbable.blogspot.com/2010/05/rotunda-presencia-de-don-vasco-de.html.

58. Rita Eder, "The Icons of Power and Popular Art," 64.

59. Krippner-Martínez, *Rereading the Conquest*, 7, 159–160.

60. Ibid., 155. Fernando Gómez notes historians' universal praise for Quiroga: *Good Places*, 41.

61. Ruiz to Cárdenas, no date, 533.3/61 LCR/AGN; Rollo 42 (20 Segunda Parte), Archivo Privado Lázaro Cárdenas, AGN; María Luisa Ocampo, "La última obra escultórica de Guillermo Ruíz," press clipping, Centro de Documentación y Investigaciones, Morelia; Ivonne Solano Chávez, "Entre la historia y el testimonio," 55–56.

62. "En defensa de Pátzcuaro," 36.

63. Bay Pisa, *Los rincones históricos*, 13.

64. Ibid., 22; Toussaint, *Pátzcuaro*, 32.

65. Toor, Frances Toor's *Motorist Guide*, 175.

66. Julián Bonavit, "Esculturas tarascas de caña de maíz y orquídeas fabricadas bajo la adirección del ILMO Señor Don Vasco de Quiroga."

67. Toor, *Frances Toor's Motorist Guide*, 175.

68. Bay Pisa, *Los rincones históricos*, 18.

69. According to Toussaint, the museum "honors Don Vasco's memory": *Pátzcuaro*, 33.

70. Kaplan, "Mexican Marketplace," 182.

71. Guillermina Ramírez Montes, *La catedral de Vasco de Quiroga* (Zamora, Michoacán: Colegio de Michoacán, 1986), 80–85; and Toussaint, *Pátzcuaro*, 108, cited in Krippner-Martínez, *Rereading the Conquest*, 155. Krippner-Martínez also discusses Quiroga's power struggle with the Franciscans: *Rereading the Conquest*, 77–79.

72. Vicente Rivas Palacio, *México a través de los siglos*, 226; discussed in Krippner-Martínez, *Rereading the Conquest*, 166.

73. Commissión del Monumentos reports, Oct. 1, 1937, Gobierno, Dirección General, vol. 12, 1937, sección 4, exp. 212; Oficina de Monumentos Coloniales y de la República, "Informe sintético de las labores realizadas conformado al Plan Sexenal, el año 1938," Gobierno, Dirección General, vol. 14, 1938, sección 3, exp. 261; Arquitecto

José Gorbea to Dir. del INAH, Nov. 23, 1939, Gobierno, Dirección General, 1939, vol. 17, sección 21, exp. 198; Lic. Alfoso Caso to Oficial Mayor de Ramo, Nov. 17, 1939, Gobierno, Dirección General, 1939, vol. 17, sección 7; exp. 297, AHIBNAH, Mexico City.

74. *Morelia, Pátzcuaro, Uruapan,* 21.

75. Martínez Rubio wrote on behalf of Sr. Leopoldo Paz, who had dedicated a local plaque honoring this history, Martínez Rubio to Cárdenas, Oct. 6, 1936, 562.2/45 LCR/AGN. Today there are monuments to both Quiroga and Cárdenas.

76. Based on Friar Juan de Grijalva's description, excerpted in Gómez, *Good Places,* 34–41. See also Krippner-Martínez, *Rereading the Conquest,* 93–97.

77. Zavala and Estrada, *La "Utopia" de Tomás Moro.*

78. Krippner-Martínez, *Rereading the Conquest,* 172; O'Gorman, "Autobiografía," 26.

79. Ortiz Vidales, "Los frescos de R. Bárcenas," 26.

80. Krippner Martínez characterizes the conflict this way: *Rereading the Conquest,* 172.

81. On such debates, see Palacios, "Social Sciences"; and Susana Quintanilla, "La educación en México durante el periodo de Lázaro Cárdenas."

82. El Primero Congreso Interamericano de Indigenistas, *Boletín* 1, Apr. 19, 1940, 7.

83. El Primero Congreso Interamericano de Indigenistas, *Boletín* 4, Apr. 23, 1940, 1–2. This staging suggests that Don Vasco's remains were moved from the Compañía to the basilica at this time.

84. An oversized advertisement promoting the hotel's traditional style and modern convenience appeared in *Mapa* (Feb. 1939).

85. Lic. Agustín Leñero to "Biblioteca Indígena 'Eréndira,'" Pátzcuaro, June 19, 1940, 531.2/460 LCR/AGN.

86. Leonora Saavedra, "Staging the Nation: Race, Religion, and History in Mexican Opera of the 1940s," 9, 11–15.

87. Ibid., 10–12.

88. Albert L. Michaels, "Modification of the Anti-Clerical Nationalism of the Mexican Revolution by General Lázaro Cárdenas and Its Relationship to the Church State Détente in Mexico," *Americas* 26, no. 1 (July 1969): 48–49.

89. Lorena Díaz Núñez, *Miguel Bernal Jiménez: Catálogo y otras fuentes documentales,* 23, 51.

90. Manuel Chust and Víctor Mínguez, eds., *La construcción del héroe en España y Mexico (1789–1847).*

91. Solano Chávez, "Entre la historia y el testimonio," 47.

92. Aguirre Beltrán, *La población negra,* 275. He cites Lucas Alamán, *Historia de México* (Mexico City, 1849), vol. 2, 241. Baptismal records indicate that he was Spanish, though Aguirre Beltrán notes that changes from *mulato* to Spanish were often made.

93. Romero Flores, *Michoácan,* 254.

94. See Ramón Alonso Pérez Escutia, "Los orígenes del panteón cívico Michoacáno, 1823–1834"; and Gonzales, "Imagining Mexico in 1910," 520.

95. Pérez Escutia, "Los orígenes del panteón," 87, 105.

96. Carlos María Bustamante, Morelos's biographer, unsuccessfully petitioned the state to create his portrait in 1824: see Pérez Escutia, "Los orígenes del panteón," 100.

97. Guillerma Guadarrama Peña, "El Congreso de Apatzingán: El fusilmiento de Gertrudis Bocanegra, Fermín Revueltas."

98. Antonio M. Valdespine, Municipal Pres. of Túxpan, Mich., to Cárdenas, Sept. 36, 1939, 562.2/14, LCR/AGN; Rui to Cárdenas, 1940, 562.2/14, LCR/AGN.

99. Morelia's leftist paper *Surco* repeatedly linked Cárdenas and Morelos: for example, *Surco* (Morelia), Oct. 22, 1938, 1; Gral. Francisco Múgica to Cárdenas, June 28, 1940; Cárdenas to Múgica, June 29, 1940, 609/32, LCR/AGN.

100. Enrique Franco and Agustín Arteaga, "Lo nacional como vanguardia: Escultura, identidad e historia," 127.

101. Ibid.

102. G. Ruiz to Cárdenas, June 15, 1939, 562.2/14, LCR/AGN. Both are now at the Museo Casa Morelos, Morelia.

103. Cárdenas to Gral. Dr. José Siurob, Nov. 13, 1936; Gral. Núñez to Cárdenas, Nov. 12, 1936, 609/210 LCR/AGN; Francisco Rodríguez Macaboo to Cárdenas, June 23, 1937, 609/210 LCR/AGN; Manuel Núñez to C. Cosme Hinojosa, Jefe del Dept. Central del DF, Mar. 22, 1937, 562.2/14, LCR/AGN; Héctor T. Rentería to Luis I. Rodríguez, July 22, 1935, 562.2/14, LCR/AGN.

104. Fernández, *Pátzcuaro*, 53; Ángel Guzmán, José Campos, y Silverio Silvestre to Cárdenas, July 25, 1940, LCR/AGN; Zizumbo Villareal, "Pátzcuaro," 157, 163. According to Zizumbo Villareal, owners of restaurants and *artesanías* shops constituted a new (middle) class on the island. The land had originally been ceded to Cardenas by a local Indian, Antonio de la Cruz: see Romero Flores, *Lázaro Cárdenas*, 44.

105. "Mexico Builds Her Own 'Statue of Liberty,'" *Popular Science* (Feb. 1936), no pagination; Terry, *Terry's Guide*, 505–507.

106. Carlos Herrejón, "La imagen heróica de Morelos," 244.

107. Librado Basilio, *Ramón Alva de la Canal*, 57; Ramón Alva de la Canal, "Proyecto de la decoración mural dentro del monumento erigido en la isla de Janitzio, en el Lago de Pátzcuaro, Michoacán," 562.2/14 LCR/AGN; Albert L. Michaels, "Modification of the Anti-Clerical Nationalism," 38.

108. Ruiz to Cárdenas, June 15, 1939, 562.2/14 LCR/AGN.

109. For a phenotype classification system used the 1940s, see Aguirre Beltrán, *La población negra*, 164–172.

110. Ibid., 200–201.

111. Toussaint, *Pátzcuaro*, 192; "Lagos: Pátzcuaro," 39–40.

112. Toussaint, *Pátzcuaro*, 192; Terry, *Terry's Guide*, 505–507.

113. Arteaga, "Guillermo Ruiz," 35–38.

114. Fernández, *Pátzcuaro*, 54–55.

115. Ángel Guzmán, José Campos, and Silverio Silvestre to Cárdenas, July 25, 1940, 568/9 LCR/AGN.

116. Zizumbo Villareal, "Pátzcuaro," 151–168.

117. Alicia Tecuanhuey, "La imagen de las heroínas mexicanas," 71, 81–83, 86–87.

118. Ángel Pola, "Vida y hecho de una insurgente," *Periódico Oficial del Estado de Michoacán* 3 (Jan. 8, 1893), cited in Elías García Rojas to Cárdenas, 562.2/56 LCR/AGN.

119. Rodolfo Toquero to Sr. Lic. Dn. Raúl Castellanos, Sept. 22, 1938, 568/9 LCR/ AGN; Romero Flores, "Gertrudis Bocanegra de Lazo de la Vega: Heroína de Pátzcuaro," *SURCO* (Morelia), Sept. 15, 1938.

120. Major accounts of Bocanegra include Manuel Ortega Reyes, *Historia del verdadera liberador: General D. Vicente Guerrero y de la heroína de Pátzcuaro Doña Gertrudis Bocanegra de Vega* (Mexico City: Mariano Viamonte, 1905); and Jesús Romero Flores, *Gertrudis Bocanegra de Lazo de la Vega: Heroína de Pátzcuaro*.

121. Romero Flores, *Gertrudis Bocanegra*, 20; Fernández, *Pátzcuaro*, 34; Dorian Aarón García García, "María Gertrudis Bocanegra Mendoza de Lazo y de la Vega," 68–69.

122. Romero Flores, *Gertrudis Bocanegra*, 21–22.

123. Leduc to Cárdenas, June 1, 1938, 568/9 LCR/AGN.

124. See Becker, *Setting the Virgin on Fire*.

125. Elías García Rojas to Cárdenas, Jan. 25, 1938, 562.2/54 LCR/AGN.

126. Ruiz to Cárdenas, Sept. 1940, 562.2/74 LCR/AGN.

127. Sr. Avelino Ruiz to Cárdenas, Sept. 12, 1940, Nov. 21, 1940; Sr. Rafael de la Cruz to Cárdenas, no date, 562.2/74 LCR/AGN. Conversation with Miguel Monje, Dec. 2010. The monument was moved to the main plaza in 1967, but a plaque remains in the original site.

128. Thomas Benjamin, "From the Ruins of the Ancien Régime: Mexico's Monument to the Revolution," 172.

129. Carmen López Núñez, interview, Morelia, Dec. 2010; Carmen López Núñez, "El papel de la hacienda como forma de vivienda colectiva y sus transformaciones en la región de Morelia, Mich., México," *Scripta Nova: Revista Electrónica de Geografía y Ciencias Sociales* 7, no. 146 (Aug. 2003): http://www.ub.edu/geocrit/sn/sn-146%28054%29 .htm.

130. See the album of Ruiz's work for Cárdenas in the CERM archive, Jiquilpan.

131. O'Gorman, "Autobiografía," 140.

132. Enrique Cervantes, *Pintura de Juan O'Gorman en la Biblioteca de Gertrudis Bocanegra en Pátzcuaro, Mich.*, [1].

133. See Adriana Zavala, "Mexico City in Juan O'Gorman's Imagination," 493.

134. Gloria Villegas Moreno, "Los 'éxtasis' del pasado: La historia en la obra mural de Juan O'Gorman," 145. On the mural's content see Cervantes, *Pintura de Juan O'Gorman*; and Tracy Novinger, "The Juan O'Gorman Mural in Pátzcuaro": ogormanpatz cuaro.wordpress.com (2010): now available at http://ogorman-mural.blogspot.com/p /mural-guide.html.

135. Ida Rodríguez Prampolini, "El creador, el pensador, el hombre," 215.

136. "One Lynching Spurs Congress to Stop Others," *Life* (Apr. 26, 1937): 26.

137. Elena Poniatowska, "Juan O'Gorman de los Fifís a San Jerónimo," 311.

138. Jorge Alberto Manrique, "Edmundo O'Gorman, 1906–1995," 196.

139. Gloria Blanca López (head librarian, Biblioteca Pública Gertrudis Bocanegra), e-mail, June 3, 2011.

140. Teresa Rivera, "Festejan hoy los 475 años de la ciudad de Pátzcuaro," *Cambio de Michoacán*, Sept. 28, 2009: http://www.skyscrapercity.com/showthread.php?t=728428 &page=21.

1. Adolfo Gilly, "El general escribe en su despacho: Ocho escenas de la vida de Lázaro Cárdenas," in *Lázaro Cárdenas: Iconografía*, 11.

2. Verónica Vázquez Mantecón, *El mito de Cárdenas*, 12, 14, 17, 22–23.

3. Nathaniel Weyl and Sylvia Weyl describe accompanying him to the Los Altos region: *The Reconquest of Mexico: The Years of Lázaro Cárdenas*, 9. Photographs and reports of Cárdenas's travels around the country further testify to journalists' presence.

4. Luis Anaya Merchant, Marcos T. Águila M., and Alberto Enríquez Perea, "La de los años treinta: Una generación de constructors," in *Personajes, ideas, voluntades: Políticos e intelectuales mexicanos en los años treinta*, 5–9.

5. Vaughan, *Cultural Politics*.

6. López, *Crafting Mexico*, 20.

7. Knight, "Cárdenas and Echevarría," 36. See also Knight, "Cardenismo: Juggernaut or Jalopy?"

8. Exceptions include Coffey, *How a Revolutionary Art Became Official Culture*; López, *Crafting Mexico*; Cruz Porchini, "Proyectos culturales."

9. See Xavier Guerrero's print *La tierra es de quien la trabaja con sus manos* appearing in *El machete* (1924) or Rivera's 1926 murals for the administrative offices at the Chapingo Agricultural School.

10. Vázquez Mantecón, *El mito de Cárdenas*, 13–14.

11. Vázquez Mantecón also points out that Salvador Novo was already discussing this in the 1930s: ibid., 37–38, 66; William H. Beezley and Colin M. MacLachlan, *Mexicans in Revolution*, 107–128.

12. Weyl and Weyl, *Reconquest of Mexico*.

13. Kiddle and Muñoz, *Populism in 20th Century Mexico*, 6; Nora Hamilton, *Mexico: Political, Social, and Economic Evolution*, 50; Beezley and MacLachlan, *Mexicans in Revolution*, 108–134. Palacios questions this reputation, in "The Social Sciences, Revolutionary Nationalism, and Interacademic Relations," 72.

14. Martín N. Méndez Huaxcuatitla, "Āmatlapohualistli de Don Lázaro Cárdenas: A Written Account concerning Lázaro Cárdenas," trans. David Tuggy: http://www-01.sil.org/~tuggyd/tetel/F001i-Cardenas-nhg.htm., 13; Wendy Waters, "Remapping Identities: Road Construction and Nation Building in Post-Revolutionary Mexico," 232.

15. Romero Flores, *Lázaro Cárdenas*, 44–45. See also Thomas Rath, *Myths of Demilitarization in Postrevolutionary Mexico, 1920-1960*, 39–43.

16. Tibol, "El nacionalismo en la plástica," 238–252.

17. Dafne Cruz Porchini identifies key figures, including Gabriel Fernández Ledesma and Francisco Díaz de León, Ermilo Abreu Gómez, José Gorostiza, Graciela Amador, Enrique Gutmann, and Gustavo Casasola: "Proyectos culturales," 30, 52.

18. Judith Alanís, "Comentario [a Tibol]."

19. Arteaga, "Guillermo Ruiz," 38.

20. A painted panel added within the *Monumento a Morelos* during the restoration of its murals lists Tirado Valle as the sculptor. He complained further in a memoir, cited

in Solano Chavéz, "Entre la historia y el testimonio," 59; Solano Chavéz, e-mail to author, September 19, 2013. Cárdenas's assistant, Col. José Manuel Núñez, also secured extended leaves with stipends of MX$150 from the ENAP for professors Moisés del Águila, Modesto Hernández, and Pedro Coria to continue their work with Ruiz. Col. J. Manuel Nuñez to Rector Luis Chico Goerne, Mar. 3, 1938, exp. 7, caja 19, Archivo de la ENBA/AP, UNAM, Mexico City.

21. Ruiz to Cárdenas, June 15, 1939, 568/9 LCR/AGN.

22. Arteaga, "Cronología," in *Guillermo Ruiz y la Escuela Libre*, 36–37.

23. Ibid., 39–40, 46.

24. Leduc to Cárdenas, Oct. 25, 1935; Leduc to Cárdenas, Dec. 3, 1935, Feb. 15, 1936; Leduc to Cárdenas, Apr. 13, 1936, May 12, 1936, Dec. 11, 1937, 609/210 LCR/AGN; Leduc to Cárdenas Dec. 11, 1936, Dec. 12, 1939, 568/9 LCR/AGN.

25. http://www.indaabin.gob.mx/dgpif/historicos/republica_salvador.htm; and subdirector Arq. Alberto Leduc to Sr. Matías Pacheco, Feb. 4, 1950, private collection: http://magdalenogutierrez.blogspot.com/.

26. Cárdenas, *Apuntes*, cited in Julio Moguel, "*Eclipse y Caricias*: Dos fragmentos del libro en preparación *El último aliento del general*," *La Jornada Michoacán*, Oct. 19, 2005: http://www.lajornadaMichoacán.com.mx/2005/10/19/16n1cul.html (no longer available); and Amalia Solórzano, "*Buenos días, general*," excerpted in *La Jornada Michoacán*, Dec. 12, 2009: http://www.lajornadaMichoacán.com.mx/2009/12/12/index.php?section=politica&article=006n1pol (no longer available).

27. Xavier Guzmán Urbiola, "Los años radicales, 1930–1940," 180.

28. G. Rivas [Howard Phillips], "Ricardo Bárcenas."

29. Rector Chico Goerne, May 18, 1937, Apr. 1937, exp. 20, caja 19, Archivo de la ENBA/AP, UNAM, Mexico City.

30. "[Plan]," Mar. 15, 1937, exp. 20, caja 19, Archivo de la ENBA/AP, UNAM, Mexico City.

31. "Programa de servicios sociales," no date, exp. 20, caja 19, Archivo de la ENBA/AP, UNAM, Mexico City.

32. Marcela del Río, "Alberto Beltrán habla de Ricardo Bárcenas, la ELAP y otros temas"; and Silvia Fernández H., "Del dibujo académico al diseño visual," 305.

33. On usefulness, see Palacios, "Social Sciences."

34. Rector to Bárcenas, Jan. 10, 1938; Bárcenas to Rector, Jan. 11, 1938; Machote para un concurso [n.d.]; Rector Chico Goerne to Bárcenas [n.d.], Bárcenas to Rector, Mar. 15, 1938; Francisco Nicodemo to Bárcenas, Apr. 18, 1939, exp. 7, caja 19, Archivo de la ENBA/AP, UNAM, Mexico City.

35. Lic. Octavio Medellín Ostos to Ricardo Bárcenas, June 20, 1938; Bárcenas to Rector, June 21, 1938; Bárcenas to Rector, May 4, 1938, exp. 7, caja 19, Archivo de la ENBA/AP, UNAM, Mexico City. On the Xochimilco project, see also Gobierno, Dirección General, vol. 14, 1938, sección 6, exp. 264, AHIBNAH, Mexico City.

36. Sr. Leopoldo Salazar Viniegra to Bárcenas, June 10, 1938, exp. 7, caja 19, Archivo de la ENBA/AP, UNAM, Mexico City; Fernández H., "Del dibujo académico," 305–306.

37. Julieta Ortiz Gaitán, *Imágenes del deseo: Arte y publicidad en la prensa ilustrada mexicana (1894–1939)*, 184; and Río, "Alberto Beltrán habla de Ricardo Bárcenas."

38. "Roberto Cueva del Río," *Agora*, second series, 11, no. 26 (Nov.–Jan. 2007): 1.

39. Director Diego Rivera to Gobernador del Estado de Puebla, Jan. 6, 1930, Private Archive, published on "Roberto Cueva del Río," Wikipedia, https://commons.wiki media.org/wiki/File:Carta_de_Diego_Rivera.jpg; "Los sobrevivientes de la Mansion McVeagh," Sept. 27, 2009: http://wilberttorre.wordpress.com/2009/09/27/los-sobre vivientes-de-la-mansion-mcveagh/.

40. Lic. David Franco Rodríguez to Sr. Roberto Cueva del Río, Apr. 9, 1943, exp. 2, caja 2, Fs1, Secretaría Administrativa, Archivo del la Universidad Michoacána de San Nicolás de Hidalgo.

41. Mónika Gutiérrez Legorreta, "Catalogo Documental, Fondo: Consejo Universitario, Sección: Secretaría, Serie: Actas, 1918–1960," thesis (Morelia: UMSNH, Facultad de Historia, 2008), 546–547.

42. Don Fernando Benítez, in *Novedades* 27 (Nov. 1949); Garibay, *Nuestra sangre*. See also López, *Crafting Mexico*, 115.

43. The Solchaga album is part of the collections of the Museo de Artes e Industrias Populares, Pátzcuaro.

44. Thiele, *El maque*, 63–65.

45. Glusker, *Avant-Garde Art and Artists in Mexico*, 115; *Daybooks of Edward Weston*, 175.

46. López, "Lo más mexicano de México," 189.

47. Thiele, *El maque*, 63; "El Templo del Calvario fue salvado de convertirse en ruinas," *Record* (Pátzcuaro), Nov. 2, 1962.

48. *Anales del Museo Michoacano*, second series, 3 (Sept. 1944): 108.

49. Cárdenas, "Decree," Nov. 28 1940, 609/210 LCR/AGN.

50. Leduc, "Teatro Popular Lázaro Cárdenas," 1935, 609/210 LCR/AGN.

51. John Mraz, "Today, Tomorrow, and Always: The Golden Age of Illustrated Magazines in Mexico, 1937–1960," 117–118.

52. On Cárdenas's campaign images, see Dafne Cruz Porchini, "Imágenes de poder: La prensa periódica y la campaña presidencial de Lázaro Cárdenas," 241–248. Cruz Porchini points out that the unequal scale in these "dialogs" expresses the power differential of the candidate versus the masses (246).

53. Renato González Mello, "Los pinceles del siglo XX: Arqueología del régimen," 23.

54. Mraz, "Today, Tomorrow, and Always," 153.

55. Ibid., 119–120.

56. Vázquez Mantecón, *El mito de Cárdenas*, 35–36; Beezley and MacLachlan, *Mexicans in Revolution*, 108–110; Hamilton, *Mexico*, 50; González Mello, "Los pinceles," 23.

57. Beezley and MacLachlan, *Mexicans in Revolution*, 110.

58. Vázquez Mantecón, *El mito de Cárdenas*, 35–36.

59. Knight, "Cárdenas and Echevarría," 35.

60. González Mello, "Los pinceles," 23.

61. Alva de la Canal, "Proyecto de la decoración mural dentro del monumento eri-

gido en la isla de Janitzio, en el Lago de Pátzcuaro, Michoacán," exp. 562.2/14, LCR/AGN.

62. "En la comitiva del Presidente Cárdenas," *Hoy*, May 22, 1937.

63. *El Maestro Rural* 4, no. 1 (Jan. 1936): 20–21.

64. "Ases de la cámara: Decano de los fotógrafos de prensa, XVII: Antonio Carrillo" *Mañana* 163 (Oct. 12, 1946): 24–26.

65. Novo, "Plan Sexenal," *Hoy*, June 5, 1937, cited in Novo, *La vida en México*, 63–68.

66. "Una vista al estado de Michoacán: Sus carreteras, su importancia, sus bellezas naturales," Gobierno, 1928–1931, caja Michoacán, Archivo Ramón Fernández y Fernández, COLMICH, Zamora.

67. *Los Piños: Esta es tu casa* (Mexico City: Agueda, 2002).

68. *Rotofoto* poked fun at this version of Cárdenas too: see "Así se gana Cárdenas un sitio en la historia," *Rotofoto* (June 12, 1938).

69. On this idea, see Jack Quinan, *Frank Lloyd Wright's Martin House: Architecture as Portraiture* (New York: Princeton Architectural Press, 2004).

70. Ruiz to Cárdenas, Mar. 10, 1935; and Ruiz to Cárdenas, Nov. 12, 1935, 562.2/14 LCR/AGN; Leduc to Cárdenas, May 12, 1936; and Luis Rodríguez to Leduc, May 19, 1936, 609/210, LCR/AGN. Note that while Guzmán Urbiola ("Los años radicales," 180) credits Leduc with constructing both Los Piños and La Quinta Eréndira, in fact the nineteenth-century La Hormiga ranch was merely remodeled as Los Piños in 1934; likewise, I have only found documentation connecting Leduc with Eréndira in 1935.

71. In 1957 Ruiz returned to add a cast statue dedicated to the *Trilogía Continental—Lincoln, Juárez, and Martí*, to mark a third renovation that transformed the structure into its current purpose, as the center of CREFAL.

72. López Argüelles, "Fermín Revueltas: Roberto Cueva del Río," 177–178; Carla Zurián, *Fermín Revueltas: Constructor de espacios*, 86, 136; Cueva del Río to Cárdenas, Feb. 10, 1938; "Audiencias Sr. Presidente," Feb. 11, 1938, 111/2313, LCR/AGN.

73. Weyl and Weyl, *Reconquest of Mexico*, 21.

74. Jesús Romero Flores, "La raza purépecha." *Universidad Michoacana. Revista Mensual de Cultura* 2, nos. 10–11 and 12 (June–July and Aug. 1938): 36–47.

75. Vázquez Mantecón, *El mito de Cárdenas*, 46.

76. "Cárdenas, el superhombre," *El Eco Revolucionario*, Feb. 24, 1934, 3, cited in Cruz Porchini, "Imágenes de poder," 243.

77. "Los ojillos proyectados sobre el líder; el gesto de hombres sencillos que llegan con la convicción de encontrar a quien sabrá comprenderlas: Sobre esta foto de Carillo, que sintetiza toda una época de la vida mexicana, podría incrutarse la leyenda que acompaña al monumento de fray Bartolomé de las Casas: 'Lector, détente y contempla: este es Lázaro Cárdenas, protector de los indios,'" *Rotofoto* 2 (May 29, 1938).

78. José F. Rojas, "No hará el gobierno más expropiaciones."

79. Novo, "Contemplative Cárdenas," *Hoy*, Dec. 10, 1938, reprinted in Novo, *La vida en México*, 280.

80. Bennett, *The Birth of the Museum*, 67.

81. Carrera, *Traveling from New Spain*, chapter 6.

82. Hugo Arciniega Ávila, "Introducción," 22–23.

83. "[E]l sentido de su nacionalidad, la trayectoria seguía, tácitamente, por una sucesión de generaciones hacia la afirmación de una patria con carácter, con alma propia, leal para con nuestros paisajes y para con nuestra sangre": "En defensa de Pátzcuaro," 33.

84. Along with this visual transformation, the heiress also gives up her plans for the logging business (especially the idea that she would fire the hero and replace him with his competitor), revealing that economic power and control were at stake in such aesthetic transformations. On the merging of femininity and the traditional in Mexico, see Zavala, *Becoming Modern*.

85. Maillefert, *Laudanza de Michoacán*, 136.

86. "Dos años de honesta labor en beneficio del pueblo michoacano," *Surco*, Sept. 15, 1938, 3.

87. On accepting the perspective presented by a work of art (the result of compensating for the difference between one's actual position and the angle of incidence created within an artist's linear perspective system), see Whitney Davis, "Virtually Straight" *Art History* 19, no. 3 (Sept. 1996): 343–363.

88. Alberto de Lachica and Miguel Monje, "Patzcuaro's Lakeshore Towns and Villages," *Voices of Mexico* 67 (2004): 104: http://www.revistascisan.unam.mx/Voices/pdfs/6719.pdf.

89. On the group's visit, see André Breton, *Free Rein*, 40–41; Fabienne Bradu, *André Bretón en México*, 198–202; Mark Polizzotti, "When Breton Met Trotsky," *Partisan Review* 62, no. 3 (Summer 1995): 406–418.

90. Originally the pair had planned a series of evening conversations that would be published as "Conversations in Pátzcuaro," but Breton became ill after the first night, curtailing their conversations. Bradu suggests that this was a means of forestalling an impending break between the two men:, *André Bretón*, 200.

91. Robin Adèle Greeley, "For an Independent Revolutionary Art: Breton, Trotsky and Cárdenas's Mexico," 220–221.

92. On Lazcano's role in Pátzcuaro, see Martínez Aguilar, *El Pátzcuaro de ayer en el imaginario*, 61, 67, 145–146.

93. Zizumbo Villareal, "Pátzcuaro."

94. Van Zantwijk, *Los servidores de los santos*, 87–88.

95. Solchaga family album, Museo de Artes e Industrias Populares, Pátzcuaro; Gerardo Díaz archive, Pátzcuaro; Familia Arías y Martínez archive, Fototeca, UMSNH, Morelia.

Bibliography

ARCHIVES

Archivo de la Escuela Nacional de Bellas Artes/Artes Plásticas (ENBA/AP), UNAM, Mexico City.

Archivo de la Universidad Michoacana de San Nicolás de Hidalgo (UMSNH), Morelia.

Archivo Fotográfico, Instituto de Investigaciones Históricas, Universidad Michoacana de San Nicolás de Hidalgo (AF-IIH-UMSNH), Morelia.

Archivo Fotográfico Manuel Toussaint, Instituto de Investigaciones Estéticas (IIE), UNAM, Mexico City.

Archivo General de la Nación (AGN), Mexico City.

Archivo Histórico Institucional, Biblioteca Nacional de Antropología e Historia (AHIBNAH), Mexico City.

Archivo Histórico Municipal de Pátzcuaro.

Archivo General e Histórico del Poder Ejecutivo de Michoacán (AGHPEM), Morelia.

Biblioteca Justino Fernández, Instituto de Investigaciones Estéticas, Universidad Nacional Autónoma de México (BJF, IIE/UNAM).

Centro de Documentación y Investigación, Clavijero, Morelia.

Centro de Estudios de la Historia de México (CEHM), Mexico City.

Centro de Estudios de la Revolución Mexicana Lázaro Cárdenas (CERM), Unidad Académica de Estudios Regionales de la Coordinación de Humanidades de la UNAM, Jiquilpan.

Colección Manuel Toussaint, Archivo Histórico y de Investigación Documental, IIE, UNAM, Mexico City.

Colegio de Michoacán (COLMICH), Zamora.

Centro de Cooperación Regional para la Educación de Adultos en América Latina y el Caribe (CREFAL), Pátzcuaro.

El Fondo Aerofotográfico de Fundación ICA, Mexico City.

Fototeca, Archivo General e Histórico del Poder Ejecutivo de Michoacán (AGHPEM), Morelia.

Fototeca Nacional, Instituto Nacional de Arqueología e Historia, Mexico City.

Hemeroteca, Morelia.

Hemeroteca, UNAM, Mexico City.

Museo de Artes e Industrias Populares, Pátzcuaro.

Personal archive, Gerardo Díaz, Pátzcuaro.

Personal archive, Jorge González Servín, Pátzcuaro.

SELECTED PUBLISHED SOURCES

Afanador-Pujol, Angélica Jimena. *The* Relación de Michoacán *(1539-1541) and the Politics of Representation in Colonial Mexico.* Austin: University of Texas Press, 2015.

Aguirre Beltrán, Gonzalo. *La población negra de México.* Mexico City: Ediciones Fuente Cultural, 1946.

Alanís, Judith. "Comentario [a Tibol]." In *El nacionalismo y el arte mexicano,* 252-253. Mexico City: UNAM, IIE, 1986.

Alardin, Gabriela Lee. "Apuntes sobre la conservación y restauración del patrimonio en México." *Revista CPC [Centro de Preservação Cultural]* (São Paulo), 6 (2008): 7-20.

Albers, Patricia. *Shadows, Fire, Snow: The Life of Tina Modotti.* Berkeley: University of California Press, 2002.

Álbum de Pátzcuaro. Cincinnati, OH: Imprenta de S. Ignacio Amapolas, ca. 1899.

Anales del Museo Michoacáno. Morelia: Universidad Michoacano, 1939-1945.

Anaya Merchant, Luis, Marcos T. Águila M., and Alberto Enríquez Perea, eds. *Personajes, ideas, voluntades: Políticos e intelectuales mexicanos en los años treinta.* Mexico City: Universidad Autónoma del Estado de Morelos, 2011.

Anderson, Benedict. *Imagined Communities.* London, New York: Verso, 1983.

Anreus, Alejandro, Leonard Folgarait, and Robin Greeley, eds. *Mexican Muralism: A Critical History.* Berkeley: University of California, 2012.

Apuntes históricos de la ciudad de Pátzcuaro. [Morelia: Arquidócesis de Michoacán], 1924.

Arciniega Ávila, Hugo. "Introducción." In *Una memoria de 75 años, 1935-2010: El Instituto de Investigaciones Estéticas,* 19-28. Mexico City: Instituto de Investigaciones Estéticas, 2010.

Arqueología del régimen, 1910-1955. Mexico City: Museo Nacional de Arte, 2003.

Arriaga, Antonio, and D. López Sarrelangue. "Riberas del Lago de Pátzcuaro" issue. *Artes de México* (Mexico City) 120 (1969).

Arteaga, Agustín. "Guillermo Ruiz: Estoicismo y heroicidad." In *Guillermo Ruiz y la Escuela Libre de Escultura y Talla Directa,* 35-45. Mexico City: Museo Casa Diego Rivera y Frida Kahlo, 2010.

Asociación Mexicana de Turismo. *Viajes de vacaciones*. Mexico City: Asociación Mexicana de Turismo, 1939.

Azevedo Salomao, Eugenia, María de los Ángeles Zambrano González, and Luis Alberto Torres Garibay, eds. *Michoacán: Arquitectura y urbanismo*. Morelia: Universidad Michoacana de San Nicolás de Hidalgo, 1999.

Barthes, Roland. "Myth Today." In *Mythologies*, 109–159. Paris, France: Éditions du Seuil, 1957.

Bartra, Roger. "Paradise Subverted: The Invention of the Mexican Character." In *Primitivism and Identity in Latin America*, edited by Erik Camayd-Freixas and José Eduardo Gonzalez, 3–22. Tucson: University of Arizona, 2000.

Basilio, Librado. *Ramón Alva de Canal*. Jalapa: Universidad Veracruzana, 1992.

Bassols, Narciso. "Plática del Secretario de Educación Pública a los miembros de las Misiones Culturales, sustentada en el Teatro Orientación la noche del 4 de marzo de 1932." *Maestro Rural* 1, no. 2 (March 15, 1932): 3–8.

Bataille, Georges. "Architecture" (1929). In *Rethinking Architecture*, edited by Neil Leach, 19–21. London, New York: Routledge, 2005.

Baud, Michiel, and Annelou Ypeij. *Cultural Tourism in Latin America*. Leiden, Boston: Brill, 2009.

Bay Pisa, Jorge. *Los rincones históricos de la ciudad de Pátzcuaro: Guía del turista*. Pátzcuaro: Tip. La Pluma de Oro, 1930.

Beaumont, Fray Pablo. *Crónica de Michoacán (1778–80)*. Mexico City: Talleres Gráficos de la Nación, 1932.

Becker, Marjorie. "Black and White and Color: Cardenismo and the Search for a *Campesino* Identity." *Comparative Studies in Society and History* 29, no. 3 (July 1987): 453–465.

———. *Setting the Virgin on Fire: Lázaro Cárdenas, Michoacán Peasants, and the Redemption of the Mexican Revolution*. Berkeley: University of California Press, 1995.

Beezley, William H., and Linda A. Curcio-Nagy, eds. *Popular Culture in Latin America*. Lanham, MD: Scholarly Resources, 2000.

Beezley, William H., and Colin M. MacLachlan. *Mexicans in Revolution*. Lincoln: University of Nebraska Press, 2009.

Beezley, William H., Cheryl English Martin, and William F. French, eds. *Rituals of Rule, Rituals of Resistance*. Wilmington, DE: Rowman and Littlefield, 1994.

Belnap, Jeffery. "Caricaturing the Gringo Tourist: Diego Rivera's *Folkloric and Touristic Mexico* and Miguel Covarrubias's *Sunday Afternoon in Xochimilco*." In *Seeing High and Low*, edited by Patricia Johnson, 266–279. Berkeley: University of California Press, 2006.

Benítez, Don Fernando. "Primera fuga a Michoacán." *Novedades* 43 (November 27, 1949): 1–2.

Benjamin, Thomas. "From the Ruins of the Ancien Régime: Mexico's Monument to the Revolution." In *Latin American Popular Culture: An Introduction*, edited by William H. Beezley and Linda A. Curcio-Nagy, 169–182. Wilmington, DE: Scholarly Resources, 2000.

————. *Revolución: Mexico's Great Revolution as Memory, Myth, and History*. Austin: University of Texas Press, 2000.

Bennett, Tony. *The Birth of the Museum: History, Theory, Politics*. London: Routledge, 1995.

————. "The Exhibitionary Complex." *New Formations* 4 (Spring 1988): 73–102.

Berger, Dina. *The Development of Mexico's Tourism Industry: Pyramids by Day, Martinis by Night*. New York: Palgrave Macmillan Press, 2006.

Berger, Dina, and Andrew Grant Wood, eds. *Holiday in Mexico: Critical Reflections on Tourism and Tourist Encounters*. Durham: Duke University Press, 2010.

Blancas López, Gloria. *Pátzcuaro*. Pátzcuaro: Impresiones Garcés, 2009.

Bonavit, Julián. "Esculturas tarascas de caña de maíz y orquídeas fabricadas bajo la dirección del ILMO Señor Don Vasco de Quiroga." *Anales del Museo Michoacáno*, second series, 3 (September 1944): 65–79.

Bonavit, Julián, and Carlos Treviño. *Breve guía histórica de la ciudad de Pátzcuaro*. Morelia: Escuela Industrial Militar, 1908.

Boyer, Christopher. *Becoming Campesinos: Politics, Identity, and Agrarian Struggle in Postrevolutionary Michoacán, 1920–1935*. Palo Alto, CA: Stanford University Press, 2005.

Brading, David. "Manuel Gamio and Official *Indigenismo* in Mexico." *Bulletin of Latin American Research* 7, no. 1 (1988): 75–89.

Bradu, Fabienne. *André Bretón en México*. Mexico City: Editorial Vuelta, 1996.

Braun, Barbara. "Diego Rivera's Collection: Pre-Columbian Art as a Political and Artistic Legacy." In *Collecting the Pre-Columbian Past*, edited by Elizabeth Hill Boone, 251–270. Washington, DC: Dumbarton Oaks, 1993.

Breglia, Lisa. *Monumental Ambivalence*. Austin: University of Texas Press, 2006.

Brehme, Hugo. *México pintoresco*. Mexico City: Fotografía Artística H. Brehme, 1923.

Brehme, Hugo, and Walther Taub. *Picturesque Mexico: The Country, the People and the Architecture*. New York: Brentano's, 1925.

Brenner, Anita. *Your Mexican Holiday*. London, New York: Putnum's Sons, 1932.

Breton, André. *Free Rein* (1953). Translated by Michel Parmentier and Jacqueline D'Amboise. Omaha: University of Nebraska Press, 1995.

Broglio, Ron. *Technologies of the Picturesque*. Lewisburg, PA: Bucknell University Press, 2008.

Bromley, R. J., and Richard Symanski. "Marketplace Trade in Latin America." *Latin American Research Review* 9, no. 3 (Autumn 1974): 3–38.

Buzard, James. *The Beaten Track*. London, New York: Oxford University Press, 1993.

Calderón de la Barca, Madame. *Life in Mexico during a Residence of Two Years in That Country*. London: Chapman and Hall, 1843.

Calderón Mólgora, Marco A. "Festivales cívicos y educación rural en México." *Relaciones, Estudios de Historia y Sociedad* 106, no. 27 (Spring): 17–56.

Cárdenas, Lázaro. *Apuntes*. Mexico City: UNAM, 1972–1974.

¡Cárdenas habla! Mexico City: PRM, 1940.

Carney, Judith. *In the Shadow of Slavery: Africa's Botanical Legacy in the Atlantic World*. Berkeley: University of California Press, 2009.

Carrera, Magali. *Imagining Identity in New Spain: Race, Lineage, and the Colonial Body in Portraiture and Casta Paintings*. Austin: University of Texas Press, 2003.

———. *Traveling from New Spain to Mexico*. Durham: Duke University Press, 2012.

Castelló Yturbide, Teresa. *Pátzcuaro: Cedazo de recuerdos*. Pátzcuaro: n.p., 1983.

Castilleja González, Aida. *El Lago de Pátzcuaro: Su gente, su historia y sus fiestas*. Mexico City: INAH, 1993.

Cervantes, Enrique. *Pátzcuaro en el año mil novecientos treinta y seis*. [Mexico City], 1949.

———. *Pintura de Juan O'Gorman en la Biblioteca de Gertrudis Bocanegra en Pátzcuaro, Mich*. Mexico City: n.p., 1945.

Chi, Lily H. "On the Use of Architecture: The Destination of Buildings Revisited." In *Chora 2: Intervals in the Philosophy of Architecture*, edited by Alberto Pérez-Gómez and Stephen Parcell, 18–36. Montreal: McGill-Queens Press, 1996.

Choay, Françoise. *The Invention of the Historical Monument*. Cambridge: Cambridge University Press, 2000.

Chon, Kye-Sung. "The Role of Destination Image in Tourism: A Review and Discussion." *Tourism Review* 45, no. 2 (1990): 2–9.

Chronicles of Michoacán. Translated and edited by Eugene Craine and Reginald C. Reindorp. Norman: University of Oklahoma Press, 1970.

Chust, Manuel, and Victor Mínguez, eds. *La construcción del héroe en España y México (1789–1847)*. Valencia: Universitat de Valéncia, 2003.

Coffey, Mary K. *How a Revolutionary Art Became Official Culture*. Durham: Duke University Press, 2012.

———. "The 'Mexican Problem': Nation and 'Native' in Mexican Muralism and Cultural Discourse." In *The Social and the Real*, edited by Alejandro Anreus, Diana Linden, and Jonathan Weinberg, 43–70. University Park: Pennsylvania State University Press, 2004.

Colega. Pátzcuaro, 1942–1943.

Conger, Amy. *Weston in Mexico*. San Francisco: Museum of Art, 1983.

Cortés Zavala, María Teresa. *Lázaro Cárdenas y su proyecto cultural en Michoacán, 1930–1950*. Morelia: UMSNH, IIH, 1995.

Covarrubias, "A Southward View" (1946). Reprinted in *Artes de México* 49 (2000): 86–88.

Craib, Ray. *Cartographic Mexico: A History of State Fixations and Fugitive Landscapes*. Durham, NC: Duke University Press, 2004.

Craven, David. *Art and Revolution in Latin America*. New Haven: Yale University Press, 2003.

Crónica de 50 años de ecología y desarrollo en la región de Pátzcuaro, 1936–1986. Pátzcuaro: Centro de Estudios Sociales y Ecológicos, 1986.

Crouch, David, and Nina Lübbren, eds. *Visual Culture and Tourism*. Oxford, New York: Berg, 2003.

Cruz Porchini, Dafne. "Imágenes de poder: La prensa periódica y la campaña presidencial de Lázaro Cárdenas." In *Arte americano: Contextos y formas de ver*, edited by Juan Manuel Martínez, 241–248. Terceras Jornadas de Historia del Arte. Santiago, Chile: Ril, 2005.

———. "Proyectos culturales y visuales en México a finales del Cardenismo." Dissertation, Mexico City, UNAM, IIE, 2014.

Cuevas-Wolf, Cristina. "Guillermo Kahlo and Casasola: Architectural Form and Urban Unrest." *History of Photography* 20, no. 3 (Autumn 1996): 196–207.

Curiel, Gustavo. "Perception of the Other and the Language of 'Chinese Mimicry' in the Decorative Arts of New Spain." In *Asia and Spanish America*, edited by Donna Pierce and Ronald Otsuka, 19–36. Denver: Art Museum, 2006.

Danly, Susan, ed. *Casa Mañana: The Morrow Collection of Mexican Popular Arts*. Albuquerque: University of New Mexico Press, 2001.

The Daybooks of Edward Weston. Vol. 1. New York: Aperture, 1973.

Debroise, Olivier. "Mexican Art on Display." In *Effects of the Nation: Mexican Art in an Age of Globalization*, edited by Carl Good and John V. Waldron, 20–36. Philadelphia: Temple University Press, 2001.

Díaz Núñez, Lorena. *Miguel Bernal Jiménez: Catálogo y otras fuentes documentales*. Mexico City: INBA, Centro Nacional de Investigación, Documentación e Información, 2000.

Diccionario de escritores mexicanos, siglo XX: Desde las generaciones del Ateneo y novelistas de la Revolución hasta nuestros días. Mexico City: UNAM, 1993.

Dietz, Gunther, Kirsten Stolley de Gámez, Gerrit Höllmann, and Frank Garbers. *Las artesanías en la cuenca del Lago de Pátzcuaro: El caso del tallado de madera y la alfarería*. Hamburg: Dept. of American Anthropology, Universität Hamburg, 1991.

Dinerman, Ina R. "Patterns of Adaptation among Households of US-Bound Migrants from Michoacán, Mexico." *International Migration Review* 12, no. 4 (Winter 1978): 485–501.

Dorrian, Mark, and Frédéric Pousin, eds. *Seeing from Above: The Aerial View in Visual Culture*. London: I. B. Tauris, 2013.

Drewal, Henry John. "Mami Wata: Arts for Water Spirits in African and Its Diaspora." *African Arts* 41, no. 2 (Summer 2008): 60–83.

Drewal, Henry John, Marilyn Houlberg, Bogumil Jewsiewicki, Amy L. Noell, John W. Nunley, and Jill Salmons. *Mami Wata: Arts for Water Spirits in Africa and Its Diaspora*. Los Angeles: Fowler Museum of UCLA and University of Washington Press, 2008.

Eder, Rita. "The Icons of Power and Popular Art." In *Mexican Monuments*, edited by Helen Escobar, 59–77. New York: Abbeville Press, 1989.

Eisenberg, Emanuel. "Battle of the Century." *New Masses*, 17, no. 11 (December 10, 1935): 18–20.

El Maestro Rural (Mexico, esp. 1930–1940).

El Primero Congreso Interamericano de Indigenistas. *Boletín* 1–4, (April 1940).

"En defensa de Pátzcuaro." *Mapa* (Dec. 1936): 32–36, 63.

Escobar, Helen, ed. *Mexican Monuments*. New York: Abbeville Press, 1989.

Escudero Luján, Carolina. *Una mujer en la historia de México*. Morelia: Instituto de Cultura Michoacana, 1992.

Escultura mexicana: De la academia a la instalación. Mexico City: INBA and Landucci, 2000.

Ettinger, Catherine R., ed. *Jaime Sandoval*. Morelia: UMSNH, 2010.

———, ed. *Michoacán: Arquitectura y urbanismo*. Morelia: UMSNH, 2008.

European Traveler Artists in Nineteenth-Century Mexico. Mexico City: Fomento Cultural Banamex, 1996.

Fernández, Justino. *Pátzcuaro: Su situación, historia y características*. Mexico City: Talleres de Impresíon de Estampillas y Valores, 1936.

———. "Semblanza de Don Vasco de Quiroga." Lecture, Mar. 15, 1937, Biblioteca del Congreso de la Unión. In *Santo Tomás More y "La Utopia de Tomás Moro en la Nueva España*," edited by Edmundo O'Gorman and Justino Fernández, 1–22. Mexico City: Alcancia, 1937.

Fernández, María. *Cosmopolitanism in Mexican Visual Culture*. Austin: University of Texas Press, 2014.

Fernández, Martha. "Las politicas editoriales de 1935 a 1990." In *Una memoria de 75 años, 1935–2010: El Instituto de Investigaciones Estéticas*, 73–81. Mexico City: IIE, 2010.

Fernández H., Silvia. "Del dibujo académico al diseño visual." In *La enseñanza del arte*, edited by Aurelio de los Reyes, 93–130. Mexico City: IIE, 2010.

Fierro Gossman, Rafael R. *La grand corriente ornamental del siglo XX: Una revisión de la arquitectura neocolonial en la ciudad de México*. Mexico City: Universidad Ibero-america, 1998.

Fischer, Helene. *Die Jünger und Fischer am Pátzcuaro-See: Ein Bildbericht*. Leipzig: n.p., 1939.

Flores, Tatiana. "Strategic Modernists: Women Artists in Post-Revolutionary Mexico." *Women's Art Journal* 29, no. 2 (2008): 12–22.

Folgarait, Leonard. *Mural Painting and Social Revolution in Mexico: Art of a New Order*. Cambridge: Cambridge University Press, 1998.

Foster, George M. *Empire's Children: The People of Tzintzuntzan*. Mexico City: Imprenta Nuevo, 1948.

———. *Tzintzuntzan: Mexican Peasants in a Changing World*. Boston: Little, Brown, and Co., 1967.

Franco, Enrique, and Agustín Arteaga. "Lo nacional como vanguardia: Escultura, identidad e historia." In *Escultura mexicana: De la academia a la instalación*, 115–205. Mexico City: INBA and Landucci, 2000.

Gabara, Esther. *Errant Modernism: The Ethos of Photography in Mexico and Brazil*. Durham: Duke University Press, 2008.

García Canclini, Néstor. *Hybrid Cultures*. Minneapolis: University of Minnesota, 1995.

———. "Modos de mirar los murales." In *Quimera de los murales del Palacio de Bellas Artes*, edited by Mercedes Iturbe, 33–43. Mexico City: INBA, 2004.

———. *Transforming Modernity*. Austin: University of Texas Press, 1993.

García Cubas, Antonio. *Atlas pintoresco e histórico de los Estados Unidos Mexicanos*. Mexico City: Debray Sucesores, 1885.

García García, Dorian Aarón. "María Gertrudis Bocanegra Mendoza de Lazo y de la Vega." In *Guillermo Ruiz y la Escuela Libre de Escultura y Talla Directa*, 66–70. Mexico City: Museo Casa Diego Rivera y Frida Kahlo, 2010.

García Maroto, Gabriel. *Acción Artística Popular: 24 grabados en madera*. Morelia: Edición del Gobierno del Estado de Michoacán, 1932.

———. *Acción plástica popular: Educación y aprendizaje a escala nacional, con ciento cinco reproducciones*. Mexico City: Editorial Plástica Americana, 1945.

———. *Seis meses de Acción Artística Popular, Michoacán, México*. Morelia: Edición del Gobierno del Estado, 1932.

García Sánchez, Eder. "La valoración ramificada: Visiones en torno a la Quinta Eréndira de Pátzcuaro." In *Patrimonio Arquitectura del siglo XX: Intervención y valoración*, edited by Catherine R. Ettinger McEnulty and Enrique X. de Anda Alanís, 112–132. Morelia: UMSNH, 2014.

———. "Turismo en Pátzcuaro (México): Percepciones del visitante extrajero entre 1880–1920." *Pasos* 13, no. 3 (2015): 477–489.

Garibay, Salvador. *Nuestra sangre: Apuntes genealógicos de la familia Solchaga*. Mexico City: n.p., 1950.

Gillespie, Jeanne L. "The Case of the *China Poblana*." In *Imagination beyond Nation*, edited by Eva Paulina Bueno and Terry Caesar, 19–27. Pittsburgh: University of Pittsburgh Press, 1998.

Gilly, Adolfo. *Lázaro Cárdenas: Iconografía*. Morelia: Secretaría de Cultura del Estado, 2007.

Ginzberg, Eitan. *Lázaro Cárdenas: Gobernador de Michoacán (1928–1932)*. Zamora: Colmich and UMSNH, 1999.

Glusker, Susannah Joel, ed. *Avant-Garde Art and Artists in Mexico: Anita Brenner's Journals of the Roaring Twenties*. Austin: University of Texas Press, 2010.

Gómez, Fernando. *Good Places and Non-Places in Colonial Mexico*. Lanham, MD: University Press of America, 2001.

Gómez Goyzzueta, Fernando. "Análisis del desarrollo disciplinar de la arqueología mexicana y su relación con el patrimonio arqueológico en la actualidad." *Cuicuilco* 14, no. 41 (Sept.–Dec. 2007): 226–229.

Gómez Millefert, E. M. "Lacas." *Ethnos* 1, no. 5 (May 1925): 114–115.

Gonzales, Michael J. "Imagining Mexico in 1910: Visions of the Patria in the Centennial Celebration in Mexico City." *Journal of Latin American Studies* 39, no. 3 (August 2007): 495–533.

González, Carlos. "La ceremonia de la ofrenda a los muertos en el cemetario de la isla de Janitzio." *Ethnos* 1, no. 1 (1925).

González Cruz Manjarrez, Maricela. *La polémica Siqueiros-Rivera*. Mexico City: Museo Dolores Olmedo Patiño, 1996.

González Matute, Laura. "A New Spirit in Post-Revolutionary Art: The Open-Air Painting Schools and the Best Maugard Drawing Method, 1920–1930." In *Mexican Modern Art, 1900–1950*, 28–43. Mexico City/Ottawa: INBA/National Gallery of Canada, 1999.

González Mello, Renato. "Los pinceles del siglo XX: Arqueología del régimen." In *Arqueología del régimen, 1910–1955*, 17–36. Mexico City: Museo Nacional de Arte, 2003.

González Sánchez, Isabel, ed. *El Obispado de Michoacán en 1765*. Morelia: Gobierno de Michoacán, 1985.

Graburn, Nelson. "Tourism: Sacred Journey" (1977). In *Hosts and Guests: The Anthropology of Tourism*, edited by Valerie Smith, 21–35. Philadelphia: University of Pennsylvania Press, 1989.

Greeley, Robin Adèle. "For an Independent Revolutionary Art: Breton, Trotsky and Cárdenas's Mexico." In *Surrealism, Politics and Culture*, edited by Raymond Spiteri and Donald LaCoss, 204–225. London: Ashgate, 2003.

Grosz, Elizabeth. "Bodies—Cities." In *The Feminism and Visual Culture Reader*, edited by Amelia Jones, 507–514. London, New York: Routledge, 2003.

Guadarrama Peña, Guillerma. "El Congreso de Apatzingán: El fusilmiento de Gertrudis Bocanegra, Fermín Revueltas" and "Vida de Morelos." In *Escenas de la independencia y la revolución en el muralismo mexicano*, edited by Leticia López Orozco, 57–69. Mexico City: Comité de Asuntos Editoriales, Asemblea Legislativa del Districto Federal, 2010.

Guevara Escobar, Arturo. "Fotógrafos y productores de postales." Jan. 2012. *Tarjetas postales en profundidad*: http://losprotagonistas-tarjetaspostales.blogspot.com/2012/01 /letra-z-fotografos-y-productores-de.html.

Guía de arquitectura y paisaje: Michoacán. Morelia: Gobierno Constitucional del Estado de Michoacán, 2007.

Guía del desfile histórico de la ciudad de Pátzcuaro, 8 de diciembre de 1929. Pátzcuaro: Tipografía "El Arte," 1929.

Guillermo Ruiz y la Escuela Libre de Escultura y Talla Directa. Mexico City: INBA, 2010.

Guzmán Urbiola, Xavier. "Los años radicales, 1930–1940." In *Arquitectura escolar: SEP 90 años*, edited by Axel Arañó, 166–185. Mexico City: SEP, 2011.

Hamilton, Nora. *Mexico: Political, Social, and Economic Evolution*. New York, Oxford: Oxford University Press, 2011.

Hellier-Tinoco, Ruth. *Embodying Mexico: Tourism, Nationalism, and Performance*. Oxford: Oxford University Press, 2011.

Herrejón, Carlos. "La imagen heróica de Morelos." In *La construcción del héroe en España y México (1789–1847)*, edited by Manuel Chust and Víctor Mínguez, 243–252. Valencia: Universitat de Valéncia, 2003.

Híjar, Alberto. "Tésis por los treinta." *Revista Crónicas* 5–6 (2000): 11–15.

Hooks, Margaret. *Tina Modotti: Photographer and Revolutionary*, San Francisco: Pandora, 1993.

Humboldt, Baron Alexander von. *Political Essay on the Kingdom of New Spain*. 4 vols. Translated by John Black. New York: I. Riley, 1811.

Hurlburt, Laurance. *Mexican Muralists in the United States*. Albuquerque: University of New Mexico, 1989.

Indych-López, Ana. *Muralism without Walls: Rivera, Orozco, and Siqueiros in the United States, 1927–1940*. Pittsburgh: University of Pittsburgh Press, 2009.

Jackson, Robert H. *Race, Caste, and Status: Indians in Colonial Spanish America*. Albuquerque: University of New Mexico Press, 1999.

Jolly, Jennifer. "Art for the Mexican Electricians' Syndicate: Beyond Siqueiros." *Künst und Politik* (2005): 111–139.

———. "David Alfaro Siqueiros's Communist Proposition for Mexican Muralism."

In *Mexican Muralism: A Critical History*, edited by Alejandro Anreus, Leonard Folgarait, and Robin Greeley, 75–92. Berkeley: University of California Press, 2013.

Jones, Gareth A., and Ann Varley. "Contest for the City Center." *Bulletin of Latin American Research* 13, no. 1 (January 1994): 27–44.

Juárez, Nicolás B. *Canciones del Islenas, Lago de Pátzcuaro*. Mexico City, 1938.

———. *Sones isleños del Lago Pátzcuaro*. Introduction by Antonio Salas de León. Mexico City: DAPP, 1937.

Kaplan, David. "The Mexican Marketplace in Historical Perspective." PhD dissertation, Ann Arbor, University of Michigan, 1960.

Kemper, Robert V. "Tourism in Taos and Pátzcuaro: A Comparison of Two Approaches to Regional Development. *Annals of Tourism Research* 6, no. 1 (January–March 1979): 9–110.

Kiddle, Amelia M., and María L. O. Muñoz, eds. *Populism in 20th Century Mexico*. Tucson: University of Arizona Press, 2010.

Knight, Alan. "Cárdenas and Echevarría: Two 'Populist' Presidents Compared." In *Populism in 20th Century Mexico*, edited by Amelia Kiddle and María Muñoz, 15–37. Tucson: University of Arizona Press, 2010.

———. "Cardenismo: Juggernaut or Jalopy?" *Journal of Latin American Studies* 26 (1994): 73–107.

———. "Revolutionary Project, Recalcitrant People." In *The Revolutionary Process in Mexico*, ed. J. E. Rodríguez O., 227–264. Los Angeles, UCLA, 1990.

Kolb Neuhaus, Roberto. "Leyendo entre líneas, escuchando entre pautas: Marginalia paleográfica de Silvestre Revueltas." In *Diálogo de resplandores: Carlos Chávez and Silvestre Revueltas*, 68–97. Mexico City: Teoría y Práctica del Arte, 2002.

Krauze, Enrique. *Biography of Power*. New York: Harper Collins, 1998.

Krippner, James, et al. *Paul Strand in Mexico*. New York: Aperture, 2010.

Krippner-Martínez, James. "Invoking 'Tato Vasco': Vasco de Quiroga, Eighteenth–Twentieth Centuries." *Americas* 56, no. 3 (January 2000): 1–28.

———. *Rereading the Conquest: Power, Politics, and the History of Early Colonial Michoacán, Mexico: 1521–1565*. University Park: Pennsylvania State University Press, 2001.

Lacas mexicanas. Mexico City: Artes de México, 1997.

"Lagos: Pátzcuauro." *Mapa* (Mexico City) (April 1936): 39–40.

Lasansky, Medina. *The Renaissance Perfected: Architecture, Spectacle, and Tourism in Fascist Italy*. University Park: Pennsylvania State University Press, 2004.

Leach, Neil, editor. *Rethinking Architecture*. London, New York: Routledge, 2005.

Leask, Nigel. "'The Ghost in Chapultepec': Fanny Calderón de la Barca, William Prescott and Nineteenth-Century Mexican Travel Accounts." In *Voyages and Visions: Towards a Cultural History of Travel*, edited by Jas Elsner and Joan-Pau Rubies, 184–209. London: Reaktion Books, 1999.

Lechuga, Ruth. "Origins and Forms of Lacquerwork." In *Lacas mexicanas*, 66–68. Mexico City: Artes de Mexico, 1997.

LeFebvre, Henri. *Everyday Life in the Modern World* (1946). Translated by Sacha Rabinovitch. London: Allen Lane/Penguin, 1971.

————. "Production of Space." In *Rethinking Architecture*, edited by Neil Leach, 139–147. London, New York: Routledge, 1997.

León, Francisco, and Fernando Ledesma. *Esmaltes de Uruapan*. Mexico City: DAPP, 1939.

León, Nicolás. *Los indios tarascos del Lago de Pátzcuaro*. Mexico City: Secretaría de Educación Pública, 1934.

Libro ideal para el hogar: Primera edición cultural pro-estado de Michoacán. Mexico City: n.p., 1935.

Lippard, Lucy. "On the Beaten Track: Tourism, Art, and Place." *Public Art Review* 12, no. 1 (Fall–Winter 2000): 10–11.

Lomnitz-Adler, Claudio. "Concepts for the Study of Regional Culture." *American Ethnologist* 18, no. 2 (1991): 95–214.

————. *Exits from the Labyrinth*. Durham: Duke University Press, 2006.

López, Rick A. *Crafting Mexico: Intellectuals, Artisans, and the State after the Revolution*. Durham: Duke University Press, 2010.

————. "Lo más mexicano de México: Popular Arts, Indians, and Urban Intellectuals in the Ethnicization of Postrevolutionary National Culture, 1920–1972." PhD dissertation. Yale University, 2001.

————. "The Morrows in Mexico: Nationalist Politics, Foreign Patronage, and the Promotion of Mexican Popular Arts." In *Casa Mañana: The Morrow Collection of Mexican Popular Arts*, edited by Susan Danly, 47–63. Albuquerque: University of New Mexico Press, 2001.

————. "Noche Mexicana and the Exhibition of Popular Arts: Two Ways of Exalting Indianness." In *The Eagle and the Virgin: Nation and Cultural Revolution in Mexico, 1920–1940*, edited by Mary Kay Vaughan and Stephen E. Lewis, 23–42. Durham, NC: Duke University Press, 2006.

López Argüelles, Jesús Ernesto. "Fermín Revueltas: Roberto Cueva del Río en Jiquilpan: Breves apuntes." In *Nadie sabe lo que tiene . . . centro noreste de Michoacán*, edited by Álvaro Ochoa Serrano, 175–186. Morelia: Secretaría de Cultura, Michoacán, Morevallado Editores, 2009.

————. "Resimbolización del espacio público en la etapa posrevolucionaria: De Santuario de Guadalupe a Biblioteca Pública." In *México y España: Huellas contemporáneas — Resimbolización, imaginarios, iconoclastia*, edited by A. Azuela de la Cueva and C. González Martínez, 113–129. Mexico City, 2010.

López Orozco, Leticia, ed. *Escenas de la independencia y la revolución en el muralismo mexicano*. Mexico City: Asamblea Legislativa del Distrito Federal, 2010.

Löschner, Renate. "The Life and Work of Johann Moritz Rugendas." In *El México luminoso de Rugendas*, 13–82. Mexico City: Cartón y Papel de México, 1985.

Lowe, Sarah M. *Tina Modotti and Edward Weston: The Mexico Years*. London, New York: Merrell, 2004.

Luis Márquez en el mundo del mañana. Mexico City: Instituto de Investigaciones Estéticas, 2012.

Luna Arroyo, Antonio. *Juan O'Gorman: Autobiografía, antología, juicios críticos y docu-*

mentación exhaustiva sobre su obra. Mexico City: Cuadernos Populares de Pintura Mexicana Moderna, 1973.

MacCannell, Dean. *The Tourist*. New York: Schocken Books, 1976.

Macía, Pablo. *Pátzcuaro*. Morelia: Gobierno del Estado de Michoacán, 1978.

Macías, Eugenia. "ICA Foundation Historical Archive: History, Technology and the Specific Nature of the Aerial Gaze in Mexico." In *Transformaciones del paisaje urbano en México*, edited by Peter Krieger, 212–251. Mexico City: Museo Nacional del Arte, 2012.

Maillefert, Alfredo. *Laudanza de Michoacán: Morelia, Pátzcuaro, Uruapan*. Mexico City: Ediciones de la Universidad Nacional de México, 1937.

Manrique, Jorge Alberto. "Edmundo O'Gorman, 1906–1995." *Anales del Instituto de Investigaciones Estéticas* 67 (1995): 195–200.

Mapa (Mexico City, especially 1936–1940).

Martínez Aguilar, José Manuel. *El Pátzcuaro de ayer en el imaginario*. Morelia: Secretaría de Cultura Michoacán, 2012.

Medina González, Isabel. "Pre-hispanic Lacquerwork: A Long-Standing Debate." In *Lacas mexicanas*, 68–70. Mexico City: Artes de Mexico, 1997.

Mejía Barquera, Fernando. "Departamento Autónomo de Prensa y Publicidad (1937–1939)." *Revista Mexicana de Comunicación* (Nov.–Dec. 1988): 46–49: https://storify .com/fmb_org/departamento-autonomo-de-prensa-y-publicidad-1937.

Mejía Lozada, Diana Isabel. *La artesanía de México*. Zamora: Colegio de Michoacán, 2004.

Memoria de Departamento Autónomo de Prensa y Propaganda, enero–agosto de 1937. Mexico City, DAPP, 1937.

Memoria de la Secretaría de Educación Pública, septiembre de 1935–agosto de 1936. Mexico City: SEP, 1936.

Memoria del Departamento Autónomo de Prensa y Publicidad, septiembre 1937–agosto de 1938. Mexico City: DAPP, 1938.

Memoria de los trabajos emprendidos y llevados a cabo. Mexico City: Imprenta del Gobierno Federal, 1910.

Una memoria de 75 años, 1935–2010: El Instituto de Investigaciones Estéticas. Mexico City: IIE, 2010.

Mendoza Vargas, Héctor, ed. *Lecturas geográficas mexicanas: Siglo XX*. Mexico City: UNAM, 2009.

Mérida, Carlos. *Trajes regionales mexicanos*. Mexico City: Editorial Atlante, 1945.

Merrill, Dennis. *Negotiating Paradise: U.S. Tourism and Empire in Twentieth-Century Latin America*. Chapel Hill, NC: University of North Carolina Press, 2009.

Mexican Art and Life (Mexico City, 1938–1939).

"A Mexican Land of Lakes and Lacquers" (photos by Helene Fischer, Luis Márquez, L. Pérez Parra, and Sumner W. Matteson). *National Geographic* 71, no. 5 (May 1937): 633–648.

Mexican Life: Mexico's Monthly Review (Mexico City, 1924–1937).

Mexico's Western Highways. Mexico City: PEMEX Travel Club, n.d.

Meyer, Jean. "History as National Identity." *Voices of Mexico* (Oct.–Dec. 1995): 33–38.

————. "An Idea of Mexico: Catholics in the Revolution." In *The Eagle and the Virgin: Nation and Cultural Revolution in Mexico, 1920-1940*, edited by Mary Kay Vaughan and Stephen E. Lewis, 281-296. Durham, NC: Duke University Press, 2006.

————. "La segunda Cristiada en Michoacán." In *La cultura Purhe: II Coloquio de Antropologia e Historia Regionales*, edited by Francisco Miranda, 245-276. Zamora: Colegio de Michoacán, 1981.

Michaels, Albert L. "Modification of the Anti-Clerical Nationalism." *Americas* 26, No. 1 (July 1969): 35-53.

Misiones culturales, los años utópicos, 1920-1938. Mexico City: INBA, CNCA, Museo Casa Estudio Diego Rivera y Frida Kahlo, 1999.

Molina Enríquez, R. "Las lacas de México." *Ethnos* 1, no. 5 (May 1925): 115-124.

Monsiváis, Carlos. "On Civic Monuments and the Spectators." In *Mexican Monuments*, edited by Helen Escobar, 105-128. New York: Abbeville Press, 1989.

Morelia, Pátzcuaro, Uruapan. Mexico City: Secretaría de Gobernación, Departamento del Turismo, [c. 1943].

Moyssen, Xavier. "The Revelation of Light and Space." In *El México luminoso de Rugendas*, 83-146. Mexico City: Cartón y Papel de Mexico, 1985.

Mraz, John. *Looking for Mexico*. Durham: Duke University Press, 2009.

————. "Today, Tomorrow, and Always: The Golden Age of Illustrated Magazines in Mexico, 1937-1960." In *Fragments of a Golden Age: The Political Culture in Mexico Since 1940*, edited by Joseph Gilbert, Anne Rubenstein, and Eric Zolov, 116-157. Durham, NC: Duke University Press, 2001.

Murillo, Gerardo (Dr. Atl). *Las artes populares en México*. 2nd ed. Mexico City: Cultura, 1922.

Noguez Becerril, Juan E. *Datos históricos del mural al fresco existente en la Biblioteca Pública "Gertrudis Bocanegra" de la ciudad de Pátzcuaro*. [Pátzcuaro, 1942-1960].

Nora, Pierre. "Between Memory and History: Les Lieux de Mémoire." In "Memory and Counter-Memory," special issue, *Representations* 26 (Spring 1989): 7-24.

Noticia histórica de la venerable Imagen de Ntra. Sra. de la Salud de Pátzcuaro. Mexico City: Impr. Encuadernación y Rayados Ntra. Sra. de Lordes, 1911.

Novo, Salvador. "Curiosidades mexicanas." *El Maestro Rural* 1, no. 1 (Mar. 1, 1932): 6-7.

————. *La vida en México durante el periodo presidencial de Lázaro Cárdenas*. Mexico City: Empresas Editoriales, 1964.

Ochoa Serrano, Álvaro, ed. *Nadie sabe lo que tiene . . . el centro noreste de Michoacán*. Morelia: Secretaría de Cultura, Michoacán, Morevallado Editores, 2009.

Oettermann, Stephan. *The Panorama: History of a Mass Medium*. New York: Zone, 1997.

O'Gorman, Edmundo, and Justino Fernández. *Santo Tomás More y "La Utopia de Tomás Moro en la Nueva España."* Mexico City: Alcancia, 1937.

O'Gorman, Juan. "Autobiografía." In *Juan O'Gorman: Autobiografía, antología, juicios críticos y documentación exhaustiva sobre su obra*, edited by Antonio Luna Arroyo, 69-195. Mexico City: Cuadernos Populares de Pintura Mexicana Moderna, 1973.

Oikión Solano, Verónica, ed. *Historia: Nación y región*. Zamora: El Colegio de Michoacán, 2007.

————. *Los hombres del poder en Michoacán, 1924-62*. Zamora: El Colegio de Michoacán, 2004.

————. *Manos michoacanas*. Zamora and Morelia: El Colegio de Michoacán and Instituto de Investigaciones Históricas, 2007.

Oles, James. *Art and Architecture in Mexico*. Oxford: Oxford University Press, 2013.

————. "Business or Pleasure." In *Casa Mañana: The Morrow Collection of Mexican Popular Arts*, edited by Susan Danly 11-29. Albuquerque: University of New Mexico Press, 2001.

————. "Industrial Landscapes in Modern Mexican Art." *Journal of Decorative and Propaganda Arts* 26 (2011): 128-159.

————. *Las hermanas Greenwood en México*. Mexico City: Consejo Nacional para la Cultura y las Artes, 2000.

————. *South of the Border*. New Haven: Yale University Press, 1993.

————. "Walls to Paint On: American Muralists in Mexico, 1933-36." PhD dissertation, Yale University, 1995.

Ortiz Gaitán, Julieta. *Imágenes del deseo: Arte y publicidad en la prensa ilustrada mexicana (1894-1939)*. Mexico City: UNAM, 2003.

Ortiz Vidales, Salvador. "Los frescos de R. Bárcenas." *Hoy* (June 3, 1937): 26.

Osirio, Fernando, and Nareni Pliego. "Captura de la imagen: Testimonio impreso." In *México: Memorias desde el aire, 1932-1969*, 25-30. Mexico City: Fundación ICA, 2007.

Palacios, Guillermo. "Postrevolutionary Intellectuals, Rural Readings and the Shaping of the 'Peasant Problem' in Mexico: El Maestro Rural, 1932-1934." *Journal of Latin American Studies* 30, no. 2 (May 1998): 309-339.

————. "The Social Sciences, Revolutionary Nationalism, and Interacademic Relations: Mexico and the US, 1930-1940." In *Populism in 20th Century Mexico*, edited by Amelia M. Kiddle and María L. O. Muñoz, 58-72. Tucson: University of Arizona Press, 2010.

Parker, D. S. *The Idea of the Middle Class: White-Collar Workers and Peruvian Society, 1900-1950*. University Park: Pennsylvania State University Press, 2010.

Paz, Octavio. *Essays on Mexican Art*. Orlando: Harcourt Brace, 1993.

Pedraza Calderón, Laura América. "Manos maqueadoras." In *Manos michoacanas*, edited by Veronica Oikión Solano, 129-144. Zamora and Morelia: Colmich and Instituto de Investigaciones Históricas, 2007.

Pérez Carrillo, Sonia, and Carmen Rodríguez de Tembleque. "Oriental and European Influences." In *Lacas mexicanas*, 70-74. Mexico City: Artes de Mexico, 1997.

Pérez Escutia, Ramón Alonso. "Los orígenes del panteón cívico michoacano, 1823-1834." *TzinTzun* (Jan.-June 2013): 81-123.

Pollock, Griselda, and Roszika Parker, "Crafty Women and the Hierarchy of the Arts." In *Old Mistresses: Women, Art, and Ideology*, 50-81. London: Pandora Press, 1981.

Polo Hernández, Marco. "Mexico: African Heritage." In *Encyclopedia of the African Diaspora: Origins, Experiences, and Culture*, edited by Carole Boyce Davies, 673-679. Santa Barbara, CA: ABC-CLIO, 2008.

Poniatowska, Elena. "Juan O'Gorman de los Fifís a San Jerónimo." In *Juan O'Gorman: Autobiografíaa, antología, juicios críticos y documentación exhaustiva sobre su obra*, edited

by Antonio Luna Arroyo, 311–312. Mexico City: Cuadernos Populares de Pintura Mexicana Moderna, 1973.

Pratt, Mary Louise. *Imperial Eyes: Travel Writing and Transculturation*. London, New York: Routledge, 1992.

Programa de desarrollo urbano de centro de población de Pátzcuaro, Mich., 2007–2027. Pátzcuaro: Ayuntamiento Constitucional de Pátzcuaro, 2005–2007.

Purnell, Jennie. *Popular Movements and State Formation in Revolutionary Michoacán*. Durham: Duke University Press, 1999.

Quintanilla, Lordes. *Liga de Escritores y Artistas Revolucionarios (LEAR)*. Mexico City: UNAM/FCPyS, 1980.

Quintanilla, Susana. "La educación en México durante el periodo de Lázaro Cárdenas." In *Diccionario de la historia de educación en México*, edited by Luz Elena Galván Lafarga: http://biblioweb.tic.unam.mx/diccionario/htm/articulos/sec 31.htm.

Ramey, James. "La resonancia de la conquista en Janitzio." *Casa del Tiempo* 3, no. 30 (2010): 54–57.

Ramírez Barreto, Ana Cristina. "'Eréndira a caballo': Acoplamiento de cuerpos e historias en un relato de conquista y resistencia." *e-misférica: Performance and Politics in the Americas* 2, no. 2 (2005): 1–19, http://hemi.nyu.edu/journal/2_2/ramirez.html.

Ramírez Romero, Esperanza. *Catálogo de monumentos y sitios de la región lacustre*. Morelia: Gobierno de Estado de Michoacán, UMSNH, 1986.

———, *Las zonas históricas de Morelia and Pátzcuaro ante el tratado de libre comercio*. Morelia: Gobierno del Estado de Michoacán, Instituto de Cultura, UMSNH, 1994.

Rath, Thomas. *Myths of Demilitarization in Postrevolutionary Mexico, 1920–1960*. Chapel Hill: University of North Carolina Press, 2013.

Renan, Ernest. "What Is a Nation?" (1882). In *Nation and Narration*, edited by Homi Bhabha, 8–22. New York: Routledge, 1990.

Reyes, Aurelio de los, ed. *La enseñanza del arte*. Mexico City: Instituto de Investigaciones Estéticas, 2010.

Reyes, Hilario. "El Monumento a Tangaxuhan," *Vida* (Pátzcuaro) 1, no. 3 (July 1938).

Río, Marcela del. "Alberto Beltrán habla de Ricardo Bárcenas, la ELAP y otros temas." *Excelsior* 44, no. 4, August 20, 1960.

Rivas, G. [Howard Phillips]. "Ricardo Bárcenas." *Mexican Life* 7, no. 11 (November 1931): 24–27.

———."Ricardo Bárcenas." *Mexican Life* 13, no. 8 (August 1937): 27–30.

Rivas Palacio, Vicente. *México a través de los siglos*. Vol. 2. Barcelona: Espasa y Compañía, 1888–1889.

Robic, Marie-Claire. "From the Sky to the Ground: The Aerial View and the Ideal of the *Vue Raissonnée* in Geography in the 1920s." In *Seeing from Above: The Aerial View in Visual Culture*, edited by Mark Dorrian and Frédéric Pousin, 163–187. London: I. B. Tauris, 2013.

Rodríguez Prampolini, Ida, "El creador, el pensador, el hombre." In *Juan O'Gorman, 100 Años: Temples, dibujos y estudios preparatorios*, 197–228. Mexico City: Consejo Nacional para la Cultura y las Artes, INBA, Fomento Cultural Banamex, 2005.

————, ed. *Muralismo Mexicano, 1920–1940*. 3 vols. Mexico City: INBA, UNAM, FCE, Universidad Veracruzana, 2012.

Rojas, José F. "No hará el gobierno más expropiaciones." *El Excelsior* 22, no. 6 (Dec. 2, 1938): 1, 3.

Romero de Terreros, Manuel. *El barón Gros y sus vistas de México*. Mexico City: Universitaria, 1953.

Romero Flores, Jesús. *Gertrudis Bocanegra de Lazo de la Vega: Heroína de Pátzcuaro*. Mexico City: Editorial México Nuevo, 1938.

————. "La raza purépecha." *Universidad Michoacána: Revista Mensual de Cultura* 2, nos. 10–11 and 12 (June–July and Aug. 1938): 36–47.

————. *Lázaro Cárdenas: Biografía de un gran mexicano*. Mexico City: Costa Amic, 1971.

————. *Michoacán histórico y legendario*. Mexico City: Talleres Gráficos del Museo Nacional de Arqueología, Historia y Etnografía, 1936.

Ross, Kristin. *The Emergence of Social Space: Rimbaud and the Paris Commune*. St. Paul: University of Minnesota Press, 1989.

Rotofoto (Mexico City, 1938).

Rowe, William, and Vivian Schelling. *Memory and Modernity: Popular Culture in Latin America*. London: Verso, 1996.

Rubín de la Borbolla, Daniel F. *Artesanías de Michoacán*. Morelia: n.p., 1969.

Ruiz, Eduardo. *Michoacán: Paisajes, tradiciones y leyendas*. 2 vols. Mexico City: Oficina Tip. de la Secretaría de Fomento, 1891, 1900.

Saavedra, Leonora. "Staging the Nation: Race, Religion, and History in Mexican Opera of the 1940s." *Opera Quarterly* 23, no. 1 (Winter 2007): 1–21.

Sáenz, Moisés. "La escuela y la cultura." *Maestro Rural* 1, no. 5 (May 1, 1932): 8.

Salas León, Antonio. *Pátzcuaro*. Mexico City: Secretaría de Educación Pública, 1941.

Saragoza, Alex. "The Selling of Mexico: Tourism and the State, 1929–1952." In *Fragments of a Golden Age*, edited by Joseph Gilbert, Anne Rubenstein, Eric Zolov, 91–115. Durham: Duke University, 2001.

Scarpaci, Joseph L. *Plazas and Barrios: Heritage Tourism and Globalization in the Latin American Centro Histórico*. Tucson: University of Arizona, 2004.

Schama, Simon. *Landscape and Memory*. New York: Knopf, 1995.

Schmelz, Itala. "*Indians Are Chic*: Cronografía de Luis Márquez Romay en Nueva York, 1940." In *Luis Márquez en el mundo del mañana*, 42–79. Mexico City: Instituto de Investigaciones Estéticas, 2012.

Seligmann, Linda J. "To Be In Between: The Cholas as Market Women." *Comparative Studies in Society and History* 31 (October 1989): 694–721.

Serge, Victor. "Earthquake." Translated by John Manson. *Penniless Press* 19 (Spring 2004): http://www.pennilesspress.co.uk/prose/earthquake.htm.

Shields, Rob. *Places on the Margin*. London: Routledge, 1991.

Sierra, Aída. "The Creation of a Symbol." *Artes de México* 49 (2000): 84–85.

Sifuentes Rodríguez, María del Carmen. "El archivo documental, memoria del Instituto de Investigaciones Estéticas." In *Una memoria de 75 años, 1935–2010: El Instituto de Investigaciones Estéticas*, 209–224. Mexico City: IIE, 2010.

Silva Mandujano, Gabriel. *La casa barroca de Pátzcuaro*. Morelia: Gobierno del Estado de Michoacán, UMSNH, IIH, 2005.

Siqueiros, David Alfaro. "New Thoughts on the Plastic Arts in Mexico" (1933). In *Art and Revolution*, translated by Sylvia Calles, 26–37. London: Lawrence and Wishart, 1976.

———. "Rivera's Counterrevolutionary Road." *New Masses* (May 1934): 16–17, 38.

Smith, Francis Hopkinson. *A White Umbrella in Mexico*. Boston, New York: Houghton, Mifflin, 1889.

Solano Chávez, Ivonne. "Entre la historia y el testimonio." In *Guillermo Ruiz y la Escuela Libre de Escultora y Talla Directa*, 47–59. Mexico City: Museo Casa Diego Rivera y Frida Kahlo, 2010.

Solórzano de Cárdenas, Amalia. *Era otra cosa de vida*. Mexico City: Nueva Imagen, 1994.

Soto González, Enrique. *Antología de Pátzcuaro*. Morelia: Instituto Michoacano de Cultura, 1988.

Stewart, Susan. *On Longing*. Baltimore: John Hopkins University Press, 1984.

Strand, Paul. *Photographs of Mexico*. New York: Virginia Stevens, 1940.

Tames, Francisco M. *Pro-Michoacán*. Mexico City, 1935.

Tangires, Helen. *Public Markets*. New York: W. W. Norton, 2008.

Tecuanhuey, Alicia. "La imagen de las heroínas mexicanas." In *La construcción del héroe en España y México (1789–1847)*, edited by Manuel Chust and Víctor Mínguez, 71–90. Valencia: Universitat de Valéncia, 2003.

Tenorio-Trillo, Mauricio. *Mexico at the World's Fairs*. Berkeley: University of California, 1996.

———. "Of Luis Márquez, Mexico, and the New York Fair, 1939–1940." In *Luis Márquez en el mundo del mañana*, 26–41. Mexico City: Instituto de Investigaciones Estéticas, 2012.

Territorios de diálogo: México, España, Argentina, 1930–1945. Mexico City: INBA, Instituto de Investigaciones Estéticas, 2006.

Terry, Thomas Phillip. *Terry's Guide to Mexico*. Boston, Hingham, MA: G. H. Ellis, 1938.

Thiele, Eva-María. *El maque: Estudio histórico sobre un bello arte*. Morelia: Instituto Michoacán de la Cultura, 1982.

Thompson, Krista. *An Eye for the Tropics: Tourism, Photography, and Framing the Caribbean Picturesque*. Durham: Duke University Press, 2006.

Tibol, Raquel. "El nacionalismo en la plástica durante el cardenismo." In *El nacionalismo y el arte mexicano: IX coloquio de la historia del arte*, 235–255. Mexico City: UNAM, Instituto de Investigaciones Estéticas, 1986.

Toor, Frances. *Frances Toor's Motorist Guide to Mexico*. Mexico City, Frances Toor Studios, 1938.

———. *Mexican Popular Arts*. Mexico City: Francis Toor Studios, 1939.

Toussaint, Manuel. *Arte mudéjar en América*. Mexico City: Editorial Porrúa, 1946.

———. *Colonial Art in Mexico*. Austin: University of Texas Press, 1967.

———. "A Defense of Baroque Art in America." In *Inter-American Intellectual Inter-*

change: Proceedings of the Inter-American Conference on Intellectual Interchange, June 16 and 17, 1943. Austin: Institute of Latin American Studies of the University of Texas, 1943.

―――. *Pátzcuaro*. Mexico City: Universitaria, 1942.

―――. *La relación de Michoacán: Su importancia artística*. Mexico City: UNAM, 1937.

Tripp Evans, R. *Romancing the Maya*. Austin: University of Texas Press, 2004.

Urry, John, and Jonas Larsen. *The Tourist Gaze, 3.0*. London: Sage, 2011.

Van Zantwijk, R. A. M. *Los servidores de los santos* (1965). Mexico City: Instituto Nacional Indigenista y SEP, 1974.

Vaughan, Mary Kay. *Cultural Politics in Revolution*. Tucson: University of Arizona, 1997.

―――. *The State, Education, and Social Class in Mexico*. DeKalb: Northern Illinois University Press, 1982.

Vaughan, Mary Kay, and Stephen E. Lewis, eds. *The Eagle and the Virgin*. Durham: Duke University, 2006.

Vázquez León, Luis. "Noche de Muertos en Xanichu: Estética del claroscuro cinematográfico, teatralidad ritual y construcción social de una realidad intercultural en Michoacán." *Estudios Michoacanos* 9 (2001): 335–400.

Vázquez Mantecón, Verónica. *El mito de Cárdenas*. Mexico City: Universidad Autónoma Metropolitana Xochimilco, 2012.

Vázquez Torres, Silvia Margarita. *Guillermo Ruíz: Obra-talla directa*. Mexico City: CONACULTA, 2006.

Vega Alfaro, Eduardo de la. *El primer cine sonoro mexicano: Siete décadas de cine mexicano*. Mexico City: Filmoteca de la UNAM, 1987.

Velarde Cruz, Sofía Irene. *Entre historias y murales: Obras ejecutadas en Morelia*. Morelia: Inst. Michoacana de Cultura, 2001.

Vida (Pátzcuaro, 1938).

Villaseñor Soto, Adrián. "Ricardo Bárcenas." In *Muralismo mexicano, 1920-1940*, edited by Ida Rodríguez Prampolini, 304–308. Vol. 2. Mexico City: INBA, UNAM, FCE, Universidad Veracruzana, 2012.

Villegas Moreno, Gloria. "Los 'extasis' del pasado: La historia en la obra mural de Juan O'Gorman." In *Juan O'Gorman: 100 años: Temples, dibujos y studios preparatorios*, 127–196. Mexico City: Fomento Cultural Banamex, 2006.

Waters, Wendy. "Remapping Identities: Road Construction and Nation Building in Post-Revolutionary Mexico." In *The Eagle and the Virgin*, edited by Mary Kay Vaughan and Stephen E. Lewis, 221–242. Durham, NC: Duke University Press, 2006.

Weyl, Nathaniel, and Sylvia Weyl. *The Reconquest of Mexico: The Years of Lázaro Cárdenas*. London and New York: Oxford University Press, 1939.

Wölfflin, Heinrich. *Principles of Art History* (1915). Excerpted in *Art History and Its Methods*, edited by Eric Fernie, 127–151. London: Phaidon, 1995.

Wortman, M. L. *Government and Society in Central America, 1680-1840*. New York: Columbia University Press, 1982.

Yamashita, Toshie. *Investigaciones en el Lago de Pátzcuaro*. Mexico City: DAPP, 1939.

Zavala, Adriana. *Becoming Modern, Becoming Tradition: Women, Gender, and Representation in Mexican Art*. University Park: Pennsylvania State University Press, 2008.

———. "Mexico City in Juan O'Gorman's Imagination." *Hispanic Research Journal* 8, no. 5 (Dec. 2007): 491–506.

Zavala, Silvio, and Genaro Estrada. *La "Utopía" de Tomás Moro en la Nueva España y otros estudios*. Mexico City: Antigua Librería Robredo, 1937.

Zizumbo Villareal, Lilia. "Pátzcuaro: El turismo en Janítzio." *Estudios Michoacanos* 1 (1986): 151–169.

Zurián, Carla. *Fermín Revueltas: Constructor de espacios*. Mexico City: Editorial RM, INBA, 2002.

Index

art education, 10, 47–51, 126–127, 174–175, 234–235, 239

arte puro movement, 13, 175, 235

artesanías (handicrafts): and antipicturesque depictions of Pátzcuaro, 45, *154*; as "art," 151–163; and Bárcenas's *Industrias de Michoacán*, 138, 149–150, 153–154, 166; and Cárdenas-era institution building, 233, 235–236, 238; and centralization of Mexican state, 11; and creation of modern Pátzcuaro, 253, 255; and creation of the Cárdenas myth, 245, 250; and cultural politics of the 1930s, 149–151, 173; and depictions of Pátzcuaro, 27; and Teatro Emperador Caltzontzin murals, 69, 138; and gender, 138, 150, 155, 158, 254; and international exchange, 157; and the market, 125, 150, 152–155, 160–163, 255; and Mexican regional identities, 8, 163; and modern vs. traditional views of Mexico, 169–170; and the Morelos monument on Janitzio, 214; and picturesque depictions of Pátzcuaro, 33, 40; and Purépecha culture in Pátzcuaro, 186; and Quiroga's legacy in Michoacán, 164–165, 202; and racial ideology, 163–169; and secularization in Pátzcuaro, 125–126; as souvenirs, 65, *66*, 151, 160, 254; and tourism promotion in Pátzcuaro, 74; and tradition vs. modernity tensions, 22–23. *See also* Museo de Artes e Industrias Populares

Artes populares: Danzas mexicanas, 154

Artes populares de México (Murillo), 110–111

art history, 131–132, 133–134, 136

art market, 6, 44, 81, 155, 172–173

Asian influences, 168–169

Atlantic slave trade, 134. *See also* slavery

Atlas pintoresco é histórico de los Estados Unidos Mexicanos (García Cubas), 26, 253

automobiles, 141

aviation, 75–78

Ávila Camacho, Manuel, 78

Ayala, Rodolfo, 160

Aztecs: appropriation of Aztec migration story, 1; and history parades, 182, 184; and monument to Tanganxuan, 195; and Purépecha culture in Pátzcuaro, 186, 193, 222, 259; and Strand's photography, 53

Balcón de Tariácuri, 71. *See also* El Estribo mirador and volcano

Banco Ejidal, 139, 144

Banco Nacional Hipotecario Urbano y de Obras Públicas, 109

Bárcenas, Ricardo: and aerial views of Pátzcuaro, 79, 81; and architecture of Plaza Chica, 120; and *artesanías*, 153, 155, 158, 160, 162–163; biography, 134–135; and Cárdenas-era institution building, 174–175, 234–235, 238–239; and creation of modern Pátzcuaro, 255–256; and cultural politics of the 1930s, 172–175; and Escuela Nacional de Artes Plásticas, 173–174, 234–235; and indigenous identity, 163, 165–169; *Industrias de Michoacán*, 149–151, plate 6; and modern vs. traditional views of Mexico, 169–171; and Pátzcuaro's cultural influence, 3; and picturesque depictions of Pátzcuaro, 93; *El Plan Sexenal* mural, 142–149, plate 5; and Quiroga's legacy in Michoacán, 201, 203; and state modernization project, 139, 141; and tradition vs. modernity tensions, 22–23

Barrio Fuerte, 194

Barthes, Roland, 57

Bartra, Roger, 36, 51, 56, 57

Basilica, 82, 91, 201, 202, 289n83

bateas, 65, 120, 138, 155, *158*, 168, 226, 236. *See also* lacquerware

Battle of the Nude Men (Pollaiuolo), 245

Baud, Michiel, 19

Bautista Moya, Juan, 223

Bay Pisa, Jorge, 95, 96, 201

Beaumont, Pablo de, 71, 189, 191, 222

Becoming Modern, Becoming Tradition (Zavala), 254

Beloff, Angelina, 170

Beltrán, Alberto, 175, 235

divination, 96

domestic tourism, 3–4, 14–21, 43, 70, 252–254, 259

Doric columns, 111, 117

Dublán, Carlos, 234–235

Eco, Umberto, 99

economic modernization, 6–7, 14, 16, 138–140. See also *El Plan Sexenal* (The Six-Year Plan); regional economies

El Eco Revolucionario, 250

Eden, 12, 140

Eisenstein, Sergei, 58

ejidos, 2, 16, 48, 74, 81, 143, 219

electrification, 6–7, 19, 67, 114, 143

Emperor Caltzontzin Theater. *See* Teatro Emperador Caltzontzin

Empresa Cinematográfica, 120

Enciso, Jorge, 8, 44, 152, 234

encomenderos and *encomienda* system, 108, 168, 200, 223, 276n49

El encuentro de rey Tanganxuan II y el conquistador Cristóbal de Olid (Cueva del Río), 249

Encuentro del Rey Tanganxuan II y el conquistador Cristóbal de Olid en las cercanías de Pátzcuaro en el año de 1522 (Cueva del Río), 75, 120, plate 3

"En defensa de Pátzcuaro," 85

Enríquez Perea, Alberto, 228

Eréndira, 136, 184–185, 188–193, 223, 248, 281n137

Erongarícuaro, 215

Escalinata hacia el gran Morelos, Pátzcuaro, Mich. (postcard), 66

Escobar, Matías, 184

Escuela de Artes Plásticas, 10, 178. *See also* Escuela de Pintura y Escultura (La Esmeralda)

Escuela de las Bellas Artes, 236

Escuela de Pintura y Escultura (La Esmeralda), 178, 220, 232, 233

Escuela Elemental Agrícola, 125

Escuela Libre de Arte y Publicidad, 175, 235

Escuela Libre de Escultura y Talla Directa:

and Cárdenas-era institution building, 232, 233, 239; and Cárdenas's cultural legacy, 3; and centralization of Mexican state, 10; and creation of Pátzcuaro history, 178; and *Monumento a Tanganxuan*, 194; and *Monumento a la revolución*, 220; and the Morelos monument on Janitzio, 63; and Ruiz directorship, 232–233. *See also* direct-carving workshops

Escuela Nacional de Antropología, 177

Escuela Nacional de Antropología e Historia, 13

Escuela Nacional de Artes Plásticas (ENAP): and Bárcenas directorship, 174–173, 234–235; and Cárdenas-era institution building, 232, 234–236, 239; and Cárdenas's cultural legacy, 3; and centralization of Mexican state, 10; and cultural politics of the 1930s, 174–175; and Pátzcuaro's regional identity, 13; and tradition vs. modernity tensions, 23

Espino Barros, Eugenio, 86

Estrada, Genaro, 203, 224–225

El Estribo mirador and volcano, 71, 72, 74, 75, 82, 222, 255–256

Estridenistas, 63

Euro-imperialism, 31

European influences, 169

Excelsior, 251

"exhibitionary complex," 20, 142, 171, 252

Exhibition of Popular Art (Mexico City, 1921), 8, 152

The Factory (O'Gorman), 78

Facultad de Ciencias, 78

Fairchild Aerial Camera Corporation, 76–77

fascism, 6, 172

Federal Commission of Electricity, 143

Fernández, Emilio "El Indio," 39, 58–60, 195–197

Fernández, Justino, 17, 71, 127–129, 132, 178, 203, 214, 253, plates 1 and 2

Fernández, María, 11

Fernández, Martha, 132

185; and La Quinta Eréndira, 190, 191, 193; and *lo típico* rhetoric, 22; and market scenes, 106, 107, 113; and the Morelos monument on Janitzio, 213; and picturesque depictions of Pátzcuaro, 39; and Purépecha culture in Pátzcuaro, 186; and tourism promotion in Pátzcuaro, 75

Método de proyectos (Sáinz), 81, 82

Metropolitan Museum of Art, 152

Mexican Army, 3, 16, 17, 60, 71, 73, 76, 78, 143, 144, 213, 217, 231, 232, 233

Mexican Art and Life, 36. See also *Mexican Life*

Mexican Automobile Association, 15

Mexican Bicentennial, 226

Mexican Communist Party, 173

Mexican Electrician's Syndicate, 43, 267n58

Mexican Folkways, 153, *154*

Mexican Life, 36, 93, *94*, *153*, 173, 234. See also *Mexican Art and Life*

Mexican Mural Movement, 4, 172–173. *See also* murals

The Mexican Portfolio (Strand), 52, *53*

Mexican Revolution, 57; and Cárdenas's modernization program, 143, 145; and Mexican regional identities, 8; and *Monumento a la revolución*, 219–221; and Pátzcuaro's urban environment, 218–219; and picturesque depictions of Pátzcuaro, 32–33; and social justice, 227

Mexican War of Independence, 60, 63, 206–218, 212, 223

Mexico City: *artesanías* in, 163, 165; artistic culture in, 44, 47, 48, 173, 220, 234, 236; Cárdenas-era institution building in, 3, 207, 228, 234; Cárdenas's homes in, 189, 234, 246–247; as center of power, 1, 4, 5, 6, 8–9, 109, 225; exhibitions and museums in, 142, 145, 160; and history parades, 181–183; images of, 41, 76, 78, 80, 129; monuments in, 193, 194, 200, 216; murals in, 8, 78, 144, 163; music in, 205

México Foto, 65, *66*, *95*, *96*, 130

México pintoresco (Brehme), 8, 34–35

México pintoresco (Covarrubias), 163

Mexico's Western Highways (Pemex guidebook), 42

Meyer, Jean, 124, 177

Michoacán: and aerial views, *26*, 75–76, 78, 79–80; and *artesanías*, 22, 139, 152, *154*, 155–158, *156*, 160–162, 167; artists active in, 29–30, 38, 42, 47, 51–52, 54, 232; and La Biblioteca Pública Gertrudis Bocanegra mural, 122; and Cárdenas-era institution building, 3, 13, 233–234, 236, 238; and the Catholic Church, 11, 71, 182, 205; and centralization of Mexican state, 10–11; and communal village-hospitals, 164, 200; and creation of modern Pátzcuaro, 22–23, 144, 149–151, 169, 253–255; and creation of Pátzcuaro *típico*, 22–23, 90, 101; and creation of the Cárdenas myth, 249, 250; and Greenwood's *Paisaje y economía de Michoacán*, 54–57, *55*; guidebooks, 33, 123; and historical zones, 68; and historic preservation in Pátzcuaro, 85–86; and history parades, 182; and indigenous identity, 167–168; and industrial-themed murals, 138–139; and land reform, 2, 116; landscape depictions, *26*; and La Quinta Eréndira, 189–191; and leftist organizing, 116, 160; and legacy of Cárdenas's Pátzcuaro project, 258; and Maroto's education plan, 47; and Mexican nation building, 16; Michoacán history as national history, 23, 74, 76, 189–193, 194–195, 198, 216; as microcosm of Mexico, 23, 101, 176; and *Monumento a la revolución*, 220; and *Monumento a Tanganxuan*, 194, 198; and the Morelos monument on Janitzio, 207–208, 212–213; and oversight of Pátzcuaro's cultural institutions, 120, 258; and Pátzcuaro's cultural influence, 2–3; and Pátzcuaro's regional identity, 13–14; and picturesque depictions of Pátzcuaro, 28–29, 32–33, 42; postcards of, 25, *26*; and promotion of domestic tourism, 16–17, 38, 73–74; and Purépecha culture, 186–187, 193; and Quiroga's legacy, 164, 200–206; and

Rivera's National Palace murals, 221–223; and secularization in Pátzcuaro, 123, 124, 126; and social realist art, 54–55; and social realist photography, 51–53; and travel writers and artists, 28–30, 32, 74, 80, 164; and unrest in, 73, 78, 90, 124, 167. *See also* Cristeros Rebellion; *La história de Michoacán* (O'Gorman); *Industrias de Michoacán* (Bárcenas); volcanoes

Michoacán: Paisajes, tradiciones y leyendas (Ruiz), 74, 189–190

middle-class, 19, 27, 35–36, 45, 51, 57, 74, 83, 238, 254

Miguel Hidalgo, 207

"The Mill" (home), 258

miradores (scenic overlooks): and aerial views of Pátzcuaro, 76, 79, 82; author's introduction to, x, 273n106; and Cárdenas-era institution building, 236; Cerro Sandino, 76, 188; and construction of Morelos monument, 230; and creation of modern Pátzcuaro, 255–256; and depictions of Pátzcuaro, 27; El Estribito Mirador, 236, 255–256, 256; and Teatro Emperador Caltzontzin murals, 69, 75, 255–256; and La Quinta Eréndira, 191, 255–256; and legacy of Cárdenas's Pátzcuaro project, 259; Mirador Tariácuri, 71–72, 72, 75, 114, 188, 190–191, 207, 230; and modernization projects, 114; and the Morelos monument on Janitzio, 80, 210, and official vision of Pátzcuaro, 80; and Pátzcuaro's independence-era history, 207; and Purépecha culture in Pátzcuaro, 188; and tourism promotion in Pátzcuaro, 70–75, 72; and visual culture of tourism, 83

Los mitos paganos y religiosos (O'Gorman), 78

Moctezuma II, 75, 191, 195, 198

modernism and modernist aesthetics: and Acción Plástica Popular, 47–48; and antipicturesque depictions of Pátzcuaro, 21, 44, 45–46, 59, 60, 69, 82, 254; and architecture of Plaza Chica, 118; and *artesanías*, 153, 161–162; and Cárdenas's legacy,

25, 109, 111, 114, 139–140, 259–260; and centralization of Mexican state, 11; and depictions of indigenous figures, 44, 107, 170; and depictions of Pátzcuaro, 25, 97; and Teatro Emperador Caltzontzin murals, 69; and historic preservation in Pátzcuaro, 86; and industrial-themed murals, 139–142; and *Industrias de Michoacán*, 149–169; and *El lago de Pátzcuaro* mural, 69; and Mexico's modernization, 169; and modernity versus tradition tensions, 139–142, 169–170; modernization, 169; and modern vs. traditional views of Mexico, 169–170; and *Monumento a Tanganxuan*, 194, 197; and Morelos statue, 60, 63–64, 213; and Pátzcuaro's regional identity, 21; and *El Plan Sexenal* mural, 142–149; and the Plaza Chica, 114; and Primera Exposición Objectiva del Plan Sexenal, 145–147; and secularization in Pátzcuaro, 123; and tourism and travel, 15, 21, 27, 44. *See also El Plan Sexenal* (The Six-Year Plan)

Modotti, Tina: and antipicturesque depictions of Pátzcuaro, 45, 46, 58; and *artesanías*, 153, 154; and creation of Pátzcuaro *típico*, 103; and picturesque depictions of Pátzcuaro, 97, 97; and secularization in Pátzcuaro, 126; travels of, 45, 59, 126, 236

Monsiváis, Carlos, 179

Montaño, Alberto Leduc. *See* Leduc, Alberto

Montenegro, Roberto, 8, 44, 152, 157–158, 161, 236

monumentality, 39, 44, 51–53, 54–57, 63, 197. *See also Monumento a Morelos* (Ruiz)

monumental realism, 173

Monumento a Cuauhtémoc (Noreña), 193

Monumento a Gertrudis Bocanegra (Ruiz), 111–112, 114, 216, 217, plate 7

Monumento a la revolución (Ruiz), 219–221, 220

Monumento a Morelos (Ruiz), 16–17, 20, 60–67, 62, 64, 65, 77, 104, 166, 207–214

Monumento a Tanganxuan (Ruiz and Zúñiga), *192*, 193–199, *195*, *196*, 204, plate 8

monuments. *See* public sculptures and monuments; *specific buildings and artworks*

More, Thomas, 200, 203, 223

Morelos de Pavón, José María, 3, 7, 60–67, 74, 207–214, 223, 229, 244–245, 249

Moreno, Manuel, 58

Morrow, Dwight D., 77

Motorist Guide to Mexico (Toor), 106

Mraz, John, 35, 104, 239

mudejar, 95, 101, 114, 133–134

Múgica, Francisco, 2, 257, 258

Mujeres de Pátzcuaro (Gómez), 104, *105*

Mujer purépecha (Purépecha Woman) (Fototeca Nacional), 134, *135*

mulatos, 89, 92, 106, 107, 213, 275n18. *See also* African heritage; Afro-Mexicans

Muñoz, Manuel, 205

murals: and aerial views of Pátzcuaro, 75–76, 78–80; and Alva de la Canal's *Vida de Morelos* in *Monumento a Morelos*, 210–213, *211*, *244–245*, 292–293n20; and *artesanías*, 153, 155, 160, 162; Bárcenas's *El Plan Sexenal*, 142–149; Bárcenas's *Industrias de Michoacán*, 149–151; and La Biblioteca Pública Gertrudis Bocanegra, 122; and Cárdenas-era institution building, 231–232, 234–236; and Cárdenas's cultural legacy, 1, 3; and Cárdenas's modernization program, 142–145; and Cárdenas's support of public art, 1–2; and creation of modern Pátzcuaro, 253, 255–256; and creation of Pátzcuaro history, 177–179, 221–223, 225–226; and creation of the Cárdenas myth, 244, 247–250; and cultural politics of the 1930s, 172–175; and depictions of Lake Pátzcuaro, 67–70; and depictions of Pátzcuaro, 25, 27; and the Teatro Emperador Caltzontzin, 68–69, 120; and the Biblioteca Pública Gertrudis Bocanegra, 122; Greenwood's *Paisaje y economía de Michoacán*, 54–57, *55*; and history parades, 181; and indigenous

identity, 165–167; and La Quinta Eréndira (Revueltas and Cueva del Rio), 189, 193, 206, 247–250; and market scenes, 104, *105*, 109, 113; and Mexican regional identities, 8; and Mexico's postrevolutionary reconstruction, 4–5; and modern vs. traditional views of Mexico, 169–172; and *Monumento a Tanganxuan*, 193, 194; and official vision of Pátzcuaro, 81; and Pátzcuaro's regional identity, 13–14, 21–23; and promotion of domestic tourism, 18; and Purépecha culture in Pátzcuaro, 187; and Quiroga's legacy in Michoacán, 201; and state modernization project, 138–139, 141–142; and visual culture of tourism, 83. See *La história de Michoacán* (O'Gorman)

Murillo, Gerardo (Dr. Atl), 8, 44, 110, 152, 155

Museo de Artes e Industrias Populares, 1–2, 142, 158, 161, 163, 171, 199, 202, 255, 258

Museo Michoacano, *238*

Museo Nacional de Arqueología, Historia y Etnografía, 3, 132

Museo Nacional de la Historia, 3

Museum of Modern Art (New York), 40

music, 11, 18, 43–44, 120, 131, 155, 198, 203, 205, 254, 283–284n51

Mussolini, Benito, 78

myth-making strategies, 12, 228–230, 239–252

El Nacional, 239, 240, 241, 243, 245

Nahuachín, 202

Nanuma, 184

national architecture, 130–137

National Autonomous University of Mexico. *See* Universidad Nacional Autónoma de México (UNAM)

National Geographic, 36, *38*, 38–39, 60, *195–197*

national geography, 163–169

nationalism, 8, 15, 139–140, 176–177, 189–190

tions of Pátzcuaro, 46, 58; and architecture of Plaza Chica, 122; and *artesanías*, 150, 157, 163, 168; and Cárdenas's cultural legacy, 1–2; and Cárdenas's monument projects, 207; and centralization of Mexican state, 11; and creation of "national" architecture, 134–136; and creation of Pátzcuaro history, 222–223, 226; and creation of Pátzcuaro *típico*, 100; and creation of the Cárdenas myth, 248–250; and depictions of indigenous figures, *34, 39–41, 40, 42, 46, 55–57, 58–60, 61, 74,* 104, 107, 134–136, *135,* 197, 222–224; and depictions of Lake Pátzcuaro, 67; and depictions of Pátzcuaro, 28–29, 39; history of, 2, 11, 67, 74, 107–108, 186–199, 222–223; and history parades, 182, 184; and indigenous identity, 167–168; and La Quinta Eréndira, 54, 188–193; and legacy of Cárdenas's Pátzcuaro project, 257, 259; and market scenes, *88,* 104; and *Monumento a Tanganxuan,* 193–199; and picturesque depictions of Pátzcuaro, 39–41, 95; and promotion of domestic tourism, 17, 20; and Purépecha culture in Pátzcuaro, 186–199; and Quiroga's legacy in Michoacán, 202, 206, *206;* and social realist murals, 54–56, *55;* and tourism promotion in Pátzcuaro, 74. *See also* indigenous peoples

Que hará mi país en seis años (Luna Arroyo), 147, *149*
¡Que lindo es Michoacán! (film), 253–254
La Quinta Eréndira, 2, *188,* 188–193, *192,* 236, 247–248, *249,* 250–251
La Quinta Tzipecua, 257
Quiroga, Vasco de: and *artesanías,* 157–158, 164–165; and Bárcenas's *Industrias de Michoacán,* 138, 165; and Cárdenas's monument projects, 207; and centralization of Mexican state, 11; and colonial background of Pátzcuaro, 199–200; and creation of Pátzcuaro history, 223–225, *224;* and creation of the Cárdenas myth, 165, 203–204, 243, 249–250; and Cueva del Río

mural, *206;* and depictions of indigenous figures, 107; and Teatro Emperador Caltzontzin murals, 138; and Eréndira/*La Sirena* myth, 281n137; and heroic iconography, 229; and historiogrpahy, 203–204; and history parades, 182–184, *183;* and indigenous identity, 166–167; influence in Michoacán, 200–206; and Jesuit churches, 130; and *Monumento a Tanganxuan,* 194; monuments to, 288n57; and O'Gorman's *La historia de Michoacán,* 224; and Pátzcuaro's cultural influence, 2; and picturesque depictions of Pátzcuaro, 91, 95–96; and the Plaza Chica, 114; and Plaza Chica fountain sculpture, 91, 276n41; and Primer Congreso Interamericano de Indigenistas, 165, 199, 204; and racial categories, 140; and secularization in Pátzcuaro, 125

race and racial ideology, 140–141; and art and architectural history, 132–134; and *artesanías,* 150–151, 163, 165–169; and art making, 51, 163; and geography, 140–141, 163–169, 188; and *lo típico,* 22, 87–90, 113, 136; and nation building, 75, 130–131, 134, 136–137, 140, 163, 190, 193; and racial categorization, 22–23, 107–108, *137,* 163–164; and temporality, 35, 51–53, 163; and tourism, 75, 171–172. See also *indigenismo; mestizaje* and mestizo identity; physiognomy
radio, 10
"Rafael" (photographer), 41–42
Ramey James, 58
Ramírez Barreto, Ana Cristina, 189, 191
Ramírez del Prado, Marcos, 184
Ramos, Feliciano, 126, 182–184
rebozo, 53, 55, 56, 90, 95, 103, 109, 112, 120, 138, 164, 166, 228
Reforma, 102, 125
regional economies, 2, 6–7, 10–11, 16, 33, 42, 45, 54, 63, 104, 164, 167, 214, 250, 259
regional folklore, 59–60. See also *artesanías;* dance; Eréndira; music; *La Sirena*